The Spivak Reader

The Spivak Reader

Selected Works of
Gayatri Chakravorty Spivak

Edited by

Donna Landry

and

Gerald MacLean

ROUTLEDGE
NEW YORK
& LONDON

Published in 1996 by

Routledge
29 West 35th Street
New York, NY 10001

Published in Great Britain by
Routledge
11 New Fetter Lane
London EC4P 4EE

Library of Congress Cataloging-in-Publication Data
Spivak, Gayatri Chakravorty.
The Spivak reader / edited by Donna Landry and Gerald MacLean.
 p. cm.
Includes bibliographical references and index.
Contents: Bonding in difference: interview with Alfred Arteaga — Explanation and culture: marginalia — Feminism and critical theory — Revolutions that as yet have no model: Derrida's Limited Inc. — Scattered speculations on the question of value — More on power/knowledge — Echo — Subaltern studies: deconstructing historiography — How to teach a "culturally different" book — Translator's preface and afterword to Mahasweta Devi, Imaginary Maps — Subaltern talk, interview with editors.

ISBN 0-415-91000-5 (cl) — ISBN 0-415-91001-3 (pbk)

 1. Culture. 2. Social history. 3. Feminist theory. 4. Feminist criticism.
 5. Feminism and literature. I. Landry, Donna. II. MacLean, Gerald M. III. Title.

HM101.S7733 1995 95-22222
306—dc20 CIP

CONTENTS

PERMISSIONS

The author and editors gratefully acknowledge the permission of the journals and publishers that follow to reprint these essays in their revised form: Duke University Press for "Bonding in Difference," from Alfred Arteaga, ed., *An Other Tongue: Nation and Ethnicity in the Linguistic Borderland* (1994), pp. 273–85; *Humanities in Society* for "Explanation and Culture: Marginalia," from 2:3 (1979), pp. 201–21; the University of Illinois Press for "Feminism and Critical Theory," from Paula Treichler, Cheris Kramerae, and Beth Stafford, eds., *For Alma Mater: Theory and Practice in Feminist Scholarship* (1985), pp. 119–42; *Diacritics: A Review of Contemporary Criticism* for "Revolutions That As Yet Have No Model: Derrida's 'Limited Inc.,'" from 10:4 (1980), pp. 29–49, and "Scattered Speculations on the Question of Value," from 15:4 (1985), pp. 73–93; State University of New York (SUNY) Press, Albany, for "More on Power/Knowledge," from Thomas E. Wartenberg, ed., *Rethinking Power* (1992), pp. 149–73; *New Literary History* for "Echo," from 24:1 (1993), pp. 17–43; Oxford University Press, New Delhi, for "Subaltern Studies: Deconstructing Historiography," from Ranajit Guha, ed., *Subaltern Studies IV: Writings on South Asian History and Society* (1985), pp. 330–63; Manchester University Press for "How to Teach a 'Culturally Different' Book," from Francis Barker, Peter Hulme, and Margaret Iverson, eds., *Colonial Discourse/Postcolonial Theory* (1994), pp. 126–50.

ACKNOWLEDGMENTS

The editors would like to thank Bill Germano for his insistence and Eric Zinner for his assistance. The Office of the Dean for Graduate Research at Wayne State University provided funds for us to travel to New York to conduct the interview. Very special thanks to Jo Dulan for spending so long away from her own research to help prepare the initial computer files. For various other forms of help without which we would never have completed this project, our thanks to Alfred Arteaga, Vivek Bald, Mary Lynn Broe, Eric Halpern, Peter Hulme, Thomas Keenan, Suchitra Mathur, Anita Roy, Leah Schoenewolf, Nigel Smith, Robert Young, and, of course, Gayatri Spivak herself.

Reading Spivak

If you have been reading Spivak, you will know that writing an introduction to her work is no easy task. In 1976 Spivak published *Of Grammatology*, an English translation of the French philosopher Jacques Derrida's *De la grammatologie* (1967). Besides introducing this influential thinker to English-speaking audiences, Spivak's "Translator's Preface" set a new standard for self-reflexivity in prefaces and introductions. It addressed from every conceivable angle the "question of the preface" and what it meant to translate and explicate the work of Derrida, who developed the form of philosophical critique known as deconstruction. In her "Preface," Spivak briefly introduced Derrida, the man or biographical subject, and Derrida, the collection of published writings, before turning to the question of the preface as a form *of* writing and an occasion or event *in* writing, with particular protocols to be observed. This attention to the particular protocols of specific occasions is one of the characteristic gestures of deconstruction.

Like Spivak introducing Derrida, we shall have to assume that some introduction to Spivak is in order.

SPIVAK

Gayatri Chakravorty was born in Calcutta on 24 February 1942, the year of the great artificial famine and five years before independence from British colonial rule. She graduated from Presidency College of the University of Calcutta in 1959 with a first-class honors degree in English, including gold medals for English and Bengali literature. At this time, degree requirements in English Literature at Calcutta compared to those at Oxbridge; a degree from Calcutta amounted to a comprehensive first-hand reading knowledge of all literature in "English" from just before Chaucer up to the mid-twentieth century, with a special focus on Shakespeare. After a Master's degree in English from Cornell and a year's fellowship at Girton College, Cambridge,

Spivak took up an instructor's position at the University of Iowa while completing her doctoral dissertation on Yeats, which was being directed by Paul de Man at Cornell. Along the way she married and divorced an American, Talbot Spivak, but has kept his surname, under which her work first appeared in print. She currently holds the Avalon Foundation Professorship of the Humanities at Columbia University.

Today, Spivak is among the foremost feminist critics who have achieved international eminence, and one of the few who can claim to have influenced intellectual production on a truly global scale. In addition to the groundbreaking translation of Jacques Derrida's *Of Grammatology*, Spivak has published four books, a volume of interviews, and numerous theoretical and critical articles. The checklist of her publications included at the end of this volume indicates the extent and range of Spivak's writing. A revised version of her dissertation, popularized on what she herself describes as a "sixties impulse," appeared in 1974, entitled *Myself Must I Remake: The Life and Poetry of W. B. Yeats. In Other Worlds: Essays in Cultural Politics*, a collection published in 1987, brought together scattered essays on topics as varied as Dante, Marx, Wordsworth, and the Indian writer Mahasweta Devi. *The Post-Colonial Critic: Interviews, Strategies, Dialogues* (1990), put together by Sarah Harasym, was an attempt to make Spivak's thinking more accessible to those who found the essays in *In Other Worlds*—now in its fifth reprinting—difficult. *Outside in the Teaching Machine* (1993) is a more integrated volume of essays, some new, some revised from previous publication, in which Spivak offers analyses of, and strategies for improving, higher education in a global context. The "Translator's Preface" and "Afterword" to *Imaginary Maps* (1994), a collection of stories by Devi translated into English by Spivak, are included in this reader. *An Unfashionable Grammatology: Colonial Discourse Revisited*, her long-awaited archival and theoretical study of gender and colonial discourse, is in preparation as *The Spivak Reader* goes to press.[1]

Gayatri Chakravorty Spivak is also this collection of texts.

Particularly in the United States, where Spivak has made her academic career, there has been within the various women's movements a strong populist impulse that has encouraged feminist critics and intellectuals to keep their work accessible to general audiences. In spite of this pressure, and the anti-intellectual tendencies of U.S. culture generally, Spivak has relentlessly challenged the high ground of established philosophical discourse. She has done so in difficult theoretical language, and on grounds recognizable to philosophers, especially those trained in the traditions of continental philosophy. Although her own primary training was in literary criticism, Spivak has a command of philosophy and ethics, as well as political economy and

social theory. Thus she has been able to challenge the practitioners of the academic disciplines of philosophy and history in the United States, Britain, India, and elsewhere in terms that, if not exactly their own, are nevertheless recognizable; terms that specifically explore the margins at which disciplinary discourses break down and enter the world of political agency. The range of this challenge has made her work seem remote and difficult to some readers, and she has been controversially received by academic philosophers, historians, literary scholars, and elite Indianists, especially those antagonistic to deconstruction, poststructuralism, subaltern studies, and post-1968 French thinking, with which her work often engages.

Yet it would be a serious mistake to assume that Spivak's work is so esoteric that she has no audience outside the academy. During the past fifteen years, her career has followed a complex intellectual trajectory through a deeply feminist perspective on deconstruction, the Marxist critique of capital and the international division of labor, the critique of imperialism and colonial discourse, and the critique of race in relation to nationality, ethnicity, the status of the migrant, and what it might mean to identify a nation or a cultural form as postcolonial in a neocolonial world. This intellectual trajectory has gained for Spivak a relatively heterogeneous international audience.

It helps, of course, that Spivak is a very powerful and charismatic speaker. When she came to Detroit, for instance, in March 1991, she addressed a large, metropolitan, racially and ethnically mixed audience at the Detroit Institute of Arts as part of its Lines speaker series on new writing in America. Her lecture, "War and Cultures," addressed questions of multiculturalism with reference to the linguistically hybrid work of Guillermo Gómez Peña, the Chicarrican artist from Tijuana-San Diego, and an installation by the Lebanese-Canadian artist Jamelie Hassan, in the highly charged political context of U.S. anti-Arab racism at the time of the Gulf War. Not only did Spivak receive a standing ovation, a fairly unusual response for a museum lecture from a cool urban crowd, but she was also accompanied afterward to the reception following her talk by an enthusiastic group of African American women not from the local university, but from the Detroit community. One woman carried a much-read copy of Spivak's translation of Derrida's *Of Grammatology*. Her daughter, also part of the group, was reading *In Other Worlds* for a course at her inner-city high school. For these women, Spivak's feminist critique of the links between racism and capitalism had been crucial for their intellectual development. They embraced her as a profoundly political sister, not as an inaccessible academic.[2]

Though these are times of right-wing backlash on a global scale, cultural resistance continues. It would be misleading to cast Spivak as a lone crusader or an academic outsider. Despite the difficulties that some U.S.

4

readers have experienced with her ideas and writings, Spivak's contributions to the critical investigation of literary and cultural theory have at last been widely recognized within the U.S. academy. Since the late 1970s her reputation has become increasingly international as well. Spivak has held visiting university appointments in France, India, and Saudi Arabia, and has lectured extensively throughout the U.K., U.S., Australia, Canada, the Indian subcontinent, Belgium, Eire, Finland, France, Germany, Hong Kong, Italy, Singapore, South Africa, Sweden, Taiwan, the former Yugoslavia, and before the European Parliament in Strasbourg. Her sustained critical engagement with the intellectual tradition represented by the writings of Freud, Lacan, Marx, Derrida, and Foucault has been instrumental in transforming and politicizing the reception of the feminist and poststructuralist critiques of psychoanalytic and Marxist thought. Moreover, her wide-ranging critical and theoretical challenges continue to influence the development of multicultural studies, postcolonial studies, and feminist theory not only in the U.S., but also internationally.

Considerable as it already is, then, Spivak's intellectual achievement is so far from being "over" or completed that any summary runs the risk of foreclosing on what is, both in fact and effect, a continuing politico-intellectual global activism. Nevertheless, if we were to formulate the essential Spivak for the contemporary moment, the following slogans could serve as a beginning:

UNLEARNING ONE'S PRIVILEGE AS ONE'S LOSS

This is one of the most powerful tasks set readers by Spivak's writing and teaching. The injunction to "unlearn," recently advocated by the young African American filmmaker John Singleton in publicizing the anti-racist message of his most recent film, *Higher Learning*, means working critically back through one's history, prejudices, and learned, but now seemingly instinctual, responses. If we can learn racism, we can unlearn it, and unlearn it precisely because our assumptions about race represent a closing down of creative possibility, a loss of other options, other knowledge. Whoever we are, if we are reading Spivak, we are likely to be comparatively privileged, at least in terms of educational opportunity, citizenship, and location within the international division of labor. Unlearning one's privilege by considering it as one's loss constitutes a double recognition. Our privileges, whatever they may be in terms of race, class, nationality, gender, and the like, may have prevented us from gaining a certain kind of Other knowledge: not simply information that we have not yet received, but the knowledge that we are not equipped to understand by reason of our social positions. To unlearn our privileges means, on the one hand, to do our homework, to work hard at gaining some knowledge of the others who occupy those

spaces most closed to our privileged view. On the other hand, it means attempting to speak to those others in such a way that they might take us seriously and, most important of all, be able to answer back.

Unlearning our privilege as our loss is a task for everyone, from Spivak herself to her white male students, who may feel silenced by the recent upsurge of feminism and marginality studies: "I am only a bourgeois white male, I can't speak." In an interview in *The Post-Colonial Critic*, Spivak advises them, "'Why not develop a certain degree of rage against the history that has written such an abject script for you that you are silenced?' Then you begin to investigate what it is that silences you, rather than take this very deterministic position—since my skin colour is this, since my sex is this, I cannot speak" (p. 62). Doing one's homework in the interests of unlearning one's privilege marks the beginning of an ethical relation to the Other.

ETHICS ARE NOT A PROBLEM OF KNOWLEDGE BUT A CALL OF RELATIONSHIP (WITHOUT RELATIONSHIP, AS LIMIT CASE)

In "Echo" (see p. 175), Spivak outlines a formulation of ethics through a decipherable instance of the ethical relation in the myth of Echo and Narcissus. Spivak wonders how it is that Freud and others have attributed narcissism primarily to women, when Narcissus was a boy. Where is Echo, the woman in the story? Reading Echo in all her complexity requires a critique of narcissism, that touchstone of Western imperial and masculine identities. Figuring identities and relations differently—not as narcissistic fixtures expecting mirror-reflections across the globe, but as a call to honor and embrace across impossible differences and distances—is indispensable for any movement toward decolonization. As Spivak observes in both "How To Teach a 'Culturally Different' Book" and her "Translator's Preface and Afterword" to Devi's *Imaginary Maps* (see p. 237, p. 267), we must perpetually keep in mind the question "*Who decolonizes? And how?*"

Thinking of the ethical relation as an embrace, an act of love, in which each learns from the other, is not at all the same thing as wanting to speak *for* an oppressed constituency. Throughout her work Spivak has been concerned with addressing questions of the international division of labor (of the super-exploitation of Third World female labor in particular) and she is well-known for her formulations on the subaltern, that constituency which remains most excluded from the circuits and possible benefits of socialized capital. As she explains in the interview "Subaltern Talk" (see p. 287), when she claims that the subaltern "cannot speak," she means that the subaltern as such cannot be heard by the privileged of either the First or Third Worlds. If the subaltern were able to make herself heard—as has happened when particular subalterns have emerged, in Antonio Gramsci's terms, as

organic intellectuals and spokespeople for their communities—her status as a subaltern would be changed utterly; she would cease to be subaltern. And that is the goal of the ethical relation Spivak is seeking and calling for—that the subaltern, the most oppressed and invisible constituencies, as such might cease to exist.

Such a revolutionary change will not be brought about by traditional revolutionary means, nor by intellectuals attempting to represent oppressed minorities, nor worse yet, pretending merely to let them speak for themselves. Here Spivak's deconstructive vigilance leads her to keep in mind at all times the dangers of fundamentalism in any form and to insist on the two meanings of "representation."

DECONSTRUCTION CANNOT FOUND A POLITICAL PROGRAM OF ANY KIND. YET IN ITS SUGGESTION THAT MASTERWORDS LIKE "THE WORKER" OR "THE WOMAN" HAVE NO LITERAL REFERENTS, DECONSTRUCTION IS A POLITICAL SAFEGUARD.

This passage, paraphrased from an interview in *The Post-Colonial Critic* (p. 104), exemplifies in its simplicity the practical and political Spivak, whose theorizing is always ultimately directed at intervention, at attempting to change the world. Yet how can one help to bring about change without repeating the mistakes of previous political movements that have sought liberation yet ended in repression and fundamentalism? We can make a start, Spivak suggests, by keeping in mind the two meanings of "representation," which would have been clear to Marx, writing in German, but which English usage elides: "Treading in your shoes, wearing your shoes, that's *Vertretung*. Representation in that sense: political representation. *Darstellung*—*Dar*, 'there', same cognate. *Stellen*, is 'to place', so 'placing there.' *Representing*: 'proxy' and 'portrait'.... Now, the thing to remember is that in the act of representing politically, you actually represent yourself and your constituency in the portrait sense, as well" (*The Post-Colonial Critic*, p. 108). As we have observed elsewhere, the danger lies in collapsing the two meanings, mistaking the aesthetic or theatrical sense of representation—as re-staging or portraiture—for an actual being-in-the-other's-shoes.[3] This collapsing leads to the fundamentalist mistake: assuming that always imagined and negotiated constituencies based on unstable identifications have literal referents: "the workers," "the women," "the word." But there is no *Vertretung* without *Darstellung*, without dissimulation; the two terms are locked into complicity with one another. Deconstruction perpetually reminds us of this complicity, which fundamentalism would pretend to do without.

PERSISTENTLY TO CRITIQUE A STRUCTURE THAT ONE CANNOT NOT (WISH TO) INHABIT IS THE DECONSTRUCTIVE STANCE.

These are nearly the last words of *Outside in the Teaching Machine* (p. 284), Spivak's most recent collection of essays, but they echo her most persistent take on deconstruction, repeated from the "Translator's Preface" to *Of Grammatology* until the present day. If one sets out to do a critique of metaphysics, there is no escape from the metaphysical enclosure. You cannot simply assert, "I will be anti-essentialist" and make that stick, for you cannot *not* be an essentialist to some degree. The critique of essentialism is predicated upon essentialism. This is why it is especially important to choose as an object of critique something which we love, or which we cannot not desire, cannot not wish to inhabit, however much we wish also to change it. Spivak translates Derrida in *Of Grammatology* as follows: "Operating necessarily from the inside, borrowing all the strategic and economic resources of subversion from the old structure, borrowing them structurally, that is to say, without being able to isolate their elements and atoms, the enterprise of deconstruction always in a certain way falls prey to its own work."[4]

This deconstructive liability, this self-confessed fallibility of deconstruction, is in some sense its greatest gift, according to Spivak. Her own intellectual production is as subject to its exigency as any other.

We hope that these few Spivakian rules-of-thumb provide some sense of why her work might be interesting, important, and worthy of the careful and patient unpacking it requires.

THE SPIVAK READER

In selecting from among the range of possible options presented by Spivak's list of publications, talks, and interviews, we have attempted to assemble not so much a "bluffer's guide to Spivakism" as an exemplary series of places to start reading Spivak.

We have attempted to trace what she calls the "itinerary" of her thinking over the last fifteen years. The power of this specific metaphor arises from its illustration of how Spivak's thinking proceeds: it is not fixed and finite in the form of thought as a "product," but active—think*ing*—a journey that involves moving back and forth over both familiar and less familiar intellectual terrains while constantly interrogating its own premises. Here the strong connection between Spivak's research and writing and her *teaching* should be noted, since most of her published writings have arisen from attempting to work through the critical problems that crop up in pedagogical situations.

In a certain way, Spivak's reception has been a curiously silent or oblique

one. Have her achievements seemed too formidable or complicated to be commented upon according to the usual forms? Indeed, while citations to her work can be found thickly scattered across various fields of scholarly publication, the true range and importance of her intellectual influence cannot be measured in the number of scholarly articles, chapters, or books dedicated to "explaining" Spivak. For that, we would somehow have to assess not only the conversations and ideas that her lectures and writings continue to stimulate directly, but also the immeasurable differences that her work has made to the thinking of feminists, cultural critics, and political activists in places as far flung as Delhi, New York, Riyadh, Hyderabad, Lünd, and Sydney.

The essays collected in the present volume range across Spivak's contributions to many different aspects of intellectual and political life subsequent to her introduction of Derrida to English-speaking audiences. The essays are not simply arranged in chronological sequence; we imagine that readers coming to Spivak's work for the first time will find the thematic and developmental arrangement we have adopted to be more helpful than a strict chronology would be. The nine essays are bracketed by two very recent interviews, "Bonding in Difference," with Alfred Arteaga, and "Subaltern Talk." "Can the Subaltern Speak?," published in 1988 but based on a 1983 lecture, would make the collection more complete, but we gave way to Spivak's resistance to this idea, because she is revising the essay in such a way that the first version, although unchanged in its conclusions, will, in its details, become obsolete.

The first five essays in *The Reader* represent key moments in Spivak's deconstructive critique, especially the ways it has both challenged and transformed the development of feminism, Marxist analysis, and cultural theory. The next four essays sharpen, extend, and broaden that project by examining the politics of translation and multiculturalism in a variety of textual, historical, and political arenas. This order, we trust, will usefully indicate how the itinerary of Spivak's critical thinking is not a settled achievement but a continuing process, a constant challenge to reread Freud, Marx, Derrida, and Foucault, bringing their provisional certainties to crisis as we attempt to negotiate with the daily events that constitute our political lives in both the local and the global sense. Spivak pays considerable attention to the management of the subaltern in the southern hemisphere, the developing world of the New World Order, so that by a "setting to work" of theory in these locations she can gauge the limits of the theory that influences her.

It is curious but revealing that as Spivak has increasingly expanded her interests beyond the European literary and philosophical traditions to the history of imperialism and non-elite or subaltern insurgency, she has gained

new audiences interested in race, gender, colonial discourse, and multicultural education, but also lost ground within the deconstructive establishment. To be given a hearing by Third World scholars and ethnic studies or minority discourse specialists would seem to be accompanied by being marginalized on the high deconstructivist agenda. Although Spivak initially became known as the translator of Derrida and an advocate of deconstruction, and although she remains one of the few intellectuals actually carrying out the suggestions made by the post-Enlightenment ethical movement associated with Derrida and Emmanuel Levinas, scholars who have engaged in high ethical debates in the recent past seem to have ignored her contributions. Comparison of two recent issues of *Diacritics*, a journal published by the Department of Romance Languages at Cornell University, and one that has served as one of the chief organs of deconstructivist debate, illustrates this asymmetrical reception. In the Spring 1993 issue, Rey Chow features Spivak in her essay "Ethics after Idealism." Chow, a feminist who works on questions of identity, ethnicity, and postcoloniality, reads Spivak and Slavoj Žižek as two of the "most energetic" post-Marxists writing today. Three issues later, however, in the Winter 1993 issue, two other pieces on ethical questions, including the question of the Other, neglect to mention Spivak. It is as if Spivak's work had become contaminated by too long an association with Marxism, Third Worldism, and international feminism to possess a theoretical position pure enough to be entertained any longer as high ethical discourse.[5] This foreclosure in ethics of considerations of power or politics is, of course, precisely Spivak's point in the recent interventions included in *The Reader*.

Living in an age much given to interest in the personal, we have placed "Bonding in Difference" first, since in this interview Spivak reflects autobiographically. By turning her personal recollections against their historical contexts, however, in a characteristic gesture she resists playing into the cult of personality or trading on her intellectual-celebrity status, thereby demonstrating how deconstruction interrogates claims made on behalf of the merely personal:

> Deconstruction does not say there is no subject, there is no truth, there is no history. It simply questions the privileging of identity so that someone is believed to have the truth. It is not the exposure of error. It is constantly and persistently looking into how truths are produced. That's why deconstruction doesn't say logocentrism is a pathology, or metaphysical enclosures are something you can escape. Deconstruction, if one wants a formula, is, among other things, a persistent critique of what one cannot not want. And in that sense, yes, it's right there at the beginning.

Right there at the beginning, deconstruction opens up the personalist belief in identity-as-origin not by denying experience, but by insisting upon the need to examine the processes whereby we naturalize personal experience and desire into general truth. Deconstruction is not the end of ethics, politics, or history, as Spivak makes clear in her "Translator's Preface" to Devi's *Imaginary Maps*, when she echoes Derrida on the question of deconstruction and ethics in a statement too often misread as signifying the ahistoricity of deconstruction: "Please note that I am not saying that ethics are impossible, but rather than ethics is the experience of the impossible."

Constantly stressing the interconnectedness of the seemingly disparate aspects of her intellectual production, Spivak says of herself in "Bonding": "I have two faces. I am not in exile. I am not a migrant. I am a green card-carrying critic of neocolonialism in the United States. It's a difficult position to negotiate, because I will not marginalize myself in the United States in order to get sympathy from people who are genuinely marginalized." Spivak first opened up this discussion of the foundational premises of what constitutes "truth" within the academic community at large in the first essay reprinted here, "Explanation and Culture: Marginalia" (1979). She did this by introducing the problematics of her own position as an internationalist, a feminist, and a literary critic who works within the protocols of reading named "deconstruction." With the third essay, "Revolutions That As Yet Have No Model: Derrida's 'Limited Inc.,'" *The Reader* moves from the second essay, 1985's "Feminism and Critical Theory," back to 1980, in order to pick up on questions concerning deconstruction that were greatly troubling to the English-speaking academy at that time. For many readers, this essay may prove as difficult as any that follow, but it develops directly from the previous essays by pursuing the aim announced toward the end of "Feminism and Critical Theory": to learn "how to read [our] own texts."

In "Revolutions That As Yet Have No Model," Spivak addresses in detail two texts by Derrida that she cited in "Explanations" as the source of her understanding of Derridean deconstruction and proceeds to read them deconstructively. In the first part of the essay, Spivak reads the debate between speech-act theorist John Searle and Derrida; in the second part she reads Derrida's texts alongside Heidegger. For those unfamiliar with Derrida, Searle, and Heidegger, the going will be tough and the rewards not immediately apparent. Like Marx, Spivak is often most powerfully suggestive when engaged in polemic. Here she makes no attempt at impartiality since one of her principal aims in the piece is to demonstrate how Derrida's response to Searle exemplifies many of the necessarily practical implications of Derrida's general critique of metaphysics. In a scrupulously exacting and highly nuanced style of philosophical critique, Spivak describes

what it means to take Derrida's project seriously, to read according to the strategy of what she elsewhere terms "the reversal-displacement morphology of deconstruction" ("Feminism and Critical Theory"), and, finally, to engage in undoing philosophical discourse of this very kind.

As she observes in the final paragraph of "Revolutions," students trained to read within liberal-humanist discourses of identity and meaning tenaciously claim "their opinions' center as their own self-possession." If Spivak's prose is challenging, it challenges us on our own grounds as readers, as centered producers of meaning. For those readers—and who among us is not necessarily included in this indictment?—trained to start reading by "finding oneself in the text," it might prove useful to approach this essay by glancing at the end, with the final paragraph addressed to "graduates and undergraduates."

For some, this paragraph might supply an entire evening's worth of reading and rereading precisely because its challenge can only be expressed in a language that seems "difficult," but that is, rather, the achieved vocabulary of a powerful critical discourse seeking to change the way we read our world. Here is the penultimate sentence:

> The "deconstructive" lesson, as articulated in *Limited Inc.*, can teach student and teacher alike a method of analysis that would fix its glance upon the itinerary of the ethico-political in authoritarian fictions; call into question the complacent apathy of self-centralization; undermine the bigoted elitism (theoretical or practical) conversely possible in collective practice; while disclosing in such gestures the condition of possibility of the positive.

We should notice that the operative term here is "'deconstructive' lesson" and not "deconstructionist." "Deconstructionist" is a term often used to describe the processes of deconstruction by those outside it, those who don't themselves follow the protocols of deconstruction, "in a certain way always a prey to its own critique" (*OG*, 24, translation modified). The deconstructive lesson provides a new way of looking at things and tasks. We've already encountered "itinerary" in this introduction, so we have no trouble fixing our glance on it and noticing how it here performs a new metaphorical turn, thereby announcing the allegorical figure of "the ethico-political" journeying through "authoritarian fictions." This development deserves at least a semicolon pause, whatever sort of reader we are; because yes, that is just what—by definition—authoritarian fictions do, they narrate ethico-political conflict metaphysically ("good" versus "evil") even when they might claim to be about something else. Fictions always come to an end, and in the authoritarian kind, plots are invariably "solved" by the superimposition of a third term, "power."

So, to pick up the syntax, what's to be learned from reading deconstructively is that it is particularly ethically and politically useful to look at authoritarian fictions by noticing how they figure conflicts and power, and, within the same activity of reading, to continue addressing ourselves as readers caught up in the complicities of what the quoted paragraph previously termed the "de-historicized academy." For we are surely invited to recognize ourselves—whatever positions we may occupy with respect to academic institutions—in the suggestion that student and teacher like can learn to "call into question the complacent apathy of self-centralization" that academic approaches to reading continue to encourage, especially in liberal arts programs. What's at stake here is that whenever we rest contented with saying "this is my reading, it's different from yours; but that's okay, we don't need to go any further" or whenever we feel, argue, or insist that what we do within the academy is merely academic and of such insufficient political consequence that we need do nothing because it won't count anyway, we are simply reproducing a general liberal dilemma and not doing what we think we are doing, whenever we imagine we are "thinking for ourselves."

So whenever we set about reading "our" texts and find them leading us obsessively back to ourselves, it is a good idea not to stop there, with ourselves as centers of meaning, but rather to go on and to think through the possibility that the personal might necessarily lead us outside "ourselves" to the political. The third and final part of Spivak's account of the deconstructive lesson certainly sounds political—the suggestion that we "undermine the bigoted elitism (theoretical or practical) conversely possible in collective practice; while disclosing in such gestures the condition of possibility of the positive." If her turns of language and thought here seem puzzling at first glance, this polemical rhetoric at the essay's end at least serves to warn us that there are dangers in beginning at the end of things. Spivak is, in large part, reflecting upon the conditions that made possible the very reading of Derrida, by way of Searle and Heidegger, that she has just performed.

Thus we propose that Spivak's "'deconstructive' lesson," while it can be glimpsed by sneaking a look at this final paragraph, will be more gratifyingly intelligible to those who have made the journey through the essay from the first paragraph instead.

Because of the difficulty of this essay, we have spent some time unpacking it here and in the headnote that accompanies it. The essays and interview that follow "Revolutions" may now seem like plain sailing, by contrast, though each is also prefaced by an explanatory headnote.

DONNA LANDRY and GERALD MACLEAN

NOTES

In presenting these writings, we have silently corrected errors in the original versions and standardized spelling, orthography, and reference formats as far as it has been possible to do so without significantly altering the style of the original. For example, in order to preserve the historical specificity of the original publication of "Revolutions That As Yet Have No Model" in 1980, we have left quotations and references to the 1977 publication, in *Glyph*, of Samuel Weber's and Jeffrey Mehlman's translation of Derrida's "Signature Event Context" and Weber's translation of "*Limited Inc.*" In subsequent citations of these texts by Derrida, we have followed Spivak's more recent practice and cited "Signature Event Context" from Alan Bass's translation in *Margins of Philosophy* (1982). References to Derrida's "White Mythology" throughout *The Spivak Reader* are to Bass's translation.

1. Unsolicited entries on or from "Spivak" have recently appeared in *The Johns Hopkins Guide to Literary Theory and Criticism*, Michael Groden and Martin Kreiswirth, eds. (Baltimore: Johns Hopkins University Press, 1994); *The Routledge Encyclopedia of Philosophy* (New York: Routledge, forthcoming); and the entry on "deconstruction" in *The Shorter Oxford English Dictionary*.

2. It is a bleak historical irony, but Spivak's was one of the last such guest performances at the Detroit Institute of Arts. As Kofi Natambu reports in his essay, "Nostalgia for the Present: Cultural Resistance in Detroit, 1977–1987," by March 1991 funding for the Lines program had already been cut, and by the end of that year the museum was to have its budget slashed by the recently elected Republican governor of Michigan, John Engler, as part of an economic gutting of the city. These policies included eliminating over 100,000 general assistance payments, many to disabled people, and most state monies for Medicare, Medicaid, and allotments for the homeless, in addition to funding for various arts projects and institutions; see Natambu in *Black Popular Culture*, a project by Michelle Wallace, Gina Dent, ed. (Seattle: Bay Press, 1992), pp. 173–86.

3. See Landry and MacLean, *Materialist Feminisms* (Oxford, UK and Cambridge, MA: Blackwell Publishers, 1994), pp. 197–98.

4. Derrida, *Of Grammatology,* trans. Gayatri Chakravorty Spivak (Baltimore: Johns Hopkins University Press, 1976), p. 24. Hereafter cited in the text as *OG*, followed by page references.

5. See Rey Chow, "Ethics after Idealism," *Diacritics* 23:1 (Spring 1993), pp. 3–22; Judith Butler, "Poststructuralism and Postmarxism," *Diacritics* 23:4 (Winter 1993), pp. 3–11; Robert Baker, "Crossings of Levinas, Derrida, and Adorno: Horizons of Nonviolence," *Diacritics* 23:4 (Winter 1993), pp. 12–41.

Bonding in Difference
Interview with Alfred Arteaga

<div style="text-align:right">(1993–94)</div>

ONE

This interview introduces Gayatri Spivak talking about such matters as the intersection of personal and national history, colonial discourse and bilingualism, and the different projects of working on behalf of identity and constructing new historical narratives from migrant-minority discourses in the United States, India, Bangladesh, and Britain. Alfred Arteaga, a young poet and scholar of Chicano literature and culture at the University of California, Berkeley, conducted this interview with Spivak in 1993.

In their conversation we can observe Arteaga's interest in seeing how Spivak will situate herself and her own postcolonial projects in relation to what he calls the internal colonization experienced by Chicanos and Chicanas. The historical differences between the New World and the Old; the legacy of the "failure" of Spanish imperialism in the Americas, especially when compared with British industrial-capitalist imperialism in India and Africa; and the academic competition over whose model gets to dominate the analysis of colonial discourse: each of these issues echoes throughout the conversation.

One reason why Spivak and Arteaga had this conversation is that both wish to challenge the kind of identity politics in which rival ethnicities compete for institutional precedence or academic turf. Neither of them would argue that only one who is a member of a social group can speak about or for or "represent" that group. For each of them, representation is always problematical, always double, and never adequate or complete. It entails both a standing-in-the-other's-shoes and an imaginative and aesthetic re-presentation, a staging in the theatrical sense. For some years Spivak has criticized a too-literal understanding of representation within identity politics, describing this position as "nativist," and exposing the repressive and fundamentalist politics of claiming that "only a native can know the scene." More importantly, she has also gone further than any other cultural theorist

in engaging with, retelling, and ethically and imaginatively inhabiting other people's narratives. As Ellen Rooney observes in an unpublished essay, "What's the Story? Narrative(s) in Feminist Theory," the strongest tendency in feminist storytelling to date has been to tell "*my* story as the story of *my* feminism." As with feminism and gender politics, so also with ethnic and other forms of identity politics. Rooney singles out Spivak's exceptional ability to tell "*your* story as the story of *my* feminism," to tell another person's story without appropriating it. She investigates and respects differences but acknowledges the anger or the political passion that the story generates as her own.

Young assistant professor and internationally known distinguished chaired professor, Arteaga and Spivak opt for solidarity rather than rivalry, for bonding in difference across historical and cultural divides.

ALFRED ARTEAGA: Tell me a little about yourself, about the influences upon you.

GAYATRI CHAKRAVORTY SPIVAK: Well, born in Calcutta in the middle of the war, 1942. Earliest memories are of the artificial famine created by the British military to feed the soldiers in the Pacific theater of the Second World War. It was obviously illegal to protest against this. As an extraordinary political move in response to this situation, was formed what became a major phenomenon, the Indian People's Theatre Association, IPTA. They took performance as the medium of protest. Obviously the British were not coming to check out street-level theater: the actors were not professional actors. What they were performing was the famine and how to organize against it.

I was growing up as a middle-class child in the shadow of the famine. The extraordinary vitality of the Indian People's Theatre Association was in the air. A relationship between aesthetics and politics was being deployed by people who were taking advantage of the fact that aesthetics had been officially defined as autonomous by colonial ideology. They were, in other words, using the enemy's definition of aesthetics as having an autonomous sphere and sabotaging that in order to bring back the relationship between aesthetics and politics in a very direct way. The fine thing was that the plays were good; the songs were good. One still sings those songs, even on marches. That's something that colored my childhood more than I knew then.

One of the big memories is of negotiated political independence, very early on. My generation was on the cusp of decolonization. On our childhood and adolescent sensibilities was played out the meaning of a negoti-

ated political independence. We were not adults; yet we were not born after independence. In a way, it's more interesting to have been in my generation than to have been a midnight's child, to have been born at independence, to be born free by chronological accident.

I come from the bottom layer of the upper middle class or the top layer of the lower middle class, depending on which side of the family you are choosing. I went to a missionary school, which is different from a convent. A convent is upper class and fashionable stuff. Mine was a cheap school, very good academic quality. By the time I was going, most of the teachers were tribal Christians, that is to say, Indian subalterns, lower than rural underclass by origin, neither Hindus nor Muslims, not even Hindu untouchables, but tribals—so called aboriginals—who had been converted by missionaries.

So that again, if the IPTA is one early experience, another early experience which then I didn't know was going to influence me so strongly was learning—as a child from a good caste Hindu family—from women who were absolutely underprivileged but who had dehegemonized Christianity in order to occupy a space where they could teach social superiors. The schooling was in Bengali, my mother tongue, until the last four years when, of course, it was hard to get us into English, since teachers and students were both Indian. But "English medium" still has glamour for the Indian middle class, presumably because it is still a better weapon for upward class mobility.

And then B.A. from Presidency College. I think that the strongest influence on students of my class going to that kind of college was the intellectual Left. It was, once again, a college known for academic excellence but not class-fixed, so that there was a sprinkling of students from working class and rural small bourgeois origins, as well as students from the upper middle, etc. It was a politically active institution. The atmosphere at the Ecole Normale on rue d'Ulm in Paris sometimes reminds me of my college. This was Calcutta, University of Calcutta. I left as a third-year graduate student for Cornell.

AA: How much English was there in your household?

GCS: Well, no, there wasn't much English in the household. That's a characteristic. Even now, for example, I will not write letters to my family in English. It's unthinkable, although they're all super educated. It is sometimes assumed that if one knows English well, then one would use English. That's not the case. One can know English as well as treasure one's own mother tongue. This is perhaps a Bengali phenomenon, rather than an Indian phenomenon, and there are historical reasons for this—or

at least one can construct a historical narrative as a reason.

To an extent there was in conversation, in writing, in reading even, in the family situation, one could say, no English. But in school, of course, English was one of the languages; English was a language that we learned in class. And we knew very well that in order to get ahead in colonial, and immediately postcolonial India, what you needed was English.

AA: I am interested in the ways diasporic intellectual workers describe themselves in light of their language use. For example, Jacques Derrida explained to me, in English, that he was raised in Algeria, a descendant of a Spanish Jewish family, but that he is not bilingual. Tzvetan Todorov, on the other hand, affirms the bilingualism and biculturalism of the Eastern European in the West. But it is an unequal bilingualism, weighted by time, distance, borders. How would you describe yourself?

GCS: From the point of view of language? I see myself as a bilingual person. As a bilingual person, I do translations from my native language. I think I would like a greater role in West Bengal as a public intellectual. Remaining in the United States was not at any point an examined choice, a real decision made. We won't go into the background now. I left India without any experience of what it was like to live and work in India. So I have kept my citizenship, and I'm inserting myself more and more into that. I have two faces. I am not in exile. I am not a migrant. I am a green-card-carrying critic of neocolonialism in the United States. It's a difficult position to negotiate, because I will not marginalize myself in the United States in order to get sympathy from people who are genuinely marginalized.

I want to have more of a role in the space where Bengali is a language for reading, writing. I write Bengali competently, with the same sort of problem making myself clear as I have in English. Mahasweta asks me to write more in Bengali. So reading, writing, public speaking, television: I want to get more involved. The cultural field in West Bengal is so rich that I'm a bit envious, you might say. It's working out slowly, and I can now see myself as a person with two fields of activity, always being a critical voice so that one doesn't get subsumed into the other.

AA: Do you think that had you remained in Calcutta, you would do as much work in English as you do now, working in the United States?

GCS: Probably so. I was an English honors student. English is my field. Remember, we are talking about a colonial country. I have colleagues there who have remained more wedded to "English," without the critical edge. There is sometimes a kind of resentment that I, living in the West,

should be cutting the ground from under them, since, for them, that's their specialty rather than a contested political field.

Recently I gave an interview for the BBC World Service regarding colonial discourse. The first question that the British questioner asked me was, "Do you think your activities in this critical theory have anything to do with the fact that you were born in India?" And I told her, "Look, in fact, if you were born and brought up in India you can have exactly the opposite view." So, yes, I probably would have been more like a traditional, solid, British-style (instead of maybe using the American style, who knows?) English scholar, probably a Yeats scholar.

AA: Is the choice of language, English or Bengali, for example, particularly significant for the writer writing in India?

GCS: Quite significant because India is a multilingual country. I have talked a lot about the concept of enabling violation. The child of rape. Rape is something about which nothing good can be said. It's an act of violence. On the other hand, if there is a child, that child cannot be ostracized because it's the child of rape. To an extent, the postcolonial is that. We see there a certain kind of innate historical enablement which one mustn't celebrate, but toward which one has a deconstructive position, as it were. In order for there to be an all-India voice, we have had to dehegemonize English as one of the Indian languages. Yet it must be said that, as a literary medium, it is in the hands of people who are enough at home in standard English as to be able to use Indian English only as the medium of protest, as mockery or teratology; and sometimes as no more than local color, necessarily from above. So, yes, there is an importance of writing in English, high-quality writing.

AA: What are your thoughts on hybrid writing and speech, on a Bengalized English?

GCS: It's very interesting that you ask me that, because that is the English that is an *Indian* language. It's not just *Bengalized.* You know there are over seventeen to nineteen languages, hundreds of dialects in India. The English I'm speaking of may be used, for example, on a bus by two people talking to each other, underclass people, who clearly share an Indian language, not English. They may at a certain point break into a kind of English sentence that you wouldn't understand. The situation changes as you climb up in class. And it is this imbrication of the dynamics of class mobility with proximity to standard English that would, as I have already indicated, make the project of hybrid writing in English somewhat artificial. And the writer

who would be a serious user of hybrid English would probably write in the local language. That is the difference in India, that there are very well developed literary traditions in some of the local languages. Many English words are, and continue to be, lexicalized in these languages in senses and connotations ex-centric to Standard English. You might say the choice to write pure or hybrid exists more realistically in those vernaculars. And the choice takes its place among other kinds of hybridizations: dialects, class variations, underclass vernacular mixings through internal migrant labor, multilingual irony. As in the case of South Africa, it would be difficult to find a clean analogy for resistant language-practice in the Indian case. Here, as in many other instances of resistant cultural practice, I think the solidarity comes from exchange of information and a bonding through acknowledgment of difference.

If we were a white country, might our hybrid English have been another English, as different from British as is American? What about the fact that we have flourishing, developing vernaculars? At any rate, the creative level of Indian English was always defined as a deviation. And the major vernacular literatures were somehow defined as *under*-developed because they had not followed the Hegel-Lukácsian line of form and content. This is by now so well established, even internalized, that it seems hopeless to speculate about a counter-factual history. The idea of the European novel as the best form and its harbingers as Cervantes and Defoe is here to stay. To get back to Indian English, it is too late in the day to undertake the project of actually introducing it into public discourse. It already is there because, in fact, public Indian English is significantly different. It can seem comical to the users of "pure" Standard English—is there such a thing?—because it is unself-conscious. And our upper crust often joins in that laughter. The celebration of that intellectualized patois in international Indian literature, or subcontinental literature written in English, would be impractical for reasons that I have already given.

AA: Let me shift the focus from India to Ireland. Could you speak to the project of writing as that of Joyce, Yeats, Beckett?

GCS: I hold on to the idea of dehegemonizing. I think I am more sympathetic with Joyce's stated deep irony. You remember Mother Grogan in *Ulysses*? Haines, the Englishman, who has learned Irish, speaks to her in Irish, and she asks, "Is it German?" Yeats, in the event, transformed English. But in his stated politics, language politics, I find him less sympathetic than Joyce. It has to be self-conscious or nothing.

I will now draw an example not from India, but from Bangladesh, because I've just had this discussion with a poet in Dhaka. When the

British became territorial, rather than simply commercial, after the Battle of Plassey in 1757, they came in through Bengal. There was already an Islamic imperial presence in India located nearly a thousand miles away in Delhi, although the Nawab of Bengal was Muslim and there was a sizable, powerful Muslim minority, both urban and rural. In order to counteract Islamic domination—and I'm obviously simplifying—they played up the Hindu Sanskrit quality of Bengali. Bengali was the language they emphasized, because they had come through Bengal and established themselves in Bengal. There was therefore a colonial hype of Bengali as an Indic-Hindu language. In fact, of course, Bengali had a strong Arabic-Pharsi element as well. Under the British, nearly all of it was erased, and subsequent Bengali nationalism also emphasized the Hindu element. (Curiously enough, the Hindu majority government of India has been playing the same game with Hindi, the national language, for some time.)

The liberation of Muslim-majority Bangladesh from Pakistan in 1971 was officially on linguistic-cultural rather than religious grounds. My friend the poet has this question: How do we restore the Islamic elements in Bengali without identifying with a program of religious fundamentalism? Bengali is my mother tongue too. So there we were: he born a Muslim, I born a Hindu, he Bangladeshi, I Indian, neither of us very religious, totally against fundamentalism, and neither of us at all interested in the crazy project of a separatist Bengal, a pipedream that is occasionally brought out for sentimental or political rhetoric. I said to him that I thought that since language cannot be interfered with self-consciously, the only way to do it is absolutely self-consciously; that is to say, write manifestos, and so on. I have a great deal of sympathy with self-conscious tampering, because one knows that language works behind and beyond and beside self-consciousness.

AA: What about Beckett's writing in French?

GCS: I see it as a sort of self-distancing. When you began you were talking about identity. I have trouble with questions of identity or voice. I'm much more interested in questions of space, because identity and voice are such powerful concept-metaphors, that after a while you begin to believe that you are what you're fighting for. In the long run, especially if your fight is succeeding and there is a leading power-group, it can become oppressive, especially for women, whose identity is always up for grabs. Whereas, if you are clearing space, from where to create a perspective, it is a self-separating project, which has the same politics, is against territorial occupation, but need not bring in questions of identity, voice, what am I, all of which can become very individualistic also.[1] It seems to me that Beckett's

project is that kind of self-separating project, that kind of clearing of a space. It is not possible to remain within the mire of a language. One must clear one's throat, if you're taking the voice metaphor, clear a space, step away, spit out the mother tongue, write in French.

I don't have that relationship to English, no. First of all, I shouldn't compare myself to Beckett. I am bilingual. Millions of Indians write in English. How many Irish write in French?

I think the South African writer J. M. Coetzee's relationship to English—"of no recognizable *ethnos* whose language of exchange is English"—is beautifully articulated with Beckett's distancing from *English*.[2] The Irish have a peculiar relationship with English, too, after all.

AA: Would you speak about *The Satanic Verses*? What do you feel about the irony that while *The Satanic Verses* criticizes First World representation of the Third, it, nevertheless, has become complicit in propagating such representational practices?

GCS: First off, let me say that I have just published a piece on reading *The Satanic Verses* in *Third Text*, and I touch on exactly the kind of questions you are asking.[3] The fact that it has become complicit is not Rushdie's fault. Rushdie was trying to create a postcolonial novel, from the points of view both of migration—being in Britain as Black British—and of decolonization—being the citizen of the new nation, India, Islamic India.

Islamic India is strange, too, because given what the minority does, its head ritually is turned toward Mecca outside the subcontinent. He's trying to deal with this. I've had a lot of conversations with people, Iranian friends, Palestinian friends, Black British, British Muslim friends, etc., the Southhall Black Sisters who are in Britain speaking up against the so-called fundamentalist reaction. If you read it from the point of view of "a secular Muslim," he is trying to establish a postcolonial readership—already in existence—who will in fact share a lot of the echoes that are in that book which you and I might miss. I, for example, get the echoes from Hindi films. I believe the Hindi film industry is the world's largest film industry, and it's been the popular international medium now for twenty, thirty years, or perhaps more? I catch that resonance. On the other hand, as an English teacher, I also catch all the quotes from *Portrait of the Artist as a Young Man*, say.

It seems to me, then, that the implied reader of *The Satanic Verses* is this international, global, postcolonial migrant person. This is not the Christian Enlightenment person for whom British literature is written; nor the jaded European of *The Waste Land*. The Ayatollah was another kind of internationalist. He does not reveal the nature of Islam as a fundamen-

talist, which is a real contradiction within all fundamentalisms. And that, for reasons of prejudice, was taken to be the real nature of Islam in the United States. In other words, the Ayatollah succeeded in his self-representation. But that is self-representation, not acting out the nature of Islam, whatever that might mean. What is the nature of a religion— always the broaching of the universal in the historical? We see the difference between the U.S. reaction and the British reaction. Rather than keeping it coded as terrorism versus freedom of expression, in Britain the incident recorded itself as fundamentalism against racism, so that you can't take either side. The only side to take is the British Black women's, who are against both. It is more complicated for them. You have to create a space for doubters and transgressors; you have to create a space for the way politics uses things. It is productively confused in Britain. It shows up the living dilemmas of politics.

AA: Does this explain the delay in the British response? It wasn't until after Susan Sontag, Norman Mailer, and American PEN issued statements of support in New York, that there was noticeable support from writers in London.

GCS: If you consider the Bradford Muslims British, the response was not delayed. But I know what you mean, of course. Liberals were uneasy. Here was a "black" religion. In Britain, Pakistanis and Indians are black. How can the writer take sides, the white writer? I mean, what are the issues? Colonial subject against the authentic natives?

AA: Was it a wait for a U.S. valorization?

GCS: I don't think so. If you look at the detail of how it is still going, nobody is following the lead of the U.S. coding. Even in the *Times Literary Supplement*, Peter Porter is obliged to say that this is the cross versus the crescent, and so on.

No, in Britain, it has been significantly different. And the unease was on grounds of possible racism, which didn't give anybody any pause in the United States. They saw it right from the beginning as those bloody Arabs. Of course the Ayatollah isn't an Arab; what's the difference? Bloody Arabs against freedom of expression.

AA: Let me move the focus of discussion once again, this time to the United States. Chicano writers have at times characterized our relationship with Anglo America as internal colonialism. As we work our strategies for our identity, it seems that it could be very helpful to hear reflections on our

24

situation from someone such as yourself, that is, an intellectual from a Third World, postcolonial country. What does colonial discourse from the external Third World offer to the U.S. internal Third World?

GCS: Where did you get the internal colonization model?

AA: From Chicano social science texts. Rodolfo Acuña's *Occupied America* and Mario Barrera's *Race and Class in the Southwest* are two examples.[4]

GCS: I needed to know that, because when I talk about internal coloniza-tion, my model is Samir Amin's *Unequal Development*, which is Afrocentric, global, and, of course, generally from Gramsci.[5] I apply it, of course, to the United States situation, but the model, especially in terms of the First Nations, has to be twisted somewhat.

My feeling is that it is necessary to see the Chicano movements as unit-ed with the colonial discourse analysts speaking from the decolonized nations outside of the United States for reasons of political solidarity. As both your authors point out, the making of the Chicano has something like a relationship with those voices. But when one is thinking of the pro-duction of knowledge, that is to say, when you are writing or teaching, it is also necessary to look at the differences. The idea of internal coloniza-tion can become significant in computing the differences.

The received idea is that the Hispanic imperial text failed partly because, again oversimplifying, the conjuncture between conquest and mode of production was not yet right. Britain with its industrial revolution was the one that could launch full-fledged capitalist imperialism. The Spanish example, as you know better than I, had a different fate and cre-ated the peculiar phenomenon of Latin America. The Chicano emerges into internal colonization from the "other" text, with differences. Shall I quote Barrera's excellent little definition here? "Internal colonialism is a form of colonialism in which the dominant and subordinate populations are intermingled, so that there is no geographically distinct 'metropolis' separate from the 'colony.'"[6]

But in the internal colonization scene, let me again offer you an analogy, because there is little I can tell you about the Chicano predicament that you don't already know. I am thinking about Central and Eastern Europe today and all the nationalisms and subnationalisms that are coming up under glasnost and their peculiar relationship with anticommunism, the peculiar relationship with the longing for welfare state-ism, etc. If one thinks there of the former script of the Ottoman Empire, the centuries of a kind of practical multinationalism without the emergence of the discours-es of nationalism as in Atlantic Europe, if one takes that into account, then

one doesn't just have to pretend as if history began at the end of the nineteenth century: 1876, the first Ottoman constitution; 1924, the first Turkish constitution; in between, the First World War; the rewriting of that area as nations. Whereas, before that there was that extraordinary, dynamic multinational presence of the empire: the Ottomans owning the Black Sea trade and the so-called Atlantic Europeans owning the Mediterranean trade, the Russian empire trying to fit in.[7] Now if one looks at that script and then the emergence of national models on the model of correct nationalism coming up through Atlantic Europe, then one realizes that the story of the Central European and Eastern European nationalisms cannot begin only as a reaction against the Bolshevik revolution.

The story of the Hispanic American—and I'm now thinking of the Americas as both of the American continents—is another story from the successful adventure of industrialist capitalist imperialism: largely Great Britain, but also Dutch and French. We should not take the British or the French-Algerian examples as models for understanding the script of the failure of the Spanish Empire and then its rewriting into the Ariel-Caliban mode and then today's Mexico, today's Chicano. It's a different version of the script of a colonial discourse, strictly speaking, for decolonization as such could not be staged in the wake of the Spanish Empire. Varieties of colonial discourse analyses therefore relate as different scripts: that is the nature of the solidarity.

This is the most exciting part of our conversation for me because I see here a real future, a future that is already afoot. And for me what is most interesting is that it is *not* close to what I still think of as my home. My home situation is the aftermath of industrial capitalist imperialism, negotiated political independence seen as decolonization, passing into neo-colonialism. That is one story out of which colonial discourse studies come. But the other story, the previous conjuncture, the conjuncture that didn't catch, which is where decolonization proper, which is not decolonization in the strict sense, could not be narrativized, excites me because it too is a model—of the failure of decolonization that is inscribed, and not as an accident, in the most aggressive decolonization narratives. There you have the whole complex phenomenon of Latin America, Central America, the United States, and the Chicano. That's a story that should not take its model from established colonial discourse, but open it up as well. Express solidarity, but as difference.

You are writing a different story, and the subject *for* that story, not so much a subject *of* that history or the world-historical subject, will be the Chicano/Chicana living here, but a new narrativization. History, is after all, a storying. The French language has it very conveniently in the word *histoire* which means both 'history' and 'story'.

AA: It works the same in Spanish, *historia*.

GCS: Right, of course. I wasn't thinking of it, because I know French. You can go to town with it with Spanish, not that it has anything to do with being French or Spanish. I'm just taking advantage of *that* accident of *that* language. What I'm saying is that history *is* a storying, secondarily also by the arrangement and interpretation of "facts," and facts are *facta*, past participle of *facio*, things that are made—made from conventional standards of truth-establishing, so that you can get a hold of "what really happened." When you make an alternative history, it is this element of fact-making that comes most strongly to the fore. You *are* making a story in the robust sense—and there are those who will insist that you are making up a story; after all, the history books tell us otherwise, don't they?— whose characters are different from the characters that have been given prominence.

To take an example, the high holiday of Indian Hindus is the Triumph of Durga. I was told by Mahasweta Devi, on whose work I write, that for Indian tribals (the First Nations), or at least for certain groups of tribals, this day is mourned as a day of defeat. Because the golden-yellow-colored goddess, winning over the principle of evil, who is in the disguise of a buffalo, might very well conceal the seeds of a historical-mythic event which for tribals betokens the defeat in the hands of the invading "Aryan" Hindus. It is a different story for them. What for "us" is the story of triumph is for "them" the story of defeat. And most caste-Hindus don't even know this. It's like Thanksgiving Day, or indeed the story of Columbus. What one has, then, is a different story with a different cast of characters or a different hero. (Factually, the "Aryans" did not exist—it is the name of the language—and the Aryan-speaking groups migrated, but does this disqualify the mourning?)

In some languages, this fact that history is a storying is not as clear as it is in some other languages. French happens to be one I know. This alternate storying doesn't give you an identity, if you think of identity as something intimately personal which lets you know who you are. It gives you a whole field of representation within which something like an "identity" can be represented as a basis for agency.

From that point of view, although I certainly understand the political reasons for embracing the expression "Third World," I also feel that it's becoming too identitarian. The Third World was not a label for non-Anglo peoples. The Third World was an economic label that had to do with the reparceling out of the world after the Second World War, after the long first phase of industrial-capitalist imperialism. And that label should not be turned into a description of your difference within the

scene. There you're modeling yourself too much on something which is exactly not your narrative. So although I recognize the importance of solidarity, in the production of knowledge and the new narrativization of that older script it has to be treated with some caution; Third World peoples in the First World claiming that title has to be treated with some caution. Perhaps even because, in the very locus of their struggle, they have an interest in dominant global capitalism.

AA: Let me ask you two interrelated questions which point to the future, to what can be done. First these new narrativizations of the older scripts must, of course, be localized, but in all cases, must they begin with deconstruction? And second, what about literary writing in the project of new narrativizations?

GCS: Well with the first question, I would have to know what you're meaning by deconstruction.

AA: I meant Derrida's notion of writing.

GCS: Well, yes and no. Because writing in the general sense, that we begin in difference, is something over which one has no control. That's the structure of, that's the predication of, being, as it were. So that's not something you can do anything with. You acknowledge it as what constitutes the present as event. But if you take writing in a strong but more restricted sense, as among other things the inscription of cultures as miraculating and miraculated agencies, as inscriptions that generate scripts, then I think you may say that no matter where you are, the move is deconstructive.

The argument that people who have never had a foot in the house should not knock the father's mansion as the favored sons do, is not a good argument. It's like saying, people who have never had the benefits of capitalism should choose capitalism. Everything has to happen at the same time, and the deprived must also undertake and perform the critique of capitalism. One the broad scale, nationalism, for example, fetishizes the goal of winning, decolonization. Once it is won, the people want really an entry into the haunted house inhabited by the colonizers, a house that "the best people" think is not such a grand hotel.

So right from the beginning, the deconstructive move. Deconstruction does not say there is no subject, there is no truth, there is no history. It simply questions the privileging of identity so that someone is believed to have the truth. It is not the exposure of error. It is constantly and persistently looking into how truths are produced. That's why deconstruction doesn't say logocentrism is a pathology, or metaphysical enclosures are

something you can escape. Deconstruction, if one wants a formula, is, among other things, a persistent critique of what one cannot not want. And in that sense, yes, it's right there at the beginning.

And your second question: how about literary writing? Within our discursive formations, literary writing has a certain claim to autonomy. I was talking about this in terms of the Indian People's Theatre Association right at the beginning. I think, strategically, we should use that, so that, in fact, the work of constructing new narrativizations of what is taken to be truth—in other words, history—can be helped by what is taken to be the field of nothing but narrative. Fiction-making can become an ally of history when it is understood that history is a very strong fictioning where, to quote Derrida, the possibility of fiction is not derived from anterior truths. Counterfactual histories that exercise imaginative responsibility—is that the limit?

NOTES

1. At the time of the conversation, I was thinking about Palestine. Events in the East-Central European theater of the former Soviet Union have since complicated this question.

2. J. M. Coetzee, *Doubling the Point: Essays and Interviews*, ed. David Attwell (Cambridge, Mass.: Harvard University Press, 1992), p. 342.

3. Spivak, "Reading *The Satanic Verses*," *Third Text* 11 (1990), pp. 41–69; rpt. in *Outside*, pp. 217–41.

4. Rodolfo F. Acuña, *Occupied America: The Chicano's Struggle Toward Liberation* (San Francisco: Canfield Press, 1972), and Mario Barrera, *Race and Class in the Southwest: A Theory of Racial Inequality* (Notre Dame: University of Notre Dame Press, 1979).

5. Samir Amin, *Unequal Development: An Essay on the Social Formations of Peripheral Capitalism*, trans. Brian Pearce (New York: Monthly Review Press, 1976).

6. Barrera, *Race and Class*, p. 194.

7. Here, too, history has overtaken us. It might be of interest to the reader that I am revising this flying over Finland, itself formerly under the control of the Russian Empire, and now in a dominant relationship with Estonia. I am going to Lapland to visit Samic cultural workers, belonging to a nation spread over three European states, another narrative of colonialism that would fit in with our topics of discussion. [This note was composed in 1992.—Eds]

Explanation and Culture
Marginalia

(1979)

This essay describes a symposium, "Explanation and Culture," held at the University of Southern California's Center for the Humanities in 1979.

If at the turn of the nineteenth century, William Wordsworth and Samuel Taylor Coleridge recommended that poets write about the specific occasions that prompted their poems, in the latter part of the twentieth century, Jacques Derrida has foregrounded the occasion in philosophical discourse. Paying attention to the "occasionality" of any situation or event becomes a way of assuming some responsibility for the consequences entailed by a particular act of writing or speaking in a particular context. Here Spivak analyzes a typical academic event in the United States, a symposium to which experts from various fields have been invited to share their work in an interdisciplinary context and discuss how cultures are explained and cultural explanations constructed.

Spivak uses the occasion of the symposium to offer a lesson in practical deconstruction after Derrida, chiefly inspired by two of his essays that had recently appeared in English translation: "Signature Event Context," *Glyph 1* (1977), pp. 172–97 and "Limited Inc abc...," *Glyph 2* (1977), pp. 162–254. Both are reprinted in *Limited Inc* (Evanston, IL: Northwestern University Press, 1988). Demonstrating how reversing and displacing binary oppositions can be useful to feminist and Marxist critiques of such institutional occasions, Spivak here presents an early example of what will become characteristic of her intellectual signature: an incomparable ability to address the specific circumstances in which she finds herself and intervene accordingly. Spivak returns to offer detailed readings of these texts by Derrida in "Revolutions That As Yet Have No Model" (1980), the third essay included here. For both these chapters, we have preserved page references to the original printings of Derrida's texts in *Glyph*.

I tried writing a first version of this piece in the usual disinterested academic style. I gave up after a few pages and after some thought decided to disclose a little of the undisclosed margins of that first essay. This decision was based on a certain program at least implicit in all feminist activity: the deconstruction of the opposition between the private and the public.

According to the explanations that constitute (as they are the effects of) our culture, the political, social, professional, economic, intellectual arenas belong to the public sector. The emotional, sexual, and domestic are the private sector. Certain practices of religion, psychotherapy, and art in the broadest sense are said to inhabit the private sector as well. But the institutions of religion, psychotherapy, and art, as well as the criticisms of art, belong to the public. Feminist practice, at least since the European eighteenth century, suggests that each compartment of the public sector also operates emotionally and sexually, that the domestic sphere is not the emotions' only legitimate workplace.[1]

In the interest of the effectiveness of the women's movement, emphasis is often placed upon a reversal of the public-private hierarchy. This is because in ordinary sexist households, educational institutions, or workplaces, the sustaining explanation still remains that the public sector is more important, at once more rational and mysterious, and, generally, more masculine, than the private. The feminist, reversing this hierarchy, must insist that sexuality and the emotions are, in fact, so much more important and threatening that a masculist sexual politics is obliged, repressively, to sustain all public activity. The most "material" sedimentation of this repressive politics is the institutionalized sex discrimination that seems the hardest stone to push.

The shifting limit that prevents this feminist reversal of the public-private hierarchy from freezing into a dogma or, indeed, from succeeding fully is the displacement of the opposition itself. For if the fabric of the so-called public sector is woven of the so-called private, the definition of the private is marked by a public potential, since it *is* the weave, or texture, of public activity. The opposition is thus not merely reversed; it is displaced. It is according to this practical structure of deconstruction as reversal-displacement, then, that I write: the deconstruction of the opposition between the private and public is implicit in all, and explicit in some, feminist activity. The peculiarity of deconstructive practice must be reiterated here. Displacing the opposition that it initially apparently questions, it is always different from itself, always defers itself. It is neither a constitutive nor, of course, a regulative norm. If it were either, then feminist activity would articulate or strive toward that fulfilled displacement of public (male) and private (female): an *ideal* society and a sex-*transcendent* humanity. But deconstruction teaches one to question all transcendental idealisms. It is in terms of this peculiarity of deconstruction, then, that the displacement of

male-female, public-private marks a shifting limit rather than the desire for a complete reversal.

At any rate, this is the explanation that I offer for my role at the Explanation and Culture symposium and for the production of this expanded version of my essay. The explanatory labels are "feminist," "deconstructivist."

We take the explanations we produce to be the grounds of our own action; they are endowed with coherence in terms of our explanation of a self. Thus, willy-nilly, the choice of these two labels to give myself a shape produces between them a common cause. (Alternatively, the common cause between feminism and deconstruction might have made me choose them as labels for myself.) This common cause is an espousal of, and an attention to, marginality—a suspicion that what is at the center often hides a repression.

All this may be merely a preamble to admitting that at the actual symposium I sensed, and in sensing cultivated, a certain marginality. Our intelligent and conscientious moderator seemed constantly to summarize me out of the group. After hearing us make our preliminary statements, he said that we were all interested in culture as process rather than object of study. No, I would not privilege process. After the next batch of short speeches, he said that it was evident that we wanted to formulate a coherent notion of explanation and culture that would accommodate all of us. No, I would not find unity in diversity; sometimes confrontation rather than integration seems preferable. Leroy Searle, an old friend, spoke of the model of explanation having yielded to interpretation and threw me a conspirator's look. George Rousseau spoke of distrusting the text, and I wondered if he had thought to declare solidarity with a deconstructor by publicly aligning himself with what Paul Ricoeur has called "the hermeneutics of suspicion."[2] But I was not satisfied with hermeneutics—the theory of "interpretation rather than explanation"—"suspicious" or not, as long as it did not confront the problem of the critic's practice in any radical way. I thought the desire to explain might be a symptom of the desire to have a self that can control knowledge and a world that can be known; I thought to give oneself the right to a correct self-analysis and thus to avoid all thought of symptomaticity was foolish; I thought therefore that, willy-nilly, there was no way out but to develop a provisional theory of the practical politics of cultural explanations.

The group repeatedly expressed interest in my point of view because it appeared singular. But the direct question of what this point of view was was never posed, or rather, was posed at the end of a three-hour session given over to the correct definition of the role, say, of cognition in aesthetics. *Is a poem cognitive? A picture?* And so on. But I had no use for these phantasmic subdivisions (cognition, volition, perception, and the

like) of the labor of consciousness except as an object of interpretation of which I was a part. A deconstructive point of view would reverse and displace such hierarchies as cognitive-aesthetic. I would bleat out sentences such as these in the interstices of the discussion. Kindly participants would turn to me, at best, and explain what I meant or didn't mean. At worst, the discussion of cognition and aesthetics would simply resume. On one occasion I had captured the floor with a rather cunning, if misguided, series of illustrations from Nietzsche. The response was a remark that Nietzsche was a worthless philosopher, although rather fun. I countered hotly that cheap derision was out of place in a scholarly discussion. I was assured that fun was an essential element in all proper philosophers, and no harm had been meant.

This exchange illustrates yet another way I had solidly put myself in the margin. I questioned the structure of our proceedings whenever I felt it to be necessary—for the structure or means of production of explanations is, of course, a very important part of the ideology of cultural explanations that cannot be clearly distinguished, in fact, from the explanations themselves. It seemed an unrecognizable principle to this group of pleasant and gifted scholars. It didn't help that my manner in such situations is high-handed, and my sentences hopelessly periodic and Anglo-Indian. Every intervention was read as an expression of personal pique or fear. "Don't worry, no one will bother you on the big public day." I kept myself from gnashing my teeth, because that would only show that I still legitimated the male right to aggression. In fact, I was quite tough in public, having been trained before the hard-won triumphs of the latest wave of the women's movement, indeed, initially in a place by comparison more sexist than academic America; my arguments had not been in the interest of my personal safety but rather against *their* masculist practice, mistaken as the neutral and universal practice of intellectuals. In fact, I was assured at one point that male animals fought, even in play. I believe I did say that I knew it only too well; it was just that I thought some of it was curable.

Following the precarious and unrigorous rule of the deconstruction of the public and the private, I spoke of my marginality at the public session. I did not reserve my thrusts for the privacy of the bedroom or the kitchen table (in this case, the collegial dinner, lunch, or corridor chat), where decent men reprimanded their wives. (It would take me too far afield to develop and present the idea, based on a good deal of observation, that the academic male model for behavior toward so-called female equals was that of the bourgeois husband.) I received no personal criticism "in public," of course. Taken aside, I was told I had used my power unfairly by posing as marginal; that I could criticize the establishment only because I spoke its language too well (English, masculinese, power play?). Both of these kinds of remarks

would have produced lively and profitable discussion about explanation and cultural persuasion if, in fact, they had been put to me in public. But in this case, one kind of situational explanation was culturally prohibited, except as the exceptional, but more "real," matter of marginal communication.

About the worst of these asides even I feel obliged to remain silent.

Now, when a Jacques Derrida deconstructs the opposition between private and public, margin and center, he touches the texture of language and tells how the old words would not resemble themselves any more if a trick of rereading were learned. The trick is to recognize that in every textual production, in the production of every explanation, there is the itinerary of a constantly thwarted desire to make the text explain. The question then becomes: What is this explanation as it is constituted by and as it effects a desire to conserve the explanation itself; what are, in Edmund Husserl's terms, the "means devised in the interest of the problem of a possible objective knowledge"?[3]

I wrote above that the will to explain was a symptom of the desire to have a self and a world. In other words, on the general level, the possibility of explanation carries the presupposition of an explainable (even if not fully) universe and an explaining (even if imperfectly) subject. These presuppositions assure our being. Explaining, we exclude the possibility of the *radically* heterogeneous.

On a more specific level, every explanation must secure and assure a certain *kind* of being-in-the-world, which might as well be called our politics. The general and specific levels are not clearly distinguishable, since the guarantee of sovereignty in the subject toward the object is the condition of the possibility of politics. Speaking for the specific politics of sexuality, I hoped to draw our attention to the productive and political margins of our discourse in general. I hoped to reiterate that, although the prohibition of marginality that is crucial in the production of any explanation is politics as such, what inhabits the prohibited margin of a particular explanation specifies its particular politics. To learn this without self-exculpation but without excusing the other side either is in my view so important that I will cite here a benign example from Derrida before he became playful in a way disturbing for the discipline.[4]

In *Speech and Phenomena* (1967), Derrida analyzes Husserl's *Logical Investigations I*. In the last chapter of the book, Derrida produces this explanation: "The history of metaphysics therefore can be expressed as the unfolding of the structure or schema of an absolute will to hear-oneself-speak."[5]

Now this is indeed the product of the careful explication of Husserl through the entire book. This is also, as we know, one of the architraves of Derrida's thought. Yet, if *Speech and Phenomena* is read carefully, by the

time we arrive at this sentence we know that the role of "expression" as the adequate language of theory or concept is precisely what has been deconstructed in the book. Therefore, when Derrida says, "can be expressed as," he does not mean, "is." He proffers us his analytical explanation in the language that he has deconstructed. Yet he does not imply that the explanation is therefore worthless, that there is a "true" explanation where the genuine copula ("is") can be used. He reminds us rather that all explanations, including his own, claim their centrality in terms of an excluded margin that makes possible the "can" of the "can be expressed" and allows "is" to be quietly substituted for it.

The implications of this philosophical position cannot remain confined to academic discourse. When all my colleagues were reacting adversely to my invocations of marginality, they were in fact performing another move within the center (public truth) and margin (private emotions) set. They were inviting me into the center at the price of exacting from me the language of centrality.

"Several of our excellent women colleagues in analysis," Freud wrote, explaining femininity, "have begun to work at the question [of femininity].... For the ladies, whenever some comparison seemed to turn out unfavorable to their sex, were able to utter a suspicion that we, the male analysts, had been unable to overcome certain deeply rooted prejudices against what was feminine, and that this was being paid for in the partiality of our researches. We, on the other hand, standing on the ground of bisexuality, had no difficulty in avoiding impoliteness. We had only to say: 'This doesn't apply to you. You're an exception, on this point you're more masculine than feminine.'"[6]

That passage was written in 1932. Adrienne Rich, speaking to the students of Smith College in 1979, said:

> There's a false power which masculine society offers to a few women who "think like men" on condition that they use it to maintain things as they are. This is the meaning of female tokenism: that power withheld from the vast majority of women is offered to a few, so that it may appear that any truly qualified woman can gain access to leadership, recognition, and reward; hence that justice based on merits actually prevails. The token woman is encouraged to see herself as different from most other women, as exceptionally talented and deserving; and to separate herself from the wider female condition; and she is perceived by "ordinary" women as separate also: perhaps even as stronger than themselves.[7]

In offering me their perplexity and chagrin, my colleagues on the panel were acting out the scenario of tokenism: you are as good as we are (I was

less learned than most of them, but never mind), why do you insist on emphasizing your difference? The putative center welcomes selective inhabitants of the margin in order better to exclude the margin. And it is the center that offers the official explanation; or, the center is defined and reproduced by the explanation that it can express.

I have so far been explaining our symposium in terms of what had better be called a masculist centrism. By pointing attention to a feminist marginality, I have been attempting, not to win the center for ourselves, but to point at the irreducibility of the margin in all explanations. That would not merely reverse but displace the distinction between margin and center. But in effect such pure innocence (pushing all guilt to the margins) is not possible and, paradoxically, would put the very law of displacement and the irreducibility of the margin into question. The only way I can hope to suggest how the center itself is marginal is by not remaining outside in the margin and pointing my accusing finger at the center. I might do it rather by implicating myself in the center and sensing what politics make it marginal. Since one's vote is at the limit for oneself, the deconstructivist can use herself (assuming she is at her own disposal) as a shuttle between the center (inside) and the margin (outside) and thus narrate a displacement.

The politics in terms of which all of us at the symposium as humanists are marginalized is the politics of an advanced capitalist technocracy.[8] I should insist here that the practice of advanced capitalism is intimately linked with the practice of masculism.[9] As I speak of how humanists on the margin of such a society are tokenized, I hope these opening pages will remind the reader repeatedly how feminism, rather than being a special interest, might prove a model for the ever-vigilant integration of the humanities. Here, however, in the interest of speaking from inside our group at the symposium, I will speak of this marginalization as a separate argument.

Although there are a mathematician and a physicist in our midst, we represent the humanist enclave in the academy. The mathematician is a philosopher, and the physicist, a philosopher of science. As such they represent acts of private good sense and intellectual foresight, which does not reproduce itself as a collective ideological change. These colleagues bring a flavor of pure science into our old-fashioned chambers and become practicing humanists much more easily than we could become practicing theoreticians of science. Together we represent the humanist enclave in the academy.

Our assigned role is, seemingly, the custodianship of culture. If, as I have argued, the concept and self-concept of culture as systems of habit are constituted by the production of explanations even as they make these explanations possible, our role is to produce and be produced by the *official* explanations in terms of the powers that police the entire society, emphasizing a continuity or a discontinuity with past explanations, depending on

a seemingly judicious choice permitted by the play of this power. As we produce the official explanations, we reproduce the official ideology, the structure of possibility of a knowledge whose effect is that very structure. Our circumscribed productivity cannot be dismissed as a mere keeping of records. We are a part of the records we keep.

It is to belabor the obvious to say that we are written into the text of technology. It is no less obvious, though sometimes deliberately less well recognized (as perhaps in our symposium), that as collaborators in that text we also write it, constitutitively if not regulatively. As with every text in existence, no sovereign individual writes it with full control. The most powerful technocrat is in that sense also a victim, although in brute suffering his victimhood cannot be compared to that of the poor and oppressed classes of the world. Our own victimhood is also not to be compared to this last, yet, in the name of the disinterested pursuit and perpetration of humanism, it is the only ground whose marginality I can share with the other participants, and therefore I will write about it, broadly and briefly.

Technology in this brief and broad sense is the discoveries of science applied to life uses. The advent of technology into society cannot be located as an "event." It is, however, perfectly "legitimate" to find in the so-called industrial revolution, whose own definitions are uncertain, a moment of sociological rupture when these applications began to be competitors with and substitutes for rather than supplements of human labor. This distinction cannot be strictly totalized or mastered by the logic of parasitism, by calling the new mode merely an unwelcome and unnatural parasite upon the previous. But for purposes of positivistic computation of our marginalization, we can locate the moments spread out unevenly over the map of the industrial revolution when what had seemed a benign enhancement of exchange value inserted itself into circulation in such a way as to actualize the always immanent condition of possibility of capital. In terms of any of these crudely located moments, it is impossible to claim that the priority of technological systems has been anything but profit maximization disguised as cost effectiveness. It is indeed almost impossible not to recognize everywhere technological systems where "sheer technological effectiveness"—whatever that might be, since questions of labor intensification introduce a peculiar normative factor—is gainsaid by considerations of the enhancement of the flow and accumulation of capital. No absolute priority can be declared, but technology takes its place with politics and economics as one of those "determinants" that we must grapple with if we wish to relate ourselves to any critique of social determinacy.[10] The production of the universities, the subdivision of their curricula, the hierarchy of the management-labor sandwich with its peculiarly flavored filling of the faculty, the specialization emphases, the grants and in-house financial

distributions that affect choice of research and specialty, faculty life- and class-style: these "items of evidence" are often brushed aside as we perform our appointed task of producing explanations from our seemingly isolated scholarly study with its well-worn track to the library.[11]

It is a well-documented fact that technological capitalism must be dynamic in order to survive and must find newer methods of extracting surplus value from labor. Its "civilizing" efforts are felt everywhere and are not to be dismissed and ignored. In every humanistic discipline and every variety of fine art, the exigencies of the production and reproduction of capital produce impressive and exquisite byproducts. In our own bailiwick, one of them would be such a group as ourselves, helping to hold money in the institutional humanistic budget, producing explanations in terms of pure categories such as cognition, epistemology, the aesthetic, interpretation, and the like; at the other end might be the tremendous exploitable energy of the freshman English machine as a panacea for social justice. Between the two poles (one might find other pairs) the humanities are being trashed.[12]

(I have not the expertise to speak of the hard sciences. But it would seem that the gap between the dazzling sophistication of the technique and the brutal precritical positivism of the principle of its application in the practice of technology indicates the opposite predicament. For, as we hear from our friends and colleagues in the so-called "pure sciences" and as we heard from the "pure scientists" on the panel, the sophistication in the scientific community extends to ontology, epistemology and theories of space and time. Here the marginalization is thus produced by excess rather than lack [a distinction that is not tenable at the limit]. While the main text of technocracy makes a ferocious use of the substantive findings of a certain kind of "science," what is excluded and marginalized is precisely the workings of the area where the division of labor between "the sciences" and "the humanities"—excellent for the purposes of controlling and utilizing the academy for ideological reproduction—begins to come undone.)

In the case of the humanities in general, as in the case of feminism, the relationship between margin and center is intricate and interanimating. Just as the woman chosen for special treatment by men (why she in particular was chosen can only be determined and expressed in terms of an indefinitely prolonged genealogy) can only be tolerated if she behaves "like men," so individuals in the chosen profession of humanists can only be tolerated if they behave in a specific way. Three particular modes of behavior are relevant to my discussion: (1) to reproduce explanations and models of explanation that will take so little notice of the politico-economico-technological determinant that the latter can continue to present itself as nothing but a support system for the propagation of civilization; (2) to

proliferate scientific analogies in so-called humanistic explanations: learned explanation of high art in terms of relativity or catastrophe theory, presentations of the mass seduction of the populace as the organic being-in-art of the people; and (3) at the abject extreme, the open capitulation at the universities by the humanities as agents of the minimization of their own expense of production.

It is in terms of this intricate interanimating relationship between margin and center that we cannot be called mere keepers of records. I would welcome a metaphor offered by a member of the audience at the symposium: We are, rather, the disc jockeys of an advanced capitalist ethnocracy. The discs are not "records" of the old-fashioned kind, but productions of the most recent technology. The trends in taste and the economic factors that govern them are also products of the most complex interrelations among a myriad of factors such as international diplomacy, the world market, the conduct of advertisement supported by and supporting the first two items, and so on. To speak of the mode of production and constitution of the radio station complicates matters further. Now within this intricately determined and multiform situation, the disc jockey and his audience think, indeed are made to think, that they are free to play. This illusion of freedom allows us to protect the brutal ironies of technocracy by suggesting either that the system protects the humanist's freedom of spirit, or that "technology," that vague evil, is something the humanist must confront by inculcating humanistic "value," by drawing generalized philosophical analogues from the latest spatiotemporal discoveries of the magical realms of "pure science," or yet by welcoming it as a benign and helpful friend.[13]

This has been a seemingly contextual explanation of our symposium. It should be noted, however, that the explanation might also be an analysis of the production of contexts and contextual explanations through marginalization centralization. My explanation cannot remain outside the structure of production of what I criticize. Yet, simply to reject my explanation on the ground of this theoretical inadequacy that is in fact its theme would be to concede to the two specific political stances (masculist and technocratic) that I criticize. Further, the line between the politics of explanation and the specific politics that my text explains is ever wavering. If I now call this a heterogeneous predicament constituted by discontinuities, I hope I will be understood as using vocabulary rather than jargon.[14] This is the predicament as well as the condition of possibility of all practice.

The accounts of each others' work that we had read before the symposium can also be examined through the thematics of marginalization centralization. Writing today in Austin, Texas (typing the first draft on the way to Ann Arbor, in fact), I cannot know what relationship those hastily written

pre-symposium summaries will have with the finished essays for *Humanities in Society*, nor if the participants will have taken into account the public session whose indescribable context I describe above. The blueprint of an interminable analysis that I include in this section might therefore be of special interest to our readers. It might give them a glimpse of the itinerary telescoped into the text they hold in their hands.

A specific sense of the importance of politics was not altogether lacking in these preliminary accounts. Norton Wise's project description concerned an especially interesting period in modern political and intellectual history. "In my present research I am attempting to draw connections between scientific and social concerns for a particularly revealing historical case: the reception of thermodynamics in Germany between about 1850 and 1910, including both the period of political unification and consolidation under Bismarck and the increasingly tension-ridden Wilhelmian period prior to the First World War."[15] The focus at work in the symposium did not allow him to develop his ideas in detail; I look forward to the finished project, to be completed through study of "internal published sources," "public discussions," and "general biographical information on approximately fifty people." Although the only limits to speculation that Wise can envisage are "empirical" rather than irreducibly structural, the idea that the reception of scientific "truths" can be historically vulnerable I find appealing.

It is more interesting, however, that Wise did not notice that it was not merely "Ernst Haeckel [who] employed his notion of a 'mechanical cell soul' to bridge the gap between mechanical reduction in biology and organic purposive action in the individual and the state." Here is a passage from the first edition of the first volume of *Capital*:

> The value-form, whose fully developed shape is the money-form, is very simple and slight in content. Nevertheless, the human mind has sought in vain for more than 2,000 years to get to the bottom of it, while on the other hand there has been at least an approximation to a successful analysis of forms which are much richer in content and more complex. Why? Because the complete body is easier to study than its cells. Moreover, in the analysis of economic forms neither microscopes nor chemical reagents are of assistance. The power of abstraction must replace both. But for bourgeois society, the commodity-form of the product of labor, or the value-form of the commodity, is the economic cell-form. To the superficial observer, the analysis of these forms seems to turn upon minutiae. It does in fact deal with minutiae, but so similarly does microscopic anatomy.[16]

Such a metaphor does indeed "reveal" as it is produced by, or as it conditions, "connections between social and scientific values and beliefs." Wise

has put his finger upon the great nineteenth-century theme of ideology (an unquestioningly accepted system of ideas that takes material shape in social action) and extended it to the production of scientific values. This is interesting because many contemporary critics of ideology maintain that a scientific politico-economic and socio-cultural explanation *can* be produced through a rigorous ideological critique, and that a series of structural explanations can indeed be ideology-free. Another group of thinkers, generally of different political persuasion(s), suggests that the production of the discourse and even the methods of science must remain ideological and interpretable and need not be reasonable to be successful.[17] Wise's study would therefore be enriched if it were situated within this debate about cultural (in the broadest sense) explanation.

The study of "organic purposive action in the individual and the state" through the efficient method of scientific reduction is the issue here. Even the critics of a value-free scientific *discourse* and method would not question the plausibility of such a project, allowing for a system of compensations when the object of study is human reality.[18] The opening section of my essay should have made clear that I would be most pleased if a powerful project such as Wise's questioned even this last assumption: that "the sign" (in this case the various documentary and other evidence of the reception of thermodynamics at a certain period in Germany) is a "representation of the idea" (the basic assumptions of socio-political reality) "which itself represented the object perceived" (both the *real truth* of that socio-political reality *and* thermodynamics as such).[19] Not to be open to such questioning is, in the long run, not merely to privilege a transcendent truth behind words, but also to privilege a language that can capture (versions of) such a truth and to privilege one's trade as the place where such a language can be learned.[20] I shall come back to this point.

I have a suspicion that the same sort of disciplinary vision that makes Wise overlook the Marxian passage makes Clifford Hooker and George Rousseau limit their political concern in specific ways.

Rousseau speaks of the "politics of the academy": "yet ironically, only for a brief moment during the late sixties was it apparent to most American academics that the 'politics of the academy' count." It seems to me, all structural analyses aside, that it could just as easily be argued that a political activity often operating out of an academic base had an apparent effect upon American foreign policy in the sixties precisely because the academy began to see itself as the active margin of a brutal political centralism. The politics of the academy ceased to be merely academic. There are, of course, a good many problems with even this convenient cultural explanation. Many of the workers in the political arena of the sixties chose to step out of the academy. And even those workers have increasingly come to express,

if one could risk such a generalization, the structure and thematics of the technocracy they inhabit.[21]

These pages are obviously not the appropriate place for disputing such scientific issues. Yet, even as I applaud Rousseau's introduction of the political into our agenda, I feel this particular myopia appears also in his definition of pluralism: "Pluralism, originally an economic and agricultural concept, is the notion of the one over the many, as in pluralistic societies." Nearly every survivor of the sixties would rather identify pluralism with "repressive tolerance." "Tolerance is turned from an active into a passive state, from practice to nonpractice: laissez-faire the constituted authorities."[22]

Clifford Hooker, too, is concerned with the effects of social reality upon the production of knowledge. His project is particularly impressive to me because he is a "hard scientist," a theoretical physicist. I am moved by his enquiry into science "as a collective (species) institutionalized activity." I am disappointed, though, when the emphasis falls in the very next sentence upon science as an "*epistemic* institution." The explanation of the production of scientific knowledge is then to be explained, we surmise, in terms of abstract theories of how an abstractly defined human being *knows*. We are to be concerned, not with a cultural, but with a phenomenological explanation. No mention will be made of the complicity of science and technology except by way of the kind of comment to which I have already pointed: that the technocrats know nothing about the vast changes in the concepts of space and time and knowledge that have taken place in the "pure" sciences. The confident centrality of the "purity" of science, with hapless technology in the margins, has a certain Old World wistfulness about it. Ignoring the immensely integrative effect of the world market, such a denial of history can only hope to establish an integrated view of all human activity through the supremacy and self-presence of the cognizing suprahistorical self. The arts will be legitimated as a possible special form of cognition. This further centralism of the all-knowing mind, which can also know itself and thus the universe, is, once again, something I will mention in my last section.

In my opening pages I call "politics as such" the prohibition of marginality that is implicit in the production of any explanation. From that point of view, the choice of particular binary oppositions by our participants is no mere intellectual strategy. It is, in each case, the condition of the possibility for centralization (with appropriate apologies) and, correspondingly, marginalization. We might read the symposium thus:

Humanities/Culture: Are the humanities culture-bound?
Philosophy/Science: In the eighteenth century social philosophy was

transformed into social science.

Scientific/Social: What is the connection between the scientific and the social?

Internal/External: Internal criticism is to examine the coherence of a system with its premises; external criticism is to examine how those premises and the principles of coherence are produced and what they, in turn, lead to.

Speculative/Empirical: Speculative possibilities are limited only by empirical observations.

Theory/Cultural Ideology: Many objections adduced as "theoretical" are instead objections to a cultural ideology.

Biological Activity/Abstract Structure: Is science most fruitfully viewed as one or the other (I am curious about the first possibility: "science as a biological activity")?

Description-Prediction/Prescription-Control: Is science aimed at one or the other?

Human Artifacts/Nature: Does the study of one or the other constitute an important difference among the sciences?

(In fact, a compendious diagram accompanying Hooker's statement offers, like most diagrams, a superb collection of binaries and shows us, yet again, how we think we conquer an unknown field by dividing it repeatedly into twos, when in fact we might be acting out the scenario of class [marginalization centralization] and trade [knowledge is power].)

These shored-up pairs, a checklist that might have led to an exhaustive description of the field that was to have been covered by the symposium, cannot, I think, allow that "theory" itself is a "cultural ideology" of a specific class and trade which must seek to reproduce itself, and upon whose reproduction a part of the stability of a technocracy depends. They cannot allow that the exclusivist ruses of theory reflect a symptom and have a history. The production of theoretical explanations and descriptions must, according to the view that produces these binaries, be taken to be the worthiest task to be performed toward any "phenomenon"; it must be seen as the best aid to enlightened practice and taken to be a universal and unquestioned good. Only then can the operation of the binaries begin. It is this unspoken premise that leads us to yet another "intellectual strategy," not necessarily articulated with the splitting into binaries: the declaration of a project to integrate things into adequate and encompassing explanations. The integration is sometimes explicitly, and always implicitly, in the name of the sovereign mind. Thus one project will work through "a conflation of social, philosophical, and scientific ideas," refusing to recognize the heterogeneity of the nonsocial, the nonphilosophical, the nonspecific that is not merely the other of society, philosophy, science. Another will attempt an

"integrated view of human activity" and place the chart of this activity within a firmly drawn outline called a "consistency loop," banishing the risk of inconsistency at every step into the outer darkness.

It is thus not only the structure of marginalization centralization that assures the stability of cultural explanations in general. The fence of the consistency loop, as I argue, also helps. To go back to my initial example, in order to make my behavior as a female consistent with the rest of the symposium, I would have to be defined as a sexless (in effect, male) humanist— and the rest of me would be fenced out of the consistency loop. The strongest brand of centralization is to allow in only the terms that would be consistent anyway, or could be accommodated within an argument based on consistency. The consistency loop also keeps out all the varieties of inconsistencies to which any diagram plotted in language owes its existence. Every word, not to mention combinations of parts of words, in a language is capable of producing inexhaustible significations linked to contextual possibilities, possibilities that include citation or fictionalization "out of context." The strictly univocal or limited multivocal status of the words in a diagram operates by virtue of their difference from all the rest of this inexhaustible field. The field is kept out by reinterpreting the difference as the unique and most viable identity of the word.

In a more specific way, the plan for sweeping integrations also assures the stability of *one specific kind* of explanation, whose idealism would exclude all inconsistencies of what had best be called class, race, sex; although, if such analyses were taken far enough, even these names would begin to show the ragged edges of their own limits as unitary determinations. Thus in the theoretical establishment of the establishment of theory, mind is allowed to reign over matter, and explanation, in a certain sense, over culture as the possibility of history, or as the space of dispersion of the politics of class, race, and sex. All human activity is seen as specifically integrative *cognitive* activity and the end becomes a "theory of theories." "[Literary] critical theorizing" is, in one case, seen as the "central *discipline* [the italics are presumably there to emphasize the sense of law and ordering rather than that of academic division of labor] in what we loosely call the 'humanities' or the 'human sciences'...the central form of self-conscious reflective thought." Such a frame of mind must disavow the *possibility* that the dream of the centralization of one's trade and one's class, and the dream of a self-present self-consciousness, intimately linked as they are, might be symptomatic and class-protective. Here the will to power through knowledge is so blind to itself that it takes the ontological question as necessarily answerable *before* theory: "the *self-evident fact* that no discipline can possibly pretend to have an adequate theory until it is possible to say *what* such a theory would have to explain."

> Oh! Blessed rage for order, pale Ramón
> The maker's rage to order words of the sea,
> Words of the fragrant portals, dimly-starred,
> And of ourselves and of our origins,
> In ghostlier demarcations, keener sounds.[23]

Within the disciplinary mapping of the humanities, which permits them to remain preoccupied with hubris, poetry, especially modern poetry, is the thing that is allowed to make the kinds of suggestions that I have been making above. And this neutralizing permissiveness, resembling the permissiveness enjoyed by the humanities in general, would allow literary critics of even the most "theoretical" or "Marxist" bent to put the language of poetry (as well as "the *avant-garde* text and the discourse of the unconscious") out of play by claiming for them the status of special "uses of language which exceed communication."[24] That is not very far from the entrenched privatism of "spontaneous overflow of powerful feeling," the controlled detachment of "willing suspension of disbelief" or "escape from personality," the Olympian (and obvious) transhistoricity of "criticism of life."[25] Given such ferocious apartheid, the binary opposition of the literalist language of the conceptualism of pure theory and the metaphorical language of the figurative "cognition" of art becomes fully plausible. Your political allegiance can be pretty well plotted out in terms of which one you want to centralize—the concept or the metaphor.

If we could deconstruct (as far as possible) this marginalization between metaphor and concept, we would realize not only that no pure theory of metaphor is possible, because any premetaphoric base of discussion must already assume the distinction between theory and metaphor; but also that no priority, by the same token, can be given to metaphor, since every metaphor is contaminated and constituted by its conceptual justification. If neither metaphor nor concept is given priority (or both are), the passage of poetry above could be taught as a serious objection to the privileging of theory that takes place when humanists gather to discuss "cultural explanations." Yes, I know "blessed" is an ambiguous and overdetermined expression, that "pale Ramón" aesthetically neutralizes the "real" Ramón Fernández, that "to order" and "for order" are not synonymous, that "of" (meaning perhaps "out of" or "belonging to" or both) is undecidable and that, lacking a predication, the lines carry no apparent judgment. But, questioning the prejudice that a "serious objection" must look like a literalist proposition, these very poetic and figurative gestures can be read as the conditions of the possibility of a stand against a "rage for order." Indeed, "to order" and "for order" can then be seen as at least the field of measure and coherence as well as unquestioning command and obedience, even the

mass production of consumer goods for no one's particular use, and not as merely being there for the sake of an exercise in polysemic interpretation.

At a time when the rage for order defeminates the humanities from every side, I can "make use" of such lines.[26] I have little interest in vindicating Wallace Stevens or in disclosing a plethora of "valid" readings, where *valid* is a word to dodge around the harsher and more legalistic *correct*. The line I am suggesting I have called, in a feminist context, "scrupulous and plausible misreadings." Since all readings, including the original text, are constituted by, or effects of, the necessary possibility of misreadings, in my argument the question becomes one of interpretations for use, built on the old grounds of coherence, without the cant of theoretical adequacy. And the emphasis falls on alert pedagogy.

It is not only poetry that can be taught in this way, of course. The eighteenth-century historian Giambattista Vico had a theory of language that put metaphor at the origin and suggested, I think, that first was best. It so happens that Vico took this theory seriously and at crucial moments in his arguments put the burden of proof upon metaphorical production. In his speculation upon the principles of the history of human nature, Vico suggested that the sons of Noah, terrified by the first thunderclap, overcome by guilt and shame, hid in caves, dragging with them the indocile women they had been pursuing. In those caves, "gentile humanity" was founded. Although the place of guilt and shame in this story is very important, the reason for those two emotions, unlike in the Adam and Eve story, is not made clear. (Pursuing indocile women is clearly no grounds for either.) "Thus it was fear which created gods in the world...not fear awakened in men by other men, but fear awakened in men by themselves." It is because Vico was working his origin through metaphoric practice that this curious lack of clarity is encountered. It cannot be caught within the discourse of literalist explanations, where the adequation of cause and effect is the criterion of success. According to the literalist view, the fear of the thunderclap is itself produced through a metaphorical "mistake." Thinking of nature as "a great animated body," our fathers (Noah's sons) interpret the thunder as a threatening growl, the *response* to an act that should bring guilt and shame. The figure is metalepsis or prolepsis. The threat of the thunder, *result* of a transgression, is seen as the *cause* of the flight into the caves; or, variously, the threatening thunder *anticipates* the guilt and shame that should have produced it. Whichever is the case, the explanation hinges on a metaphor.

Again, speaking of legal marriage, or "solemn matrimony," which imposes civil status upon the patrician, Vico uses the metaphor of light. "[Juno] is also known as Lucina, who brings the offspring into the light; not natural light, for that is shared by the offspring of slaves, but the civil light by reason of which the nobles are called illustrious." Now there is

a previous invocation of light at the beginning of book 1, section 3 ("Principles") which seems to anticipate the light that can only come with marriage and render the one I quoted first (but which comes later in the book) logically suspect. "But in the night of thick darkness enveloping the earliest antiquity, so remote from ourselves, there shines the eternal and never-failing light of a truth beyond all question: that the world of civil society has certainly been made by men, and that its principles are therefore to be found within the modification of our human mind." For the first figure of light seems to anticipate the effect and origin of the civil light that can shine only with the establishment of domestic society in the distant future. Once again it is prolepsis at work. Vico used the same mechanism, the structure of figuration, to produce his theoretical discourse which, he argued, produced the first and best language.[27]

If the discipline of literary criticism is merely permitted to indulge in the praise of metaphor, the discipline of history is expected to eschew metaphor as anything but the incidental ornamentation of the reportage of fact. The sort of reading I am describing would be dismissed by most self-respecting academic historians as reading "Vico as literature." The contribution of a critical humanist pedagogy in this case would be to take the metaphors in Vico as yet another example of the questioning of the supremacy of adequate theory, and not to relegate it to (or exalt it as) the semipoetic free-style social *philosophy* that preceded social *science*. Thus my two examples would emphasize the conceptuality of poetic language and the metaphoricity of historical language *to similar pedagogical ends*.

These examples are not audacious and revolutionary. It is not possible for a lone individual to question her disciplinary boundaries without collective effort. That is why I had hoped to hear some news of pedagogy at our symposium, not merely theory exchange. In the humanities classroom the ingredients for the methods of (the official) cultural explanation that fixes and constitutes "culture" are assembled. As a feminist, Marxist deconstructivist, I am interested in the theory-practice of pedagogic practice-theory that would allow us constructively to question privileged explanations even as explanations are generated.

It should be clear by now that I could not be embarked upon a mere reversal—a mere centralizing of teaching-as-practice at the same time as research-as-theory is marginalized. That slogan has led to the idea of teaching as the creation of human rapport or the relieving of anxiety and tension in the classroom that I have heard described as "pop psych" teaching and that I myself call "babysitting."[28] What I look for rather is a confrontational teaching of the humanities that would question the students' received disciplinary ideology (model of legitimate cultural explanations) even as it pushed into indefiniteness the most powerful ideology of the

teaching of the humanities: the unquestioned explicating power of the theorizing mind and class, the need for intelligibility and the rule of law. If we meet again, as I hope we will, that is the question I will put on the agenda: the pedagogy of the humanities as the arena of cultural explanations that question the explanations of culture.

NOTES

1. Stirrings of such a point of view can be seen in Mary Wollstonecraft, *Vindication of the Rights of Woman* (1782), by way of the apparently converse argument that reason, the animating principle of civil society, must become the guiding principle of domestic society as well.

2. Paul Ricoeur, *Freud and Philosophy: An Essay on Interpretation*, trans. Denis Savage (New Haven: Yale University Press, 1970), pp. 32–36.

3. Edmund Husserl, *Ideas: General Introduction to Pure Phenomenology*, trans. W. R. Boyce Gibson (New York: Collier Books, 1962), p. 12.

4. As I argue elsewhere, Derrida's "playfulness" is in fact a "serious" and practical critique of pure seriousness (see "Revolutions That As Yet Have No Model," pp. 95–99 below). Here suffice it to point out that the disciplinary unease that is the straight reaction to the later Derrida can be described in the following way: "Here [is] a *new object*, calling for new conceptual tools, and for fresh theoretical foundations....[Here] is a true monster...[not someone who is] committing no more than a disciplined error" (italics mine). Michel Foucault, "The Discourse on Language," in *The Archaeology of Knowledge*, trans. A. M. Sheridan Smith (London: Tavistock, 1972), p. 224.

5. Jacques Derrida, *Speech and Phenomena: And Other Essays on Husserl's Theory of Signs*, trans. David B. Allison (Evanston: Northwestern University Press, 1973), p. 102.

6. Sigmund Freud, *The Standard Edition of the Complete Psychological Works of Sigmund Freud*, trans. James Strachey, et al. (London: Hogarth Press, 1953–74), vol. 22, pp. 116–17.

7. Adrienne Rich, "On Privilege, Power, and Tokenism," *Ms.*, 8:3 (September 1979), p. 43.

8. By "technocracy" I am not referring to the "technocracy movement [which] was a short-lived episode of the thirties" and "was rooted in the nineteenth-century strand of thought that identified technology as the dominant force capable of fulfilling the American dream." I am referring rather to the practical sellout of this dream which is a condition of the possibility of the theory of technocracy: "The modern postindustrial state—with its centralization, its emphasis on replacing politics with administrative decisions, and its meritocratic élite of specially trained experts—bears a more striking resemblance to the progressive formulation, which was the starting point for the technocrats. The progressive intellectuals, progressive engineers, and scientific

managers of the early twentieth century saw the outlines of the future political economy with amazing clarity. But the 'immensely enriched and broadened life within reach of all,' which Harlow Person predicted, remains a dream that technology and engineering rationality seem incapable of fulfilling." William F. Akin, *Technocracy and the American Dream: The Technocrat Movement, 1900–1941* (Berkeley and Los Angeles: University of California Press, 1977), pp. xi, xiii, 170. My essay speculates in a very minor way about the theoretical humanists' unself-conscious role in sustaining this inevitable sellout. For preliminary information on some of the major actors in this drama, see Ronald Radosh and Murray N. Rothbard, eds., *A New History of Leviathan: Essays on the Rise of the American Corporate State* (New York: Dutton, 1972).

9. I am simply referring as "masculism" to old-fashioned humanism, which considers the study of woman to be a special interest and defines woman invariably in terms of man. Among the many studies of the relationship between capitalism and masculism, I cite two here: *Feminism and Materialism: Women and Modes of Production*, Annette Kuhn and AnnMarie Wolpe, eds., (London: Routledge & Kegan Paul, 1978); and Zillah R. Eisenstein, ed., *Capitalist Patriarchy and the Case for Socialist Feminism* (New York: Monthly Review Press, 1979).

10. A simple test case of how politics-economics-technology (i.e., technocracy) becomes a collective determinant where "the last instance" can only be situated provisionally, temporarily, and in a slippery way, is the revisions of Edison's technological systems as recorded in the publications of the Edison Electric Institute. A humanist analysis of technology, choosing to ignore the transformation in the definition of technology, situates *technè* as the dynamic and undecidable middle term of the triad *theoria-technè-praxis*. The *loci classici* are, say, Aristotle's *Metaphysics* (1.1 and 2) and *Nicomachean Ethics* (6). For extensive documentation, Nikolaus Lobkowicz, *Theory and Practice: History of a Concept from Aristotle to Marx* (Notre Dame: University Press of America, 1967), is useful. Heidegger's "The Question Concerning Technology," in *The Question Concerning Technology and Other Essays*, trans. William Lovitt (New York: Harper & Row, 1977) may be cited as a modern humanist study of the question. I am suggesting, of course, that such a text as the last can be made to produce a reading "against itself" if technology is understood as the disruptive middle term between politics and economics, or between science and society, making arguments from binary oppositions or "the last instance" productively undecidable.

11. I am leaving out of the argument the fact that this very "scholarly life" is sustained by bands of workers—secretarial and janitorial staff—who inhabit another world of pay scale and benefits and whose existence as labor is often, as at my own university, denied by statute.

12. I have so internalized the power of this phrase that I had forgotten in the first draft that Professor Norman Rudich had said with great passion at the

Marxist Literary Group Summer Institute (1979): "They are trashing the humanities...."

13. The last suggestion was offered by the executive secretary of the Modern Language Association at an unpublished lecture at the University of Texas-Austin in October 1979.

14. That the poststructuralists have developed a vocabulary that is on principle somewhat fluid has offended three groups who have no interest in studying them carefully. One group (represented by E. P. Thompson and E. J. Hobsbawm, as well as, curiously enough, Terry Eagleton) would seek to establish the disciplinary privilege of history over philosophy, or of an ultimately isomorphic theory of material and literary form over a theory that questions the convenience of isomorphism. "If we deny the determinate properties of the object, then no discipline remains." Thompson, *The Poverty of Theory and Other Essays* (New York: Monthly Review Press, 1978), p. 41. This book, containing some astute criticism of Althusser, seems finally to claim—as Althusser claimed about Marx's (philosophical) theory—that Marx had not developed an adequate (historical) theory. The real issue seems to be to *keep the disciplines going* so that theory can endorse "enlightened practice." For a lexical analysis of Thompson's text, see Sande Cohen, *Historical Culture* (Berkeley: University of California Press, 1986), pp. 185–229. As that thinker of a rather different persuasion, Barrington Moore, Jr., wrote in 1965: "Objective here means simply that correct and unambiguous answers, independent of individual whims and preferences, are in principle possible." *A Critique of Pure Tolerance*, ed. Robert Paul Wolff, et al. (Boston: Beacon Press, 1965), p. 70. The second group is made up of conservative academic humanists like Gerald Graff, *Literature Against Itself: Literary Ideas in Modern Society* (Chicago: University of Chicago Press, 1979), or Peter Shaw, "Degenerate Criticism," *Harper's* 259:1553 (October 1979), pp. 93–99. These literary disciplinarians refuse to recognize that the poststructuralist vocabulary emerges in response to the problem of practice in the discourse of the human sciences. The fault is not altogether theirs for, given the ideology of American literary criticism (hinted at cryptically by way of Wallace Stevens in my final section), American deconstructivism seems repeatedly to demonstrate that theory as such is defunct and there to make an end. A Derrida or a Foucault would and does ask, if theory *as such* is defunct, what are the conditions of possibility of a practice that is not merely practice *as such*? The academic conservatives would rather argue, if a deconstructive view of things threatens business as usual, no one should be allowed to think deconstructive thoughts. In Thompson's words, the situation can be represented as a refusal to "argue with inconvenient evidence," (*Poverty*, p. 43). The third group is the resolutely anti-intellectual communalist political activists whose slogan seems to be "if you think too much about words, you will do no deeds."

15. All the quotations in this section, unless otherwise indicated, are from the typed material by each of the participants circulated among us before the symposium.

16. Karl Marx, *Capital: A Critique of Political Economy*, trans. Ben Fowkes (New York: Vintage Books, 1977), vol. 1, pp. 89–90. Hereafter cited in text as C1, followed by page number.

17. As representative figures of two sides of this exceedingly complex debate, let us choose the Althusser of *For Marx*, trans. Ben Brewster (London: Monthly Review Press, 1969), and The Paul K. Feyerabend of *Against Method: Outline of an Anarchistic Theory of Knowledge* (London: New Left Books, 1975).

18. Such a generalization would be able to include the Pierre Bourdieu of *Outline of a Theory of Practice*, trans. Richard Nice (Cambridge: Cambridge University Press, 1977) and the Jürgen Habermas of *Theory and Practice*, trans. John Viertel (Boston: Beacon Press, 1973), and *Knowledge and Human Interests*, trans. Jeremy J. Shapiro (Boston: Beacon Press, 1971).

19. Jacques Derrida, "Signature Event Context," *Glyph 1* (1977), p. 179. In this passage Derrida is questioning a naive critique of ideology that assumes an isomorphic and continuous relationship between things of the mind and things of the world. I should add that I am indebted to this and its companion essay "Limited Inc.," *Glyph 2* (1977), pp. 162–254 for much of my understanding of deconstructive practice.

20. I refer the reader to the play of disciplinary allegiances broadly outlined in note 14. Michel Foucault's work on the genealogy of disciplines is of interest here. I have already cited "The Discourse on Language" (see note 4). Pertinent also are *The Birth of the Clinic: An Archaeology of Medical Perception*, trans. A. M. Sheridan Smith (New York: Pantheon Books, 1973) and *Discipline and Punish: The Birth of the Prison*, trans. Alan Sheridan (New York: Random House, 1977). One could do worse than cite the young Marx and Engels: "*The occupation assumes an independent existence owing to division of labor.* Everyone believes his craft to be the true one. Illusions regarding the connection between craft and reality are the more likely to be cherished by them because of the very nature of the craft," Karl Marx and Friedrich Engels, *Collected Works* (New York: International Publishers, 1976), vol. 5, p. 92.

21. One could ponder, for example, the splintering of Students for a Democratic Society: Progressive Labor, the New American Movement, Democratic Socialist Organizing Committee. Each splinter has taken on certain idioms permitted by American socio-political discourse as it has moved from a politics of personal freedom (even in a collective guise) to a politics of social justice.

22. Herbert Marcuse, "Repressive Tolerance," in Robert Paul Wolff and Barrington Moore, Jr., eds., *A Critique of Pure Tolerance* (Boston: Beacon Press, 1965), p. 82.

23. Wallace Stevens, "The Idea of Order at Key West," in *The Collected Poems of Wallace Stevens* (New York: Knopf, 1954, p. 130).

24. Rosalind Coward and John Ellis, *Language and Materialism: Developments*

in Semiology and the Theory of the Subject (London: Routledge & Kegan Paul, 1977), p. 23.

25. Wordsworth, Coleridge, T. S. Eliot, and Matthew Arnold, of course.

26. Such a "making use" Foucault would call "the task[of] beco[ming] a curative science" based on a "historical sense" linked to Nietzsche's "active forgetfulness," which must make a "cut" in knowledge in order to act. "Nietzsche, Genealogy, History," in *Language, Counter-Memory, Practice*, trans. Donald F. Bouchard and Sherry Simon (Ithaca: Cornell University Press, 1977), pp. 156, 154. *Defeminates* is used as *emasculates*.

27. *The New Science of Giambattista Vico*, trans. Thomas Goddard Bergin and Max Harold Fisch (Ithaca: Cornell University Press, 1948), pp. 100, 109–110, 107, 106, 105, 155, 85. I am grateful to Professors Sidney Monas and James Schmidt for invoking these problematic passages.

28. Jean Bethke Elshtain, "The Social Relation of the Classroom: A Moral and Political Perspective," in *Studies in Socialist Pedagogy*, ed. T. M. Norton and Bertell Ollman (New York: Monthly Review Press, 1978). I am grateful to Professor Michael Ryan for calling my attention to this essay.

Feminism and Critical Theory

(1985)

THREE

This selection is a rewritten and expanded version of a talk entitled "Feminism and Critical Theory" (1978) and of the essay "Three Feminist Readings: McCullers, Drabble, Habermas" (1979). Here Spivak aims primarily at reaching a United States feminist audience, which was in 1985 still relatively unfamiliar and often uncomfortable with abstract theoretical writing. Hence she strives for clarity of expression without oversimplification, once again introducing deconstructive reading strategies, this time directed toward the texts of Marx, Freud, and Margaret Drabble.

In the first section, based on the 1978 talk, Spivak demonstrates that Marx's theory of the alienation of the worker from the product of his labor is based on inadequate evidence, because it does not take into account the instance of the womb as workshop, and the very different forms of alienation of product from labor represented by childbirth and by women's domestic work as unpaid, and thus unvalued, labor. Freud's account of penis envy as the chief determinant of femininity similarly avoids confronting the womb as a place of production, or the possibility of womb envy as penis envy's interactive complement. Thus Spivak proposes that feminists use the texts of Marx and Freud by reading them "beyond" themselves, producing a new "common currency" with which to understand society.

In a characteristic maneuver we observed in the previous essay, Spivak addresses the occasionality of publication by reflecting on, in the second section of the essay, the limitations of the first section. Since producing the earlier readings of Marx and Freud, she has recognized the crucial importance of race and the history of colonialism to an international feminist project. These concerns shape her reading of Drabble's novel *The Waterfall* (1971), and inform her exposure of the complicities of First World feminism with the heightened exploitation of Third World women's labor brought about by multinational corporations in the microelectronics indus-

try. Reading the world and our own positions in it demands the skills and attention to textuality required of literary critics in deconstruction's wake.

What has been the itinerary of my thinking during the past few years about the relationships among feminism, Marxism, psychoanalysis, and deconstruction? The issues have been of interest to many people, and the configurations of these fields continue to change. I will not engage here with the various lines of thought that have constituted these changes, but will try instead to mark and reflect upon the way these developments have been inscribed in my own work. The first section of the essays is a version of a talk I gave several years ago. The second section represents a reflection on that earlier work. The third section is an intermediate moment. The fourth section inhabits something like the present.

I.

I cannot speak of feminism in general. I speak of what I do as a woman within literary criticism. My own definition of a woman is very simple: it rests on the word "man" as used in the texts that provide the foundation for the corner of the literary criticism establishment that I inhabit. You might say at this point, defining the word "woman" as resting on the word "man" is a reactionary position. Should I not carve out an independent definition for myself as a woman? Here I must repeat some deconstructive lessons learned over the past decade that I often repeat. One, no rigorous definition of anything is ultimately possible, so that if one wants to, one could go on deconstructing the opposition between man and woman, and finally show that it is a binary opposition that displaces itself.[1] Therefore, "as a deconstructivist," I cannot recommend that kind of dichotomy at all, yet, I feel that definitions are necessary in order to keep us going, to allow us to take a stand. The only way that I can see myself making definitions is in a provisional and polemical one: I construct my definition as a woman not in terms of a woman's putative essence but in terms of words currently in use. "Man" is such a word in common usage. Not *a* word, but *the* word. I therefore fix my glance upon this word even as I question the enterprise of redefining the premises of any theory.

In the broadest possible sense, most critical theory in my part of the academic establishment (Lacan, Derrida, Foucault, the last Barthes) sees the text as that area of the discourse of the human sciences—in the United States called the humanities—in which the *problem* of the discourse of the human sciences is made available. Whereas in other kinds of discourses there is a move toward the final truth of a situation, literature, even within this argument, displays that the truth of a human situation *is* the itinerary

of not being able to find it. In the general discourse of the humanities, there is a sort of search for solutions, whereas in literary discourse there is a playing out of the problem as the solution.

The problem of human discourse is generally seen as articulating itself in the play of, in terms of, three shifting "concepts": language, world, and consciousness. We know no world that is not organized as a language—languages that we cannot possess, for we are operated by those languages as well. The category of language, then, embraces the categories of world and consciousness even as it is determined by them. Strictly speaking, since we are questioning the human being's control over the production of language, the figure that will serve us better is writing, for there the absence of the producer and receiver is taken for granted. A safe figure, seemingly outside of the language-(speech)-writing opposition, is the text—a weave of knowing and not-knowing which is what knowing is. (This organizing principle—language, writing, or text—might itself be a way of holding at bay a randomness incongruent with consciousness.)

The theoreticians of textuality read Marx as a theorist of the world (history and society), as a text of the forces of labor and production-circulation-distribution; and Freud as a theorist of the self, as a text of consciousness and the unconscious. Human textuality can be seen not only *as* world and self, *as* the representation of a world in terms of a self at play with other selves and generating this representation, but also *in* the world and self, all implicated in an "intertextuality." It should be clear from this that such a concept of textuality does not mean a reduction of the world to linguistic texts, books, or a tradition composed of books, criticism in the narrow sense, and teaching.

I am not, then, speaking about Marxist or psychoanalytic criticism as a reductive enterprise which diagnoses the scenario in every book in terms of where it would fit into a Marxist or a psychoanalytical canon. To my way of thinking, the discourse of the literary text is part of a general configuration of textuality, a placing forth of the solution as the unavailability of a unified solution to a unified or homogeneous, generating or receiving, consciousness. This unavailability is often not confronted. It is dodged and the problem apparently solved, in terms perhaps of unifying concepts like "man," the universal contours of a sex-, race-, class-transcendent consciousness as the generating, generated, and receiving consciousness of the text.

I could have broached Marx and Freud more easily. I wanted to say all of the above because, in general, in the literary critical establishment here, those two are seen as reductive models. Now, although nonreductive methods are implicit in both of them, Marx and Freud do also seem to argue in terms of a mode of evidence and demonstration. They seem to bring forth evidence from the world of man or man's self, and thus prove certain kinds

of truths about the world and self. I would risk saying that their descriptions of world and self are based on inadequate evidence. In terms of this conviction, I would like to fix upon the idea of alienation in Marx, and the idea of normality and health in Freud.

One way of moving into Marx is in terms of use-value, exchange-value, and surplus-value. Marx's notion of use-value is that which pertains to a thing as it is directly consumed by an agent. Its exchange-value (after the emergence of the money form) does not relate to its direct fulfillment of a specific need, but is rather assessed in terms of what it can be exchanged for in either labor-power or money. In this process of abstracting through exchange, by making the worker work longer than necessary for subsistence wages or by means of labor-saving machinery, the buyer of the laborer's work gets more (in exchange) than the worker needs for his subsistence while he makes the thing.[2] This "more-worth" (literally, in German, *Mehrwert*) is surplus-value.

One could indefinitely allegorize the relationship of woman within this particular triad—use, exchange, and surplus—by suggesting that woman in the traditional social situation produces more than she is getting in terms of her subsistence, and therefore is a continual source of the production of surpluses, *for* the man who owns her, or *by* the man for the capitalist who owns *his* labor-power. Apart from the fact that the mode of production of housework is not, strictly speaking, capitalist, such an analysis is paradoxical. The contemporary woman, when she seeks financial compensation for housework, seeks the abstraction of use-value into exchange-value. But the situation of the domestic workplace is not one of "pure exchange." The Marxian exigency would make us ask at least two questions: What is the use-value of a woman's unremunerated work for husband or family? Is the willing insertion into the wage structure a curse or a blessing? How should we fight the idea, universally accepted by men, that wages are the only mark of value-producing work? (Not, I think, through the slogan "Housework is beautiful.") What would be the implications of denying women entry into the capitalist economy? Radical feminism can here learn a cautionary lesson from Lenin's capitulation to capitalism.

These are important questions, but they do not necessarily broaden Marxist theory from a feminist point of view. For our purpose, the idea of externalization (*EntäuBerung/VeräuBerung*) or alienation (*Entfremdung*) is of greater interest. Within the capitalist system, the labor process externalizes itself and the worker as commodities. Upon this idea of the resultant fracturing of the human being's relationship to himself and his work as commodities rests the ethical charge of Marx's argument.[3]

I would argue that, in terms of the physical, emotional, legal, custodial, and sentimental situation of the woman's product, the child, this picture of

the human relationship to production, labor, and property is incomplete. The possession of a tangible place of production, the womb, situates women as agents in any theory of production. Marx's dialectics of externalization-alienation followed by fetish formation are inadequate because he has not taken into account one fundamental human relationship to a product and labor.[4]

This does not mean that, if the Marxian account of externalization-alienation were rewritten from a feminist perspective, the special interest of childbirth, childbearing, and childrearing would be inserted. It seems that the entire problematic of sexuality, rather than remaining caught within arguments about overt sociosexual politics, would be fully broached.

Having said this, I would reemphasize the need to interpret reproduction within a Marxian problematic.[5]

In both so-called matrilineal and patrilineal societies the legal possession of the child is an inalienable fact of the property right of the man who "produces" the child.[6] In terms of this legal possession, the common custodial definition, that women are much more nurturing of children, might be seen as a dissimulated reactionary gesture. The man retains legal property rights over the product of the woman's body. On each separate occasion, the custodial decision—which parent will have custody?—is a sentimental questioning of man's right. The current struggle over abortion rights has foregrounded this unacknowledged agenda.

In order not simply to make an exception to man's legal right, or to add a footnote from a feminist perspective to the Marxist text, we must engage and correct the theory of production and alienation upon which the Marxist text is based and with which it functions. As I suggested above, much Marxist feminism works on an analogy with use-value, exchange-value, and surplus-value relationships. Marx's own writings on women and children seek to alleviate their condition in terms of a desexualized labor force.[7] If there were the kind of rewriting that I am proposing, it would be harder to sketch out the rules of economy and social ethics; in fact, one would see that in Marx there is a moment of major transgression where rules for humanity and criticism of societies are based on inadequate evidence. Marx's texts, including *Capital*, presuppose an ethical theory: alienation of labor must be undone because it undermines the agency of the subject in his work and his property. I would like to suggest that if the nature and history of alienation, labor, and the production of property are reexamined in terms of women's work and childbirth, it can lead us to a reading of Marx beyond Marx.

One way of moving into Freud is in terms of his notion of the nature of pain as the deferment of pleasure, especially the later Freud who wrote *Beyond the Pleasure Principle*.[8] Freud's spectacular mechanics of imagined,

anticipated, and avoided pain write the subject's history and theory, and constantly broach the never-quite-defined concept of normality: anxiety, inhibition, paranoia, schizophrenia, melancholy, mourning. I would like to suggest that in the womb, a tangible place of production, there is the possibility that pain exists *within* the concepts of normality and productivity. (This is not to sentimentalize the pain of childbirth.) The problematizing of the phenomenal identity of pleasure and unpleasure should not be operated only through the logic of repression. The opposition pleasure-pain is questioned in the physiological "normality" of woman.

If one were to look at the never-quite-defined concepts of normality and health that run through and are submerged in Freud's texts, one would have to redefine the nature of pain. Pain does not operate in the same way in men and women. Once again, this deconstructive move will make it much harder to devise the rules.

Freud's best-known determinant of femininity is penis envy. The most crucial text of this argument is the essay on femininity in *New Introductory Lectures*.[9] There, Freud begins to argue that the little girl is a little boy before she discovers sex. As Luce Irigaray and others have shown, Freud does not take the womb into account.[10] Our mood, since we carry the womb as well as being carried by it, should be corrective.[11] We might chart the itinerary of womb envy in the production of a theory of consciousness: the idea of the womb as a place of production is avoided both in Marx and in Freud. (There are exceptions to such a generalization, especially among American neo-Freudians such as Erich Fromm. I am speaking here about invariable presuppositions, even among such exceptions.) In Freud the genital stage is preeminently phallic, not clitoral or vaginal. This particular gap in Freud is significant. The hysteron remains the place which constitutes only the text of hysteria. Everywhere there is a nonconfrontation of the idea of the womb as a workshop, except to produce a surrogate penis. Our task in rewriting the text of Freud is not so much to declare it possible to reject the idea of penis envy, but to make available the idea of a womb envy as something that interacts with the idea of penis envy to determine human sexuality and the production of society.[12]

These are some questions that may be asked of the Freudian and Marxist "grounds" or theoretical "bases" that operate our ideas of world and self. We might want to ignore them altogether and say that the business of literary criticism has to do with neither your gender (such a suggestion seems hopelessly dated) nor the theories of revolution or psychoanalysis. Criticism must remain resolutely neuter and practical. One should not mistake the grounds out of which the ideas of world and self are reproduced with the business of the appreciation of the literary text. If one looks closely, one will see that, whether one diagnoses the names or not, certain

kinds of thoughts are presupposed by the notions of world and conscious-ness of the most "practical" critic. Part of the feminist enterprise might well be to provide "evidence" so that these great male texts do not become great adversaries, or models from whom we take our ideas and then revise or reassess them. These texts must be rewritten so that there is new material for the grasping of the production and determination of literature within the general production and determination of consciousness and society. After all, the people who produce literature, male and female, are also moved by general ideas of world and consciousness to which they cannot give a name.

If we work in this way, the common currency of the understanding of society will change. I think that kind of change, the coining of new money, is necessary. I certainly believe that such work is supplemented by research into women's writing and research into the conditions of women in the past. The kind of work I have outlined would infiltrate the male academy and redo the terms of our understanding of the context and substance of literature as part of the human enterprise.

II.

What seems missing in these earlier remarks is the dimension of race. Today I would see my work as the developing of a reading method that is sensi-tive to gender, race, and class. The earlier remarks would apply indirectly to the development of class-sensitive and directly to the development of gender-sensitive readings.

In the matter of race-sensitive analyses, the chief problem of American feminist criticism is its identification of racism as such with the constitu-tion of racism in America. Thus, today I see the object of investigation to be not only the history of "Third World women" or their testimony, but also the production, through the great European theories, often by way of lit-erature, of the colonial object. As long as American feminists understand "history" as a positivistic empiricism that scorns "theory" and therefore remains ignorant of its own, the "Third World" as its object of study will remain constituted by those hegemonic First World intellectual practices.[13]

My attitude toward Freud today involves a broader critique of his entire project. It is a critique not only of Freud's masculism but of nuclear-famil-ial psychoanalytical theories of the constitution of the sexed subject. Such a critique extends to alternative scenarios to Freud that keep to the nuclear parent-child model; as it does to the offer of Greek mythical alternatives to Oedipus as the regulative type-case of the model itself; as it does to the romantic notion that an extended family, especially a community of women, would necessarily cure the ills of the nuclear family. My concern with the production of colonial discourse thus touches my critique of Freud as well as most Western feminist challenges to Freud. The extended or

corporate family is a socioeconomic (indeed, on occasion political) organization which makes sexual constitution irreducibly complicit with historical and political economy.[14] To learn to read that way is to understand that the literature of the world, itself accessible only to a few, is not tied by the concrete universals of a network of archetypes—a theory that was entailed by the consolidation of a political excuse—but by a textuality of material, ideological, psychosexual production. This articulation sharpens a general presupposition of my earlier remarks.

Pursuing these considerations, I proposed recently an analysis of "the discourse of the clitoris."[15] The reactions to that proposal have been interesting in the context I discuss above. A certain response from American lesbian feminists can be represented by the following quotation: "In this open-ended definition of phallus/semination as organically *omnipotent* the only recourse is to name the clitoris as orgasmically phallic and to call the uterus the reproductive extension of the phallus.... You must stop thinking of yourself privileged as a heterosexual woman."[16] Because of its physiologistic orientation, the first part of this objection sees my naming of the clitoris as a repetition of Freud's situating of it as a "little penis." To the second part of the objection I customarily respond: "You're right, and one cannot know how far one succeeds. Yet, the effort to put First World lesbianism in its place is not necessarily reducible to pride in female heterosexuality." Other uses of my suggestion, both supportive and adverse, have also reduced the discourse of the clitoris to a physiological fantasy. In the interest of the broadening scope of my critique, I should like to reemphasize that the clitoris, even as I acknowledge and honor its irreducible physiological effect, is, in this reading, also a shorthand for women's excess in all areas of production and practice, an excess which must be brought under control to keep business going as usual.[17]

My attitude toward Marxism now recognizes the historical antagonism between Marxism and feminism, *on both sides*. Hardcore Marxism at best dismisses and at worst patronizes the importance of women's struggle. On the other hand, not only the history of European feminism in its opposition to Bolshevik and Social Democrat women, but the conflict between the suffrage movement and the union movement in this country must be taken into account. This historical problem will not be solved by saying that we need more than an analysis of capitalism to understand male dominance, or that the sexual division of labor as the primary determinant is already given in the texts of Marx. I prefer the work that sees that the "essential truth" of Marxism or feminism cannot be separated from its history. My present work relates this to the ideological development of the theory of the imagination in the eighteenth, nineteenth, and twentieth centuries. I am interested in class analysis of families as it is being practiced by,

among others, Elizabeth Fox-Genovese, Heidi Hartmann, Nancy Hartsock, and Annette Kuhn. I am myself bent upon reading the text of international feminism as operated by the production and realization of surplus-value. My own earlier concern with the specific theme of reproductive (non)alienation seems to me today to be heavily enough touched by a nuclear-familial hystero-centrism to be open to the critique of psychoanalytic feminism that I suggest above.

On the other hand, if sexual reproduction is seen as the production of a product by an irreducibly determinate means (conjunction of semination and ovulation), in an irreducibly determinate mode (heterogeneous combination of domestic and politico-civil economy), entailing a minimal variation of social relations, then two original Marxist categories would be put into question: use-value as the measure of communist production and absolute surplus-value as the motor of primitive (capitalist) accumulation. For the first: the child, although not a commodity, is also not produced for immediate and adequate consumption or direct exchange. For the second: the premise that the difference between a subsistence wage and labor-power's potential of production is the origin of original accumulation can only be advanced if reproduction is seen as identical with subsistence; in fact, the reproduction and maintenance of children would make heterogeneous the original calculation in terms of something like the slow displacement of value from fixed capital to commodity.[18] These insights take the critique of wage-labor in unexpected directions.

When I earlier touched upon the relationship between wage theory and "women's work," I had not yet read the autonomist arguments about wage and work as best developed in the work of Antonio Negri.[19] Exigencies of work and limitations of scholarship and experience permitting, I would like next to study the relationship between domestic and political economies in order to establish the subversive power of "women's work" in models for the construction of a "revolutionary subject." Negri sees this possibility in the inevitable consumerism that socialized capitalism must nurture. Commodity consumption, even as it realizes surplus-value as profit, does not itself produce the value and therefore persistently exacerbates a crisis.[20] It is through reversing and displacing this tendency within consumerism, Negri suggests, that the "revolutionary subject" can be released. Mainstream English Marxists sometimes think that such an upheaval can be brought about by political interventionist teaching of literature. Some French intellectuals think this tendency is inherent in the "pagan tradition," which pluralizes the now-defunct narratives of social justice still endorsed by traditional Marxists in a postindustrial world. In contrast, I now argue as follows:

It is women's work that has continuously survived within not only the vari-

eties of capitalism but other historical and geographical modes of production. The economic, political, ideological, and legal heterogeneity of the relationship between the definitive mode of production and race- and class-differentiated women's and wives' work is abundantly recorded. Rather than the refusal to work of the freed Jamaican slaves in 1834, which is cited by Marx as the only example of zero-work, quickly recuperated by imperialist maneuvers, it is the long history of women's work which is a sustained example of zero-work: work not only outside of wage-work, but, *in one way or another*, "outside" of the definitive modes of production. The displacement required here is a transvaluation, an uncatastrophic *implosion* of the search for validation via the circuit of productivity. Rather than a miniaturized and thus controlled metaphor for civil society and the state, the power of the *oikos*, domestic economy, can be used as the model of the foreign body unwittingly nurtured by the *polis*.[21]

With psychoanalytic feminism, then, an invocation of history and politics leads us back to the place of psychoanalysis in colonialism. With Marxist feminism, an invocation of the economic text foregrounds the operations of the new imperialism. The discourse of race has come to claim its importance in this way in my work.

I am still moved by the reversal-displacement morphology of deconstruction, crediting the asymmetry of the "interest" of the historical moment. Investigating the hidden ethico-political agenda of differentiations constitutive of knowledge and judgment interests me even more. It is also the deconstructive view that keeps me resisting an essentialist freezing of the concepts of gender, race, and class. I look rather at the repeated agenda of the situational production of those concepts and our complicity in such a production. This aspect of deconstruction will not allow the establishment of a hegemonic "global theory" of feminism.

Over the last few years, however, I have also begun to see that, rather than deconstruction simply opening a way for feminists, the figure and discourse of women opened the way for Derrida as well. His incipient discourse of women surfaced in *Spurs* (first published as "La Question du Style" in 1975), which also articulates the thematics of "interest" crucial to political deconstruction.[22] This study marks his move from the critical deconstruction of phallocentrism to "affirmative" deconstruction (Derrida's phrase). It is at this point that Derrida's work seems to become less interesting for Marxism.[23] The early Derrida can certainly be shown to be useful for feminist practice, but why is it that, when he writes under the sign of woman, as it were, his work becomes solipsistic and marginal? What is it in the history of that sign that allows this to happen? I will hold this question until the end of this essay.

III.

In 1979 and 1980, concerns of race and class were beginning to invade my mind. What follows is in some sense a checklist of quotations from Margaret Drabble's *The Waterfall* that shows the uneasy presence of those concerns.[24] Reading literature "well" is in itself a questionable good and can indeed be sometimes productive of harm and "aesthetic" apathy within its ideological framing. My suggestion is to use literature, with a feminist perspective, as a "nonexpository" theory of practice.

Drabble has a version of "the best education" in the Western world: a First Class in English from Oxbridge. The tradition of academic radicalism in England is strong. Drabble was at Cambridge when the prestigious journal *New Left Review* was being organized. I am not averse to a bit of simple biographical detail: I began to reread *The Waterfall* with these things in mind as well as the worrying thoughts about sex, race, and class.

Like many woman writers, Drabble creates an extreme situation, presumably, to answer the question, "Why does love happen?" In place of the mainstream objectification and idolization of the loved person, she situates her protagonist, Jane, in the most inaccessible privacy—at the moment of birthing, alone by choice. Lucy, her cousin, and James, Lucy's husband, take turns watching over her in the empty house as she regains her strength. *The Waterfall* is the story of Jane's love affair with James. In place of legalized or merely possessive ardor toward the product of his own body, Drabble gives to James the problem of relating to the birthing woman through the birth of "another man's child." Jane looks and smells dreadful. There is blood and sweat on the crumpled sheets. And yet "love" happens. Drabble slows language down excruciatingly as Jane records how, wonders why. It is possible that Drabble is taking up the challenge of feminine "passivity" and making it the tool of analytic strength. Many answers emerge. I will quote two, to show how provisional and self-suspending Jane can be:

> I loved him inevitably, of necessity. Anyone could have foreseen it, given those facts: a lonely woman, in an empty world. Surely I would have loved anyone who might have shown me kindness.... But of course it's not true, it could not have been anyone else.... I know that it was not inevitable: it was a miracle....What I deserved was what I had made: solitude, or a repetition of pain. What I received was grace. Grace and miracles. I don't much care for my terminology. Though at least it lacks that most disastrous concept, the concept of free will. Perhaps I could make a religion that denied free will, that placed God in his true place, arbitrary, carelessly kind, idly malicious, intermittently attentive, and himself subject, as Zeus was, to necessity. Necessity is my God. Necessity lay with me when James did [pp. 49–50].

And, in another place, the "opposite" answer—random contingencies:

> I loved James because he was what I had never had: because he belonged to
> my cousin: because he was kind to his own child: because he looked unkind:
> because I saw his naked wrists against a striped tea towel once, seven years
> ago. Because he addressed me an intimate question upon a beach on
> Christmas Day. Because he helped himself to a drink when I did not dare
> to accept the offer of one. Because he was not serious, because his parents
> lived in South Kensington and were mysteriously depraved. Ah, perfect
> love. For these reasons, was it, that I lay there, drowned was it, drowned
> or stranded, waiting for him, waiting to die and drown there, in the oceans
> of our flowing bodies, in the white sea of that strange familiar bed [p. 67].

If the argument for necessity is arrived at by slippery happenstance from
thought to thought, each item on this list of contingencies has a plausibili-
ty that is far from random.

She considers the problem of making women rivals in terms of the man
who possesses them. There is a peculiar agreement between Lucy and her-
self before the affair begins:

> I wonder why people marry? Lucy continued, in a tone of such academic
> flatness that the topic seemed robbed of any danger. I don't know, said Jane,
> with equal calm.... So arbitrary, really, said Lucy, spreading butter on the
> toast. It would be nice, said Jane, to think there were reasons.... Do you
> think so? said Lucy. Sometimes I prefer to think we are victims.... If there
> were a reason, said Jane, one would be all the more a victim. She paused,
> thought, ate a mouthful of the toast. I am wounded, therefore I bleed. I am
> human, therefore I suffer. Those aren't reasons you're describing, said
> Lucy.... And from upstairs the baby's cry reached them—thin, wailing, des-
> perate. Hearing it, the two women looked at each other, and for some rea-
> son smiled [pp. 26–27].

This, of course, is no overt agreement, but simply a hint that the "reason"
for female bonding has something to do with a baby's cry. For example,
Jane records her own deliberate part in deceiving Lucy this way: "I forgot
Lucy. I did not think of her—or only occasionally, lying awake at night *as
the baby cried,* I would think of her, with pangs of irrelevant inquiry, pangs
endured not by me and in me, but at a distance, pangs as sorrowful and
irrelevant as another person's pain" (p. 48; italics mine).

Jane records inconclusively her gut reaction to the supposed natural con-
nection between parent and child: "Blood is blood, and it is not good
enough to say that children are for the motherly, as Brecht said, for there

are many ways of unmothering a woman, or unfathering a man.... And yet, how can I deny that it gave me pleasure to see James hold her in his arms for me? The man I loved and the child to whom I had given birth" (p. 48).

The loose ending of the book also makes Jane's story an extreme case. Is this love going to last, prove itself to be "true," and bring Jane security and Jane and James happiness? Or is it resolutely "liberated," overprotesting its own impermanence, and thus falling in with the times? Neither. The melodramatic and satisfactory ending, the accident which might have killed James, does not in fact do so. It merely reveals all to Lucy, does not end the book, and reduces all to a humdrum kind of double life.

These are not bad answers; necessity if all else fails, or perhaps random contingency; an attempt not to trivialize women; blood bonds between mothers and daughters; love free of social security. The problem for a reader like me is that the entire question is carried on in what I can only see as a privileged atmosphere. I am not saying, of course, that Jane is Drabble (although that, too, is true in a complicated way). I am saying that Drabble considers the story of so privileged a woman the most worth telling. Not the well-bred lady of pulp fiction, but an impossible princess who mentions in one passing sentence toward the beginning of the book that her poems are read on the BBC.

It is not that Drabble does not want to rest her probing and sensitive fingers on the problem of class, if not race. The account of Jane's family's class prejudice is incisively told. Her father is headmaster of a public school.

> There was one child I shall always remember, a small thin child...whose father, he proudly told us, was standing as Labour Candidate for a hopeless seat in an imminent General Election. My father teased him unmercifully, asking questions that the poor child could not begin to answer, making elaborate and hideous semantic jokes about the fruits of labor, throwing in familiar references to prominent Tories that were quite wasted on such...tender ears; and the poor child sat there, staring at his roast beef...turning redder and redder, and trying, pathetically, sycophantically, to smile. I hated my father at that instant [pp. 56–57].

Yet Drabble's Jane is made to share the lightest touch of her parents' prejudice. The part I have elided is a mocking reference to the child's large red ears. For her the most important issue remains sexual deprivation, sexual choice. *The Waterfall*, the name of a card trick, is also the name of Jane's orgasms, James's gift to her.

But perhaps Drabble is ironic when she creates so classbound and yet so analytic a Jane? It is a possibility, of course, but Jane's identification with the author of the narrative makes this doubtful. If there is irony to be generated

here, it must come, as they say, from "outside the book."

Rather than imposing my irony, I attempt to find the figure of Jane as narrator helpful. Drabble manipulates her to examine the conditions of production and determination of microstructural heterosexual attitudes within her chosen enclosure. This enclosure is important because it is from here that rules come. Jane is made to realize that there are no fixed new rules in the book, not as yet. First World feminists are up against that fact, every day. This should not become an excuse but should remain a delicate responsibility: "If I need a morality, I will create one: a new ladder, a new virtue. If I need to understand what I am doing, if I cannot act without my own approbation—and I must act, I have changed, I am no longer capable of inaction—then I will invent a morality that condones me. Though by doing so, I risk condemning all that I have been" (pp. 52–53).

If the cautions of deconstruction are heeded—the contingency that the desire to "understand" and "change" are as much symptomatic as they are revolutionary—merely to fill in the void with rules will spoil the case again, for women as for human beings. We must strive moment by moment to practice a taxonomy of different forms of understanding, different forms of change, dependent perhaps upon resemblance and seeming substitutability—figuration—rather than on the self-identical category of truth:

> Because it's obvious that I haven't told the truth, about myself and James. How could I? Why, more significantly, should I?... Of the truth, I haven't told enough. I flinched at the conclusion and can even see in my hesitance a virtue: it is dishonest, it is inartistic, but it is a virtue, such discretion, in the moral world of love.... The names of qualities are interchangeable: vice, virtue: redemption, corruption: courage, weakness: and hence the confusion of abstraction, the proliferation of aphorism and paradox. In the human world, perhaps there are merely likenesses.... The qualities, they depended on the supposed true end of life.... Salvation, damnation.... I do not know which of these two James represented. Hysterical terms, maybe; religious terms, yet again. But then life is a serious matter, and it is not merely hysteria that acknowledges this fact: for men as well as women have been known to acknowledge it. I must make an effort to comprehend it. I will take it all to pieces. I will resolve it to parts, and then I will put it together again, I will reconstitute it in a form that I can accept, a fictitious form [pp. 46, 51, 52].

The categories by which one understands, the qualities of plus and minus, are revealing themselves as arbitrary, situational. Drabble's Jane's way out—to resolve and reconstitute life into an acceptable fictional form that need not, perhaps, worry too much about the categorical problems—seems, by itself, a classical privileging of the aesthetic, for Drabble hints at the

limits of self-interpretation through a gesture that is accessible to the humanist academic. Within a fictional form, she confides that the exigencies of a narrative's unity had not allowed her to report the whole truth. She then changes from the third person to the first.

What can a literary critic do with this? Notice that the move is absurdity twice compounded, since the discourse reflecting the constraints of fiction-making goes on then to fabricate another fictive text. Notice further that the narrator who tells us about the impossibility of truth in fiction—the classic privilege of metaphor—is a metaphor as well.[25]

I should choose a simpler course. I should acknowledge this global dismissal of any narrative speculation about the nature of truth and then dismiss it in turn, since it might unwittingly suggest that there is somewhere a way of speaking about truth in "truthful" language, that a speaker can somewhere get rid of the structural unconscious and speak without role-playing. Having taken note of the frame, I will thus explain the point Jane is making here and relate it to what, I suppose, the critical view above would call "the anthropomorphic world"; when one takes a rational or aesthetic distance from oneself one gives oneself up to the conveniently classifying macrostructures, a move dramatized by Drabble's third-person narrator. By contrast, when one involves oneself in the microstructural moments of practice that make possible and undermine every macrostructural theory, one falls, as it were, into the deep waters of a first person who recognizes the limits of understanding and change, indeed the precarious necessity of the micro-macro opposition, yet is bound not to give up.

The risks of first-person narrative prove too much for Drabble's fictive Jane. She wants to plot her narrative in terms of the paradoxical category— "pure corrupted love"—that allows her to *make* a fiction rather than try, *in* fiction, to report on the unreliability of categories: "I want to get back to that schizoid third-person dialogue. I've one or two more sordid conditions to describe, and then I can get back there to that isolated world of pure corrupted love" (p. 130). To return us to the detached and macrostructural third-person narrative after exposing its limits could be an aesthetic allegory of deconstructive practice.

Thus Drabble fills the void of the female consciousness with meticulous and helpful articulation, though she seems thwarted in any serious presentation of the problems of race and class, and of the marginality of sex. She engages in that microstructural dystopia, the sexual situation in extremis, that begins to seem more and more a part of women's fiction. Even within those limitations, our motto cannot be Jane's "I prefer to suffer, I think," the privatist cry of heroic liberal women; it might rather be the lesson of the scene of writing of *The Waterfall*; to return to the third person with its grounds mined under.

IV.

It is no doubt useful to decipher women's fiction in this way for feminist students and colleagues in American academia. I am less patient with literary texts today, even those produced by women. We must of course remind ourselves, our positivist feminist colleagues in charge of creating the discipline of women's studies, and our anxious students, that essentialism is a trap. It seems more important to learn to understand that the world's women do not all relate to the privileging of essence, especially through "fiction," or "literature," in quite the same way.

In Seoul, South Korea, in March 1982, 237 women workers in a factory owned by Control Data, a Minnesota-based multinational corporation, struck over a demand for a wage raise. Six union leaders were dismissed and imprisoned. In July, the women took hostage two visiting U.S. vice-presidents, demanding reinstatement of the union leaders. Control Data's main office was willing to release the women; the Korean government was reluctant. On July 16, the Korean male workers at the factory beat up the female workers and ended the dispute. Many of the women were injured; two suffered miscarriages.

To grasp this narrative's overdeterminations (the many telescoped lines—sometimes noncoherent, often contradictory, perhaps discontinuous—that allow us to determine the reference point of a single "event" or cluster of "events") would require a complicated analysis.[26] Here, too, I will give no more than a checklist of the determinants. In the earlier stages of industrial capitalism, the colonies provided the raw materials so that the colonizing countries could develop their manufacturing industrial base. Indigenous production was thus crippled or destroyed. To minimize circulation time, industrial capitalism needed to establish due process, and such civilizing instruments as railways, postal services, and a uniformly graded system of education. This, together with the labor movements in the First World and the mechanisms of the welfare state, slowly made it imperative that manufacturing itself be carried out on the soil of the Third World, where labor can make many fewer demands, and the governments are mortgaged. In the case of the telecommunications industry, which makes old machinery obsolete at a more rapid pace than it takes to absorb its value in the commodity, this is particularly practical.

The incident that I recounted above, not at all uncommon in the multinational arena, complicates our assumptions about women's entry into the age of computers and the modernization of "women in development," especially in terms of our daily theorizing and practice. It should make us confront the discontinuities and contradictions in our assumptions about women's freedom to work outside the house, and the sustaining virtues of the working-class family. The fact that these workers were women was not

merely because, like those Belgian lacemakers, oriental women have small and supple fingers. It is also because they are the true army of surplus labor. No one, including their men, will agitate for an adequate wage. In a two-job family, the man saves face if the woman makes less, even for a comparable job.

Does this make Third World men more sexist than David Rockefeller? The nativist argument that says "do not question Third World mores" is of course unexamined imperialism. There *is* something like an answer to this vexed question, which makes problematic the ground upon which we base our own intellectual and political activities. No one can deny the dynamism and civilizing power of socialized capital. The irreducible search for greater production of surplus-value (dissimulated as, simply, "productivity") through technological advancement; the corresponding necessity to train a consumer who will need what is produced and thus help realize surplus-value as profit; the tax breaks associated with supporting humanist ideology through "corporate philanthropy"—all conspire to "civilize." These motives do not exist on a large scale in a comprador economy like that of South Korea, which is neither the necessary recipient nor the agent of socialized capital. The surplus-value is realized elsewhere. The nuclear family does not have a transcendent ennobling power. The fact that ideology and the ideology of marriage have developed in the West since the English revolution of the seventeenth century has something like a relationship to the rise of meritocratic individualism.

These possibilities overdetermine any generalization about universal parenting based on American, Western European, or laundered anthropological speculation.

Socialized capital kills by remote control. In this case, too, the American managers watched while the South Korean men decimated their women. The managers denied charges. One remark made by a member of Control Data management, as reported in *Multinational Monitor*, seemed symptomatic in its self-protective cruelty: "Although 'it's true' Chae lost her baby, 'this is not the first miscarriage she's had. She's had two before this.'"[27] However active in the production of civilization as a byproduct, socialized capital has not moved far from the presuppositions of a slavery mode of production. "In Roman theory, the agricultural slave was designated an *instrumentum vocale*, the speaking tool, one grade away from the livestock that constituted an *instrumentum semi-vocale*, and two from the implement which was an *instrumentum mutum*."[28]

One of Control Data's radio commercials speaks of how its computers open the door to knowledge, at home or in the workplace, for men and women alike. The acronym of the computer system in this ad is PLATO. One might speculate that this noble name helps to dissimulate a quantitative

and formula-permutational vision of knowledge as an instrument of efficiency and exploitation by surrounding it with an aura of the unique and subject-expressive wisdom at the very root of "democracy." The undoubted historical-symbolic value of the acronym PLATO shares in the effacement of class history that is the project of "civilization" as such: "the slave mode of production which underlay Athenian civilization necessarily found its most pristine ideological expression in the privileged social stratum of the city, whose intellectual heights its surplus labour in the silent depths below the *polis* made possible."[29]

Why is it, I asked above, that when Derrida writes under the sign of woman his work becomes solipsistic and marginal?

His discovery of the figure of woman is in terms of a critique of propriation—proper-ing, as in the proper name (patronymic) or property.[30] Suffice it to say here that, in thus differentiating himself from the phallocentric tradition under the aegis of a(n idealized) woman who is the "sign" of the indeterminate, of that which has impropriety as its property, Derrida cannot think that the sign "woman" is indeterminate by virtue of its access to the tyranny of the text of the proper. It is this tyranny of the "proper"—in the sense of that which produces both property and proper names of the patronymic—that I have called the suppression of the clitoris, and that the news item about Control Data illustrates.[31]

Derrida has written a magically orchestrated book—*La carte postale*—on philosophy as telecommunication (Control Data's business) using an absent, unnamed, and sexually indeterminate woman (Control Data's victim) as a vehicle for the reinterpretation of the relationship between Socrates and Plato (Control Data's acronym) taking it through Freud and beyond. The determination of that book is a parable of my argument. Here deconstruction becomes complicit with an essentialist bourgeois feminism. The following paragraph appeared recently in *Ms.*: "Control Data is among those enlightened corporations that offer social-service leaves.... Kit Ketchum, former treasurer of Minnesota NOW, applied for and got a full year with pay to work at NOW's national office in Washington, D.C. She writes: 'I commend Control Data for their commitment to employing and promoting women....' Why not suggest this to your employer?"[32] Bourgeois feminism, because of a blindness to the *multi*national theater, dissimulated by "clean" national practice and fostered by the dominant ideology, can participate in the tyranny of the proper and see in Control Data an extender of the Platonic mandate to women in general.

The dissimulation of political economy is in and by ideology. What is at work and can be used in that operation is at least the ideology of nation-states, nationalism, national liberation, ethnicity, and religion. Feminism lives in the master text as well as in the pores. It is not the determinant of the

last instance. I think less easily of "changing the world" than I did in the past. I teach a small number of the holders of the can(n)on, male or female, feminist or masculist, how to read their own texts, as best I can.

NOTES

1. For an explanation of this aspect of deconstruction, see Spivak, "Translator's Preface" to Derrida, *Of Grammatology.*

2. It seems appropriate to note, by using a masculine pronoun, that Marx's standard worker is male.

3. I am not suggesting this by way of what Harry Braverman describes as "that favorite hobby horse of recent years which has been taken from Marx without the least understanding of its significance" in *Labor and Monopoly Capital: The Degradation of Work in the Twentieth Century* (New York and London: Monthly Review Press, 1974), pp. 27, 28. Simply put, alienation in Hegel is that structural emergence of negation which allows a thing to sublate itself. The worker's alienation from the product of his labor under capitalism is a particular case of alienation. Marx does not question its specifically philosophical justice. The revolutionary upheaval of this philosophical or morphological justice is, strictly speaking, also a harnessing of the principle of alienation, the negation of a negation. It is a mark of the individualistic ideology of liberalism that it understands alienation as only the pathetic predicament of the oppressed worker.

4. In this connection, we should note the metaphors of sexuality in *Capital.*

5. I remember with pleasure my encounter, at the initial presentation of this paper, with Mary O'Brien, who said she was working on precisely this issue, and who later produced the excellent book *The Politics of Reproduction* (London: Routledge and Kegan Paul, 1981). I should mention here that the suggestion that mother and daughter have "the same body" and therefore the female child experiences what amounts to an unalienated pre-Oedipality argues from an individualist-pathetic view of alienation and locates as *discovery* the essentialist *presuppositions* about the sexed body's identity. This reversal of Freud remains also a legitimation.

6. See Jack Goody, *Production and Reproduction: A Comparative Study of the Domestic Domain* (Cambridge: Cambridge University Press, 1976), and Maurice Godelier, "The Origins of Male Domination," *New Left Review* 127 (May/June 1981), pp. 3–17.

7. Collected in *Karl Marx on Education, Women, and Children* (New York: Viking Press, 1977).

8. No feminist reading of this text is now complete without Jacques Derrida's "Speculer—sur Freud," *La Carte postale: de Socrate à Freud et au-delà* (Paris: Aubier-Flammarion, 1980).

9. Freud, *Works,* vol. 22.

10. Luce Irigaray, "La tâche aveugle d'un vieux rêve de symmétrie," in *Speculum de l'autre femme* (Paris: Minuit, 1974).

11. I have moved, as I explain later, from womb envy, still bound to the closed circle of coupling, to the suppression of the clitoris. The mediating moment would be the appropriation of the vagina, as in Derrida: see Gayatri Chakravorty Spivak, "Displacement and the Discourse of Woman," in Mark Krupnick, ed., *Displacement: Derrida and After* (Bloomington: Indiana University Press, 1983), pp. 169–95.

12. One way to develop notions of womb envy would be in speculation about a female fetish. If, by way of rather obvious historico-sexual determinations, the typical male fetish can be said to be the phallus, given to and taken away from the mother ("Fetishism," Freud, *Works*, vol. 21), then the female imagination in search of a name from a revered sector of masculist culture might well fabricate a fetish that would operate the giving and taking away of a womb to a father. I have read Mary Shelley's *Frankenstein* in this way. The play between such a gesture and the Kantian socio-ethical framework of the novel makes it exemplary of the ideology of moral and practical imagination in the Western European literature of the nineteenth century. See Gayatri Chakravorty Spivak, "Three Women's Texts and a Critique of Imperialism," in *"Race," Writing, and Difference*, ed. Henry Louis Gates, Jr. (Chicago: University of Chicago Press, 1986), pp. 262–80; first published in *Critical Inquiry* 12:1 (Autumn 1985), pp. 243–61.

13. As I have repeatedly insisted, the limits of hegemonic ideology are larger than so-called individual consciousness and personal goodwill. See Gayatri Chakravorty Spivak, "The Politics of Interpretations," in *In Other Worlds: Essays in Cultural Politics* (New York: Methuen, 1987), pp. 118–33; and "A Response to Annette Kolodny," widely publicized but not yet published.

14. This critique should be distinguished from that of Gilles Deleuze and Félix Guattari, *Anti-Oedipus: Capitalism and Schizophrenia*, trans. Robert Hurley, et al. (New York: Viking Press, 1977), with which I am in general agreement. Its authors insist that the family romance should be seen as inscribed within politico-economic domination and exploitation. My argument is that the family romance effect should be situated within a larger familial formation.

15. Gayatri Chakravorty Spivak, "French Feminism in an International Frame," in *Worlds*, pp. 134–53.

16. Pat Rezabek, unpublished letter.

17. What in man exceeds the closed circle of coupling in sexual reproduction is the entire "public domain."

18. I understand Lise Vogel is currently developing this analysis. One could analogize directly, for example, with a passage such as Karl Marx, *Grundrisse: Foundations of the Critique of Political Economy*, trans. Martin Nicolaus (New York: Vintage Books, 1973), p. 710. Hereafter cited in text as *GR*, followed by page number.

19. Antonio Negri, *Marx Beyond Marx*, trans. Harry Cleaver, et al. (New York: J. F. Bergen, 1984). For another perspective on a similar argument, see Jacques Donzelot, "Pleasure in Work," *Ideology & Consciousness* 9 (Winter 1981–82), pp. 3–28.

20. An excellent elucidation of this mechanism is to be found in James O'Connor, "The Meaning of Crisis," *International Journal of Urban and Regional Research* 5:3 (1981), pp. 317–29.

21. The self-citation is from "Woman in Derrida," unpublished lecture, School of Criticism and Theory, Northwestern University, 6 July 1982. In it, my references are to: Jean-François Lyotard, *Instructions païens* (Paris: Union générale d'éditions, 1978); Tony Bennett, *Formalism and Marxism* (London: Methuen, 1979), p. 145 and passim; and Marx, *GR*, 326.

22. See Gayatri Chakravorty Spivak, "Love Me, Love My Ombre, Elle," *Diacritics* 14:4 (Winter 1984), pp. 19–36.

23. Michael Ryan, *Marxism and Deconstruction: A Critical Articulation* (Baltimore: Johns Hopkins University Press, 1982), p. xiv.

24. Margaret Drabble, *The Waterfall* (Harmondsworth: Penguin, 1971). Subsequent references are included in the text. Part of this reading has appeared in a slightly different form as "Three Feminist Readings: McCullers, Drabble, Habermas," in *Union Seminary Quarterly Review* 35:1/2 (Fall/Winter 1979–80), pp. 15–34.

25. As in Paul de Man's analysis of Proust in *Allegories of Reading: Figural Language in Rousseau, Nietzsche, Rilke, and Proust* (New Haven: Yale University Press, 1979), p. 18.

26. For definitions of "overdetermination," see Freud, *Works*, vol. 4, pp. 279–304, and Louis Althusser, *For Marx*, pp. 89–128.

27. "Was Headquarters Responsible? Women Beat Up at Control Data, Korea," *Multinational Monitor* 3:10 (September 1982), p. 16.

28. Perry Anderson, *Passages from Antiquity to Feudalism* (London: Verso, 1978), pp. 24–25.

29. *Ibid.*, pp. 39–40.

30. See Spivak, "Love Me."

31. I have already made the point that "clitoris" here is not meant in a physiological sense alone. I had initially proposed it as the reinscription of a certain physiological emphasis on the clitoris in some varieties of French feminism. I use it as a name (close to a metonym) for women in excess of coupling-mothering. When this excess is in competition in the public domain, it is suppressed in one way or another. I can do no better than refer to the very end of an earlier essay, where I devise a list that makes the scope of the metonym explicit. See Spivak, "French Feminism," *Worlds*, p. 184.

32. Anne Pillsbury, "Penny Stocks—A Good Gamble for the Small Investor," *Ms.* 10:11 (May 1982), p. 30. In this connection, it is interesting to note how so

gifted an educator as Jane Addams misjudged nascent socialized capital. She was wrong, of course, about the impartiality of commerce: "In a certain sense commercialism itself, at least in its larger aspect, tends to educate the working man better than organized education does. Its interests are certainly world-wide and democratic, while it is absolutely undiscriminating as to country and creed, coming into contact with all climes and races. If this aspect of commercialism were utilized, it would in a measure counterbalance the tendency which results from the subdivision of labor," *Democracy and Social Ethics* (Cambridge, MA: Harvard University Press, 1964), p. 216.

Revolutions That As Yet Have No Model

Derrida's "Limited Inc."

(1980)

FOUR

First published in 1980, this essay, although initially difficult for readers unaccustomed to deconstructive thinking to grasp, provides valuable lessons in learning to think deconstructively. Acquiring a deconstructive mindset or undergoing what Spivak calls here a "revolutionary change of mind," has important political as well as philosophical consequences. Hence the urgency with which a critic such as Spivak, for whom political and pedagogical outcomes are a critical part of developing theoretical strategy, teases out the far from obvious consequences of Derrida's critique of speech act theory. Spivak's conclusions have special relevance in the post-Soviet New World Order.

In this reading of the second of the two essays she often cites as guides to deconstructive practice, Spivak lays the groundwork for a political appropriation of Derrida's work. She focuses upon the second essay, "Limited Inc.: abc," translated by Samuel Weber and published in *Glyph* 2 (1977), pp. 162–254. This essay was a response to John Searle's "Reiterating the Differences: A Reply to Derrida," which was itself a response to Derrida's earlier essay, "Signature Event Context," translated by Samuel Weber and Jeffrey Mehlman and published in *Glyph* 1 (1977), pp. 172–97.

Deconstruction alone cannot found a political program. As Spivak cautions in this essay, "a mere change of mindset, however great, will not bring about revolutions." "Yet," she continues, "without this revolutionary change of mind, revolutionary 'programs' will fall into the same metaphysical bind of idealized and repeatable intention and context that Derrida plots in speech act theory." And having shown how the logic of the repeatable and the idealized hides an "iron fist" of repression and exclusion, she goes on to read Derrida *toward* politics, against the grain of philosophy or theory for its own sake. Distinguishing Derrida's work from Martin

Heidegger's and Paul de Man's is helped by reading Derrida toward the political theater of Bertold Brecht, who is radically pedagogical for Walter Benjamin in the way that Derrida is pedagogical for Spivak.

What Brecht and Derrida share is "the graphic of iterability rather than the logic of repetition." This particular piece of vocabulary joins others in Derrida's continuing critique of the logocentrism of Western metaphysics through deconstruction, the reversal and displacement of such binary oppositions as "spoken" and "written." Hence the substitution of a "graphic," a word borrowed from writing, supposedly at one remove from speech, for a "logic," a concept assuming the self-presence of the speaker in the spoken, as the logos is the word of God: "God said, 'Let there be light!' and there was light." The trace structure without the sign's confidence in an organized system can merely suggest that at the beginning there was something else, perhaps. This resembles our common experience of writing and therefore the name "graphematic" or "graphic" is used, by contrast to a logic based on verifiable reason. Thus there can be no reassuring simple origin in the self-identity of a speaker and his or her intentions. Every speech act is thus susceptible to tracing by virtue of its irreducible potential for difference, both within and from itself. Someone listens. At the beginning there is something else, perhaps.

"Iterability" names the recognition that every repetition is an alteration. This recognition, as Spivak observes, puts in question "both a transcendental idealism that claims that the idea is infinitely repeatable as the same and a speech act theory that bases its conclusions on intentions and contexts that can be defined and transferred within firm outlines"—by the iron fist of exclusionary logic. What is most frequently excluded from philosophical discourse is the nonserious. Even Derrida's puns and jokes can be seen to be part of his critique, demonstrating the play of the excluded and impure that is repressed within "straight" philosophy, including Heidegger's, despite the many affinities Derrida and Heidegger otherwise share.

Although there can be no repetition without difference, repetition is also the basis of identification. "Thus," as Spivak comments, "if repetition alters, it has to be faced that alteration identifies and identity is always impure. Thus iterability—like the trace structure—is the *positive* condition of possibility or identification, the very thing whose absolute rigor it renders impossible." In later commentary, Spivak will stress how much deconstructive recognitions can guard against theoretical and political fundamentalism. In this essay, she brings Derrida's critique home to the classroom. Those skeptical about the need to wade patiently through its lessons in deconstructive thinking might do well to turn first to the last paragraph, where the "'deconstructive' lesson, as articulated in 'Limited

Inc.'" is made explicit. It should then be obvious why the entire essay is structured according to "a,b,c"—here is Spivak spelling out what Derrida himself sought to spell out in his response to John Searle.

Jacques Derrida. "Limited Inc.: abc." Baltimore: The Johns Hopkins University Press, 1977; trans. Samuel Weber, in *Glyph* 2, 1977.

In 1971, Derrida read a paper entitled "Signature évènement contexte" in Montreal. In 1972, it was included in his collection *Marges de la philosophie* (Paris: Minuit). In 1977, in the first issue of *Glyph*, appeared its English version, "Signature Event Context." This piece was followed by "Reiterating the Differences: A Reply to Derrida" by John Searle. In Derrida's essay the limits and implications of the philosophical strategy of J. L. Austin, the founder of speech act theory, are discussed. In his short reply Searle, himself a speech act theorist, picks out what in his opinion are some of Derrida's obvious mistakes, and corrects them in a tone of high disdain. The piece in review here is Derrida's response to Searle's "Reply," published simultaneously and under the same title in French and English— in French as a pamphlet, in English as part of *Glyph* 2. In it, with a mocking show of elaborate patience, Derrida exposes Searle's critique to be off the mark in every way. Whereas Searle's essay is brusque and all too brief, Derrida's is long and parodistically courteous and painstaking.

I.

I list below some of the issues around which Derrida cancels Searle's objections. I have not reproduced the actual tactic of refutation nor kept to the order in which they appear in Derrida's text:

A. *The Ethico-Political Implications of Austin's Strategic Exclusions.* The concept of ordinary language in Austin is marked by an exclusion. Austin thought that parasitic discourse ("said by an actor on the stage, or...introduced in a poem, or spoken in soliloquy") is part of ordinary language (Searle thinks Derrida is unaware of this), but only as a parasite, an extrinsic "part" that lives off of the whole.[1] "The concept of the 'ordinary,' thus [since the parasite is not *normally* a part of *normal* ordinary language] of ordinary language to which he has recourse is clearly marked by this exclusion."[2] It is this implicit definition of the norm that "reproduce[s] in a discourse said to be theoretical the founding categories of all ethico-political statements" (pp. 69, 240). Although these exclusions "*present them-*

selves as...strategic or methodological suspension...they are fraught with metaphysical presuppositions" (pp. 57–58, 227). These metaphysical presuppositions inhere in the totalization and idealization of the norm (the appropriate context) for a performative.[3] They also inhere in (a) describing "the relation of the positive [or standard] values to those which are opposed to them...as one of *logical dependence*," and (b) not realizing that "even if this were the case, nothing proves that it would be *this* relation of *irreversible* anteriority or of *simple* consequence" (pp. 64, 234). "Distinguish[ing] clearly between *possibility* [that performatives can always be cited] and *eventuality* [that such possible events—citations, 'unhappinesses'—do indeed happen], Derrida suggests that the protection and definition of a standard or norm which is obligatory to all ethico-political institutions is carried out by Austin's creation of a "theoretical fiction"—the logically prior norm or standard—"that excludes this eventuality in order to purify his analysis" (pp. 59, 60, 229, 230).[4] This does not mean, as Searle suggests, that "Signature Event Context" (*Sec* for short in 'Limited Inc.') "suggested beginning with theatrical or literary [*romanesque*] fiction." But, Derrida continues, "I do believe that *one neither should nor can begin by excluding* the possibility of these eventualities: first of all, because this *possibility* is part of the structure called 'standard'" (pp. 61, 231).

B. *The Difference Between Speech and Writing.* The necessary possibility of these eventualities Derrida collectively and structurally calls "writing." Part of this argument in *Sec* is that speech act theory excludes Writing. In order to advance his argument he lists in that essay "the essential predicates in a minimal determination of the classical concept of writing."[5] Invoking the Husserl of *Logical Investigations*[6] and *The Origin of Geometry*,[7] he suggests that a certain Husserl articulated the suspicion that spoken utterances also shared these essential predicates of writing, and then went on to garner a place where Speech would shine forth alone. A detailed analysis of Husserl's itinerary is to be found in Derrida's introduction to *The Origin of Geometry* and in *Speech and Phenomena, and Other Essays on Husserl's Theory of Signs*.[8] Here Derrida focuses on the supposition that writing imitates speech but cannot share in the immediate link between speech and its context of production: "Every sign, linguistic or non-linguistic, spoken or written (in the current sense of this opposition), in a small or large unit, can be *cited*, put between quotation marks; in so doing it can break with every given context, engendering an infinity of new contexts in a manner which is absolutely illimitable."[9] Husserl takes care of this crisis through the general principle of phenomenological reduction; Austin through a programmatic, initial, and initiating exclusion. The rest of the argument I have summarized under A.

In "Limited Inc.," Derrida points out that Searle resolutely refuses to see that the former is attempting to rewrite the opposition Speech-Writing through what I shall call an ideology critique (although Derrida would object to that phrase and call his critique ethico-political) of the interest of such an opposition. Among other things, Searle sees writing as *transcription* of speech, and sees text and (oral) context as distinct and different, whereas Derrida demonstrates that the principle of an undecidable and/or alterable (to the point of rupture) context is the condition of possibility of every mark, *written or spoken.*

Searle, then, refutes Derrida's views on speech and writing by "a too quick retranslation" of them into "a standard and trivial idiom" (pp. 23, 188). Now, right from the start, Derrida's project has been paleonymic, urging a rereading of old words such as "writing." More recently and by way of the work of Nicolas Abraham, a name for the sustained need for a re-reading of every production of language that would take into account the permanent parabasis that Paul de Man calls "allegory" has been found: "anasemia."[10] The common problem with readings of Derrida's work is a disciplinary refusal even to entertain the possibility of undertaking such a re-reading; Searle is not free of this. But what we are speaking of here is an ignoring of even such obvious demands for scrupulousness as "a neologism in italics" (pp. 23, 188). Thus, "the remains [*restance*, in French a neologism] of a grapheme in general" is retranslated into "*permanence* or survival or a 'written language' in the standard sense" (pp. 23, 188). As far back as *of Grammatology*, Derrida made it quite clear that, if one insisted that the being of writing was in the technique of making a system of *tangible* marks on tangible material, the grounds of difference between speech and writing could be quite legitimately sustained (*OG*, p. 56). The pertinent question is, is this difference ground-ly [*gründlich*], irreducible? If this question is pushed, then a different answer seems to disclose itself: that there is a mark-ability (graphematicity) in speech *and* writing; and that it is by means of that mark-ability that *something*—never tangibly self-identical—is carried over in acts of speech *and* writing. That *something*, that minimal rather than total idealization that is different from itself in every case, is "the remains of a grapheme in general" and not "the permanence or survival of a 'written language' in the standard sense," where the context remains irretrievably oral. "Once he had begun to neglect totally the necessity of passing from writing (in the standard sense) to the grapheme in general, an essential movement of *Sec*, Sarl [see below p. 82.—Eds.] could only go from one confusion to another" (pp. 24, 189).

Searle's argument is that, although writing and speech are quite different in their relationship to context (indeed the latter might be considered the necessary context of the former), "intentionality plays exactly the same

role in written as in spoken communication" (pp. 27, 193). This is a rough restatement of the Husserlian position, with which Derrida has never fully disagreed. But the status of intention is so large a part of Derrida's concerns in this essay that I shall give it a separate rubric in my summary.

C. *The Situation of Intention.* The *OED* defines the term "intention" as used in logic as follows: "the direction or application of the mind to an object." And here is a definition of Intentionality offered by Searle in a piece written well after the Derrida-Searle exchange: "Intentionality-with-a-t is that property of the mind by which it is able to represent other things."[11] These are good places to begin in order to understand how, for the sake of emphasizing the similarity between speech and writing, Searle can write: "Writing makes it possible to communicate with an absent receiver, but it is not necessary for the receiver to be absent. Written communication can exist in the presence of the receiver, as for example when I compose a shopping list for myself or pass notes to my companion during a concert or lecture."[12]

One response to this is contained in the answer that I summarize above: a possibility/eventuality is a *necessary* component of the structural definition of language (p. 78). But Derrida also argues that the problem with classical concepts of intentionality is that they seek to actualize and totalize it into self-presence and self-possession. It is this telos of the concept of intentionality that he is calling into question. In this context, it is not so much the ever-necessary possibility of the writer/reader's absence to the context, but the claim of the writer-reader's presence to himself in certain privileged contexts, that Derrida deconstructs, arriving back at the position that the necessary possibility of the absence of sender and receiver is the *positive* condition of possibility of "communication." We shall come back to this suggestion later. Here a gist of the point at issue will suffice:

> To affirm…that the receiver is *present* at the moment when *I write* a shopping list *for myself*, and, moreover, to turn this into an argument against the essential possibility of the receiver's absence from every mark, is to settle for the shortest, most facile analysis. If both sender and receiver were entirely present when the mark was inscribed, and if they were thus present to themselves—since, by hypothesis, being present and being present-to-oneself are here the same—how could they even be distinguished from one another? How could the message of the shopping list circulate among them? And the same holds force, *a fortiori*, for the other example, in which sender and receiver are hypothetically considered to be neighbors, it is true, but still as two separate persons occupying two different places, or seats…. But these notes are only writable or legible to the extent that…these two

possible absences construct the possibility of the message at the very instant of my writing or his reading [pp. 21–22, 186].

(This theme, that self-presence is irreducibly differentiated, is also to be found most extensively elaborated in *Speech and Phenomena* [especially in "The Voice That Keeps Silence"], a text that is closely related to Derrida's discussion of speech act theory. That relationship can be put simply as follows: two theories so seemingly disparate as Husserlian phenomenology and speech act theory share metaphysical presuppositions that make the latter's claim to pragmatic practicality somewhat dubious.)

Such a critique of intentionality does not, however, mean that intentionality must be "effaced or denied…as Sarl claims. On the contrary, *Sec* insists on the fact that 'the category of intention will not disappear, it will have its place'" (pp. 30, 196). Events, objects, acts, meanings—as "intended" by ego—as well as intentions themselves might well be the effects of a desire precisely to have a self-identical intention that can produce interpretations. This is a limit that no concept of simple intention can cross, for such a desire cannot be thought in terms of a fully intending subject. It remains irreducibly structural. Yet, even as intention is situated within such limits, Derrida insists that it is these very limits, demarcating intention, that produce it, and allow it to function as such. If this point is missed, then Derrida is seen as an absurd nihilist. "What is valid for intention, always differing, deferring [*différante*] and without plenitude, is also valid, correlatively, for the object (signified or referent) thus aimed at. However, this limit, I repeat ('without' plenitude), is also the ('positive') condition of possibility of what is thus limited" (pp. 29, 195). If one is prepared to stand the Hegelian system on its head to displace the deconstructive cipher, one might compare this limiting possibility to the status of determination at the very beginning of *The Science of Logic*. Whereas in Hegel, by demarcating (limiting and making possible) *Dasein* out of *Sein*, determination also makes possible the production of the rigorous terminology of the self-critical language of philosophy; in Derrida the originary self-division of intention "limits what it makes possible while rendering its rigor or purity impossible" (pp. 31, 197).

One of the marks of Derrida's programmatic lack of rigor in "Limited Inc." is his elaborate and uneasy-making jokes. I shall speak at greater length about this strategy later. Here I will comment on the title of the piece and Derrida's use of the question of the copyright.

A footnote to the title of Searle's "A Reply to Derrida" discloses that the matter of Searle's essay is also a product of discussions among himself, H. Dreyfus, and D. Searle. The text thus has a plurality of authorships which can be conveniently copyrighted under one signature or proper name. To

keep this possibility even in our minds, Derrida refers to the author of "A Reply to Derrida" as "Sarl" (*S. a. r. l.—Société aux responsabilités limités— limited liability* in English, *incorporated* in American) and entitled his own piece "Limited Inc." The recuperating of a plural, divided, heterogeneous, different, differing intentionality under the rubric of a single self-present sovereign and generative intention has something in common with these (in Derrida's case ironic) procedures: "That Searle's Seal should become, at once and without waiting for me, *Sarl's seal*, is not an accident. A little like the multiplicity of stockholders and managers in a company or corporation with limited liability, or in a limited, incorporated system; or, like that limit which is supposed to distinguish stockholders from managers" (pp. 28–29, 194). Exactly the opposite of what happens to the "'subject' in the scene of writing"—the I who, putatively, writes, and, having left her mark, leaves the scene. The classical concept of writing would say that, having removed her selfhood and her proper identity from the written page, the "I" of the writer (not merely of the "literary text") allows a multiplicity of anonymous readers to invest it with their *selfhoods*.[13] Derrida is suggesting that this subject in the scene of writing is also the subject in the very house of its own proper intention.

D. *The Structural Unconscious.* The picture of an irreducibly pluralized and heterogeneous subject can find its place in structuralist and poststructuralist interpretations of Freud. Such interpretations must see the conscious ego as an effect of the work of the "psyche" (whose outlines are, by that very token, more like an entangling network, structured by traces and postponements, than a neat geographical boundary), rather than as fully identical with the self as a whole. In speech act theory, however, "the identity of the 'speaker' or the 'hearer' [is] visibly identified with the conscious ego…[and] the identity of an intention (desire or non-desire, love or hate, pleasure or suffering) or of an effect (pleasure or non-pleasure, advantage or disadvantage, etc.)" can be located in terms of "the conscious ego" (pp. 44, 216).

Derrida's work is deeply marked by Freud: "in as much as it touches the originary constitution of objectivity and of the value of the object…psychoanalysis is not a simple regional science" (*OG*, 88). Indeed, the debate with speech act theory relates precisely to the fact that, whereas Husserl, seeing the irreducible crisis of the instituted trace inscribed in the sign, had carefully written psychology out of phenomenology; speech act theory, seemingly introducing issues such as situationality and the human mind into the question of meaning, uses an interpretably oversimple model of both situation and mind—"a psychology of language (mechanistic, associationist, substantialist, expressivist, representationalist, pre-Saussurian, prephenomenological, etc.), more exactly a pre-critical psychologism" (pp. 38,

205). Derrida is rightly careful that his interest in psychoanalysis should not be confused with the therapeutic model of psychoanalytic practice—psychoanalysis as a regional science. Yet, since all of Derrida's work has been largely devoted to a critique of philosophy's need to adumbrate a fully conscious and self-conscious self-presence, it is curious that Searle seems to think that, according to Derrida, "intentions must all be conscious."[14]

In response, Derrida carefully points out that "*Sec*'s enterprise is in its principle designed to demonstrate such 'a structural unconscious' which seems alien, if not incompatible with speech act theory, given its current axiomatics" (pp. 45, 213). "Unconsciousness" in such an enterprise does not mean, as it does when Searle invokes unconscious intentions, "an implicit or potential reserve of consciousness, a kind of lateral virtuality of consciousness." It is the best available name ("for example and for the moment" [pp. 46, 214]) for radical alterity. We have already discussed what it might mean to say that intentionality is irreducibly graphematic, that it is always already plural, an effect, heterogeneous, divided, and that that is precisely what allows it to work. Otherwise, identical with itself, "eyes closed tight, nostrils pinched shut, ears stopped up" it would be the "pure" body without organs, Undivided Mind.[15] In order to work with such a graphematic intentionality, one needs a name for something that is at every moment divisively other yet indispensable to the production of the same, an "it" that resolutely leaves its track at every intended origin or goal. This "it" is not a transcendental unity, because with every heterogeneous move of receiver, sender, and the world of meanings, it changes its shape and fills the (no)place that marks a contingent limit. It is not a conscious motor of things in general; therefore it had better be called the Unconscious.

(The irreducible structure of this radical alterity that is also the condition of possibility of ipseity is, as I have already remarked, sometimes called Writing by Derrida. Of late there has been considerable interest in the confusion and distinctions between Derrida's position and that of Paul de Man. It seems relevant to note that de Man's term for the irreducible oscillation of undecidability that is *his* last word is Reading, not Writing. Whereas writing in Derrida is *both* the trace structure in general *and* empirical forms of writing in the narrow sense, even as it annuls that very opposition (*OG*, 74), in de Man "the word 'reading'...is...deprived of any referential meaning whatsoever."[16] For Derrida, what one discovers in the Unconscious is not "the whole structure of language." On the one hand, conviction of that discovery might itself be a symptomatic effect; on the other, the structural unconscious is also that which stands in the way of any *exhaustive* concept of structure of language. What one discovers in the unconscious is also not a reading effect. If one examines the essential predicates of the classical

concept of Reading—halfway between Speech and Writing—notions of control and privilege are not far to seek; even in reading "the flight of meaning" or an "allegory of unreadability," the putative agent restores that context which the classical concept of writing, by its essential predication, loses as it preserves that in Speech which it can slavishly imitate.[17]

More specifically, such a structural unconscious also undermines the pigeonholing of meanings and speech acts. It can mark and undermine the conscious ego's decision to situate intended meaning in itself and for another conscious ego. "The specific law of...the displacement [*Entstellung*] of the signifier" that constitutes the production of a self-identical intentionality "governs those psychoanalytic effect that are decisive for the subject: such as foreclosure [*Verwerfung*], repression [*Verdrängung*], denial [*Verneinung*] itself."[18] The ego's speech act in this reading might very well be a rubric indicating what it cannot say. If the unconscious is a place of possibilities of signification, the itinerary of the ego's self-constitutive need to manufacture its sovereignty activates different clusters of signification with an irregular periodicity. In this sense, too, the radically other makes possible as its limits the ego's intention. Because speech act theory cannot recognize these limits it "excludes all other ultimate criteria than the distinct, determining, and determinable consciousness of the intention, desires, or needs involved."

> The rigorous distinction between promise and warning or threat, for instance, is established only by this expedient. Yet what would happen if in promising to be critical I should then provide everything that Sarl's Unconscious desires, for reasons which remain to be analyzed, and that it does its best to provoke? Would my "promise" be a promise, or a threat/warning? Searle might respond that it would constitute a threat to Sarl's consciousness, and a promise for the unconscious. There would thus be two speech acts in a single utterance. How is this possible? And what if the desire was to be threatened? And what if everything that is given to please or in response to a desire, as well as everything that one promises to give, were structurally ambivalent? [pp. 47, 215]

It is within this framework that Derrida criticizes Austin's strategic exclusions:

> For in the last analysis, seriously, who ever said that a dependent (logically dependent) element, a secondary element, a logical or even chronological consequence, could be qualified...as "parasitical," "abnormal," "infelicitous," "void," etc.?... The common denominator [of all these attributes] is evidently a pejorative value judgment...more or less a mere logical

derivation. This axiological "more or less" cannot be denied. Or at least not without constituting, as far as Searle is concerned, the object of what is known [psychoanalytically] as a denial [*dénégation*] [pp. 64–65, 235; translator's parentheses].[19]

It is also in terms of the vocabulary of the structural unconscious that Derrida chides Searle for suggesting that he, Derrida, assimilates writing and fiction: "It is imprudent to assimilate too quickly, more quickly than one can, what is not easily assimilable. Otherwise, what is produced is what certain psychoanalysts call incorporation without introjection: a sort of indigestion more or less desired by the unconscious and provoked by a parasite which remains unassimilable."[20]

When Derrida makes a critique of the *discipline* of philosophy, the structural unconscious is seen as oedipalized. This is, I think, because the history of disciplines in the West is the history of oedipalization as such. In *Glas*, Derrida's disciplinary critique is in terms of the official denial of the son's desire for the mother and the thematics of fetishism. Here it is in terms of the homoeroticism of the (patriarchal) disciplines, the jealously guarded relay of truth passing from father to son. If we regard the following examples as "merely a joke in poor taste," we overlook the insertion, in Derrida's works, of psychoanalysis into the exclusivist *discipline* of philosophy. It is an interdisciplinary endeavor that would put the properties of the disciplinary subdivision of labor into question.

Searle scolds Derrida for hassling Austin over his exclusions; for Searle has himself now established a general speech act theory of fiction.[21] The complaint about exclusions no longer applies. Derrida points out that the relevant Searle essay appeared well after *Sec* and that it ends in the following inconclusive way: "...there is as yet no general theory of the mechanisms by which such serious illocutionary intentions are conveyed by pretended illocutions" (pp. 69, 240). Derrida's critique of programmatic exclusions might still stand.

It is, however, upon the way in which Searle announces himself as carrying on Austin's work that Derrida comments:

> As to the "general theory," Sarl would like Austin both to have had one...and also, having died too young, not to have really had...one, so that the copyright of the "general theory" in the proper, literal sense...could be the rightful property only of the more or less anonymous company of his sons....This is why...the paragraph beginning with "Once one has a general theory of speech acts..." is...a masterpiece of metaphysical-oedipal rhetoric. Imagine the scene: Austin's will is about to be unsealed. Although the envelope has not yet been entirely opened, the lawyer of one of the sons

begins to speak: "Once one has a general theory of speech acts…" Once? We still don't know if Austin had one or was going to have one. I sincerely regret that "Austin did not live long enough."… But through my tears I still smile at the argument of a "development" (a word sufficiently ambiguous to mean both produce, formulate, as well as continue, in order to reach "detailed" answers), that a longer life might have led to a successful conclusion [pp. 66–67, 237–38].

The disciplines, and they are inescapably patriarchal, would present themselves as disinterested if not metaphysical. A patriarchy, however, works according to the love-hate rules of the oedipal scene which it has spent its energy proclaiming to be the correct structural explanation of all human relationships. There is both the "patricide"—Austin could not have done it without me—and the dynastic pride—I am carrying on Austin's work.

In allowing the psychoanalytic argument to sweep from the irreducible structural unconscious in intentionality as such to the oedipal functioning of the disciplinary tradition, Derrida performs a critique of the disinterest that is supposed to inform all academic discussion as well as the history of ideas.

E. *Iterabilty* (*Citationality, Parasitism*). Over the years, even as he has been practicing paleonymy, Derrida has been deploying an alternate denomination for the method of metaphysics, disclosed or undisclosed, that inhabits the language of the human sciences. There are many names on this list. The most recognizable might be: the graphic of the trace rather than the logic of the simple origin; the graphic of *différence* rather than the logic of identity; the graphic of supplementarity rather than the logic of non-contradiction. *Sec* and "Limited Inc." add another: the graphic of iterability rather than the logic of repetition.

The substitution of graphic for logic is also an example of this alternate denomination. Derrida's method is not centered on the putative self-enclosed self-presence of the logos as the identity of voice-consciousness in the act of speech; it shares rather the structure of irreducible self-alterity carried by the backward and forward and many-planed tracing of intentions in writing. In other words, it seeks to be graphematic rather than logocentric. Hence its name is graphic rather than logic.

One of the corollaries of the structure of alterity, which is the revised version of the structure of identity, is that every repetition is an alteration. This would put into question both a transcendental idealism that claims that the idea is infinitely repeatable as the same and a speech act theory that bases its conclusions on intentions and contexts that can be defined and transferred within firm outlines. Iterability is the name of this corollary:

every repetition is an alteration (iteration).

But repetition is the basis of identification. Thus, if repetition alters, it has to be faced that alteration identifies and identity is always impure. Thus iterability—like the trace structure—is the *positive* condition of possibility of identification, the very thing whose absolute rigor it renders impossible. It is in terms of iterable (rather than repeatable) identities that communication and consensus are established: "What is this consensus? What convention will have insured up to now the contract of a minimal agreement? Iterability" (pp. 36, 203). Searle (Sarl) seems in agreement with Derrida on this very last issue. He is not, however, ready to grant the radicality of Derrida's position: "Iterability is [not] necessarily tied to convention, and...is [not] limited by it" (pp. 74, 246). Since every identification is an iteration, the "natural," "spontaneous," "intended" utterance is as iterable as the conventional. "Iterability is precisely that which—once its consequences have been unfolded—can no longer be dominated by the opposition nature/convention" (pp. 74, 246).

Thus the exchange in the "normal" speech act cannot, strictly speaking, be *structurally* differentiated from one where both intention and context are artificial or infelicitous. They are two cases of the alteration in repetition: iteration. "Rather than oppose...iteration to the non-iteration of an event, one ought to construct a differential typology of forms of iteration....In such a typology, the category of intention will not disappear, it will have its place, but from that place it will no longer be able to govern the entire scene and system of utterance."[22] Such a necessarily nonexhaustive typology would include all the "non-serious" uses of the performative mentioned by Austin—such as citation and the literary or theatrical parasitic use. Acknowledging "the structural iterability of the mark"—the grapheme, the unit of writing rather than that of speech—one must take into account that "language can always 'normally' become 'abnormally' its own object" (pp. 54, 223). The possibility of citing or theatricalizing is structurally inherent in every "intended" speech act.

Yet this does not mean to privilege fictional and theatrical uses of speech acts as commonly understood. Just as there is no *homogeneous* and *totalizable* intention generating the utterance, so also can it not be advanced that the utterance is simply autotelic as such.[23] It is rather that, among the many heterogeneous elements that constitute the speech act with traces leading back and forth, the iterable non-self-identical intention and context as well as the "parasitic" use are structural moments. The "theater" does not win out over "real life." The two are seen as indistinguishable and structurally implicated. "As though literature, theater, deceit, infidelity, hypocrisy, infelicity, parasitism, and the simulation of real life were not part of real life!" (pp. 62, 232). Iterability "blurs the simplicity of the line

dividing inside [real life or fiction] from outside [fiction or real life], the order of succession or of dependence between the terms [privileging real life or literature], *prohibits* (prevents and renders illegitimate) the procedure of exclusion" (pp. 64, 234; italics Derrida's). This is the point at which this reviewer's summaries began.

Iterability "itself" cannot be privileged as a "transcendental condition of possibility" (pp. 72, 244) for fiction, theater, parasite, citation, and the like. Whereas repetition presupposes a full idealization (repeatability as such), iterability entails no more than a minimal idealization which would guarantee the possibility of the re-mark. But since "the iterability of the mark does not leave any of the philosophical oppositions which govern the idealizing abstraction intact (for instance, serious/non-serious, literal/metaphorical or ironic, normal/parasitical, strict/non-strict, etc.'" (pp. 42, 209–10), this is an impure idealization, a contradiction in terms, which cannot be caught within the either-or logic of noncontradiction. "No process or project of idealization without iterability, and yet no possible idealization of iterability" (pp. 42–43, 210). In order to work with a non-transcendental, non-logical (non)-concept (or graphic) such as iterability, one must think a great change of mindset. Of course a mere change of mindset, however great, will not bring about revolutions. Yet, without this revolutionary change of mind, revolutionary "programs" will fall into the same metaphysical bind of idealized and repeatable intention and context that Derrida plots in speech act theory. Derrida hints as follows at the practical possibilities of the graphic of iterability: "it constantly disturbs, subverts, and displaces the limit [between nature and convention]. It has an essential rapport with the force (theoretical and practical, 'effective,' 'historical,' 'psychic,' 'political,' etc.) of the deconstruction of these oppositional limits" (pp. 74, 246).

Our own arena of practice is the production of theoretical discourse. This practice would be significantly altered if it recognized that theoretical discourse were irreducibly iterable (and it is a mark of the necessary "impurity" of a graphic that such recognition must come through that very conscious intention that the graphic calls into question):

> What must be included in the description, in *what* is described, but also in the practical discourse and in the writing of that describing [*décrivante*—dewriting—undermining graphematicity by its attempt at unitary idealization] description, is not merely the factual reality of corruption and of alteration [*de l'écart*], but corrupt*ability* (to which it would be better henceforth not to give this name, which implies generally a pathological disfunction, a degeneration or an ethico-political defect) and dissoci*ability*, all the characteristics tied to iterability which *Sec* proposed to account for. That can

only be done if the "-bility"...is recognized from the inception [*dés l'en-tame*] as broached and breached [*entamée*] in its "origin" by *iterability* [pp. 50, 218–19; all bracketed parentheses, translator's].

A case of such altered practice is a section title in *Sec*: "*Parasites. Iter, Of Writing: That It Perhaps Does not Exist.*" The page and a half (pp. 52–54, 224–26) where Derrida explicates himself are spectacular. Briefly, the lines of argument are as follows: Derrida's subtitle grafts itself on a Cartesian "original," *De essentiâ rerum materialum; et iterum de Deo, quod existat (On the Essence of Material Things: And Likewise of God, That He Exists)*. This is not just an "example" of invoking a "presence" through a deliberate citation. Descartes himself is also iterating; for this is a "repetition" (iteration) of an earlier Cartesian argument for the proof of God's existence. But it is not even merely a *case* of iteration, for the word "iter" is also *mentioned*. In that sense it is also "literally" an "iter"-ation. Thus the text mimes a deconstruction of the oppositions between literal and figural, use and mention. "Iter" is not only "simulacrum"—likewise—as the English translation of the subtitle suggests. It is also "alter" or other. A corroboration of Derrida's insistence that the suppression of othering or iteration carries an ethico-political charge is borne out by the fact that, in the usage of the modern languages of Northern India, "itara"—other—not only means "inferior," but is also the name of the untouchable castes.) Derrida is questioning the "allegorical" and "literal" in terms of his own reading of Descartes, as well as in reading "as such":

> The iterability of the proof (of God's existence) *produces* writing, makes one write [*fait écriture*—italics Derrida's] and draws the name of God (of the infinite Being) into a graphematic drift [*dérive*] [a double take by Descartes, in this case, on an earlier text of his own] that forbids (for instance) any decision as to whether the "name of God" refers to God or to the name of God, whether God is more than the name of God, whether it signifies "normally" or "cites," etc., God being here, *like/as* [*comme*] writing, what at the same time renders possible and impossible, probable and improbable the purity of the opposition between the "normal" and, for example, the citational or the parasitical, the serious and the non-serious, the strict and the non-strict or less strict [pp. 55, 255].

So Derrida chooses to memorialize this subtitle in his own because it launches the name of God into the double take of writing. Derrida puts writing in the place of God: "Iter, Of Writing." But writing is not in opposition to God. In order to let the opposition play, God as Logos "certainly should exist." Only of writing as graph can it be said "that it perhaps does

not exist." It does not *certainly* have being as defined by the either-or struc-ture of ontological discourse (the language of the logic of being).[24]

It should perhaps be remarked here that, if a reading such as this were to be translated to the social text, it would require an extremely sharp eye for "history." Clear-cut oppositions between so-called material and ideologi-cal formations would be challenged as persistently as those between literal and allegorical uses of language. The sedimentation and investment of his-tory as political, economic, sexual "construction" would be seen as irre-ducible. Material objects, and seemingly non-textual events and phenome-na would have to be seen not as self-identical, but as the space of dispersion of such "constructions," as the condition or effect of interminable itera-tions. Yet, since iterability fractures intention as well, a simple stockpiling of "authoritative analyses from this point of view" without intervention in enabling and disabling auto- and disciplinary critiques would be beside the point.

II.

"The matter we are discussing here concerns the value, possibility, and sys-tem of what is called logic in general. The laws and the effects with which we have been dealing, those of iterability for example, govern the possibil-ity of every logical proposition.... No constituted logic or any rule of logi-cal order can, therefore, provide a decision or impose its norms upon these prelogical possibilities of logic" (pp. 65, 235).

This seems an iteration of Heidegger's placing of "assertion" [*Aussage*]—the logical language of philosophical prediction—as "aris[ing] from circumspective interpretation."[25] "The basic stock of 'categories of signification,' which passed over into the subsequent science of language, and which in principle is still the standard, is oriented towards discourse as assertion. But if on the contrary we take this phenomenon in the funda-mental principle of primordiality and breadth of an existentiale, then there emerges the necessity of settling the science of language on foundations which are ontologically more primordial" (*BT*, 209).

Given his own comments on the "metaphysical-oedipal rhetoric," it is interesting that Derrida has recently disclaimed continuous filiation with Heidegger in his Reply to Ricoeur:

> Ricoeur inscribes his entire reading of "White Mythology" in dependence on
> his reading of Heidegger..., as if I had attempted no more than an extension
> or a *continuous* radicalization of the Heideggerian movement.... Everything
> takes place as if I had only generalized what Ricoeur calls Heidegger's "limit-
> ed criticism" and as if I had stretched it inordinately, beyond all bounds. A
> little further on, in the same gesture of assimilation,... Ricoeur resorts to the

figure of a "theoretical core common to Heidegger and to Derrida."...This continuist assimilation or setting into filiation surprised me.... I see myself the object, after being assimilated to Heidegger, of an objection whose principle I had myself formulated previously.[26]

What follows makes no pretense at figuring out the relationship between Heidegger and Derrida. It is simply yet another summary or checklist of certain moments in Heidegger that bring "Limited Inc." to mind, followed by a few suggestions as to how Derrida might be different. To interpret the possibility of a metaphysical-oedipal disclaimer would call for a different strategy.

My reading of Heidegger is somewhat anthropologistic. I have been guided by Derrida's insight: "We see, then, that *Dasein*, if it is *not* man, is *not*, however, *other* than man."[27] Although I am attempting to show that a Derridian practice would question "the name of man as *Dasein*," my reading of Derrida might also seem anthropologistic. I think I must insist that a deconstructivist position cannot reduce out anthropologism *fully*. Like the paradox of minimal idealization (see p. 79, 80), the trace of anthropologism obstinately clings as *restance* to the practice of deconstruction.

Heidegger shows that philosophical assertion, the ideal of scientific rigor, and common sense share a certain exclusivism or restriction.

Of philosophical assertion, Heidegger writes: "Determining [or predicating] does not first discover the seen...as such; it rather *restricts* the seen as a mode of showing, in the first instance, to that which shows itself...as such so that by this expressive [*ausdrücklich*] *restriction* of our view, the manifest may be made *expressively* manifest in its determinateness [*Bestimmtheit*]" (*BT*, 197).[28] I invoke Hegel's notion of determination on p. 81. The title of this second chapter in Hegel's *Science of Logic* is "Dasein"—generally translated as "Determinate Being." Heideggerian *Dasein* would not take the philosophical mode of assertion as its privileged determination. In looking for a pre-predicative place of *Dasein's* operation, Heidegger looks forward to the Derridian project. Indeed, Derrida's critique of speech act theory can be put this way: speech act theory attempts to go beyond the privileged philosophical mode of predication, which Austin calls the constative. Yet, in assigning a totalizable and homogeneous intention and context to the performative, it falls prey to the same metaphysical presuppositions that the constative shares.

Of scientific rigor and common sense, Heidegger writes as follows: "Because understanding, in accordance with its existential meaning, is Dasein's own being-capacity [*Seinkönnen*], the ontological presuppositions of historiological [*historisch*] knowledge in principle go beyond [*übersteigen*] the idea of rigor held in the most exact sciences. Mathematics is

not more rigorous than historiology [*Historie*], but only narrower, because the existential foundations relevant for it lie within a narrower range" (*BT*, 195). Derrida's suggestion about the language (theory and practice) of the human sciences is that the condition of the possibility of its being (its onto-logical presuppositions)—iterability—is what denies it rigor. In that Heidegger relates these ontological presuppositions to the impossibility of a fundamental ontology, he remains recuperable to a Derridian idiom. In that he describes this relationship as a principled transcendence he seems to sketch a privileging of which Derrida would be as critical as he is of the metaphysical underpinnings of speech act theory.

Comparably, of assertion as communication, Heidegger writes: "As something communicated [*als Mitgeteilte*], the asserted [*das Ausgesagte*] can be 'shared' ['*geteilt*'] by others with the person making the assertion, without his having to have the entity which he has pointed out and deter-mined within graspable and visible proximity [*ohne dass sie selbst das aus-gezeigte und bestimmte Seiende in greif—und sichtbarer Nähe haben*]: The asserted can be passed along in 'further retelling.' ...But at the same time, what has been pointed out may become veiled again in this further retelling" (*BT*, 197). One could find the itinerary of iterability here. But only the labor of interpretation can establish that the Heideggerian terms "entity," "pointing out," "grasping and seeing," "becoming veiled" are untotalizable, and that Heidegger is contrasting the definiteness of deter-mination to something irreducibly indefinite. Derrida confronts "commu-nication" head on in *Sec*, and suggests that determinations are themselves indeterminate: "If *communication* possessed several meanings and if this plurality should prove to be irreducible, it would not be justifiable to define communication *a priori* as the transmission of a [determinate] *meaning*, even supposing that we could agree on what each of these words (trans-mission, meaning, etc.) involved."[29]

Yet when Derrida writes, "However, even to articulate and to propose this question I have had to anticipate the meaning of the word *communi-cation*: I have been constrained to predetermine communication as a vehi-cle,"[30] we cannot but sense the strong Heideggerian theme on the pre-, the inevitable forestructure of interpretation and the as-structure of under-standing.

The Heideggerian *Dasein*, structurally in between this *pre-* and the fol-lowing *post-*, is the scene of non-self-identity: "*Dasein* is always 'beyond itself' [*über sich hinaus*], not as a way of behaving towards other entities which it is *not*, but as Being towards the being-capacity which it is itself. This being-structure of the essential 'is an issue,' we shall denote as Dasein's 'Being-ahead-of-itself'" (*BT*, 236; parenthesis translator's). Such a principle of an irreducible non-self-identity is indeed Derrida's theme as well. Yet the

relationship between the two philosophers is not one of *continuous* radicalization. It is rather the prying open of the Heideggerian text (and is thus discontinuous with it) by turning the *principle* of non-self-identity into iterability, which will grant neither a totalizable horizon nor homogeneity. It is here that the structural unconscious plays its role. Lacking such a category, the closest Heidegger comes in *Sein und Zeit* to a practical recognition of alterity is: "The laying-bare of Dasein's originary being must rather be *wrested* from Dasein as a counter-move [*im Gegunzug*] to the falling ontico-ontological tendency of interpretation" (*BT*, 359).

It is in this matter of practical imperatives that Heidegger again looks forward to Derrida. Understandably, Heidegger does not see his own practice as "express[ing] a priority of the 'practical' attitude over the theoretical" (*BT*, 238). Yet in suggesting that "care [*Sorge*]...always caring [*Besorgen*] and caring-for [*Fürsorge*], even if only privately...as an originary structural totality, lies 'before' [*vor*] every factical 'attitude' and 'situation' of Dasein," he is introducing the category of what might be called 'affect in general' into ontology—a category that would conventionally find no place there, and that is still resisted by disciplinary cognitive interpretations of "care." Here too the structural unconscious displaces the reserves of Heidegger's thought. For Derrida, a category such as care cannot be neatly distinguished from other desiring affects such as "willing, wishing, urge, addiction" (*BT*, 238–39). Care can no longer be "ontologically 'earlier' *within the full 'ontological horizon*,'" for the thought of a full horizon would itself be contained within a philosophical affect.

Following this pattern of a deconstructive insight recuperated by an idealist blindness which Derrida has noticed in Heidegger since "Structure, Sign, and Play," the Heideggerian imperative for the authentic ontology of Dasein is: "Our efforts must rather aim at leaping into this 'circle,' originarily and wholly, so that we ensure a *full view* of Dasein's circular Being, even as a Dasein analysis is broached" (*BT*, 363; italics mine).

The circle in question is the impossibility of ever producing an interpretation and an understanding that are free of the existentially (though not empirically) motivated structures of as- and for- and beyond. "Historiology [*Historie*; what one might call the human sciences; translator's note] must then come to terms with [*abfinden*] less rigorous possibilities of knowing [than scientific knowledge], for "according to the most elementary rules of logic, this circle is a *circulus vitiosus*" (*BT*, 194). Science and common sense attempt to ignore this vicious circle. But "what is decisive is not to get out of the circle but come into it the right way" (*BT*, 195). It is in search of this right way that the Heidegger of *Being and Time* recognizes the ontological priority of care and proposes the leap. But here too a certain complication must, at least, be set down; "the ontologically elemental totality of the care-

structure cannot be traced back to some ontical 'arch-element'" (*BT*, 241).

To engage in analytical and interpretive activity with a full awareness of the circularity of determinate Being is then the articulation of authentic *Dasein*. In its broad outlines, this might seem sympathetic to the deconstructive project. In its detail, a certain rewriting becomes necessary. Iterability, as I have indicated, takes away the possibility of a full awareness. It rewrites the enclosure of the circle as, at best, an ellipse that stands in for the impossibility of pure or geometric figuration. The end of the project—the articulation of authentic *Dasein*—becomes impossible because authenticity—*Eigentlichkeit* (ownness, properness, literalness, trueness)— is at the limit a denial of the lack of self-identity which Heidegger himself posits and which in Derrida becomes irreducible. In place of the leap into the circle comes the need to "get used to the idea that, knowingly or not, willingly or not, [we] deal fictively with things which are marked in advance by the possibility of fiction, either as the iterability of acts or as the system of conventionality. [We] cannot therefore *de-limit* the object-fiction or the object-parasite, except by a counter-fiction" (pp. 72, 243).[31]

(If this were an extended discussion of the trace structure as condition of possibility and denial of rigor, one would direct one's attention to Heidegger's "The Origin of the Work of Art,"[32] one of Derrida's texts in "The *Retrait* of Metaphor." In these pages I have followed my surmise that, if one wished to plot the dynamics between Heidegger and Derrida in terms of a theory of (the) practice (of theory and so on), one could do worse than to examine the trace—here iterability—in terms of the Heideggerian ontic-ontological difference; a possibility suggested by Derrida himself in "Differance."[33]

It should by now be clear that Derrida's invocation of "fictions" does not mean indenturing the discipline of philosophy to the discipline of literature. One might think of it perhaps as deconstructing the Hegelian opposition and ranking between the ethical and the aesthetic. That particular undertaking can be located in the analysis of *Sittlichkeit* in the left-hand column of *Glas*.

III.

It is well known that Heidegger must rewrite nearly every word in the vocabulary of philosophy because he has seen through the rigor of philosophical language. It is possible to situate Derrida's increasing experimentation with language in a comparable impulse. As I remark above, he seems to be bent upon coining a multiplicity of terms for *more or less* the same thing: trace, supplement, differance, parergon, retrait, iterability—and many more. He also twists and pluralizes style and typography to account for the fact that a unitary message about a unitary object from a unitary

author to a unitary reader is what his writing calls into question.

Where Derrida is strikingly different from Heidegger is in his entertainment of the "non-serious." (Here one might speculate upon his relationship to Nietzsche.) Since "Limited Inc." is an especial critique of pure seriousness as ethico-political centralization, the non-serious element is most pertinent here.

The mingling of serious and non-serious in a critique of seriousness is well exemplified in the following passage:

> [Iterability] carries an internal and impure limit that prevents it from being identified, gathered to itself, or in its presence [*en soi ou auprès de soi*], from being reappropriated, just as it forbids the reappropriation of that whose iteration it nonetheless broaches and breaches [*entame*]. But under such conditions, one will reply, no scientific or philosophical theory of speech acts in the rigorous, serious, and pure sense would be possible. That is, indeed, the question.... A theoretical discourse of this (classical, traditional) type must indeed tend, in accordance with its proper ethics and teleology, to produce speech acts that are in principle serious, literal, strict, etc. The only way that speech act theory might escape this traditional definition would be for it to assert (theoretically and practically) the right of its own speech acts not to be serious, etc., or rather not simply serious, strict, literal. Has it done this up to now? Might it have escaped me? In all seriousness, I cannot exclude this possibility. But am I serious here?... The drama of this family of theoreticians: the more they seek to produce serious utterances, the less they can be taken seriously. It is up to them to seize this opportunity or to transform this infelicity into delight [*jouissance*] [pp. 43–44, 210–12].

"But am I serious here?" Within the disciplines of philosophy and literary criticism, that is the question that many readers of Derrida have not been able to answer. Yes, Derrida is "making fun of" Searle; and "one does not write philosophy like that." But also, to repeat, the charge is precisely against that seemingly impenetrable but ultimately perhaps even stupid seriousness of the academic intellectual; that is the "condition or effect— take your pick" of ethico-political repression. And one should give Derrida the benefit of the doubt that, when he asks such a question it does not only mean "you can't tell, can you?" but that, "given the implications of my critique, I can't tell either; yet I will take my stand and make the critique nonetheless." It is a critique of the vanguardism of the theoretician. "It is right also that philosophy should be called knowledge of the truth. For the end of theoretical knowledge is truth, while that of practical knowledge is action (for even if they consider how things are, practical men do not study the eternal, but what is relative and in the present)."[34]

It is all the more poignant that since he is himself caught up in an international academic lifestyle, Derrida can behave as a nonserious marginal (given that his model is the criminal or defendant rather than the revolutionary) in limited ways.[35] I should insist that, to undermine the plausibility of one's arguments, to give the reader the ingredients for "situating" one's own "intention," remains a considerable risk. (Indeed, such an undermining makes many devoted readers wonder why Derrida has turned "autobiographical," why he does not rigorously "deconstruct texts" anymore.) It is a sign of the dynamism and power of the ideology that Derrida questions that this undermining can be recuperated into varieties of esoteric game-playing.

So much said, let me once again tabulate. I have spoken already of the significance of the thematics of the copyright, and the argument—if that is indeed what it is—about the oedipal metaphysics of the discipline of philosophy. Apart from these, one of the most noticeable items of nonseriousness in "Limited Inc." is that its sections are alphabetized. Its subtitle is "abc," which is pronounced *abaissé*—laid low. The implications are obvious. "ABC" might also mean a primer, as in the following passage: "One of [*Sec*'s] conventions which, like all others, cannot be rigorously justified, supposed the knowledge of certain *abc*s of classical philosophy..." (pp. 73, 244). In which case what we read might he intended as a primer of how to bring down the incorporation of the copyrighted liability organization that is the philosophical establishment. Further, the masquerading of the authority of the alphabet, the representative of phonographic writing in the narrow sense, might be to polarize the absurdity of accepting the authority of the "representative" of speech as the generative moment of voice-consciousness, as the explanatory speech-act convention, or yet as the determining sovereign intention. We are caught up short when, at the end of the next to the last section, Derrida writes: "And, for the second time, I am going to conclude a bit abruptly, since I see that all I have left is the letter z" (pp. 77, 249). I should add, of course, that I cannot guarantee Derridian authorization for any of these meanings.

After *abc*, *d* occupies itself with the critique of the legal copyright to *one's own words* and mimes citationality by testing the seriousness of "Copyright © by John D. Searle" as it is plausibly placed between more and more quotation marks. Derrida also tests the status of the signature as a man's mark by examining its every implication and reproducing "his own" in various ways.

Now these are, of course, "serious" demonstrations of Derrida's argument. But they are also, and unmistakably, high-class tomfoolery. And, in that at least ambivalent tone, Derrida begins *f*: "Let's be serious"; since it is only the "serious" tone of the performative that Austin will consider—and

non-serious, parasitic, marginal uses (like mischief in a philosophical essay, even if it might have its point)—will be excluded. Readers will by now be prepared to read the following passage as more than a rhetorical flourish: "Faced with this speech act ('let's be serious'), readers may perhaps feel authorized in believing that the presumed signatory of this text is only now beginning to be serious, only now *committing* himself to a philosophical discussion worthy of the name, thus admitting that he had not done so yet." Derrida does not decide if such a feeling would be correct or not but goes on to say, in the next paragraph: "But let's be serious. Why am I having such difficulty in keeping my seriousness in this debate, to which I, in turn, have been invited? Why did I take such pleasure in accepting this invitation? Nothing compelled me to accept, and I could have—the temptation could have been strong—suggested to interested readers that they simply read 'Signature Event Context'" (pp. 7, 168–69). Here the possibility that the structural unconscious might waylay every so-called conscious intention is directed at Derrida himself. It cannot, of course, be more than a question, because the unconscious is another name for the it that is inaccessible to, yet broaches and breaches the I. Another theme that runs throughout "Limited Inc." is touched upon here: that Searle unwittingly demonstrates many of the arguments of *Sec* and that his "Reply to Derrida" is thus a case of citationality.

To the question—but are we to look for such serious implications in such undisciplined language?—the answer is yes. To introduce the nonserious, to welcome the margins of the production of philosophic discourse—that is the intent of this disciplinary critique. These are the practical implications of passages such as the following: "What these 'fronts' [continental as opposed to Austinian philosophy—Searle's distinction; Derrida uses the word also in the sense of 'clandestine masks'] represent, what weighs upon them both, beyond this curious chiasmus, are non-philosophical forces. They must indeed be analyzed" (pp. 10, 172). And, "it is because of this that I agree with Sarl that the 'confrontation' here is not between two prominent philosophical traditions' but between *the* tradition and its other, an other that is not even 'its' other any longer. But this does not imply that all 'theorization' is impossible. It merely delimits a theorization that would seek to incorporate [both in the psychoanalytic and the economic senses] its object totally but can accomplish this only to a limited degree:" (pp. 43, 211).

Thus it is (not) merely impertinent to acknowledge what generally remains tacit: that the academic game is played according to rules that might not pertain altogether to the disinterested intellect. I have attempted to give a sober account of the structural unconscious in the first part of this essay. I remarked there that it seemed unusual that Searle should accuse Derrida, whose work is profoundly complicit with the general morphology

of psychoanalysis, of not acknowledging the unconscious. Derrida comments upon it in the following way: "What a fake-out, leaving me flat-footed in the camp of those insufficiently aware of the unconscious!... For [my translator's] benefit let me specify that, ever since my adolescence, I have understood the word above all as a soccer term: an active ruse designed to surprise one's opponent occupied in another direction" (pp. 45, 213). That Derrida "knows" that Searle is probably not deliberately faking him out lends the irony a double edge while at the same time risking putting the entire essay beyond the pale of academic courtesy.

Derrida makes a rather belabored and elaborate joke almost at the end of "Limited Inc." Here, through the encroachment of the nonserious, Derrida makes what would normally be considered an entirely serious point: that there is something in common between the restrictive purity of theoretical discourse and the institutional restrictions imposed upon us in its "other" (not fully its other), the "real world." Yet once again, although Derrida does not like the notion of the ideological production of material institutions and vice versa in case it should smell too much of binary oppositions and isomorphism, the argument is welcome to ideology critics who would like precisely to call into question those classical constraints upon their practice. "At one moment or another [Searle] will notice that between the notion of responsibility manipulated by the psychiatric expert (the representative of law and politico-linguistic conventions, in the service of the State and of its police) and the exclusion of parasitism, there is *something like a relation*" (pp. 78–79, 251; italics mine).

The conclusion itself is a collection of questions about seriousness, promises, and confrontations. Most serious disciplinarians find these gestures offputting in published work. Why make such a thing of these marginal issues? It is because the delimiting and microstructural exigencies of practice must be acknowledged constantly, persistently. "I have said only half in jest that women...understand a kind of work which does not...lead to one's name in a bibliography or a totemized object like a book or one's proper name...lingering in the pages of history.... That sort of activity which simply repeats itself again and again and again, like keeping the house clean, is a sustaining political activity."[36] Without such interminable, inconclusive, and sustaining repetitions, theory forgets that it is also a practice, that it is at all times normed by that which it excludes; and begins to freeze, or to rot. As for example, this very binary opposition between theory and practice.

The final (non)serious item that I shall record is that Derrida manages to quote the entire "Signature Event Context" in "Limited Inc." As I have said before, one of Derrida's pervasive arguments is that Searle unwittingly proves Derrida's points while seemingly opposing him. In that sense,

"Reply to Derrida" is also a species of iteration/citation of *Sec*. In its leg-ending, then, "Limited Inc." is a parodistic double session of iterability.

A practically fractured yet persistent critique of the hidden agenda of ethico-political exclusion; a sustained though necessarily fragmented stand against the vanguardism of theory; and, most importantly, a call to attend to the ever-askew "other" of the traditional disciplines, the need persis-tently to analyze that "confrontation," to figure out and act upon that "something like a relationship" between "ideology" and "social produc-tion" which, ever non-self-identical, will not keep us locked in varieties of isomorphism. These are enabling principles for more than a constant clean-ing-up (or messing-up) of the language of philosophy, although the impor-tance of this latter is not to be underestimated. If the "other that is not quite the other" were to be conceived of as political practice, pedagogy, or femi-nism—simply to mention *my* regional commitments—one might indeed look for "'revolutions' that as yet have no model" (pp. 72, 243).

The full sentence in fact runs: "...'literatures' or 'revolutions' that as yet have no model." The inclusion of literature seems consonant with the sus-tained justification of the avant-garde that often seems to be the task of the best in European criticism. Yet Derrida's usefulness for practice is not neu-tralized by such an association. I shall explain myself by way of a European critic who wrote powerfully in support of the avant-garde and drew a care-ful distinction.

Following Bertolt Brecht's own theories, Walter Benjamin described the former's theatrical experiments as a calling into question of the identity of the so-called Aristotelian stage, a stage that was politically and economi-cally, as well as culturally, a restrictive norm upon twentieth-century European theater. The identity in question is not merely "the purging of the emotions through identification with the destiny which rules the hero's life."[37] It is also the representational identification of the stage with reality, actor with role, and finally the identification of the proper and intrinsic space of dramaturgy by the strategic exclusion of its politico-economic-ide-ological "other," which underwrites its being.

Within the rich field of Brecht's theatrical imagination, the item whose pedagogic power Benjamin singles out reminds us of citationality or iter-ability. Just as Derrida insists that no speech act is, even originarily, tied to its appropriate context; and that thus iterability disrupts the so-called unity of voice and intention even as it remains the condition of possibility of form; so also Benjamin writes: "Interruption is one of the fundamental methods of all form-giving. It reaches far beyond the domain of art. It is, to mention just one of its aspects, the origin of the quotation. Quoting a text implies interrupting its context.... 'Making gestures quotable' is one

of the essential elements of epic theatre. The actor must be able to space his gestures as the compositor produces spaced type."[38]

An extended consideration of Derrida's graphic of iterability and *its* undermining of self-identity on the one hand, and Brecht's iteration of gestures and its undermining of self-identity on the other, would involve at least a consideration of Derrida's early essay on Artaud,[39] and his many comments on "spacing" as a critique of presence. ("Spacing [notice that this word speaks the articulation of space and time, the becoming-space of time and the becoming-time of space] is always the unperceived, the non-present, and the non-conscious.... Archewriting as spacing cannot occur as such within the phenomenological experience of a presence" [*OG*, 68]. Here, however, I am more interested in the contrast that Benjamin exposes between Brecht's practice, which can be pedagogic, and Romantic Irony, which it superficially resembles. It seems to me that Derrida's position is to grasp iterability as the condition of possibility of the positive which will, however asymmetrically and unrigorously, result in the remains of a consensus; it therefore behooves us to forge theories (practices) of practice (theory), to whatever degree both are "normed" by the minutest detail of their structuring. In this, I place him with Brecht in Benjamin's discussion. American deconstruction, however, resembles what Benjamin writes of Romantic Irony; I choose one passage among many: "[The actor] must be free, at the right moment, to act himself thinking (about his part). It would be a mistake, at such moments, to draw a parallel with Romantic irony.... This has no didactic purpose; in the final analysis, all it demonstrates is the philosophical sophistication of the author, who, while writing his plays, always has at the back of his mind the notion that the world may, after all, be just a stage."[40] Indeed, the genius of American deconstructivism finds in Romanticism its privileged mode: "One may well wonder what kind of historiography could do justice to the phenomenon of Romanticism, since Romanticism (itself a period concept) would then be the movement that challenges the genetic principle which necessarily underlies all historical narrative. The ultimate test or 'proof' of the fact that Romanticism puts the genetic pattern of history in question would then be the impossibility of writing a history of Romanticism."[41] The self-transcendent trope is, indeed, Romantic Irony, as extended by the proper heir: "In a slight extension of Friedrich Schlegel's formulation, it becomes the permanent parabasis of an allegory (of figure), *that is to say*, irony. Irony is no longer a trope but the undoing of the deconstructive allegory of all tropological cognitions, the systematic undoing, *in other words*, of understanding. *As such*, far from closing off the tropological system, irony *enforces* the repetition of its aberration."[42] Rather than forging an irreducibly fragmented, untotalizable, yet "positive" or "affirmative" (words often used by Derrida) practice, such

formulations as the above, as I have tried to show in my discussion of the structural unconscious and Reading, would remind us of nothing more than the inevitability of a repetition automatism, the repetition, in fact, of an aberration. The scenario is dramatized in the words I have italicized: after the lesson of deconstruction (the substitution-consciousness of "that is to say," "in other words,") comes the "irony" of the iron fist ("as such," "enforces"). Because critics from the left and the right tend to see in deconstruction nothing but this itinerary of skepticism, any attempt, on the part of deconstruction, to disturb the status quo of theory is dismissed as "a certain Byronic chic.... Deconstruction...is cogent enough to induce an occasionally felt scruple, but not a determination to change one's ways."[43]

For a more specifically political (if not in every detail) deconstructive practice of theory, one should perhaps turn to the "life" and "work" of Antonio Negri. I should like to end with the account of a humble pedagogic benefit that I receive from Derrida's generalized analogy.

Graduates and undergraduates alike seem caught in a doctrine of individual uniqueness. In a dehistoricized academy, they find no difficulty in claiming their opinions' center as their own self-possession. This is matched by the ease with which collectivities in the person are assigned centralized unitary descriptions: the fifties, the sixties, the seventies; Romanticism, Structuralism, Phenomenology. In the meantime, even in the most superficial and minimal analysis, one of the most striking characteristics of any version of advanced capitalism is the fragmentation and decentralization of the individual's putative political and economic control over her own life. One of the peculiar and paradoxical byproducts of this system is to generate a conviction of individual centrality among most members of the intellectual, bourgeois, as well as managerial classes—"the internal regulation of the capitalist system which must limit concentration and decision-making power in order to protect itself against its own 'crisis'" (pp. 57, 226), accompanied by either a dispirited anguish against "their" power, or a spirited faith in "our" proliferation, with assorted permutations and combinations, of course. The official philosophy of this group is an individualism more or less disguised as pluralism. The generalizable result: lack of any conceivable interest in a collective practice toward social justice, or in recognizing the ethico-politically repressive construction of what presents itself as theoretical, legal, benign, free, or natural. The "deconstructive" lesson, as articulated in "Limited Inc.," can teach student and teacher alike a method of analysis that would fix its glance upon the itinerary of the ethico-political in authoritarian fictions; call into question the complacent apathy of self-centralization; undermine the bigoted elitism (theoretical or practical) conversely possible in collective practice; while disclosing in such gestures the condition of possibility of the positive. My point here, I suppose, is that the

range and risks of such a morphology (whose examples cannot match its discourse) can go rather further than a new school of literary-philosophical criticism, or even a mere transformation of consciousness.

NOTES

1. Derrida, *Glyph* 1, p. 190.

2. I have indicated the page number of the French text first, followed by reference to the English translation. The references are henceforth incorporated in my text. The page references to this passage are pp. 70, 241.

3. A performative speech act occurs when "it seems clear that to utter the sentence (in, of course, the appropriate circumstances) is not to *describe* my doing of what I should be said in so uttering to be doing or to state that I am doing it; it is to *do* it." J. L. Austin, *How To Do Things with Words* (Cambridge, MA: Harvard University Press, 1962), p. 6; italics author's.

4. Once such a "theoretical fiction" helps prove a point, author and reader tend to forget its situational fictiveness. Such is the case with Freud's "primary"—the adjective has the same normative ring as "standard"—process: "It is true that, so far as we know, no psychical apparatus exists which possesses a primary process only and that such an apparatus is to that extent a theoretical fiction." Freud, "The Interpretation of Dreams," in *Works*, vol. 5, p. 603.

5. Derrida, *Glyph* 1, pp. 181–82.

6. Trans. J. N. Findlay (London: Routledge and Kegan Paul, 1970).

7. Trans. John P. Leavey (New York: Nicolas Hays, 1977).

8. Trans. David B. Allison (Evanston, IL: Northwestern University Press, 1973).

9. Derrida, *Glyph* 1, p. 185.

10. Derrida, "Me—Psychoanalysis: An Introduction to the Translation of 'The Shell and the Kernel' by Nicolas Abraham," trans. Richard Klein, *Diacritics* 9:1 (Spring 1979), pp. 4–15.

11. John R. Searle, "What Is an Intentional State?," unpublished manuscript, p. 17. It should be mentioned that, according to Searle, although he has "made fairly heavy use of the notion of representation...it is not essential to do so; one could make all the same points in terms of conditions of satisfaction or conditions of success of the Intentional states without explicitly using the notion of representation" (p. 25). The piece as a whole is curious, open once again to every criticism presented in "Limited Inc." Right at the end, however, there is this acknowledgment of aporia: "I do not believe it is possible to give an analysis of Intentionality. Any attempt to characterize Intentionality must inevitably use Intentional notions, and thus any such attempt will move within what I have elsewhere called the circle of Intentionality.* [Searle's note:] *Intentionality and the Use of Language*, by J. R. Searle, forthcoming," (p. 25).

Later I shall speak of the circle of interpretation and Heidegger's theory of a practice that might take it into account (pp. 93–94). It is therefore worth noticing here that Searle's theory of disciplinary philosophical practice is to take everything "inside the circle" as self-evident and everything "outside" as irrelevant; a clear case of the exclusion of the other as such so that a normative interior can be defined.

12. John R. Searle, "Reiterating the Differences: A Reply to Derrida," *Glyph* 1, p. 200.

13. I used my customary feminine pronoun here because I think of the writer, critic, philosopher and the like as "being like myself." But the reason why Derrida links (the historical position of) women with writing becomes immediately apparent. Since woman is constituted as the legal object of exchange, as evidenced by her so-called proper name(s), it is indeed in the house of her (legal) intention that she is by definition to be invested by other selfhoods in turn. See Claude Lévi-Strauss, *Structuralist Anthropology*, trans. Claire Jacobson and Brooke Grundfest Schoepf (New York: Basic Books, 1963), pp. 61–62 and passim (Lévi-Strauss's disavowal of his own sexism is interpretable); Jack Goody, *Production and Reproduction: A Comparative Study of the Domestic Domain* (Cambridge: Cambridge University Press, 1979); and Lesley Caldwell, "Church, State, and Family: The Women's Movement in Italy," in *Feminism and Materialism: Women and Modes of Production*, eds. Annette Kuhn and AnnMarie Wolpe (London: Routledge and Kegan Paul, 1978), pp. 75–82.

14. Searle, *Glyph* 1, p. 202.

15. Deleuze and Guattari, pp. 37–38. In associating "body without organs" with "Undivided Mind" I am suggesting that there is an unacknowledged complicity with transcendental phenomenology in the schizo-analysis articulated by this otherwise extraordinary book. Deconstruction, by putting the trace structure at the place of the origin or *épochè*, has repeatedly acknowledged a similar complicity. See especially *Speech and Phenomena* pp. 153–60, and OG, p. 62.

16. Paul de Man, *Allegories of Reading: Figural Language in Rousseau, Nietzsche, Rilke, and Proust* (New Haven: Yale University Press, 1979), p. 77.

17. For the Unconscious as the structure of language and a reading effect, see Jacques Lacan, "The Agency of the Letter in the Unconscious or Reason Since Freud," in *Ecrits*, trans. Alan Sheridan (New York: Norton, 1977), p. 147; and Shoshana Felman, "Turning the Screw of Interpretation," *Yale French Studies* 55–56 (1977), pp. 94–207.

18. Jacques Lacan, "Seminar on 'The Purloined Letter,'" trans. Jeffrey Mehlman, *Yale French Studies* 48 (1972), p. 40.

19. "To negate something in a judgment is, at bottom, to say: 'This is something which I should prefer to repress,'" Freud, "Negation," in *Works*, vol. 19, p. 236.

20. In introjection, the ego is altered so that a lost object can be given up. In incorporation, the ego refuses to give up the object, and wants to keep it by swallowing it. The resulting "indigestion" is melancholia (Freud, "Mourning and Melancholia," in *Works*, vol. 14) or "cryptomania" (Nicholas Abraham and Maria Torok, *Le Verbier de l'homme-aux-loups* [Paris: Flammarion, 1976]).

21. Searle, "The Logical Status of Fictional Discourse," *NLH* 6:2 (Winter 1975), pp. 319–32; cited in Searle, *Glyph* 1, p. 208.

22. Searle, *Glyph* 1, p. 192.

23. Derrida's rewriting of Mallarmé's famous sentence, at the end of "White Mythology," problematizes the position that language may be purely self-referential or autotelic. Mallarmé: "I say, a flower! and out of the forgetfulness to which my voice relegates any contour, in so far as it is something other than known calyxes, musically arises, the idea itself and sweet, the one absent from all bouquets [a word Derrida playfully "translates" as "anthology"] [*Crise de vers*]." Derrida: "There is always, absents from every garden, a dried flower in a book; and by virtue of the repetition in which it endlessly puts itself into abyme [s'abŷme], no language can reduce into itself the structure of an anthology." Derrida, "White Mythology: Metaphor in the Text of Philosophy," trans. Alan Bass in *Margins of Philosophy* (Chicago: University of Chicago Press, 1982), p. 271.

24. It should be repeated that this displacement of God by writing is another case of the placing of the trace structure at the origin or the transcendental condition of possibility of which I write in note 15. For another case, one might look at how Derrida elsewhere launches Descartes's "proper name" (as authoritative as God in this example) into the drift of writing—to describe the impossibility of making a proper beginning outside of the chain of metaphoricity. The "master-metaphor" in that argument is the famous Cartesian "pilot in his ship," which Derrida uses against the Cartesian grain. The sentence that interests me runs as follows: "That is why just now I have been moving from digression to digression, from one vehicle to another without being able to brake or stop the autobus [transportation is *metaphora* in modern Greek]." Derrida, "The *Retrait* of Metaphor," *Enclitic* 2:2 (1978), p. 7. The italicized passage, indicating the impossibility of authoritative origins, runs in French "*d'écart en écart*." If one makes a liaison between the first two words, one gets the proper name of the celebrated philosopher, its nominative articulation—an accident in itself—dependent upon the humble syncategoreme "*en*."

25. Heidegger, *Being and Time*, trans. John McQuarrie and Edward Robinson (New York: Harper and Row, 1962), p. 200. Hereafter cited as *BT* in the text, followed by page references.

26. Derrida, "*Retrait*," p. 13.

27. Derrida, "The Ends of Man," *Philosophy and Phenomenological Research* 30:1 (1969), p. 48.

28. If the choice of metaphors or examples in a conceptual text is not fortuitous, it should be noticed that Heidegger's illustration for the thing escaping predication or assertion is "the hammer itself." Is it fanciful to recall that, in *The Twilight of the Idols*, trans. R. J. Hollingdale (Baltimore: Penguin, 1968), Nietzsche wished to "philosophize with a hammer"?

29. Derrida, *Glyph* 1, pp. 172–73.

30. *Ibid.*, p. 172.

31. The irruption of such fictionality in the most serious categories of class analysis may be seen in the "abnormal" use of strikes made by the microstructural hierarchy of the working class. "The trick of, say, bribing two days' wages in the shape of TO [overtime] by Class III employees easily wins the support of Class IV staff in a day's 'successful' token strike." Timir Basu, "Calcutta Notebook," *Frontier* 12:36 (1980), pp. 5–6. If a macrostructural class theory sees this as a sign of working-class solidarity, it should and should not be mistaken. Quite appropriately, Basu continues, "thus, withdrawal of labour in any form or strike does not necessarily signify the workers' inbuilt strength." The next crucial step is to acknowledge that such parasitic fictions will consistently norm the majestic calculations of theory.

32. See Heidegger, *Poetry, Language, Thought*, trans. Albert Hofstadter (New York: Harper Colophon, 1975), pp. 15–87.

33. See Derrida, *Speech and Phenomena*, p. 130 and passim.

34. Aristotle, "Metaphysics," in *The Basic Works of Aristotle*, ed. Richard McKeon (New York: Random House, 1941), p. 712.

35. His involvement with GREPH (Groupe de recherches sur l'enseignement de la philosophie)—a multilevel national group of students and teachers in the institutional pedagogy of philosophy—should be mentioned. "For GREPH—there is no Philosophy with a capital P [*il n'y a pas la philosophie*]," *Qui a peur de la philosophie*, eds. Sylvaine Agacinski et al. (Paris: Flammarion, 1977), p. 5.

36. Spivak, in Spivak, Bill Galston, and Michael Ryan, "A Dialogue on the Production of Literary Journals, the Division of Disciplines and Ideology Critique," *Analecta* 6 (1980), p. 84.

37. Benjamin, "What Is Epic Theatre?" (second version), in *Understanding Brecht*, trans. Anna Bostock (London: New Left Books, 1973), p. 18.

38. Benjamin, "Epic Theatre," p. 19.

39. Derrida, "The Theatre of Cruelty and the Closure of Representation," in *Writing and Difference*, trans. Alan Bass (Chicago: University of Chicago Press, 1978).

40. Benjamin, "Epic Theatre," pp. 21–22.

41. de Man, *Allegories*, p. 82.

42. *Ibid.*, pp. 300–01; italics mine.

43. Denis Donoghue, "Deconstructing Deconstruction," *New York Review of*

Books 27:10 (1980), p. 41. On the other hand, serious and well-meaning sympathizers might also be overlooking an important point when they insist that deconstruction belongs to the philosophical traditions and should not be trifled with by people from other disciplines. What they might be recuperating is the impulse to confront the "other" of philosophy not as the other as such. I am thinking of, say, David Carroll, "History as Writing," *Clio* 7 (1978), pp. 443–44, 459–66; and of Rodolphe Gasché's recent influential essay, "Deconstruction as Criticism," in *Glyph* 6 (1979), pp. 177–215.

Scattered Speculations on the Question of Value

(1985)

If we follow Spivak's intellectual itinerary closely, a difference emerges between Spivak speaking or lecturing and Spivak on the printed page. If the experience of the Spivakian page often seems one of insurmountable difficulty, and its effect to exaggerate one's sense of one's own ignorance or dimness, and one's sense of the ineffectuality of theory, the effect of her live performances can be the opposite: a galvanization toward political action. By her own admission, this essay was composed from "scattered" teaching notes and published "as is," betraying all the marks of inhabiting the spaces between thinking and speaking, writing and explaining. It was written in the hope of clarifying for herself and her students some aspects of the texts of Marx, texts which she continues to teach over and over. It has, nevertheless, had a great deal of academic influence, especially among economists, who rarely, if ever, find the work of literary theorists of any interest.

Since Spivak has published a number of essays on the writings of Marx and continues to appear at international conferences where Marxism and left politics are on the agenda, the explicitly politicizing effect of her public and pedagogical presence should not be underestimated. Political speech-making and left-wing organizing "on the ground" have been part of her intellectual formation, from her student days in Calcutta to the present, broken by what she describes as "a few years of culture shock" in between. And yet both the distinction between "speaking" and "writing" and the question of authorial "presence" are peculiarly problematical for the deconstruction that influences Spivak.

Moreover, given that the breakup of the former Soviet bloc has caused many in the capitalist West triumphantly to proclaim the death of socialism, why does a cultural critic like Spivak continue to argue for the relevance of Marx's thinking to contemporary politics and economics? The short answer

to this question can be found in *The Post-Colonial Critic*: "What Marxism really has to offer is global systems" and, especially in the Third World, "crisis theory" (p. 138). Marx gives us a way of conceptualizing capitalist logic on a global scale; and while the continued development of capitalism depends upon this, it is something that has become increasingly difficult for people to comprehend in their everyday existence. The interconnectedness between events happening on Wall Street, in European or U.S. universities and shopping malls, and in the factories and villages of the Third World has become difficult to grasp. This knowledge gap allows various forms of complicity between Western prosperity, including education systems, and the spectacular dynamics of exploitation to continue. This complicity through nonknowledge of the international division of labor is something Spivak frequently takes pains to point out, particularly emphasizing the importance of women's labor to these international calculations.

In addition to consistently teaching the texts of Marx, Spivak has published on them on several occasions. This essay, originally published in *Diacritics* 15:4 (Winter 1985), pp. 73–93, and reprinted in *Worlds*, is undoubtedly her most influential attempt. In an interview in 1971, Derrida commented that he had not yet found any satisfactory protocols for reading the texts of Marx, particularly when he considered the "decisive importance of its [the Marxist text's] historical stakes" (*Positions* [Chicago: University of Chicago Press, 1981], pp. 62–63). Twenty-three years later, Derrida's book on Marx has appeared (see p. 308 of the *Reader*). Spivak's essays can be read as initial forays into finding her own strategy for reading the Marxist text. By her own account, though she hopes someday to publish on the place of the ethical in Marx, she finds herself not yet quite ready to do so.

Her efforts to date involve attending precisely to the *textuality* of Marx's texts, to their refusals of economic reductionism as scientific law, their indeterminacies, and the leverage offered by Marx's materialist predication of the subject (as labor-power) for posing the question of value in literary and cultural studies, in a way not entirely ignorant of the international division of labor. Her work here has yet to be superseded, by Derrida or anyone else. Along the way, Spivak gently cautions that Derrida's own understanding of Marx is limited by his equation of capital with interest-bearing commercial capital, as opposed to industrial capital, predicated upon the extraction and appropriation of surplus-value. And she also cautions readers of Fredric Jameson's influential work on postmodernism as the "cultural logic" of late capitalism that "*as long as no attempt is made to specify the post-modern space-specific subject-production*" he has in mind—that of urban consumers in the industrialized West, with no regard for the super-exploitation happening elsewhere—his analysis, far from

being emancipatory in its implications for a politics of postmodernism, will be entirely complicit with the logic of Wall Street investors busily recruiting new participants in global financialization, regardless of the global cost.

One of the determinations of the question of value is the predication of the subject. The modern "idealist" predication of the subject is consciousness. Labor-power is a "materialist" predication. Consciousness is not thought, but rather the subject's irreducible intendedness towards the object. Correspondingly, labor-power is not work (labor), but rather the irreducible possibility that the subject be more than adequate—super-adequate—to itself, labor-power: "it distinguishes itself [*unterscheidet sich*] from the ordinary crown of commodities in that its use creates value, and a greater value than it costs itself" (C1, 342; translation modified).

The "idealist" and the "materialist" are both exclusive predications. There have been attempts to question this exclusivist opposition, generally by way of a critique of the "idealist" predication of the subject: Nietzsche and Freud are the most spectacular European examples. Sometimes consciousness is analogized with labor-power as in the debates over intellectual and manual labor. Althusser's notion of "theoretical production" is the most controversial instance.[1] The anti-oedipal argument in France seems to assume a certain body without predication or without predication-function. (The celebrated "body without organs" is one product of this assumption—see Gilles Deleuze and Félix Guattari, *Anti-Oedipus: Capitalism and Schizophrenia*.)[2] I have not yet been able to read this as anything but a last-ditch metaphysical longing. Since I remain bound by the conviction that subject-predication is methodologically necessary, I will not comment upon this anti-oedipal gesture. The better part of my essay will concern itself with what the question of value becomes when determined by a "materialist" subject-predication such as Marx's.[3] This is a theoretical enterprise requiring a certain level of generality whose particular political implications I have tabulated in passing and in conclusion. Here it is in my interest to treat the theory-politics opposition as if intact.

Before I embark on the generalized project, I will set forth a practical deconstructivist-feminist-Marxist position on the question of value in a narrow disciplinary context. The issue of value surfaces in literary criticism with reference to canon formation. From this narrowed perspective, the first move is a counter-question: *Why* a canon? What is the ethico-political agenda that operates a canon? By way of a critique of phallogocentrism, the deconstructive impulse attempts to decenter the desire for the canon. Charting the agenda of phallocentrism involves the feminist, that of logocentrism the Marxist interested in patterns of *domination*. Yet for a decon-

structive critic it is a truism that a full undoing of the canon-apocrypha opposition, like the undoing of any opposition, is impossible. ("The impossibility of a full undoing" is the curious definitive predication of deconstruction.) When we feminist Marxists are ourselves moved by a desire for alternative canon formations, we work with varieties of and variations upon the old standards. Here the critic's obligation seems to be a scrupulous declaration of "interest."

We cannot avoid a kind of historico-political standard that the "disinterested" academy dismisses as "pathos." That standard emerges, mired in overdeterminations, in answer to the kinds of counter-questions of which the following is an example: What subject-effects were systematically effaced and trained to efface themselves so that a canonic norm might emerge? Since, considered from this perspective, literary canon formation is seen to work within a much broader network of successful epistemic violence, questions of this kind are asked not only by feminist and Marxist critics, but also by anti-imperialist deconstructivists. Such counter-questions and declarations are often seen as constituting the new Marxist (feminist-deconstructivist) point of view on literary value. Since I share the point of view they subtend, I place them on the threshold of my essay as I move into my more generalized (more abstract?) concerns.

The first distinction to make, then, is that the point of view above focuses on *domination*. Concentrating on the desire for the canon, on the complicity with old standards, and on epistemic violence, the practical perspective of the discipline of literary studies in the narrow sense need do no more than persistently clean up (or muddy) the "idealist" field as it nourishes the question of value. Any consideration of the question of value in its "materialist" predication must, however, examine Marx's investigation of *exploitation*.

On the level of intellectual-historical gossip, the story of Marx's investigation of exploitation is well-known. Around 1857, Marx set out to unpack the concept-phenomenon money in response to the analyses and crisis-managerial suggestions of Frédéric Bastiat and Henry Charles Carey, and to the utopian socialist projects endorsed by Proudhon. It is our task to suggest that, by lifting the lid of that seemingly unified concept-phenomenon, Marx uncovered the economic *text*. Sometimes it seems that cooking is a better figure than weaving when one speaks of the text, although the latter has etymological sanction. Lifting the lid, Marx discovers that the pot of the economic is forever on the boil. What cooks (in all senses of this enigmatic expression) is Value. It is our task also to suggest that, however avant-gardist it may sound, in this uncovering Value is seen to escape the onto-phenomenological question. It is also our task to emphasize that this is not

merely asking ourselves to attend once again to the embarrassment of the final economic determinant, but understanding that, if the subject has a "materialist" predication, the question of value necessarily receives a textualized answer.[4]

Let us deal with the continuist version of Marx's scheme of value.[5] Here is a crude summary: use-value is in play when a human being produces and uses up the product (or uses up the unproduced) immediately. Exchange-value emerges when one thing is substituted for another. Before the emergence of the money-form, exchange-value is ad hoc. Surplus-value is created when some value is produced for nothing. Yet even in this continuist version value seems to escape the onto-phenomenological question: what is it (*ti esti*)? The usual answer—value is the representation of objectified labor—begs the question of use-value.

This continuist version is not absent in Marx, and certainly not absent in Engels. The intimations of discontinuity are most noticeably covered over in the move from the seven notebooks now collectively called the *Grundrisse* to the finished *Capital 1*. It is a secondary revision of this version that yields the standard of measurement, indeed the calculus that emerges in the move from *Capital 1* to *Capital 3*. Vestiges of the "primary" continuist version linger in Derrida, whose version clearly animates Jean-Joseph Goux's *Numismatiques*, where most of the supporting evidence is taken from *Capital 1*. Goux's reading, squaring the labor theory of value with the theories of ego formation and signification in Freud and the early Lacan, is a rather special case of analogizing between consciousness and labor-power. Since my reading might seem superficially to resemble his, I will point at the unexamined presence of continuism in Goux in the next few paragraphs.

Goux's study seems ostensibly to issue from the French school of thought that respects discontinuities. Derrida gave *Numismatiques* his endorsement in "White Mythology," itself an important essay in the argument for discontinuity.[6] Goux takes the continuist version of the value schema outlined above as given in Marx, though of course he elaborates upon it somewhat. Within that general continuist framework, then, Goux concentrates upon a unilinear version of the development of the money-form and draws an exact isomorphic analogy (he insists upon this) between it and the Freudian account of the emergence of genital sexuality. He concentrates next on Marx's perception that the commodity which becomes the universal equivalent must be excluded from the commodity function for that very reason. Here the analogy, again, resolutely isomorphic, is with Lacan's account of the emergence of the phallus as transcendental signifier. (For an early succinct account see Jacques Lacan, "The Signification of the Phallus."[7]) Here is the claim: "It is the *same* genetic process, it is the same

principle of discontinuous and progressive structuration which commands
the accession to normative sovereignty of gold, the father and the phallus.
The phallus is the universal equivalent of *subjects*; just as gold is the uni-
versal equivalent of *products*."[8] Goux's establishment of a relationship
between Marx and Lacan in terms of gold and the phallus is based on his
reading of exchange as mirroring and thus a reading of the origin of Value
in the Lacanian "mirror-phase." Goux does notice that exchange-value
arises out of superfluity, but the question of use-value he leaves aside, per-
haps even as an embarrassment.

Goux's argument is ingenious, but in the long run it seems to be an exer-
cise in the domestication of Marx's analysis of Value. No doubt there are
general morphological similarities between centralized sign-formations. But
in order to see in those similarities the structural essence of the formations
thus analogize, it is necessary to exclude the fields of force that make them
heterogeneous, indeed discontinuous. It is to forget that Marx's critique of
money is functionally different from Freud's attitude toward genitalism or
Lacan's toward the phallus. It is to exclude those relationships between the
ego/phallus and money that are attributive and supportive and not analog-
ical. (Inheritance in the male line by way of patronymic legitimacy, indi-
rectly sustaining the complex lines of class-formation is, for example, an
area where the case of the money-form, and that of the ego-form in the
dialectic of the phallus, support each other and lend the subject the attrib-
utes of class and gender identity.) It is also to overlook the fact that Marx is
a materialist dialectical thinker when he approaches the seemingly unified
concept-phenomenon money. It is not the unilinear progressive account of
the emergence of the money-form (Goux's model) that is Marx's main "dis-
covery." It is in the full account of value-formation that the textuality of
Marx's argument (rather than the recuperable continuist schema) and the
place of use-value are demonstrated, and the predication of the subject as
labor-power (irreducible structural super-adequation—the subject defined
by its capacity to produce more than itself) shows its importance.

(To draw an adequate analogy between the emergence of the money-
form and the Oedipal scenario is also to conserve the European Marx. It is
in my political interest to join forces with those Marxists who would rescue
Marxism from its European provenance. It is not surprising that in a later
book Goux argues for a kinship between Marx and Freud in terms of their
Jewish heritage. This argument may well be cogent, but it should not be
seen as clinching the question of the historical differential in the geopoliti-
cal situation of Marxism and psychoanalysis.)

In comparison to these problems, the problem of winning Marx over to
structuralist formalism would be a minor one, were it not that Anglo-
United States continuist interests tend to lump together all attempts to read

Marx in a structuralist way. The main enemy is here seen to be Althusser. Although I am critical of Althusser in many details of his argument, I would also pay tribute to a certain forgotten Althusser, precisely against the spirit of constructing phantom scapegoats, a personality-cultism in reverse.[9] Derrida innocently contributes to this by putting Althusser and Goux together in "White Mythology." If one looks up nothing but the references given by Derrida to certain passages in *Reading Capital*, one sees immediately that Althusser's attempt, for better or for worse, is to read Marx's text through the straining logic of the metaphors in the Marxian text. Goux's continuist reading proceeds by way of certain slippages. I will draw my discussion of Goux to a close by citing only one: It seems unwise to suggest, as Goux does, that because *exchange* springs up within what is superfluous to a person's use, the exclusion of the *universal symbol* of value (the money-material) from the commodity function is therefore due to being-in-excess. By the Marxian argument, all value is in excess of use-value. But Value is not therefore excluded. The universal symbol measures this excess (of "deficit," as Goux correctly notes) and is excluded from the commodity function so that it does not, inconveniently, operate on two registers at once, both measuring and carrying Value. (The only limited analogy here is that the *theory* of the phallus must exclude its penis function.) This is to collapse value, exchange-value, surplus-value, and money by way of an inflation of the concept of excess. In fact Goux, when he notices Marx's frequent metaphorizations of money as monarch, seems to elide the important differences between value theory and theories of state formation.

In opening the lid of Money as a seemingly unitary phenomenon, Marx discovers a forever-seething chain in the pot: Value →Money→Capital. As in Hegel—of course Marx is not always a Hegelian, but he seems to be here—those arrows are not irreversible. Logical schemes are not necessarily identical with chronological ones. But for purposes of philosophical cogitation and revolutionary agitation, the self-determination of the concept capital can be turned backward and forward every which way. (Perhaps it was the relative ease of the former and the insurmountable difficulties of the latter that led Marx to question philosophical justice itself.) Keeping this in mind, let us flesh the seething chain with names of relationships:

$$\text{Value} \xrightarrow{\text{representation}} \text{Money} \xrightarrow{\text{transformation}} \text{Capital}$$

(My account here is a rough summary of "The Chapter on Money," and section 1 of "The Chapter on Capital" in the *Grundrisse*. This chain is "textual" in the general sense on at least two counts.[10] The two ends are

open, and the unified names of the relationships harbor discontinuities.

Exigencies of space will not permit elaboration of what is at any rate obvious—from the details of everyday life, through the practical mechanics of crisis-management, to the tough reasonableness of a book like *Beyond the Waste Land*[11]—that the self-determination of capital as such is to date open-ended at the start. That moment is customarily sealed off in conventional Marxist political economic theory by extending the chain one step:

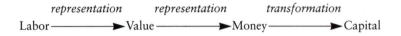

In fact, the basic premise of the recent critique of the labor theory of value is predicated on the assumption that, according to Marx, Value represents Labor.[12]

Yet the definition of Value in Marx establishes itself not only as a representation but also as a differential. What is represented or represents itself in the commodity differential is Value: "In the exchange-relation of commodities their exchange-value appeared to us as totally independent of their use-value. But if we abstract their use-value from the product of labor, we obtain their value, as it has just been defined. The common element that represents itself (*sich darstellt*) in the exchange-relation of the exchange-value of the commodity, is thus value" (C1, 128; translation modified). Marx is writing, then, of a differential representing itself or being represented by an agency ("we") no more fixable than the empty and ad hoc place of the investigator or community of investigators (in the fields of economics, planning, business management). Only the continuist urge that I have already described can represent this differential as representing labor, even if "labor" is taken only to imply "as objectified in the commodity." It can be justly claimed that one passage in *Capital 1* cannot be adduced to bear the burden of an entire argument. We must, however, remember that we are dealing here with *the* definitive passage on Value upon which Marx placed his imprimatur. For ease of argument and calculation, it is precisely the subtle open-endedness at the origin of the economic chain or text seen in this passage that Marx must himself sometimes jettison; or, for perspectivizing the argument, must "transform."[13]

I will presently go on to argue that the complexity of the notion of use-value also problematizes the origin of the chain of value. Let us now consider the discontinuities harbored by the unified terms that name the relationships between the individual semantemes on that chain. Such resident discontinuities also textualize the chain.

First, the relationship named "representation" between Value and Money. Critics like Goux or Marc Shell comment on the developmental

narrative entailed by the emergence of the Money-form as the general representer of Value and establish an adequate analogy between this narrative on the one hand and narratives of psychosexuality or language-production on the other.[14] My focus is on Marx's effort to open up the seemingly unified phenomenon of Money through the radical methodology of the dialectic—opening up, in other words, the seemingly positive phenomenon of money through the work of the negative. At each moment of the three-part perspective, Marx seems to indicate the possibility of an indeterminacy rather than stop at a contradiction, which is the articulative driving force of the dialectical morphology. Here is the schema, distilled from the *Grundrisse*:

Position: The money commodity—the precious metal as medium of universal exchange—is posited through a process of separation from its own being as a commodity exchangeable for itself: "From the outset they represent superfluity, the form in which wealth originally appears [*urspünglich erscheint*]" (*GR*, 166; translation modified). As it facilitates commodity exchange, "the simple fact that the commodity exists doubly, in one aspect as a specific product whose natural form of existence ideally contains (latently contains) its exchange value, and in the other aspect as manifest exchange value (money), in which all connection with the natural form of the product is stripped away again—this double, *differentiated* existence must develop into a *difference*" (*GR*, 147). When the traffic of exchange is in labor-power as a commodity, the model leads not only to difference but to indifference: "In the developed system of exchange…the ties of personal dependence, of distinctions, of education, etc. are in fact exploded, ripped up…; and individuals *seem* independent (this is an independence which is at bottom merely an illusion, and it is more correctly called indifference [*Gleichgültgkeit—im Sinne der Indifferenz*:— Marx emphasizes the philosophical quality of indifference]" (*GR*, 163).

Negation: Within circulation seen as a constantly repeated circle or totality, money is a vanishing moment facilitating the exchange of two commodities. Here its independent positing is seen as "a *negative* relation to circulation," for "cut off from all relation to [circulation], it would not be money, but merely a simple natural object" (*GR*, 217). In *this* moment of appearance its positive identity is negated in a more subtle way as well: "If a fake £ were to circulate in the place of a real one, it would render absolutely the same service in circulation as a whole as if it were genuine" (*GR*, 210). In philosophical language: the self-adequation of the idea, itself contingent upon a negative relationship, here between the idea of money and circulation as totality, works in the service of a functional *in*adequation (fake = real).

Negation of negation: Realization, where the actual quantity of money matters and capital accumulation starts. Yet here too the substantive specificity is contradicted (as it is not in unproductive hoarding). For "to dissolve the things accumulated in individual gratification is to realize them" (*GR*, 234). In other words, the logical progression to accumulation can only be operated by its own rupture, releasing the commodity from the circuit of capital production into consumption in a simulacrum of use-value.

I am suggesting that Marx indicates the possibility of an indeterminacy rather than only a contradiction at each of these three moments constitutive of the chain:

$$\text{Value} \xrightarrow{\quad representation \quad} \text{Money} \xrightarrow{\quad transformation \quad} \text{Capital}$$

This textualization can be summarized as follows: the utopian socialists seemed to be working on the assumption that money is the root of all evil: a positive origin. Marx applies the dialectic to this root and breaks it up through the work of the negative. At each step of the dialectic something seems to lead off into the open-endedness of textuality: indifference, inadequation, rupture. (Here Derrida's implied critique of the dialectic as organized by the movement of semantemes and by the strategic exclusion of syncategoremes[15] would support the *conduct* of Marx's text.

Let us move next to the relationship named "transformation between Money and Capital," a relationship already broached in the previous link. (This is not identical with the "transformation problem" in economics.) An important locus of discontinuity here is the so-called primitive or originary accumulation. Marx's own account emphasizes the discontinuity in comical terms, and then resolves it by invoking a process rather than an origin.

> We have seen how money is transformed into capital; how surplus-value is made through capital, and how more capital is made from surplus-value. But the accumulation of capital presupposes surplus-value; surplus-value presupposes capitalist production; capitalist production presupposes the availability of considerable masses of capital and labor-power in the hands of commodity producers. The whole movement, therefore, seems to turn around in a neverending circle, which we can only get out of by assuming a "primitive" [*ursprünglich*: originary] accumulation; an accumulation which is not the result of the capitalist mode of production but its point of departure. This primitive accumulation plays approximately the same role in political economy as original sin does in theology. Adam bit the apple, and thereupon sin fell on the human race [C1, 873].

Marx's resolution:

> The capital-relation presupposes a complete separation between the workers and the ownership of the conditions for the realization of their labor.... So-called primitive accumulation, therefore, is nothing else than the historical process of divorcing the producer from the means of production [C1, 874–75].

This method of displacing questions of origin into questions of process is part of Marx's general Hegelian heritage, as witness his early treatment, in the "Economic and Philosophical Manuscripts," of the question: "Who begot the first man, and nature in general?"[16]

When, however, capital is fully developed—the structural moment when the process of extraction, appropriation, and realization of surplus-value begins to operate with no extra-economic coercions—capital logic emerges to give birth to capital as such. This moment does not arise either with the *coercive* extraction of surplus-value in precapitalist modes of production, or with the accumulation of surplus-value in precapitalist modes of production, or with the accumulation of interest capital or merchant's capital (accumulation out of buying cheap and selling dear). The moment, as Marx emphasizes, entails the *historical* possibility of the definitive predication of the subject as labor-power. Indeed, it is possible to suggest that the "freeing" of labor-power may be a description of the social possibility of this predication. Here the subject is predicated as structurally super-adequate to itself, definitively productive of surplus-labor over necessary labor. And because it is this necessary possibility of the subject's definitive super-adequation that is the origin of capital as such, Marx makes the extraordinary suggestion that Capital consumes the *use*-value of labor-power. If the critique of political economy were simply a question of restoring a society of use-value, this would be an aporetic moment. "Scientific socialism" contrasts itself to a "utopian socialism" committed to such a restoration by presupposing labor outside of capital logic or wage labor. The radical heterogeneity entailed in that presupposition was dealt with only very generally by Marx from the early "Economic and Philosophical Manuscripts" onwards. Indeed, it may perhaps be said that, in revolutionary practice, the "interest" in social justice "unreasonably" introduces the force of illogic into the good use-value fit—*philosophical* justice—between Capital and Free Labor. If pursued to its logical consequence, revolutionary practice must be persistent because it can carry no theoretico-teleological justification. It is perhaps not altogether fanciful to call this situation of open-endedness an insertion into textuality. The more prudent notion of associated labor in maximized social productivity working according to "those foun-

dations of the forms that are common to all social modes of production" is an alternative that restricts the force of such an insertion (C3, 1016).

In the continuist, romantic anti-capitalist version, it is precisely the place of use-value (and simple exchange or barter based on use-value) that seems to offer the most secure anchor of social "value" in a vague way, even as academic economics reduces use-value to mere physical coefficients. This place can happily accommodate word processors (of which more later) as well as independent commodity production (handsewn leather sandals), our students' complaint that they read literature for pleasure not interpretation, as well as most of our "creative" colleagues' amused contempt for criticism beyond the review, and mainstream critics' hostility to "theory." In my reading, on the other hand, it is use-value that puts the entire textual chain of Value into question and thus allows us a glimpse of the possibility that even textualization (which is already an advance upon the control implicit in linguistic or semiotic reductionism) may be no more than a way of holding randomness at bay.

For use-value, in the classic way of deconstructive levers, is both outside and inside the system of value-determinations.[17] It is outside because it cannot be measured by the labor theory of value—it is outside of the circuit of exchange: "A thing can be a use-value without being a value" (C1, 131). It is, however, not *altogether* outside the circuit of exchange. Exchange-value, which in some respects is the species term of Value, is also a superfluity or a parasite of use-value: "This character (of exchange) does not yet dominate production as a whole, but concerns only its superfluity and is hence itself more or less *superfluous*...an accidental enlargement of the sphere of satisfactions, enjoyments.... It therefore takes place only at a few points (originally at the borders of the natural communities, in their contact with strangers)" (*GR*, 204).

The part-whole relationship is here turned inside-out. (Derrida calls this "invagination."[18]) The parasitic part (exchange-value) is also the species term of the whole, thus allowing use-value the normative inside place of the host as well as banishing it as that which must be subtracted so that value can be defined. Further, since one case of use-value can be that of the worker wishing to consume the (affect of the) work itself, that necessary possibility renders indeterminate the "materialist" predication of the subject as labor-power or super-adequation as calibrated and organized by the logic of capital. In terms of that necessarily possible "special case," this predication can no longer be seen as the excess of surplus labor over *socially* necessary labor. The question of *affectively* necessary labor brings in the attendant question of desire and thus questions in yet another way the mere philosophical justice of capital logic without necessarily shifting into utopian idealism.

If a view of *affectively* necessarily labor (as possible within the present state of socialized consumer capitalism) as *labor* as such is proposed without careful attention to the international division of labor, its fate may be a mere political avant-gardism. This, in spite of its sincere evocations of the world economic system, is, I believe, a possible problem with Antonio Negri's theory of zero-work.[19] The resistance of the syncategoremes strategically excluded from the system so that the great semantemes can control its morphology (Derrida) can perhaps be related to the *heterogeneity* of use-value as a private grammar. For Derrida, however, capital is generally interest-bearing commercial capital. Hence surplus-value for him is the super-adequation of *capital* rather than a "materialist" predication of the *subject* as superadequate to itself. This restricted notion can only lead to "idealist" analogies between capital and subject, or commodity and subject.

The concept of socially necessary labor is based on an identification of subsistence and reproduction. Necessary labor is the amount of labor required by the worker to "reproduce" himself in order to remain optimally useful for capital in terms of the current price-structure. Now if the dynamics of birth-growth-family-life reproduction is given as much attention as, let us say, the relationship between fixed and variable capitals in their several moments, the "materialist" predication of the subject as labor-power is rendered indeterminate in another way, without therefore being "refuted" by varieties of utopianism and "idealism." This expansion of the textuality of value has often gone unrecognized by feminists as well as mainstream Marxists, when they are caught within hegemonic positivism or orthodox dialectics.[20] They have sometimes tried to close off the expansion, by considering it as an opposition (between Marxism and feminism), or by way of inscribing, in a continuist spirit, the socializing or ideology-forming functions of the family as direct means of producing the worker and thus involved in the circuit of production of surplus-value for the capitalist. They have also attempted to legitimize domestic labor within capital logic. Most of these positions arise from situational exigencies. My own involvement with them does not permit critical distance, as can be witnessed in the last page of this essay. That these closing-off gestures are situationally admirable is evident from the practical difficulty of offering alternatives to them.

Let us consider the final item in the demonstration of the "textuality" of the chain of value. We have remarked that in circulation as totality, or in the moment of negation in Marx's reading of money, money is seen as in a negative relation to circulation because, "cut off from all relation to (circulation) it would not be money, but merely a simple natural object." Circulation as such has the morphological (if not the "actual") power to insert Money back into *Nature*, and to *banish* it from the textuality of

Value. Yet it is also circulation that *bestows* textuality upon the Money-form. Textuality as a structural description indicates the work of differen-tiation (both plus and minus) that opens up identity as adequation. Circulation in the following passage does precisely that with the restricted circuit of adequation within the money-form itself: "You may turn and toss an ounce of gold in any way you like, and it will never weigh ten ounces. But here in the process of circulation one ounce practically does weigh ten ounces." Marx describes this phenomenon as the "*Dasein*" of the coin as "value sign" (*Wertzeichen*). "The circulation of money is an outer move-ment [*aussere Bewegung*].... In the friction with all kinds of hands, pouch-es, pockets, purses...the coin rubs off.... By being used it gets used up."[21]

If in its first dialectical "moment" circulation has the morphological potential of canceling Money back into Nature, in its third "moment" it is shown to run the risk of being itself sublated into *Mind*: "The continuity of production presupposes that circulation time has been sublated [*aufge-hoben*]. The nature of capital presupposes that it travels through the dif-ferent phases of circulation not as it does in the idea-representation [*Vorstellung*] where one concept turns into the other at the speed of thought [*mit Gedankenschnelle*], in no time, but rather as situations which are sep-arated in terms of time" (*GR*, 548; translation modified). By thus sublat-ing circulation into Mind, production (of Value) as *continuous* totality would annul Value itself. For Value would not be value if it were not real-ized in consumption, strictly speaking, outside of the circuit of production. Thus capital, as the most advanced articulation of value, "presupposes that it travels through different phases." The scheme is made problematic by the invagination of use-value, as discussed earlier in this essay.

Has the circulation time of capital been sublated into the speed of Mind (and more) within telecommunication? Has (the labor theory of) Value become obsolete in microelectronic capitalism? Let us mark these tantaliz-ing questions here. I shall consider them at greater length below.

The consideration of the textuality of Value in Marx, predicated upon the subject as labor-power, does not answer the onto-phenomenological question "What is Value?"—although it gives us a sense of the complexity of the mechanics of evaluation and value-formation. It shows us that the Value-form in the general sense and in the narrow—the economic sphere, as commonly understood, being the latter—are irreducibly complicitous. It implies the vanity of dismissing considerations of the economic as "reduc-tionism." I have already indicated various proposed formulations that have the effect of neutralizing these suggestions: to find in the development of the money-form an adequate analogy to the psychoanalytic narrative; to see in it an analogy to metaphor or language; to subsume domestic or intel-lectual labor into a notion of the production of value expanded within cap-

ital logic. What narratives of value-formation emerge when consciousness itself is subsumed under the "materialist" predication of the subject?

If consciousness within the "idealist" analogy is seen as necessarily superadequate to itself by way of intentionality, we can chart the emergence of ad hoc universal equivalents that measure the product of value in what we may loosely call "thought." Like the banishment of the money commodity from the commodity function, these equivalents can no longer themselves be treated as "natural examples." (Because these analogies are necessarily loose, one cannot be more specific in that last phrase.) One case of such a universal equivalent is "universal humanity"—both psychological and social—as the touchstone of value in literature and society. It is only half in jest that one would propose that the "credit" of certain "major" literatures is represented by capital accumulation in terms of the various transformations of this universal equivalent. "Pure theory," within the Althusserian model of "theoretical production," may be seen as another case of a universal equivalent. The relativization of Value as a regression into the narrative stage where *any* commodity could be "cathected" as the value-form is, to follow Goux's analogy, the Freudian state of polymorphous perversion, and can be channeled into aesthetics as varied as those of symbolism and postmodernism.

I have already commented on Goux's gloss on the Freudo-Lacanian narrative of the emergence of the phallus in the genital stage as the universal equivalent of value. Nietzsche in *The Genealogy of Morals* gives us two moments of the separation and transformation of an item from within the common circuit of exchange. They are worth mentioning because *The Genealogy of Morals* is Nietzsche's systematic attempt at a "critique of moral values," a "put[ting] in question [*in Frage stellen*]" of "the value of these values" (*GR*, 348; translation modified). The Nietzschean enterprise is not worked out on what I call a "materialist" subject-predication as laborpower, but rather by way of a critique of the "idealist" subject-predication as consciousness, through the double determinants of "philology" and "physiology."[22] Because it is a reinscription of the history of value as obliterated and discontinuous semiotic chains—ongoing sign chains—disconnected references to money (guilt and punishment as systems of exchange) and to the inscription of coins abound. The more crucial moment, the *separation* of the money commodity, is touched upon once at the "beginning" and once at the inauguration of the "present," as the separation of the scapegoat and the sublation of that gesture into mercy, respectively. That sublation is notoriously the moment of the creditor sacrificing himself for the debtor in the role of God's son in the Christ story (*Genealogy*, pp. 77, 72). (Any notions of "beginning" and "present" in Nietzsche are made problematic by the great warning against a successful genealogical method: "All concepts in which

an entire process is semiotically concentrated elude definition; only that which has no history is definable" [*Genealogy*, p. 80]).

I think there can be no doubt that it is this separation rather than inscription or coining that is for Marx the philosophically determining moment in the discourse of value. Attention to Marx's concept-metaphor of the foreign language is interesting here. Often in our discussion of language the word seems to retain a capital *L* even when it is spelled in the lower case or rewritten as *parole*. Using a necessarily precritical notion of language, which suggests that in the mother tongue "word" is inseparable from "reality," Marx makes the highly sophisticated suggestion that the development of the value-form separates "word" and "reality" (signifier and signified), a phenomenon that may be appreciated only in the learning of a foreign language: "To compare money with language is...erroneous.... Ideas which have first to be translated out of their mother tongue into a foreign language in order to circulate, in order to become exchangeable, offer a *somewhat better* analogy; but the analogy then lies not in language, but in the foreignness of language" (*GR*, 163). (If this were a technical discussion where it was necessary to respect the specificity of the vocabulary of linguistics, I would not equate word/reality and signifier/signified.) It is certainly of interest that, using a necessarily postmonetary notion of Value-in-exchange, which must suggest that "political economy [is]...concerned with a system of equivalence [*système d'équivalence*]...[between a specific] labor and [a specific] wage [*un travail et un salaire*]," Saussure shows us that, even in the mother tongue, it is the work of difference that remains originary, that even as it is most "native," language is always already "foreign," that even in its "incorporeal essence," "the linguistic signifier...[is] constituted not by its material substance but only [*uniquement*] by the differences that separate its acoustic image from all others."[23]

The binary opposition between the economic and the cultural is so deeply entrenched that the full implications of the question of Value posed in terms of the "materialist" predication of the subject are difficult to conceptualize. One cannot foresee a teleological moment when these implications are catastrophically productive of a new evaluation. The best one can envisage is the persistent undoing of the opposition, taking into account the fact that, first, the complicity between cultural and economic value systems is acted out in almost every decision we make, and, secondly, that economic reductionism is, indeed, a very real danger. It is a paradox that capitalist humanism does indeed tacitly make its plans by the "materialist" predication of Value, even as its official ideology offers the discourse of humanism as such; while Marxist cultural studies in the First World cannot ask the question of Value within the "materialist" predication of the subject, since the question would compel one to acknowledge that the text

of exploitation might implicate Western cultural studies in the internation-
al division of labor.[24] Let us, if somewhat fancifully, invoke the word
processor again. It is an extremely convenient and efficient tool for the pro-
duction of writing. It certainly allows us to produce a much larger quanti-
ty of writing in a much shorter time and makes fiddling with it much easi-
er. The "quality" of writing—the "idealist" question of value—as well as
the use-value of manual composition—affectively necessary labor—are ren-
dered irrelevant here. (It is of course not to be denied that the word proces-
sor might itself generate affective use-value.) From within the "idealist"
camp, one can even say, in the wake of a trend that runs from Professor A.
B. Lord to Father Walter J. Ong, the following: we were not in on the
"inception" of writing, and can copiously deplore the harm it did to the
orality of the verbal word; we are, however, present at the inception of
telecommunication and, being completely encompassed by the historical
ideology of efficiency, we are unable to reckon with the transformations
wrought by the strategic exclusions of the randomness of bricolage oper-
ated by programming.[25]

These are not the objections that I emphasize. I draw attention, rather, to
the fact that, even as circulation time attains the apparent instantaneity of
thought (and more), the continuity of production ensured by that attain-
ment of apparent coincidence must be broken up by capital: its means of
doing so is to keep the labor reserves in the comprador countries outside
of this instantaneity, thus to make sure that multinational investment does
not realize itself fully there through assimilation of the working class into
consumerist-humanism.[26] It is one of the truisms of *Capital 1* that techno-
logical inventions open the door to the production of relative rather than
absolute surplus-value (C1, 643–54). ("Absolute surplus-value" is a
methodologically irreducible theoretical fiction.) Since the production and
realization of relative surplus-value, usually attendant upon technological
progress and the socialized growth of consumerism, increase capital expen-
diture in an indefinite spiral, there is the contradictory drive within capi-
talism to produce more absolute and less relative surplus-value as part of
its crisis management. In terms of this drive, it is in the "interest" of capital
to preserve the comprador theater in a state of relatively primitive labor
legislation and environmental regulation. Further, since the optimal rela-
tionship between fixed and variable capital has been disrupted by the accel-
erated rate of obsolescence of the former under the rapid progress within
telecommunications research and the attendant competition, the com-
prador theater is also often obliged to accept scrapped and out-of-date
machinery from the postindustrialist economies. To state the problem in
the philosophical idiom of this essay: as the subject as super-adequation in
labor-power seems to negate itself within telecommunication, a negation

of the negation is continually produced by the shifting lines of the international division of labor. This is why any critique of the labor theory of value, pointing at the unfeasibilty of the theory under postindustrialism, or as a calculus of economic indicators, ignores the dark presence of the Third World.[27]

It is a well-known fact that the worst victims of the recent exacerbation of the international division of labor are women. They are the true surplus army of labor in the current conjuncture. In their case, patriarchal social relations contribute to their production as the new focus of super-exploitation.[28] As I have suggested above, to consider the place of sexual reproduction and the family within those social relations should show the pure (or free) "materialist" predication of the subject to be gender-exclusive.

The literary academy emphasizes when necessary that the American tradition at its best is one of individual Adamism and the loosening of frontiers.[29] In terms of political activism within the academy, this free spirit exercises itself at its best by analyzing and calculating predictable strategic effects of specific measures of resistance: boycotting consumer items, demonstrating against investments in countries with racist domestic politics, uniting against genocidal foreign policy. Considering the role of telecommunication in entrenching both the international division of labor and the oppression of women, this free spirit should subject its unbridled passion for subsidizing computerized information retrieval and theoretical production to the same conscientious scrutiny. The "freeing" of the subject as super-adequation in labor-power entails an absence of extra-economic coercion. Because a positivist vision can only recognize the latter, that is to say, *domination*, within postindustrial cultures like the United States, telecommunication seems to bring nothing but the promise of infinite liberty for the subject. Economic coercion as *exploitation* is hidden from sight in "the rest of the world."

These sentiments expressed at a public forum drew from a prominent United States leftist the derisive remark: "She will deny the workers their cappuccino!" I am not in fact suggesting that literary critics should be denied word processors. My point is that the question of Value in its "materialist" articulation must be asked as the cappuccino-drinking worker and the word-processing critic actively forget the actual price-in-exploitation of the machine producing coffee and words. This is certainly not required of every literary critic. But if the literary critic in the United States today decides to ask the question of Value only within the frame allowed by an unacknowledged "nationalist" view of "productivity," she cannot be expected to be taken seriously anywhere. (The real problem is, of course, that she *will* be taken seriously, and the work of multinational ideology-reproduction will go on.) If my position here is mistaken for an embar-

rassing economic determinism, the following specification may be made: "There is a short-of and a beyond-of [economic determinism]. To see to it that the beyond does not become the within is to recognize...the need of a communicating pathway (*parcours*). That pathway has to leave a wake (*sillage*) in the text. Without that wake or track, abandoned to the simple content of its conclusions, the ultra-transcendental text"—the discourse of textuality in the economic that I have been at pains to explicate and disclose—"will so closely resemble the precritical text"—economic determinism—"as to be indistinguishable from it. We must now meditate upon the law of this resemblance" (*OG*, 6). I have done no more in this essay than to encourage such a mediation, to suggest that, following Marx, it is possible to put the economic text "under erasure," to see, that is, the unavoidable and pervasive *importance* of its operation and yet to question it as a concept of the *last resort*. (Incidentally, this also emphasizes that putting "under erasure" is as much an affirmative as a negative gesture.) In 1985, Walter Benjamin's famous saying, "There has never been a document of *culture* which was not at one and the same time a document of barbarism,"[30] should be a starting rather than a stopping point for Marxist axiological investigations. A "culturalism" that disavows the economic in its global operations cannot get a grip on the concomitant production of barbarism.

If, on the other hand, the suggestion is made that in the long run, through the multinationals, *everyone* will have word processors *and* cappuccino (not to mention guns and butter), the *evaluating* critic must be prepared to enter the debate between Samir Amin and the late Bill Warren, some of the broad strokes of which I have outlined above.[31] She must be prepared to admit that the unification churches being projected by the mechanisms of Euro-currency and "the globalization of markets" (we read it as "global crisis") do not lend much credibility to this uninstructed hope.

Perhaps a word on "The Globalization of Markets," an article by Theodore Levitt, Edward W. Carter Professor of Business Administration and head of the marketing area at the Harvard Business School, is in order here. The piece is exemplary of many of the attitudes I have tried to define. Since Professor Levitt writes from the point of view of big business ("people and nations" in the passage cited below) he is not concerned with the active divisiveness of the international division of labor. Here is his theory of the relationship between money and the division of labor, and his theory of money as a unified concept, reached in turn by way of "experience" as a fetishized concept: "Nobody takes scarcity lying down; everyone wants more. This in part explains division of labor and specialization of production. They enable people and nations to optimize their conditions [a deliberately

vague word] through trade. The median [sic] is usually money. Experience teaches that money has three special qualities: scarcity, difficulty of acquisition, and transience. People understandably treat it with respect."[32] What I have been arguing is that this primitive notion of money must work complicitously with the contemporary sublation of money where it seems to question the "materialist" predication of the subject; that the postmodern, in spite of all the cant of modernization, reproduces the "premodern" on another scene. In Professor Levitt's article the two views remain in an unresolved and distanced structural parataxis. To quote: "Today money is simply electronic impulses. With the speed of light [so much for Marx's impossible limit for circulation: speed of thought] it moves effortlessly between distant centers (and even lesser places). A change of ten basic points in the price of a bond causes an instant and massive shift of money from London to Tokyo. The system has profound impact on the way companies operate throughout the world" (Levitt, p. 101).

The perspective here is unifocal and generally uncritically read (if read at all) by literary academics. I have been trying to explicate not only the parataxis above, but also the exploitation condensed and monumentalized in a seemingly scientific phrase such as "scale-efficient conditions" below (incidentally, "value" as used here is the unified continuist version that would be consonant with the Marxian definition of value relieved of its historical, ethical, or philosophical charge): "The most endangered companies in the rapidly evolving world tend to be those that dominate rather small domestic markets with high value-added products for which there are smaller markets elsewhere. With transportation costs"—the only costs specified—"proportionately low, distant competitors will now enter the now-sheltered markets of those companies with goods produced more cheaply under scale-efficient conditions" (Levitt, p. 94). These "globalizers" also have their human universals: "an ancient motivation—to make one's money go as far as possible. This is universal—not simply a motivation but actually a need" (Levitt, p. 96). Yet, in an insane parody of the basic paradox of humanistic education, Levitt describes the epistemic violence of the universalizing global market: "The purpose of business is to get and keep a customer. Or, to use Peter Drucker's more refined construction, to create and keep a customer."[33]

This is how economic reductionism operates. The disavowal of the economic is its tacit and legitimizing collaborator. In its verdict on "the multinational mind," as opposed to the globalizing mind, is to be heard the managerial version of shock at denying the workers of the First World their cappuccino: "the multinational mind, warped into circumspection and timidity by years of stumbles and transnational troubles, now rarely challenges existing overseas practices. More often it considers any departure

from inherited domestic routines as mindless, disrespectful, or impossible. *It is the mind of a bygone day.*"[34]

I should like to construct a narrative here using "The Wiring of Wall Street," an article in the *New York Times* Sunday magazine for 23 October 1983. (I choose the *New York Times* because the broad spectrum of publications that contains the Sunday supplements of newspapers, *Scientific American*, *Psychology Today*, as well as *The National Enquirer*, constitutes part of an ideological apparatus, through which the consumer becomes knowledgeable, the subject of "cultural" explanation. Could one suggest that organs such as the *Harvard Business Review* are also part of the apparatus, in that through them the investor-manager receives his "ideology"? As I suggest in note 33, feminist individualist consumerism is being appropriated within the same apparatus.)

After telecommunication, Wall Street seems to have been saved by reconciliation (rather than deconstruction) of the binary opposition between the immediate self-proximity of voice-consciousness and the visible efficiency of writing. As Georg Simmel already observes of the stock exchange at the end of the last century, it is the place where the circulation of money can be most speeded up: the "twofold condensation of values into the money form and of monetary transactions into the form of the stock exchange makes it possible for values to be rushed through the greatest number of hands in the shortest possible time."[35] "The start of a solution of the market's major dilemma, *the management of time*, appeared in 1972 when the New York Stock Exchange, the American Stock Exchange, and their member firms organized the Securities Industries Automation Corporation.... Not long ago, the executives kept up with their investments on a monthly or weekly schedule; today, the reporting can be *instantaneous* because of the computer" ("Wiring," p. 47). It is worth remarking that, even as time is thus being managed on the postindustrial capitalist front, high Marxist theory contests the labor theory of value by bracketing time as a vehicle of change: "No changes in output and...no changes in the proportions in which different means of production are used by an industry are considered, so that no question arises as to the variation or constancy of returns."[36] If money then circulates at the speed of *consciousness* by way of the computer, it *at the same time* accedes to the visible efficiency of writing. "'We had this amorphous, unorganized, mostly invisible market prior to 1971,' says Gordon S. Macklin, president of the [National] Association [of Securities Dealers]" ("Wiring," p. 73).

This reconciliation of the opposition between consciousness and writing obviously does not "refute" Freud's late protodeconstructive model of the psyche as the *Wunderblok* or the mystic writing pad.[37] If anything, the silicon chip appears to give "a plastic idea" to that pure virtuality, that

difference as such which Derrida calls "the work of dead time."[38]

But this is not the objection I emphasize here. I point out, rather, that the computer, even as it pushes the frontiers of rationalization, proves unable to achieve *bricolage*, to produce a program that will use an item for a purpose for which it was not designed. (This is the celebrated problem of programming a computer to build nests with random materials, as a bird does, that exercises Douglas Hofstadter and others.) And it is well-known that radical protodeconstructive *cultural* practice instructs us precisely to work through bricolage to "reconstellate" cultural items by wrenching them out of their assigned function. When Walter Benjamin writes: "What we require of the photographer is the ability to give his picture the caption that wrenches it from modish commerce and gives it a revolutionary use-value [*Gebrauchswert*]," he is implicitly "bricoling" or tinkering with a continuist notion of use-value (I need not repeat my earlier argument) even as he recommends bricolage as cultural practice. This recommendation can be traced from his earliest theory of allegory as the cathexis for (or occupation of) ruins and fragments by the irreducible alterity of time.[39] This is to be found in Deleuze and Guattari's bold notion of originarily unworkable machines. It can be said for Derrida that, by positioning citationality as originary, he has radicalized bricolage as the questioning of all ideologies of adequation and legitimacy.[40] These positions are now trickling down into a reckoning with the emergent ideological possibilities of the postmodern cultural phenomenon within a postmodern political economy.[41]

It is not even this possibility of a cultural theoretical practice, which sabotages the radically reconciling text of the postmodern stock exchange, that I emphasize within this narrative. My critique can find an allegorical summary in a passage about the old ticker-tape machine. "A holdover from the storied past is the old stock ticker. Fifteen minutes after trading has commenced, the ticker—a bit of technology that dates back to 1867—has already fallen behind the hectic trading by six minutes. Speed it up to match today's trading volume, and it would be a blur" ("Wiring," p. 47).

We cannot forget that *Capital* 1 is "a bit of technology that dates back to 1867," its date of publication. I have attempted to show that the Marxist historical narrative—"the storied past"—is far from a holdover. When it is expanded to accommodate the epistemic violence of imperialism as crisis-management, including its current displacements, it can allow us to read the text of political economy at large. When "speeded up" in this way it does not allow the irreducible rift of the international division of labor to blur. "The Wiring of Wall Street" speaks first of "time management" and next quotes Peter Solomon of Lehman Brothers "offer[ing] an explanation: 'Computers have shown us how to manage *risk*'" ("Wiring," p. 47). The inconvenient and outdated ticker of Marxist theory discloses the excluded

word between "time" and "risk" in the management game: crisis.

Let us retrieve the concept-metaphor of the text that we left behind a few pages back. Within this narrative replay of my argument in the previous pages it may be pointed out that whereas Lehman Brothers, thanks to computers, "earned about $2 million for…15 minutes of work," the entire economic text would not be what it is if it could not write itself as a palimpsest upon another text where a woman in Sri Lanka has to work 2,287 minutes to buy a T-shirt. The "postmodern" and "premodern" are inscribed together. It should also be remarked that Simmel argued nearly a hundred years ago that a developed money-form naturally promotes "the individual": "if freedom means only obeying one's own laws, then the distance between property and its owner that is made possible by the money form of returns provides a hitherto unheard-of freedom."[42] The best beneficiary of this "postmodernization" of Wall Street is, predictably, the individual small investor in the United States. And the apparently history-transcendent "individual subject" who will "have to hold to the truth of postmodernism…and have as its vocation the invention and projection of a global cognitive mapping"[43] will be, *as long as no attempt is made to specify the postmodern space-specific subject-production*, none other than a version of this unpromising individual.

It is within this framework of crisis-management and regulation, then, that I would propose to pursue the evaluation of the pervasive and tacit gesture that accepts the history of style-formations in Western European canonical literature as the evaluation of style as such. I am not recommending varieties of reactive nostalgia such as an unexamined adulation of working-class culture, an ostentatious rejection of elitist standards, a devotion to all non-Judeo-Christian mythologies, or the timid evocation of "poetry being written in Nicaragua." In fact, the version of historical narrative I am sketching here can be expanded to show that, in such nostalgic valuative norms as the list above, the history of the epistemic violence of imperialism as crisis-management can still operate. Regular periodization should rather be seen in its role within the historical normalization required by the world-system of political economy, engaged in the production and realization of value, the "postmodern" its latest symptom. Such evaluations would accommodate the "materialist" articulation of Value within what I described earlier as the practical position of Value in our discipline in the narrow sense, underlining the role of exploitation in understanding domination.[44]

In "Marx's (not Ricardo's) 'Transformation Problem,'" Richard A. Wolff, Bruce Brothers, and Antonio Collari suggest that when "Marx…considers a social object in which the processes of circulation constitute effective pre-

conditions for the process of production,...the relevant magnitude must be the *price of production* of the consumed means of production and *not* the abstract labor time physically embodied in them."[45] I have so far been arguing, among other things, that to set the labor theory of value aside is to forget the textual and axiological implications of a materialist predication of the subject. The passage I quote, however, seems to be an appropriate description of the perpsectival move which provisionally must set that theory aside. As a result of this move, "the equivalence of exchange *must be constructed* out of the processes specific to competitive capitalism which tend to establish a proportional distribution of unpaid labor time in the form of an average rate of profit on total capital, *no longer assumed* as in volume 1."[46] Thus the authors situate the specific arena of the labor theory of value but go on to suggest that, since "Marx's focus [was] on class relations as his object of discourse...simultaneously, however, the concept of value remains crucial to the quantification of prices of production. Price on production, as an absolute magnitude of labor time, *can be conceived only as a specific deviation from value*" (Wolff, p. 575; italics mine).

I have not touched the topic of the value-price relationship in these pages. Further, I have questioned the mechanics of limiting the definition of value to the physical embodiment of abstract labor time. I would in fact argue that the premises of *Capital 1* are themselves dependent upon a gesture of reduction that may be called a construction (C1, 135). Generalizing from the position of Wolff and his coauthors, I would find that Marx's focus on class (mode of production) must be made to accommodate his reach of crisis (world system). Yet Wolff and his coauthors' perspectival situation of the labor theory of value and concurrent definition of price of production as deviation or differential seem to us admirably just. Within the discipline of economics, which must keep any textualized notion of use-value out, it seems crucial to suggest that "Marx...affirms the interdependence of value and value form ([understood as] price of production), an interdependence which cannot be expressed by treating the relation between the two concepts as merely a functional relation between dependent and independent variables."[47] As I move more conclusively into the enclosure of my own disciplinary discourse, perhaps it might not be inappropriate to suggest that this essay does no more than point at the confused ideological space of some varieties of such an interdependence.

I will now appropriate yet another item on the threshold of this essay: the Derridean concept of "interest" as in "scrupulous declaration of interest." Derrida's own understanding of surplus-value as capital appreciation or interest is, as I have suggested above, restricted. I simply wrest it back from that "false" metaphor and "literalize" *it*.[48] If and when we ask and answer the question of value, there seems to be no alternative to declaring

one's "interest" in the text of the production of Value.

I offer this formula because the problem of "how to relate a critique of 'foundationalism,' which like its object is interminable and may always go astray, to a critique of ideology that allows for at least provisional endings and ends in research and 'political' practice" remains with us.[49] The early Derrida assured us that "deconstruction falls a prey to its own critique" and went largely unheeded (OG, 24). The later Derrida miming this precaution interminably, has been written off as, at best, a formal experimentalist or, at worst, uninteresting and repetitive. It should be clear from the last few pages that I can endorse Jean-François Lyotard's benevolent "paganism" as an axiological model as little as I can Jürgen Habemas's Europocentric rationalism.[50] One of the more interesting solutions offered is Dominick LaCapra's "historiography as transference." Yet there, too, there are certain desires to appropriate the workings of the unconscious of which we should beware. For "repetition-displacement of the past into the present" (LaCapra's version of transferential historiography) may be too continuist and harmless a version of the transactions in transference. And it might not be enough simply to say that "it is a useful critical fiction to believe that the texts or phenomena to be interpreted may answer back and even be convincing enough to lead one to change one's mind."[51] Given Lacan's elaborate unfolding of the relationship between transference and the ethical moment, I can do no better here than to reiterate an earlier doubt, expressed not in terms of historiography but rather of literary criticism:

> Nor will the difference between text and person be conveniently effaced by refusing to talk about the psyche, by talking about the text as part of a self-propagating mechanism. The disjunctive, discontinuous metaphor of the subject, carrying and being carried by its burden of desire, does systematically misguide and constitute the machine of text, carrying and being carried by its burden of "figuration." One cannot escape it by dismissing the former as the residue of a productive cut, and valorizing the latter as the only possible concern of a "philosophical" literary criticism. This opposition too, between subject "metaphor" and text "metaphor," needs to be indefinitely deconstructed rather than hierarchized.[52]

The formula—"scrupulous declaration of interest in the text of the production of Value"—that I offer comes out of the most problematic effect of the sovereign subject, the so-called deliberative consciousness. Thus, there is no guarantee in deconstruction for freezing this imperative into a coercive theoretical universal, though it is of course subject to all the constraints of ethico-logical grounding. The encroachment of the fictive (related, of course, to the textual) upon this operation cannot be appreciated

without passing through the seemingly deliberative which, even in the most self-conscious transferential situation, can, at any rate, only be resisted rather than fully avoided.

In closing, I will invoke the very threshold, the second paragraph, of this essay, where I write: "The 'idealist' and the 'materialist' are both exclusive predications." *All* predications are exclusive and thus operate on the metonymic principle of a part standing for the putative whole: "As soon as one retains only a predicate of the circle (for example, return to the point of departure, closing off the circuit), its signification is put into the position of a trope, of metonymy if not metaphor."[53] In this sense, the "idealist" and the "materialist" predications of the subject are metonyms of the subject. Lacan writes of the constitution of the subject as such: "The double-triggered mechanism of metaphor is the very mechanism by which the symptom...is determined. And the enigmas that desire seems to pose for a 'natural philosophy'...amount to no other derangement of instinct than that of...metonymy."[54] Insofar as the two predications are *concepts* of the subject, they are unacknowledged metaphoric substitute-presentations of the subject. Between metaphor and metonymy, symptom and desire, the political subject distances itself from the analysis in transference by declaring an "interest" by way of a "wild" rather than theoretically grounded practice. Lest I seem, once again, to be operating on an uncomfortable level of abstraction, let me choose a most nonesoteric source. Here is the *McGraw-Hill Dictionary of Modern Economics* on the encroachment of the fictive upon the deliberative in the operation of the economic text:

> Originally the Dow-Jones averages represented the average (arithmetical mean) price of a share of stock in the group. As stocks split, the substitution of issues in the averages, and other factors occurred, however, a formula was devised to compensate for these changes. Although the Dow-Jones averages *no longer represent the actual* average prices of these stocks in the groups, they still represent the levels and changes in the stock-prices reasonably well.[55]

I say above that "the full implications of the question of Value posed within the 'materialist' predication of the subject cannot yet be realized." I must now admit what many Marxist theoreticians admit today: that in any theoretical formulation, the horizon of full realization must be indefinitely and irreducibly postponed. On that horizon it is not utopia that may be glimpsed.[56] For utopias are historical attempts at topographic descriptions that must become dissimulative if attempts are made to represent them adequately in actual social practice. The complicity between idealisms and materialisms in the production of theory is better acknowledged, even as

one distances oneself from idealism, if one designates this open end by the name of the "apocalyptic tone."[57] This tone announces the pluralized apocalypse of the practical moment, in our particular case the set or ensemble of ideology-critical, aesthetic-troping, economically aware performative or operational value judgments. My careful language here should make clear that the practical moment is not a "fulfillment." In the pluralized apocalypse, the body does not rise. There is no particular need to see this as the thematics of castration. Why not affirm as its concept-metaphor the performative and operational evaluation of the repeated moves of the body's survival and comfort, historically named woman's work or assigned to domestic labor when it is minimally organized? Why appropriate the irreducible nonfit between theory and practice (here in the grounding and making of Value judgments) into Oedipus's hobble?

I offer, then, no particular apology for this *deliberate* attempt to show the difference between pre-critical economism and the role of the economic text in the determination of Value; and, further, to plot some of the "interests" in its foreclosure.

NOTES

I am deeply grateful to Professor John Fekete for a thorough criticism of this piece.

1. Louis Althusser, *For Marx*, pp. 173–93.

2. Deleuze and Guattari, *Anti-Oedipus*.

3. Any serious consideration of this question must take into account Georg Simmel's monumental *Philosophy of Money*, trans. Tom Bottomore and David Frisby (London: Routledge and Kegan Paul, 1978). My differences with Simmel are considerable. He writes in a brilliantly analogical vein that cannot acknowledge the discontinuity between "idealist" and "materialist" predications. Although he is technically aware of the argument from surplus-value, he is basically interested in value-in-exchange. His anti-socialism is thus directed against a pre-Marxian socialism. His few references to Marx, as the translators note in their admirable introduction, do not betray knowledge of the Marxian text. Yet I have also been deeply influenced by his meditations upon the relationship between money and individualism and upon the beginnings of what Vološinov later called "behavior ideology"; in a certain way even by his cogitation upon woman as commodity. In these respects, he should be distinguished from both the Engels of the *Origin of the Family* and the Weber of *The Protestant Ethic and the Spirit of Capitalism*.

4. I am obliged here to admit that the "answer" that follows in this essay can in no way be considered definitive. This is my third attempt at working over these questions. The first, "Marx after Derrida," is to be found in William E. Cain, ed., *Philosophical Approaches to Literature: New Essays on*

Nineteenth- and Twentieth-Century Texts (Lewisburg: Bucknell University Press, 1984). The second, an extended version of "the same piece," appears as "Speculations on Reading Marx: after reading Derrida," in Derek Attridge, Geoff Bennington, and Robert Young, eds., *Post-Structuralism and the Question of History* (Cambridge: Cambridge University Press, 1987), pp. 30–62.

5. If we think of Marx, Freud, Nietzsche (Derrida includes Heidegger) as the crucial Western thinkers of discontinuity, betrayed or obliged by their method to unbridgeable gaps and shifts in planes, a deconstructivist reading shows their texts to be a battleground between the intimations of discontinuity and the strong pull toward constructing a continuous argument with a secure beginning (arché), middle (historical enjambment), and end (telos). By and large, scholarship attempts to establish the continuity of the argument. It is therefore the continuist versions that are generally offered as the real Marx, the real Freud, the real Nietzsche.

6. See Derrida, "White Mythology," p. 215 and passim.

7. In Jacques Lacan, *Ecrits: A Selection*, trans. Alan Sheridan (New York: Norton, 1977), pp. 281–91.

8. Jean-Joseph Goux, "Numismatiques I," *Tel Quel* 35 (Autumn 1968), pp. 64–89; this passage p. 77, translation mine.

9. One of the chief complaints against Althusser is his privileging of "science" over "ideology," and his cutting up Marx into an earlier ideological and a later scientific thinker. I would submit that, in the spirit of a critique of positivism, Althusser *bricoles* or tinkers with the name of science itself, re-constellates it by spinning it out (*filer*) as a convenient metaphor even as he establishes Marx's claim to be a scientist rather than merely a philosopher of history: "When I say that Marx organized a theoretical system of scientific concepts in the domain previously monopolized by philosophies of history, I am spinning out [*filons*] a metaphor which is no more than a metaphor." This allows him to chart out the two great continents of science: physics (nature) and mathematics (idea). Marx inaugurates a science of history (humankind) because he proposes rules by which the metaleptic semiosis of history as account might be deciphered. It is not seen by Althusser as an authoritative induction leap: "Obviously this epistemological break is not exactly locatable [*ponctuel*]...[it] inaugurates a history that will never come to an end." According to Althusser, Lenin consolidates this into a clear-cut program: "Lenin thus defines the ultimate essence of philosophical practice as an *intervention* in the theoretical domain. This intervention takes a double form: it is theoretical in its formulation of definite categories; and practical in the function of these categories." This is a "wild practice" ([*pratique sauvage*] on the analogy of "*la psychanalyse sauvage*," or pop psych). Althusser "generalizes this" into a (new) practice of philosophy, which recognizes that traditional philosophy is the arena of a denegation and a game played for the high stakes of scientificity. In this context, the terms "ideology" and "science," far from

being a frozen and loaded binary opposition, are terms that must be thought over again and again: see Althusser, *Lenin and Philosophy*, trans. Ben Brewster (New York: Monthly Review Press, 1971), pp. 38–40, 61, 66. The relationship between the theory of subject-formation in Lacanian psychoanalysis and the Althusserian critique of ideology, or between Freudian notions of overdetermination and Althusser's emendation of the theory of contradictions, is established by the way of a developed argument, not, as in Goux, by an isomorphic analogy.

10. Textual criticism of this sort assumes (a), in the narrow sense, that even "theoretical" texts are produced in language, and (b), that "reality" is a fabrication out of discontinuities and constitutive differences with "origins" and "ends" that are provisional and shifting. "One no longer has a tripartition between a field of reality, the world, a field of representation, the book, and a field of subjectivity, the author. But an arrangement [*agencement*] puts in connection certain multiplicities drawn in each of these orders, so much that a book does not have its continuation in the following book nor its object in the world, nor yet its subject in one or more authors" (Deleuze and Guattari, *Mille plateaux* [Paris: Minuit, 1980], p. 34; translation mine).

11. Samuel Bowles, et al., eds. *Beyond the Waste Land: A Democratic Alternative to Economic Decline* (Garden City: Anchor, 1983).

12. I refer to this critique at greater length below. Here a brief checklist will suffice: Piero Sraffa, *Production of Commodities by Means of Commodities* (Cambridge: Cambridge University Press, 1960); Samir Amin, *The Law of Value and Historical Materialism* (New York: Monthly Review Press, 1978); Diane Elson, ed., *Value: The Representation of Labor in Capitalism* (Atlantic Highlands, NJ: Humanities Press, 1979); Ian Steedman, *Marx After Sraffa* (London: Verso, 1981); Ian Steedman, et al., *The Value Controversy* (London: Verso, 1981).

13. For a consideration of the "transformation" problem in this sense, see Richard D. Wolff, et al., "Marx's (Not Ricardo's) 'Transformation Problem': A Radical Conceptualization," *History of Political Economy* 14:4 (1982), pp. 564–82.

14. See Marc Shell, *Money, Language, and Thought: Literary and Philosophical Economies from the Medieval to the Modern Era* (Berkeley: University of California Press, 1982). It should be remarked that Shell's narrative account of the history of money is less subtle than Marx's analysis of it.

15. Derrida, "White Mythology," p. 270.

16. Marx, "Economic and Philosophic Manuscripts," in *Early Writings*, trans. Rodney Livingstone and Gregor Benton, ed. Quintin Hoare (New York: Vintage, 1975), pp. 279–400; this passage, p. 357.

17. For a discussion of deconstructive "levers," see Derrida, *Positions*, trans. Alan Bass (Chicago: University of Chicago Press, 1981), p. 71.

18. See Derrida, "The Law of Genre," *Glyph* 7 (1980), pp. 202–29. My discus-

sion of "invagination" is to be found in "Displacement and the Discourse of Woman," in Mark Krupnick, ed., *Displacement: Derrida and After* (Bloomington: Indiana University Press, 1983), especially pp. 186–89.

19. For excellent elaborations of this theory, see the "Introduction"s and indeed the entire issues of *Zerowork: Political Materials 1 & 2* (December 1975 and Fall 1977). One of the most revolutionary suggestions of this thought is that the working class includes the unwaged as well as the waged. I am suggesting that the unwaged under socialized capital has a different status and definition from the unwaged in the peripheral capitalisms.

20. One striking exception is Diane Elson, "The Value Theory of Labour," in Elson, ed., *Value*. I propose something similar in "Feminism and Critical Theory," [chapter 3] above.

21. Marx, *A Contribution to the Critique of Political Economy*, trans. S. W. Ryazanskaya (New York: International Publishers, 1970), p. 108; the translation of "*Dasein*" as "the work it performs" seems puzzling.

22. Friedrich Nietzsche, *On the Genealogy of Morals and Ecce Homo*, trans. Walter Kaufman and R. J. Hollingdale (New York: Vintage, 1967), p. 20.

23. Ferdinand de Saussure, *Course in General Linguistics*, trans. Wade Baskin, eds. Charles Bally and Albert Secehaye in collaboration with Albert Riedlinger (New York: McGraw-Hill, 1966), pp. 79, 118–19.

24. University of Birmingham, Centre for Contemporary Cultural Studies, *The Empire Strikes Back: Race and Racism in '70s Britain* (London: Hutchinson, 1982) is a significant exception. Not only are the authors aware of the connection between racism in Britain and the international division of labor; they are also aware that a study of race relations in Britain cannot pretend to be a general study of the Third World.

25. See A. B. Lord, *The Singer of Tales* (Cambridge, MA: Harvard University Press, 1960), and Walter J. Ong, *Orality and Literacy* (London: Methuen, 1982).

26. There is a steadily growing body of work dealing with this phenomenon, a glimpse of which may be found in journals such as *NACLA*, *The Bulletin of Concerned Asian Scholars*, and *Economic and Political Weekly*. A bibliographical starting point would be Kathleen Gough and Hari P. Sharma, eds., *Imperialism and Revolution in South Asia* (New York: Monthly Review Press, 1973), part 1; Samir Amin, *Unequal Development*; and Cheryl Payer, *The Debt Trap: The IMF and the Third World* (New York: Monthly Review Press, 1974) and *The World Bank: A Critical Analysis* (New York: Monthly Review press, 1982).

27. See Deborah Fahy Bryceson, "Use Values, The Law of Value and the Analysis of Non-Capitalist Production," *Capital & Class* 20 (Summer 1983), pp. 29–63. (I have differences of theoretical detail with Bryceson which are immaterial to my argument here.) My account of the "Third World" here is of the predominant "peripheral capitalist model of development," which

works through "an alliance of imperialism with the local exploiting classes"; see Samir Amin, *The Future of Maoism*, trans. Norman Finkelstein (New York: Monthly Review Press, 1982), pp. 9–10.

28. See June Nash and María Patricia Fernández-Kelly, eds., *Women, Men, and the International Division of Labor* (Albany: State University of New York Press, 1983).

29. In spite of necessary qualifications, this argument underlies much of the criticism relating to the United States in the nineteenth century and a certain twentieth century. A general line may be traced from F. O. Matthiessen, *American Renaissance: Art and Expression in The Age of Emerson and Whitman* (London: Oxford University Press, 1941), through R. W. B. Lewis, *The American Adam: Innocence, Tragedy, and Tradition in the 19th Century* (Chicago: University of Chicago Press, 1955), to, say, Sherman Paul's *The Lost America of Love* (Baton Rouge: Louisiana State University Press, 1981).

30. Walter Benjamin, *Illuminations*, trans. Harry Zohn, ed. Hannah Arendt (New York: Shocken, 1969), p. 256.

31. See Bill Warren, *Imperialism: Pioneer of Capitalism* (London: Verso, 1980); Samir Amin, "Expansion or Crisis of Capitalism?," *Third World Quarterly* 5:2 (April 1989), pp. 361–80.

32. Theodore Levitt, "The Globalization of Markets," *Harvard Business Review* 61:3 (May–June, 1983), p. 95. I am indebted to Dennis Dworkin for bringing this piece to my attention.

33. *Ibid.*, p. 101. In terms of the ideological interpellation of the subject as consumer, it is worth remarking that the semiotic field here reproduces capitalist as well as patriarchal social relations faithfully: "The Customer" (who is male) does not know what he wants; "Managers [should not be] confidently wedded to a distorted version of the marketing concept according to which you give the customer what he says he wants." But, since the item under discussion here is an automatic washer, the actual target is, of course, "the homemaker" (who is female). "Hoover's media message should have been: *This* is the machine that you, the homemaker, deserve to have to reduce the repetitive heavy daily household burdens, so that you may have more constructive time to spend with your children and your husband. The promotion should also have targeted the husband to give him, preferably in the presence of his wife, a sense of obligation to provide an automatic washer for her even before he bought an automobile for himself. An aggressively low price, combined with heavy promotion of this kind, would have overcome previously expressed preferences for particular features" (*ibid.*, p. 98). There is something like a relation between this ideological reproduction and reinforcement of the international division of labor in the discourse of patriarchal relations in consumerism, and the reproduction and reinforcement of the international division of labor in the discourse of feminist individualism within socialized capital. Examine, for instance, the following convincingly innocent and unproblematic evaluation of telecommunication in *Ms.* in light of the axiol-

ogy suggested by considerations of the "materialist" predication of the subject, which the readers of *Ms.* cannot be expected to know since that magazine too is an ideological apparatus within the social arena under consideration. (Incidentally, it is interesting to see how the time problematic is reversed within a "narrative" context, how the language of narrative-production in telecommunication seeks to recapture a naive "reality." This is a much longer argument which I hope to develop elsewhere.) Jane Bosveld, in "A Wizard of Computer Fantasy," *Ms.* 12:2 (August 1983), p. 20, writes:

Roberta Williams didn't know what she wanted to do with her life until she designed her first microcomputer adventure game three years ago. Today, she is one of the leading designers of home computer games and part owner...of a $20 million business....There is something exciting about the continuous motion in arcade games and Williams has plans...to use "real time" (industry lingo for the continuous action that is programmed into the game) within adventure games.

Later in the same issue, Susan McHenry, commenting on "The Search Industry" for women executives, uses some symptomatic metaphors: "[T]he process *is* essentially matchmaking....'You have to have that Dolly [*Hello, Dolly!*] Levi commonsense instinct [read ideology at its strongest] of who-goes-with-whom, and also the diplomacy of Kissinger," Susan McHenry, "The Search Industry," p. 73. The relationship between feminist individualism and the military-industrial complex on the one hand, and the problem of antisexism within the capitalist enclosure being understood as feminism on the other, is too overdetermined for me to deal with it in more than an endnote. The emergence of an unexamined genitalist axiology of women's suffering and universal sisterhood is also at issue here. What complicates the situation is the overarching presence of hegemonic masculism.

34. Levitt, "Globalization," p. 101; italics mine.

35. Simmel, *Philosophy of Money*, p. 506.

36. Sraffa, *Production of Commodities by Means of Commodities*, p. v.

37. See Derrida, "Freud and the Scene of Writing," in *Writing and Difference*, trans. Alan Bass (Chicago: University of Chicago Press, 1978), pp. 196–231.

38. The warning against the formation of a plastic idea is to be found in Freud, *Works*, vol. 4, p. 281; the Derrida passage is in *OG*, 68.

39. Walter Benjamin, "The Author As Producer," in *Reflections: Essays, Aphorisms, Autobiographical Writings*, trans. Edmund Jephcott, ed. Peter Demetz (New York: Harvest, 1978), p. 230.

40. I am grateful to Todd Snyder for suggesting this line of thought to me.

41. A representative essay would be Fredric Jameson, "Postmodernism and Consumer Society," in Hal Foster, ed., *The Anti-Aesthetic: Essays on Postmodern Culture* (Port Townsend, Washington: Bay Press, 1983), pp. 111–25. As is demonstrated in the revised version of this essay, to be found in *New Left Review* 146 (1984), pp. 53–92, as "Postmodernism, or the Cultural Logic of Late Capitalism," Jameson is ambivalent about these possibilities.

42. Simmel, *Philosophy*, p. 334.

43. Jameson, "Postmodernism," p. 92.

44. The Marx that is useful here is not the philosopher of history, but rather the theoretician of crisis. It is in the sketched theory of crisis that Marx most anticipates the international division of labor, and least imposes the normative narrative of modes of production in the world outside Western Europe. Concise accounts of crisis theory, and crisis theory and contemporary imperialism, are to be found in Robert I. Rhodes, ed., *Imperialism and Underdevelopment: A Reader* (New York: Monthly Review Press, 1979). A systematic development of Marx's theory of production, distribution, and circulation into the regulation of crises is to be found in Michel Aglietta, *A Theory of Capitalist Regulation: The U.S. Experience*, trans. David Fernbach (London: New Left Books, 1979). Peter F. Bell and Larry Cleaver give an account of the development of Marx's own theory of crisis in "Marx's Crisis Theory of Class Struggle," *Research in Political Economy* 5 (1982), pp. 189–261.

45. Wolff et al., "Transformation Problem," p. 574.

46. *Ibid.*, p. 572; italics mine, and I have conflated three sentences.

47. *Ibid.*, p. 576. This, incidentally, also reveals the mistake of the layperson who "refutes" the labor theory of value because "you cannot deduce prices from it." Marx's theory is one where politics, economics, and ideology are relatively autonomous in the determination of class relations in the broadest sense. The point, therefore, is not to reduce value to a calculus of price, especially within models of general equilibrium. Wolff, et al. do produce equations that take this into account. They are, however, aware that the more important issue is that the practical moment in Marx questions abstract economic rigor; even as I argue in the body of this essay that the axiological moment in Marx questions mere philosophical justice.

48. The most powerful development of this conception is the mysterious *Spurs: Nietzsche's Styles*, trans. Barbara Harlow (Chicago: University of Chicago Press, 1978). Part of the mystery lies, I think, in that Derrida is here trying to make "woman his subject" (his "interest"?) and hint enigmatically at "affirmative deconstruction." As I will soon explain, my notion of interest must take the risk of being related to deliberative consciousness. Over a year after the writing of this essay, at the point of implementing the final editorial suggestions, I began to realize how astutely Paul de Man had predicted this move from "false" metaphor to "literalization" in the field of political practice. It would take a careful elaboration of de Man's entire complex argument in *Allegories of Reading* (New Haven: Yale University Press, 1979) to establish the parallel between my move here and grammar and "figure" in the following definition of textuality: "we call text any entity that can be considered from...a double perspective: as a generative, open-ended, non-referential grammatical system and as a figural system closed off by a transcendental signification that subverts the grammatical code to which the text owes its

existence" (de Man, *Allegories*, p. 270). Suffice it here to consolidate the parallel by pointing out that, toward the bottom of the same page, de Man aphoristically describes the necessity of this subversion, this closing off, in the following way: "...and if a text does not *act*, it cannot state what it knows" (italics mine).

49. Dominick LaCapra, lecture given at Wesleyan University, 1984.

50. See: Jean-François Lyotard, *Instructions païennes* (Paris: Galilée, 1977), *Rudiments païens* (Paris: U.G.E., 1977), and, with Jean-Loup Thébaud, *Au juste* (Paris: Christian Bourgeois, 1979); and Jürgen Habermas, *Communication and the Evolution of Society*, trans. Thomas McCarthy (Boston: Beacon, 1979).

51. LaCapra, *History and Criticism* (Ithaca: Cornell University Press, 1985), . 73.

52. Spivak, "The Letter As Cutting Edge," in *Worlds*, p. 13.

53. Derrida, "White Mythology," p. 264.

54. Lacan, "The Agency of the Letter in the Unconscious," in *Ecrits: A Selection*, pp. 146–78; this passage pp. 166–67.

55. *McGraw-Hill Dictionary of Modern Economics: A Handbook of Terms & Associations* (New York: McGraw-Hill, 1973), p. 178.

56. See Fredric Jameson, *The Political Unconscious: Narrative As a Socially Symbolic Act* (Ithaca: Cornell University Press, 1982), pp. 103ff.

57. Derrida, "On an Apocalyptic Tone Recently Adopted in Philosophy," trans. John P. Leavey, Jr., *Semeia* 23 (1982), pp. 63–97. I believe it is possible to read in this obscure text a practical politics of the open end. I hope to write in detail of it in my forthcoming book on Derrida. I will content myself with quoting a relatively less aphoristic sentence: "To raise or set the tone higher...is to...make the inner voice delirious, the inner voice that is the voice of the other in us" (p. 71).

More on Power/Knowledge

(1992)

How can we use a critical philosophy ethically and politically? If decon-struction cannot found a political program; if Foucault's analysis of power is not a blueprint for resistance, alternative lifestyles, or social justice, of what use is a Derrida or a Foucault for doing ethico-political criticism? In this essay, Spivak performs a reading of Foucault and Derrida, reading each one in the other. She acknowledges their differences, but suggests we give in to both in order to learn from them some invaluable lessons about the limits of liberal humanism, dogmatic philosophy, and positivist science.

Given the distinct epistemological grids, the dominant ways of thinking and knowing, in places as different from each other as the United States and France, it should not be surprising that the American reception of Michel Foucault, even at its most sympathetic or rigorous, should tend to make the French philosopher fit for easy consumption, "to regularize him, normalize him, disciplinarize him," as Spivak puts it. But Foucault's work on the relations between power and knowledge in the history of sexuality, technologies of the body, and the care of the self resist such reduction. Like Derrida, Foucault is persistently critical, and never dogmatic without irony. Investigating the idiomatic force of Foucault's use of *pouvoir-savoir* for power-knowledge—terms that carry a sense of everyday ability, of making use of what one has, unlike the more monumentalizing terms *puissance-connaissance*—Spivak intervenes in the current packaging of Foucault to make him newly accessible and useful.

Her final move is to bring this ground-level, ethically engaged Foucault alongside the Kenyan writer and political exile Ngũgĩ Wa Thiong'o and, at greater length, the Bengali woman writer and political activist Mahasweta Devi, whose fiction Spivak has translated. Like Foucault, both these post-colonial writers exemplify the ethical necessity of maintaining a critical as well as a committed political stance or, to put it as Spivak does in her

relentlessly "gymnastic" formation derived from Derrida, they pursue "the persistent critique of what one cannot not want," including such desirable but historically contested notions as "constitutional rights," "freedom," and "democracy."

What is the relationship between critical and dogmatic philosophies of action? By "critical" I mean a philosophy that is aware of the limits of knowing. By "dogmatic" I mean a philosophy that advances coherent general principles without sufficient interest in empirical details. Kant's warning, that the Jacobins had mistaken a critical for a dogmatic philosophy and had thus brought in terror, has served generations of humanist liberals as the inevitable critique of revolutionary politics. Its latest vindication seems to be the situation of international communism. It can certainly be advanced that one of the many scripts spelling out the vicissitudes of the diversified field of the first waves of global Marxism is the consequence of the realist compromises of reading a speculative morphology as an adequate blueprint for social justice: to treat a critical philosophy as a dogmatic.

Who is the ethical subject of humanism? The misadventures of international communism might teach us something about the violent consequences of imposing the most fragile part of Marx, the predictive Eurocentric scenario, upon large parts of the globe not historically centered in Europe.

It is to ignore the role of capitalism in these scripts to read them simply as various triumphs of liberal democracy. It might be more pertinent to ask now: What is it to use a critical philosophy critically? What is it to use it ethically? Who can do so? This essay will attempt to consider these questions with reference to the word "power" in the famous opening of "Method" in the *History of Sexuality, Volume 1*.[1] I will suggest (a) that it might be useful to give the proper names to Foucault and Derrida *in* to each other, although such a move would not be endorsed by either; and (b) that the current critical possibility for Foucault's ethics of the care of the self cannot be understood from within liberal humanism, or through calls for alternatives that remind us that they are appropriate only to liberal democracies and/or postindustrial societies of the North Atlantic model.[2]

READING FOUCAULT AND DERRIDA TOGETHER

The lines of alignment and separation between these two proper names were first drawn by academic circumstance and have been redrawn authoritatively since Foucault's death by the magisterial voice of Edward W. Said, by the trivializing voice of Richard Rorty, the judicious voice of David Couzens Hoy, and others.[3] A learned anthology has been compiled on feminism and Foucault.[4] The rising tide of antideconstructionism among

individual-rights United States feminism has been clinched in, among other texts, the chapter called "Politics and/or Deconstruction" in Zillah R. Eisenstein's new book, *The Female Body and the Law*.[5] The slash between these two proper names, that "emerged out of a strange revolutionary concatenation of Parisian aesthetic and political currents which for about thirty years produced such a concentration of brilliant work as we are not likely to see again for generations," marks a certain *nonalignment*: critique, denunciation, nonresponses, uneasy peace in acknowledgement of political work, and, after the death of one, a formal tribute by the other.[6] To speak of that impossible double name—Derrida/Foucault—is not to be able to speak *for* it, to give you anything *in* that name. But perhaps one might yet be able to give in *to* both, however asymmetrically.

Let us enter the task at hand by way of the "ism" of names—"nominalism"—and open up once again that famous sentence, written to be repeated: "One needs to be a nominalist, no doubt: power, it is not an institution, and it is not a structure; it is not a certain strength [*puissance*] that some are endowed with; it is the name that one lends [*prêter*] to a complex strategical situation in a particular society."[7] This provisional "naming" by theorists is not simply to code within a given system. "This multiplicity of force relations can be coded...either in the form of 'war' or in the form of 'politics.'" The field of possible codings can be, in principle, indefinitely enlarged. The nominalism is a methodological necessity. One needs a name for this thing whose "mechanism [can be used] as a grid of intelligibility of the social order." It is called "power" because that is the closest one can get to it. This sort of proximate naming can be called catachrestic.

Much of United States Foucauldianism as well as United States anti-Foucauldianism—Said's and Sheldon Wolin's readings come to mind—spring out of a lack of sympathy for Foucault's nominalism.[8] We cannot, however, dismiss these readings as mere misunderstandings. For no other name but "power" could have been attributed to this complex situation. In "Feminism and Deconstruction, Again: Negotiations,"[9] I discuss in greater detail that nominalism must bear the responsibility of paleonymy, for names are in the history of language.

Foucault's nominalism has been noticed by critics. David Holy meticulously establishes the advantages gained by Foucault over his critics by his use of what Hoy calls "pragmatic nominalism."[10] Yet even in this sympathetic account a general, naturalized referent for the word "power" is tacitly presupposed and, indeed, attributed to Foucault. This reference is taken for granted, for example, in such important corrective sentences as: "[Foucault's] analytics of power is not intended to tell us what power really is, but only where to look." It is as if, although Foucault's interests are not realist, he has an ontological commitment to a thing named "power." Hoy's

impressive attempt, from within the North Atlantic philosophical tradition, to seize the very alienness of the French thinker, trembles on the brink of subject metaphors: "Foucault thinks of power as *intentionality* without a subject..." And, to explain Foucault's odd thinking of resistance: "to program a computer for chess, presumably *one* must include some considerations about counter-attacks."[11]

These traces of naturalized or merely systemic notions of power, present also in Irene Diamond's good interactive take on Foucault, are what I am calling the consequences of paleonymy. The word "power" points toward what we call the empirical in the history of the language. Poststructuralist nominalism cannot afford to ignore the empirical implications of a particular name.[12]

Such consequences of paleonymy are neither true to Foucault's idea of power nor untrue to them. They are functions of any subject's relationship to language. They become acutely problematic within those strategies of knowledge—that *savoir*—which demands of us that academic learning—*connaissance*—should establish the claims proper to each author in the realm of the roots and ramifications of ideas.[13] I am stating the problem, not solving or denying it. Since the phrase "subject's relationship to language" might have a psychoanalytic ring to it, let me recall my description of the mother tongue in "In a Word."

A mother tongue is a language with history—in that sense it is "instituted"—before our birth and after our death, where patterns that can be filled with anyone's "motivation" have laid themselves down. In this sense it is "'unmotivated' but not capricious."[14] We learn it in a "natural" way and fill it once and for all with our own "intentions" and thus make it "our own" for the span of our life and then leave it, without intent—as unmotivated and uncapricious as we found it (without intent) when it found us—for its other users. As Derrida writes, "The 'un-motivatedness' of the sign requires a synthesis in which the completely other is announced as such—without any simplicity, any identity, any resemblance or continuity—within what is not it."

Reading Foucault's nominalism by way of Derrida, I can see that although there is a "need" (Foucault's word) to be a nominalist, the nominalist still falls prey to the very problems that one seeks to avoid. This is marked by the "power is not" statements in the Foucault passage I began with. But the nominalist falls prey to them only *in a certain way*. This is not to "fail," this is the new making-visible of a "success" that does not conceal or bracket problems. Thus reading Foucault slashed in Derrida, let me further propose that the bestowal of the name power upon a complex situation produces power "in the general sense." The traces of the empirical entailed by the word in the history of the language give the so-called narrow senses

of power. The relationship between the general and narrow senses spans the active articulation of deconstruction in a considerable variety of ways. As I and many others have noted, writing, trace, difference, woman, origin, parergon, gift—and now, in Derrida's latest phase—such more resonant words as justice, democracy, friendship are cracked and barred in their operation by this two-sense divide. As is Derrida's habit, he does not develop a systematic description of this mode of operation. (There is, after all, no useful definition of deconstruction anywhere in Derrida's work.)

I will not go into the practical reason for this habit of elusiveness. All we need to note here is that the relationship between the two senses is never clear-cut. One bleeds into the other at all times. The relationship is certainly not that between the potential and the actual. In fact, the relationship between undecidability and the obligation and risk of deciding is something like the *rapport sans rapport* between the general and the narrow senses. But, and this seems to me important, this curious relationship between the narrow and the general senses is what makes for the necessary lack of fit between discourse and example, the necessary crisis between theory and practice, that marks deconstruction. If we remember that such a misfit between theory and practice is the main complaint brought by nearly everyone against Foucault—indeed, it is thematized by Foucault himself as putting discourse theory aside in his later phase—we can see how Derrida's speculations about the general and the narrow allow us neither to look for an exact fit between theory and practice in Foucault, nor to ignore or transform the boldest bits of his theoretical writings about power. There is certainly no doubt that Foucault would have resented this way of saving his text, and it seems idle to repeat that the status of the author's resentment is not definitive, though certainly worth accounting for, in both Foucault and Derrida. As long as it is not merely an exercise in diagnostic psychobiography, I should, just as certainly, be interested in such an account.[15]

Nor am I substituting an excuse for an accusation. Indeed, this double gesture in Derrida is the affirmative duplicity (opening up toward plurality) that allows him to claim, most noticeably in "Limited Inc." but in fact in every text, that practice *norms* theory—that deconstruction, strictly speaking, is impossible though obligatory and so on. I have myself argued this as the originary "mistake"—not to be derived from some potential correctness—that inaugurates deconstruction. Foucault is not *in* Derrida, but Foucault slashed with Derrida prevents him from being turned into a merely pragmatic nominalist, or a folk hero for American feminism.

"Power" in the general sense is therefore not only a name, but a catachresis. Like all names it is a misfit. To use this name to describe a generality inaccessible to intended description is necessarily to work with the risk that the word "is wrested from its *proper* meaning," that it is being applied

"to a thing which it does not *properly* denote" (*OED*). We cannot find a proper place—it must be effaced as it is disclosed.

It is this critical relationship between the general and the narrow that unsympathetic strong readers such as Habermas and Rorty are unable to grasp. Thus Rorty accuses Foucault's second sense of power of "a certain vacuity": "We liberal reformers[!] think that a certain ambiguity between two uses of the word 'power' vitiates Foucault's work: one which is in fact a pejorative term and the other which treats it as a neutral or descriptive term."[16] In his essay on Derrida, Habermas thinks that the asymmetrical negotiation between the narrow and the general which is the lesson of deconstruction is simply a collapsing of distinctions.[17] Quite predictably, then, Rorty decides that Foucault "refuses to separate the public and the private sphere."[18] Pushing the new pragmatism to its extreme consequences in order to give Foucault an easy out he says that the philosophy of Foucault's final phase should simply claim the same rights of autonomy and privacy as poetry rather than fuss with ethics. "Poetry," "rhetoric," et cetera are small words for these pragmatists and communicationists.[19] They cannot therefore grasp *this* particular rethinking of the dogmatic-critical divide. Indeed, Rorty sees the critical impulse as "a distraction from the history of concrete social engineering."[20]

Foucault's and Derrida's attention to the relationship between the dogmatic and the critical is in the wake of the *early* Heidegger, a course from which Heidegger himself swerved away into a more dogmatic enterprise, following the implications of a sense of poetry and language that are different from Foucault's: that a detailed analysis of the aesthetic element in the conduct of life may lead to a critical appraisal of the post-Enlightenment conception of the ethical person as merely public.

> For me Heidegger has always been the essential philosopher.... My entire philosophical development was determined by my reading of Heidegger.... I think it is important to have a small number of authors with whom one thinks, with whom one works, but about whom one does not write.[21]

If for Foucault, the dialogue with Heidegger is tacit, for Derrida the rememoration of Heidegger is interminable:

> ...more than ever, the vigilant but open reading of Heidegger remains in my eyes one of the indispensable conditions, one of them but not the least, for trying to comprehend better and to tell better why, with so many others, I have always condemned Nazism, in the horror of what, in Heidegger precisely, and so many others, in Germany or elsewhere, has ever been able to give in to it. No *immediate presentation* [a phrase in a Heideggerian

recanting statement of 1942] for thought could also mean: less ease in armed declarations and morality lessons, less haste toward platforms [*tribunes*] and tribunals [*tribunaux*], even if it were to respond to acts of violence, rhetorical or other.[22]

For both Foucault and Derrida, in different ways, the ontico-ontological difference is a thinking through of the uses and limits of a critical philosophy. Their catachrestic nominalism may be trying to touch the ontic with the thought that there is a subindividual (or random, for Derrida) space even under, or below, or before... (the grasp begins to falter here, but how can philosophers who will not admit that actual ethical practice is affected, indeed constituted by this, understand why it is worth trying?) the "preontological Being as [*Dasein*'s] ontically constitutive state...[where] Dasein *tacitly* understands and interprets something like Being" (*BT*, 39; emphasis mine). Whatever the generalizing presuppositions necessary for a systematic statement of knowledge of ethics, these are the conditions within which ethics are *performed*, by subjects constituted in different ways.

I will write further about this resistance to understanding as an epistemic clash. But let us now turn back to Foucault's text. The condition of possibility of power is the condition of possibility of a viewpoint that renders intelligible its exercise. Robert Hurley has not done us a favor by changing the first "rendering intelligible" into "understanding," while preserving "grid of intelligibility of the *social* order." Here is the sentence: "*La condition de possibilité du pouvoir, en tout cas le point de vue qui permet de rendre intelligible son exercise.... C'est le socle mouvant des rapports de force qui induisent sans cesse, par leur inegalité, des états de pouvoir.*"[23] "The condition of possibility of power, at least of the point of view that allows its exercise to be made intelligible...is the *moving base* of force relations that, by their inequality, incessantly *induce* states of power."

In this passage, Foucault *might* be speaking of the point of view of the analysis of power as intelligible rather than the point of view of power. This too can be made to resonate with Derrida. According to Derrida, even the decision that makes the trace of the other in the origin intelligible as writing in the general sense (rather than the usual practice of ignoring the instituted trace to declare a simple origin) cannot be *finally* endorsed.[24] In our Foucauldian passage, the condition of possibility of power's intelligibility is itself such a catachrestic concept-metaphor—"a moving base"—*un socle mouvant*. The metaphor in *induire* or induce, out of inequalities or differences in the magnitude of force—not the organic "engender" as in the English (generate might have been better)—may be both logical and electrical.[25] In both cases, this moving base of *force* fields clearly takes "power" quite away from the *visée* (or aimed) character of intentionality. The con-

dition of possibility of power (or power as intelligible in its exercise)—"this moving base"—is therefore unmotivated, though not capricious. Its "origin," thus heavily framed, is in "difference," inequalities in force relations. To read this only as "our experience of power," or "institutional power" (as most people—like Walter J. Ong—read "writing" as "systems of graphic marks") is the productive and risky burden of paleonymy that must be persistently resisted as it enables practice.[26] "Force" is the subindividual name of "power," not the place where the "idea" of power becomes "hollow" or "ambiguous."[27]

Why should the burden of paleonymy be resisted? Because if not, the enthusiasm of the Foucauldian can *come* to resemble the flip side of a concern for "our social infrastructure" in the interest of "quality of life, peace of mind, and the economic future."[28] This of course is precisely the element of Foucault that a Rorty would admire. And the resemblance emerges when Hoy, after emphasizing the important point that power in Foucault is productive as well as repressive, then divides the necessary results into thoroughly valorized "positive" and "negative" effects.[29] (I am encouraged by the possibility of giving these adjectives an electrical charge.) From this it follows, for Hoy, that "the exercise of power will invariably meet with resistance, which is the manifestation of freedom."[30]

Resistance can indeed be powerfully and persuasively coded in the form of the manifestation of freedom, but there is no getting around the fact that by privileging that particular coding, we are isolating a crucial narrow sense and cutting off the tremendous, unmotivated monitory force of the general.

Speaking to an interlocutor who would clearly incline to such patterns of privilege, Foucault puts the case firmly yet tactfully:

> Every power relationship implies, at lest *in potentia* [and this is a "more rational" name on the chain of power names—*puissance* in French], a strategy of struggle, in which two forces [a "less rational" name on the same chain] are not superimposed.... [A] relationship of confrontation reaches its term, its final moment...when stable mechanisms replace the free play of antagonistic reactions.[31]

Force is the name of the subindividual preontic substance traced with irreducible struggle-structures in the general sense that enables *and* limits confrontation. *Reading* (rather than merely quoting) Foucault, one notices the importance of the parentheses around "(and the victory of one of the two adversaries)," that fits into the ellipsis in the passage I have cited above. To trivialize this into mere functionalism would, mutatis mutandis, put the entire materialist tradition out of court, a consummation which Rorty, et al. would not find implausible.

I am in agreement here with the feminist philosopher Jana Sawicki when she writes, I believe in another kind of response to a similar exigency:

> Rather than seek to legitimate feminist psychoanalytic theory, a Foucauldian looks for its dangers, its normalizing tendencies, how it might hinder research or serve as an instrument of domination despite the intentions of its creators. Whether it serves to dominate or to liberate is irrelevant to judging its truth.[32]

What does this peculiar moving base of a differentiated force field look like? And how does the field polarize? Let us turn the page of *The Will to Knowledge*, where Foucault finds it possible "to advance a few propositions." Here the distinction between the force field on the one hand and its coming into play as power relations on the other is unmistakable if you are on that track: "It is to be supposed that the multiple relations of force that form themselves and play in the apparatuses of production...serve as support to the broad effects of cleavage running through the social body as a whole." "The rationality of power"—one might have said intelligibility—"is that of often explicit tactics which...find their support and their conditions *elsewhere*, finally delineate [*dessinent*] aggregative apparatuses [*dispositifs d'ensemble*]."[33] "Perhaps," writes Foucault, "we need to go one step further...and decipher power mechanisms in terms of a strategy *immanent* to the relationships of force." As indicated above, this "*need* of decipherment," of the individual to calculate that the subindividual has immanent laws of motion, should not be redrawn into the postindividualist register of a determinist functionalism, although perhaps the dominant Anglo-United States episteme can hardly avoid doing so.

The electrical metaphor is particularly strong in a nearly untranslatable sentence trying to catch the origin of resistance: "*Les résistances...sont l'autre terme, dans les relations de pouvoir; belles s'y inscrivent comme irreductible vis-à-vis.*" Surely the choice of "vis-à-vis"—a casual description of being placed facing something—over the motivated words "confrontation" or "opposition" is to be noticed here.[34] Mark also the curious comma between "term" and "in the relations of power." Surely this is to distinguish between "the *strategic* field of power relations" and the merely inductive force field, which is its support. Resistances are the other term—certainly in the sense of terminal—in the field of power relations, the ones that are inscribed there as irreducibly facing. How Foucault's language is bending here to ward us off from the freedom talk of "the philosopher-functionary of the democratic state!"[35]

On the very next page Foucault cautions, under the title "Rule of Immanence," that the force field cannot be naturalized and constituted as an

object of investigation. One must start from the "local foci" of power/ knowledge.

If this sounds too much like the provisional beginnings celebrated everywhere in deconstruction, starting with "The Discourse on Method" in *Of Grammatology*, let me assure you that, even for a reader like me, Foucault *is not* Derrida, nor Derrida Foucault. I cannot find anywhere in Foucault the thought of a founding violence. To quote Marx where one should not, Foucault always remains within the realm of necessity (even in the clinamen to his last phase) whereas Derrida makes for the realm of freedom, only to fall on his face (C3, 959). I would not choose between the two.

Indeed, Derrida's initial critique had been in terms of Foucault's ignoring of the violence that founds philosophy. If forced into the thematic by way of which I am reading the two together, the objection might be arranged this way:

In his earliest phase, Foucault makes the ontico-ontological difference workable too quickly, too easily. Madness, "naming" the ontic, becomes the self-consolidating other of Foucault's text, "producing" the ontological by being excluded. Continuing our somewhat forced reading, this Foucault is seen by Derrida as containing madness within the ontico-ontological difference and legitimizing Descartes's reversed position, where, instead of the inarticulate and proximate, it is the "intelligible [that is] irreducible to all…sensory or imaginative…analysis."[36] What Foucault is thought to overlook is madness as radical alterity, which must be "extinguished" after the necessary invocation of an undivided origin where madness and the cogito are indistinguishable.[37] Foucault is as much written as writing by this tacit extinction, philosophy's hyperbole (rather than *hubris*—Foucault's word).

> Everything can be reduced to a determined historical totality except the hyperbolical project. Now, this project belongs to the narration narrating itself and not to the narration narrated by Foucault…. The menacing powers of madness [thus remain] the adverse origin of philosophy.[38]

This is not to obliterate the difference between philosophers. The different ways in which radical alterity is denied and negotiated maps out the history of philosophy even as it historicizes philosophy: "The historicity proper to philosophy is located and constituted in the transition, the dialogue between hyperbole and the finite structure…."[39]

We must start, then, from the local foci of power/knowledge—*pouvoir/savoir*.

It is a pity that there is no word in English corresponding to *pouvoir* as there is "knowing" for *savoir*. *Pouvoir* is of course "power." But there is

also a sense of "can-do"-ness in "*pouvoir*," if only because, in its various conjugations, it is the commonest way of saying "can" in the French language. If power/knowledge is seen as the only translation of "*pouvoir/savoir*," it monumentalizes Foucault unnecessarily. The French language possesses quite a number of these doublets. In their different ways, "laissez-faire" and "vouloir-dire" are perhaps best known to us. The trick is to get some of the homely verbiness of *savoir* in *savoir-faire*, *savoir-vivre* into *pouvoir*; if you do, you might come up with something like this: if the lines of making sense of something are laid down in a certain way, then you are able to do only those things with that something which are possible within and by the arrangement of those lines. *Pouvoir-savoir*—being able to do something—only as you are able to make sense of it. This everyday sense of that doublet seems to me indispensable to a crucial aspect of Foucault's work.[40]

Power as productive rather than merely repressive resolves itself in a certain way if you don't forget the ordinary sense of *pouvoir/savoir*. Repression is then seen as a species of production. There is no need to valorize repression as negative and production as positive. (Incidentally, this is a much "truer" view of things than most theories of ideology will produce. The notion of "interpellation" is too deeply imbricated with psychoanalysis's involvement with the laws of motion of the mind.) Let us consider a homely example that has some importance for bicultural women, women who grow up as daughters of new immigrants, women who ride the hyphen of "Ethnic"-American into a different "mother tongue." We are, of course, speaking of a level still above the impersonality of the force field.[41]

Suppose the *savoir* or knowing of (exogamous) marriage in a culture for a woman is: a passing from her father's protection to her husband's in order to produce women and men to perpetuate this circuit; and finally to pass under her son's protection. In terms of this *savoir*, the woman *can* (*peut* in the French, from *pouvoir*) preserve "the stability of marriage" and be loving and loved without being sexy. Suppose on the other hand, exogamous marriage is known as the fulfillment of various kinds of interactive and creative emotive potentials in the woman. In terms of this *savoir*, the woman *can* (*peut*) seek fulfillment elsewhere if, as individually intending subject, she feels her fulfillment thwarted. Both situations are productive—of the stability of marriage on the one hand and of the perceived freedom of women's fulfillment on the other. There is, of course, felt pain involved in both. But, quite apart from that, there are terminals of resistance inscribed *under* the level of the tactics, sometimes explicit, with which these women fill their lives. If this seems a little opaque, let me invite you to think of the terminals of resistance as possibilities for reflexes of mind and activity, as an athlete has reflexes of the body to call upon. And changes in *pouvoir/savoir*

can make visible the repressive elements in both situations, even though "disciplinary" means (through the Women's Studies component of the Culture Studies collective for example) of women's freedom on the one hand, or of woman's right to a special role in the propagation of society on the other.[42]

One must not stop here, of course. The homely tactics of everyday *pouvoir/savoir*, the stuff of women's lives, lead not only to the governmentality of dress codes and work habits, guilt feelings and guilt trips, but also to the delineation of the great aggregative apparatuses of power/knowledge which deploy the family as a repressive issue, daycare as an alibi, and reproductive rights as a moral melodrama in national elections and policy.

Foucault insisted upon the difference between *savoir* and *connaissance*, as he did between *pouvoir* and *puissance*, the latter seen as lodged in the State or the Institution. He never wrote an *Archéologie du pouvoir*. The reasons have been aptly thematized as a change of heart, the changing times, and the like. Yet it is also true that, at the time of its writing, Foucault perceived the *Archaeology of Knowledge* (*savoir*) as a theoretical consolidation of all that had come before.[43]

There may be another theoretical "reason" for the absence of an archaeology of power. The differential substance of *savoir* is discourse, with its irreducible connection to language. Thus *its* archaeology can be written. The differential substance of power is force, which does not have an irreducible connection to language. It is not even necessarily structured like a language, just as a magnetic field (which is symbolizable) is not necessarily structured like a language. Writing its archaeology would entail a first step: writing *pouvoir* in terms of *savoir*. Foucault himself sometimes put this entailment somewhat more polemically, especially in his later interviews— as a turning away from mere language.

The homology I am about to draw, then, is, strictly speaking, an imperfect homology. It is between, on the one hand, *puissance, pouvoir, force* and, on the other, *connaissance, savoir, énoncé*. I repeat, it is an imperfect homology, but can serve as a guide to the status of *pouvoir/savoir*.

Again, English cannot quite match Foucault's distinction between *énoncé* and *énonciation*. There is of course the authority of the translations of *énoncé* in linguistics and semiotics—utterance, statement, etc. There is no reason to reject these translations. Yet it cannot be denied that there is, in French, a sense of the uttered, the stated, in that simple word *énoncé*.

There can be no doubt at all that the *énoncé* as "the atom of discourse" is a catachresis. I believe this word has broken under the burden of paleonymy. This is what one camp of Foucault criticisms would call the *failure* of archaeology.

All through the middle section of *The Archaeology of Knowledge*

Foucault tries to be precise about the *énoncé* even as he warns us of all the things that we might think it is because of its various meanings in the history of language. I think it is finally more effective that the distinction between force and power is kept, by contrast, elusive. The immense effort to distinguish between *énoncé* and discourse is impressive in its elegance, not its usefulness. If the element of the archive emerges at the end of these acrobatics as something like the field of power relations, the analogue of the force field is that "lacunary [*lacunaire*] and shredded [*déchiquetée*]...enunciative field," that no-place, where bits of the stated, not units, but functions, cut across structures, and are rare.

Perhaps because it is *about savoir, The Archeology of Knowledge* indicates the gap between practice and theory in its own rhetorical strategy. By this I do not mean the self-conscious imaginary dialogue at the end, but rather the placing of the "Definition of the *Énoncé*" in the middle. The peculiarly abdicatory series of gestures toward the beginning of the section are noteworthy:

> I took care [*je me suis gardé*] not to give a preliminary definition of the *énoncé*. I did not try to construct one as I advanced in order to justify the naïveté of my starting point.... I wonder whether I have not changed orientation on the way; if I have not substituted another research for my first horizon; whether...I was still speaking of *énoncés*.... Have I not varied the...word discourse as I shifted my analysis or its point of application, to the extent that I lost sight of the *énoncé* itself?[44]

It is by no means certain how these questions should be answered. To my mind, this paragraph marks that misfit between practice (the analysis practiced so far in the book) and theory (of which I spoke in the beginning). The word "definition" itself becomes a catachresis here, for, by Foucault's own rhetoric, it may not be a definition that has been or can be used.

Pouvoir/savoir, then, is catachrestic in the way that all names of processes not anchored in the intending subject must be: lines of knowing constituting ways of doing and not doing, the lines themselves irregular clinamens from subindividual atomic systems—fields of force, archives of utterance. Inducing them is that moving field of shredded *énoncés* or differential forces that cannot be constructed as objects of investigation. Ahead of them, making their rationality fully visible, are the great apparatuses of *puissance/connaissance*. Between the first and the second there is the misfit of the general and the narrow sense. Between the last two is the misfit that describes examples that seem not to be faithful to the theorist's argument. If read by way of the deconstructive theorizing of practice, this does not summon up excuses or accusation. This is how theory brings prac-

tice to crisis, and practice norms theory, and deviations constitute a forever precarious norm; everything opened and menaced by the risk of paleonymy. Thus I give the name of Foucault in to Derrida.

AN ETHICS INACCESSIBLE TO LIBERALISM

As I hope I have made clear, there is in both writers a concern with the pre-ontological ontic level of the everydayness of the being.[45] It is at this level that Derrida brings *différance* into the self-proximity of the ontic—everyday "identity" differed-deferred from itself by randomness and chance.[46] Foucault's concern with this level is already apparent in his early interest in Binswanger's "existential analysis."[47] This is not the place to construct an itinerary of that interest. I should like to give merely a sense of that itinerary by proposing a sentence imitating one Foucault wrote himself. Here is Foucault, writing on "mental illness" in 1954: "Illness is the *psychological truth* of health, to the very extent that it is its *human contradiction*."[48] Now consider this: "*Pouvoir-savoir* is the onto-phenomenological truth of ethics, to the very extent that it is its contradiction in subjecting."

Giving the proper names of Foucault and Derrida in to each other, then, and with the benefit of three decades of work by both philosophers after Derrida's initial criticism of Foucault, I would discover in "madness" the catachrestic name given by the early Foucault to that ontic dimension of Being which eludes Reason's ontology. I would suggest that in *Madness and Unreason*, his first "real" book, where Foucault takes, by his own well-known account, a serious swerve away from the history of madness to the archaeology of silence, history and philosophy (the dogmatic and the critical, loosely, if you like) have not yet brought each other to the crisis that this new politics of practice must assiduously cultivate. Foucault is himself so brilliantly involved in the construction of the name of "madness" that, at this stage, he merely "betrays" his own catachrestic use of it. Put another way, he is himself at once using the inaccessibility of madness (as "truth of Being") as a catachresis for the *ontic*—perhaps through his on-the-job training with Heideggerian existential analysis—and is sufficiently dazzled by the paleonymic promise to make an onto*logical* commitment to madness, to want to speak it in critical speech. I could reread the summing-up of the book in the Introduction to *The Archaeology of Knowledge* in this spirit.[49]

It is not surprising that readers have generally focused on the spectacular account of the definition and exclusion of madness rather than its definitive, intimate, inaccessible, ontic place. For in this early work there is an overriding tendency to shuttle between madness as a primordial ontic space and an ontologically displaced physico-moral condition. Yet the emphasis is certainly on "the essential unknowability of madness."[50] Because this

emphasis may easily be restated as "an attempt to grasp a form of human existence entirely other than our own," it is just as certainly appropriate to notice that Derrida's chief critique is the insistence that "madness is within thought."

Within these frames, both Derrida and Foucault are interested in the production of "truth." Deconstruction is not exposure of error. Logocentrism is not a pathology. Deconstruction is "justice," says Derrida. And Foucault: "My objective...has been to create a history of the different modes of objectification which transform human beings into subjects." Derrida, too, is always rusing on the track of the ruses of the subject centering itself in the act, in decision, in thought, in affirmation, with no hope of closure.

And yet the slash must be honored.

Derrida's tending of ontic "knowing" has become more and more rhetorical since the publication of *Glas* in 1974.[51] If I am right in thinking that the relationship between *folie* and *connaissance* in *Folie et déraison* is homologous to the relationship between self-proximate ontic "knowing" and ontological knowledge, it seems appropriate that no ethical position can develop to bridge so absolute a divide.[52]

The archaeology of knowledge (rather than silence) may be seen as a method that would make the divide a clinamen.[53] The articulation of *pouvoir savoir* secures the first stage of the clinamen that makes it accessible to a sense of being. The next step, since the unquestioned transparent ethical subject—the white, male, heterosexual, Christian man of property—has now been questioned into specificity and visibility, is to measure the plurality of ethics by researching the ways in which the subject "subjects" itself through "ability to know" (*pouvoir-savoir*). This is what it might mean to say: "Thus it is not power, but the subject, which is the general theme of my research."[54]

I am suggesting, then, that this line of ethical inquiry proceeds from the challenge of the robust Heideggerian notion of ontico-ontological difference, understood as implying ontico-ethical proximity, and not neutralized, as by Heidegger himself, by way of *Dichtung* or *Lichtung*.[55]

This immense project was not realized by Foucault. He established one point: that the constitution of the modern "Western" subject may be through the *pouvoir-savoir* of sexuality (even this would of course be ignored by masculist ethical philosophers); but not all subjecting is done in the same way. In fourth-century B.C. Greece it was done through the use of pleasure in the care of the self. I am incapable of judging if Foucault was right about Greece in that period. The point here is that he follows the implications of the limits of existential analysis to come to *this* way of beginning ethical investigations. Undoubtedly this sort of stage talk on my

part is to impose a continuity. But this imposition becomes strategically necessary when, from a point of view where philosophy is seen as a private enterprise, where a complete break between philosophy and "citizenship" (necessarily of the postimperialist or neocolonialist "liberal" state) is taken as normal—from such a point of view, Foucault seems to be pushing for the poet's desire for autonomy as a general ethical *goal*.[56]

The point of my strategic and heuristic use of continuism is to emphasize that, if the ethical subject is *not* taken to be without historical, cultural, or linguistic limits, then a study of its constitution(s) is the place to begin ethical investigations. As André Glucksmann writes: any ontico-ethical thinking must take into account or "make appear the dissymetries, the disequilibriums, the aporias, the impossibilities, which are precisely the objects of all commitment."[57]

Derrida too tends to the ontic, but differently, risking his disciplinary practice through the rhetoric of the everyday. His ethical concerns tend more toward a responsibility to the trace of the other than a consideration of the care of the self.[58] For Derrida, Levinas's ethics of absolute alterity has written itself upon and under the ontico-ontological difference.[59] And the being in and out of this difference has been textured by the effort to see man—the major actor—as varieties of other.[60] Foucault's last phase takes him into ground-level ethical codes of gendering.

Remember those "fee boardschool shirkers" in *Finnegans Wake*, "Will, Conn and Otto, to tell them overagait, Vol, Pov and Dev"?[61] Will, can, and ought to—*vouloir*, *pouvoir*, and *devoir* (the ethical) under scrutiny. Derrida watches out for the one who justifies practice by theory or theory by practice, compromised by both. And Foucault says, in one of his last interviews:

> One did not suggest what people ought to be, what they ought to do, what they ought to think and believe. It was a matter rather of showing how social mechanisms up to now have been able to work...and then, starting from there, one left to the people themselves, knowing all the above, the possibility of self-determination and the choice of their own existence....
> Q[uestion]: Isn't it basically a question of a new genealogy of morals?
> M F[oucault]: If not for the solemnity of the title and the imposing marks that Nietzsche left on it, I would say yes.[62]

On this generalized retrospective register, "morals" and "ethics" can be allowed to be interchangeable. We all know that other exchange, barely a year before this: "Q[uestion]: Would it be fair to say that you're not doing the genealogy of morals, because you think the moral codes are relatively stable, but what you're doing is a genealogy of ethics? A[nswer]: Yes, I'm writing a genealogy of ethics."

At this point, what we see most poignantly illustrated is the anxiety of the academic interlocutors: tell us, you *must* be doing this? And the answer comes back, yes, yes.

This essay might seem to be yet another entry in the debate over whether Foucault was from beginning to end an "archaeologist," or if he abandoned "archeology" as a dead end to take up "genealogy." I seem to have taken the position that there is an asymmetrical homology between *énoncé-savoir-connaissance* and *force-pouvoir-puissance* that has something like a relationship with subindividual-ontic-ontological. Inscribed into the field of the ethical, this homology gives us a hint of how seriously Foucault pursued the track of *critical* philosophy that was not content to assume its modernist Eurocentric *dogmatic* burden. Reading this way, one is struck by the specificity of Foucault's self-avowed clinamen—away from the "historical" to what in Heideggerian terminology one might call the "historial": "farther and farther away from the chronological outline I had first decided on…to [the] analy[sis] of the flesh."[63] There is a tone of humility in beginning with other civilizations' *souci de soi*—starting with the nearest "other," Greek antiquity—rather than the arrogance of a desire for individual autonomy.

Although I came to be struck by this through my reading of Derrida, I have indicated that this is a different project from the possibility of the ethical "within" alterity and randomness implied by Derrida's work. And indeed there is here a different kind of difference that one might dwell on for a moment.

Foucault's final focusing on the relationship to the self in the experience of the flesh is a practical ontology. Transformed into reflex, such a practical ontology comes to contaminate the ontic but, kept as a code, it straddles the ontico-ontological difference in a way that full-dress moral philosophies will, indeed can, never do: "the care of the flesh is ethically prior [*éthiquement premier*] in the measure that the relationship to the self is ontologically prior."[64] This is *pouvoir-savoir* at ground level, "the working of thought upon itself…as critical activity," not at degree zero.[65] This is "the soil that can nourish," this "the general form of problemization."[66] Habermas and others have thought this to be a swerve away from the subindividual level that was the most unusual aspect of Foucault's archaeogenealogy. (It is characteristic of Habermas's general epistemic block to this kind of thinking that he calls the subindividual "*supra*subjective.")[67] In actual fact, Foucault makes it clear that, although in search of the role of the ontic in the constitution of the ethical, he is now impelled to focus on another band of the discontinuous spectrum of *pouvoir savoir*—he is not repudiating the articulation of the subindividual level: "I will call subjec-

tivization the procedure by which one obtains the constitution of a subject, or more precisely, of a subjectivity which is of course *only one of the given possibilities of organization of a self-consciousness.*"[68] Here indeed is the consequence of that earlier position that we could only deduce: "*pouvoir-savoir* is the onto-phenomenological truth of ethics, to the very extent that it is its contradiction in subjecting" ("Final Interview," p. 22).

In embracing this consequence, Foucault does indeed move away from the *mode* of the critique of humanism that Derrida inhabits, even as, in renouncing mere chronological inquiry and only the particular forms of the technologies of power and strategies of knowledge, he come closer to the younger philosopher. In this new mode, he soberly tabulates the ingredients of the ethical habit, rather than running and floating with thought tangled in rhetoric, as does Derrida, at the other extreme. In a way, "it is [indeed] clear how far one is from an analysis in terms of deconstruction," as Foucault says right at the end.[69] But the terrain is, in another and related way, nearer. Foucault is no longer tripping up the programs of emancipation (mostly juridico-legal and political), but tracking the "practice of freedom." It is indeed clear how far he is from a Derrida who has put the *praxis* of freedom to the test by the *technè* of each act of writing. Foucault, in his final serene mood, can write: "Liberty is the ontological condition of ethics. But ethics is the deliberate [*réfléchie*] form taken by liberty."[70] The relationship between condition of (im)possibility and practice in Derrida would lead, in my understanding and formulation, to the more gymnastic "persistent critique of what one cannot not want."[71]

It is the archaeology-genealogy debate that still exercises readers of Foucault in France as well as in the United States. In the context of the United States, my position would seem to resemble that of Gary Gutting (who says all is archaeology) rather than that held by Dreyfus and Rabinow (who say archaeology was dropped).[72]

However that may be, I would like to suggest that the United States approach to Foucault, on either side of the debate, is generally within the same side of a clash of epistemes. Both Gutting on the one hand and Dreyfus and Rabinow on the other like Foucault and want to save him for philosophy. But if an episteme can be taken, loosely, to be one level of social *pouvoir savoir*, then these colleagues seem to inhabit a rather different one from Foucault's. It is as if, assembled at a race where the point is to stay on a bicycle at as slow a speed as possible—see how close you can get to *pouvoir-savoir* degree zero in order to think ethics in its "real" problems—these colleagues would murmur, you can use these machines to get places fast too, you know! It is my belief that nobody who thinks of rhetoric as "befogg[ing] by the tortuous opacities of his prose and dazzl[ing] by the seeming gratuitousness of his audacious claims" can fall into the episteme

or mindset within which Foucault labored.[73]

In order to answer the question "do his writings, beneath all the fire-works and attendant billows of smoke, in fact express a position of suffi-cient clarity, plausibility, and interest to merit sustained attention?" Every challenging thought must be made blunt by Gutting so that influences can be charted, continuities established, exam questions answered.

Dreyfus and Rabinow approach Foucault with grace and sympathy. Yet they too flatten him out and understand his "progress" as rejecting less good for more good alternatives and solutions. Their entire book is plot-ted on this assumption and never more so than in the interviews at the end, where one feels the tension of making Foucault fit for the consumption of American students and colleagues; the will to regularize him, normalize him, disciplinarize him. The desperation of the following exchange, tucked at the end of the book, is telling:

> Q. Do you think that the Greeks offer an attractive and plausible alternative?
> A. No! I am not looking for an alternative.... You see, what I want to do is not the history of solutions, and that's the reason why I don't accept the word "alternative."[74]

About Rorty's lack of epistemic consonance with Foucault I have already written. Paul Bové has written perceptively about a comparable lack in Charles Taylor.[75]

Roy Boyne's good reading of the relationship between Foucault and Derrida does not finally avoid this epistemically coded tendency to read the critical as altogether dogmatic. As a result he both hopes and regrets more. On the one hand, he sees in the two philosophers a certain "post-existen-tialist despair."[76] Given Derrida's open early warning that grammatology cannot be a positive science, he somewhat reinvents the wheel by asking and answering in the negative the question: "Is there a positive practice that can emerge from such dark 'realism'?"[77] In fact this "realism" is as "dark" as it is "light," for its persistent task is to keep grounded plans in touch with the spaciness of space. Boyne describes the survival techniques for the production of the "truth" of being in ontology that are provided by logo-centrism, rhetoricity, and techniques of the self with the moral harshness of the desire that a critical philosophy offer dogmatic alternatives: "It is possible that an utterly pervasive self-deceit, together with all but unrecog-nized rhetorical deception and conceptual violence, is functionally neces-sary for social life." Here indeed is the "humiliation" expected by Rorty from the deconstructivist. It is hard for the dogmatic philosopher to grasp that a strategist is a trickster, since there is no free play. In his view therefore, a strategic essentialism becomes a "pessimistic essentialism."[78] When he

reads Derrida as "invent[ing] a philosophical strategy which opposes reason from the inside," Boyne cannot see that the importance of this invention is in its confounding of the hope of success with the fear of failure. I am certainly in sympathy with Boyne when he writes: "the full confluence of the ideas of Foucault and Derrida may never be achieved," although what is a "full confluence"? But, in reading Foucault's interest in the care for the self as a finished project rather than a first step in the investigation of other *pouvoir/savoir* of a preontological ontology in the constitution of the subject of ethics, Boyne is both too upbeat and not upbeat enough:

> ...the vision, which is barely taking shape, of an aesthetics of existence oriented to the careful (in the fullest sense of the word) destabilization of hierarchical determinations of otherness, at least provides the possibility of an exit from the antisocial snares of liberal individualism.

This position is unfortunately open to Rorty's shots in "Moral Ideals." And the possibilities of the transformation of a care [*Sorge*]-ful acceptance of being-there [*Dasein*] into an aesthetics of existence are not necessarily socially fruitful. The critical exit is *in* liberal individualism, if that is our dominant historical moment, even as *we* are in it, by reading and writing this book. The critical (deconstructive/genealogico-ethical) being can activate this exit within, without *full* hope (which may include having *some* hope) in teleological change, and therefore without letting up. That may be the name of ethical living, with some hope in working for political change. Indeed, this position too can be trivialized and made into comfortable "loyal opposition" talk. It is hard to acknowledge that liberal individualism is a violating enablement. It is in postcoloniality and the hope for development that this acknowledgment is daily extracted; although postcoloniality—a wrenching coupling of epistemes—should not be taken as its only example.

It is customary to state epistemes as national inclinations: France and the Anglo-United States. Epistemes are of course not nationally determined. Or, to put it another way, they are as historically determined (or determining of history) as is "national character." Paul Bové is "American," and Jean Baudrillard—excepting an ontological commitment to power from the same page of *The Will to Knowledge* that we have been reading—is "French." And in fact, since we have been speaking of the *pouvoir/savoir* circuits as layered, on a certain layer the word "episteme" can stand in for "assent to the dominant."

Our notions of political activism are deeply rooted in the bourgeois revolution from whose inheritance Derrida and Foucault, descendants of 1789, have taken a distance. A call for individual rights, national or psy-

cho-sexual liberation, or constitutional agency inscribed in *pouvoir/savoir* deeply marked by the strategy-techniques of management (small *m*), cannot bring forth positive responses from them. As Foucault says, "knowing all the above, leave it to the people."[79] As Alessandro Pizzorno points out, "the 'victim' of power" is not, for Foucault, as s/he is "for Marx as for Weber,...the individual as such whom that structural power prevents from developing as he [sic] could have done in other conditions."[80] I suppose there is less harm in rewriting Derrida as a libertarian for the marginal, or Foucault as the successful practitioner of genealogy (Godot arrived on the bus, as it were) than in dismissing archaeology as nihilism, or saying, as I heard Anthony D'Amato, a lawyer stunningly ignorant of anything having to do with deconstruction, say at a conference in October 1989: "The fact that a black man is rotting away in prison for a crime is simply the real-world byproduct of Judge Easterbrook's textbook exercise in deconstruction." I continue to think that the real usefulness of these two *is* in the lesson of their refusal to be taken in by victories measured out in rational abstractions, in the dying fall of their urge persistently to critique those dogmas for the few (in the name of the many) that *we* cannot not want to inhabit. By reading Foucault in Derrida, I have tried to repeat the practical lesson of history, the perennial critique: *qui gagne perd*; who wins (also) loses. "A cautious skepticism with regard to utopian politics and a neostoic almost Camusian[?] 'pessimistic activism' in the face of ultimate meaninglessness," writes Thomas Flynn, of the same lesson.[81] By reading Foucault in Derrida in the wake of a reconsideration of Heidegger, I have tried to distinguish this trajectory from the existentialist position.

This is not as mysterious or ethereal as one might think. Urging the reader to remember all that I have said about the narrow and general senses, let me give an example. In September 1989, I heard Ngũgĩ Wa Thiong'o, the Kenyan writer and political exile, speak on Exile and Displacement at a panel on Third World Film in Birmingham, England. He spoke movingly of his sense of double exile, *in* his own country because of its betrayal of the democratic ideal, and in Britain, where he has sought refuge, because the worst elements in his country are collaborating with Britain. A South African from the audience asked him what he thought of recent developments toward a rapprochement in South Africa. Ngũgĩ spoke with immense respect and support, and very carefully made allowances for not being involved there, not being a savvy participant. But then said this: my greatest fear is that South Africa should fall into neocolonialism.

That is the voice of caution, raised at the moment of negotiated independence, a critique of what one cannot not want. It is not without interest that, in explaining his final move, Foucault uses the example of recolonization:

When a colonized [*colonisé*] people tries to free itself of its colonizer, that is truly a practice [*pratique*] of liberation, in the strict sense of the word. But as we also know, this practice of liberation does not define [*définir*] the practices of liberty which will then be necessary for this people, this society and these individuals to define themselves [*se définir*] receivable and acceptable forms of their existence or of a political society.[82]

To elaborate Foucault's understanding of this double gesture into the productive unease of a persistent critique, I will move to Mahasweta Devi.

CRITICAL-DOGMATIC IN THE POSTCOLONIAL SUBJECT

Mahasweta Devi is as unusual within the Bengali literary tradition as Foucault and Derrida within the philosophical or political mainstream in France. She is not representative of Third World feminism. Therefore my risk here is to feed too easily *our* academic *pouvoir/savoir*, that would like to familiarize her singularity into an example. Virago Press wanted to docket her as an *Indian* woman writer and put her in with Anita Desai or Bharati Mukherjee. On the other side, I have read a proposal where an effort is being made to put her within the pantheon of great Bengali women writers in the bourgeois tradition, merely as a "complementary voice." Once again, that conflation of episteme with nation! At this moment, to slash her with an "ism," even *feminism*, puts her singularity at risk.

Mahasweta is almost exactly the same age as Foucault would have been, slightly older than Derrida. She too is a sometime academic. She too lived through the Second World War, which for her was the prelude to the negotiated Independence of India. She has seen the need for the critical watchfulness of which Ngũgĩ spoke. Mahasweta's involvement with the Communist Party dates back nearly fifty years. Here too, seeing a beleaguered illegal party in British India move into electoral politics has made it necessary for her to take a distance, though she is, of course, resolutely "on the left."

It goes without saying that the real difference between Mahasweta and the two French philosophers is by way of the place of women in her texts. In terms of the narrow sense/general sense or theory/practice argument, however, a related difference is also significant. Unlike Foucault and Derrida, Mahasweta was only incidentally an academic. She is, of course, a writer of fiction. But, ever since the great artificial famine of 1942, planned to feed British soldiers in the Asian theater, she has been continuously a political activist. As she has taken a distance from party politics on the left, her work has moved more and more into the area of the politics of Indian tribals and outcastes. Paradoxically, her involvement is away from the theater of armed struggle, in the arena of tribal self-development and

Constitutional rights. She is so involved in the immense labor of making known and helping implement the sanctions for the tribals and outcastes written into the Indian Constitution of 1947–49, that the fine-tuning of her writing is beginning to suffer.

At the negotiated independence of the Indian subcontinent, the first Indian constitution was written under the aegis of Lord Mountbatten and came out of what Bhikhu Parekh has recently called "the claustrophobic post-Enlightenment enclave."[83] It is Mahasweta's subject-position as the "citizen" of a recently decolonized "nation" that puts her in a different relationship to the inheritance of 1789 from Foucault and Derrida.[84] Her position bears comparison, though is not identical, with reproductive rights feminists in the West, who must also want a share of that inheritance, and must write the woman's body in a normative and privative rational juridico-legal discourse. Mahasweta must therefore persistently critique her involvement. She too is "aware" at some level that constitutional rights cannot take their end as an unquestioned good. I believe this critique and anxiety are staged again and again in the theater of her fiction. The fiction traffics in the untotalizable where the intending consciousness cannot be privileged. Her political activism, which is not "described" in the fiction, keeps its nose to a critiqued totality. The line between the two is never very clear-cut.

With this brief introduction, let me flesh out my schema just a little further. I will be anticipating some of the principal arguments animating later chapters.

The subject-position of the citizen of a recently decolonized "nation" is epistemically fractured. The so-called private individual and the public citizen in a decolonized nation can inhabit widely different epistemes, violently at odds with each other yet yoked together by way of the many everyday ruses of *pouvoir-savoir*. "Literature," straddling this epistemic divide, cannot simply remain in the "private" sphere; and not only because it is at a "less developed stage" by some "Euro"-teleology. The embarrassing myopia of a statement like the following simply cannot see the script of the uneven epistemic violation in the decolonized theater:

> One would never guess, to read Foucault's analysis of the transformations operated in the last three centuries within European social institutions that that period has seen a considerable diminution in suffering and an equally considerable augmentation of the chances offered to the individual to choose his lifestyle himself.[85]

O brave new world.

The political claims that are most urgent in decolonized space are tacitly recognized as coded within the legacy of imperialism: nationhood, con-

stitutionality, citizenship, democracy, socialism, even culturalism. In the historical frame of exploration, colonization, decolonization, what is being *effectively* reclaimed is a series of regulative political concepts, whose supposedly authoritative narrative of production was written elsewhere, in the social formations of Western Europe. They are thus being reclaimed, indeed claimed, as concept-metaphors for which no *historically* adequate referent may be advanced from postcolonial space. That does not make the claims less urgent. For the people who are making the claims, the history of the Enlightenment episteme is "cited" even on an individual level, as the script is cited for an actor's interpretation.

"Feminism," the named movement, is also part of this heritage of the European Enlightenment. *Within* the enclosure of the heritage, it is of course inscribed as an "irreducible vis-à-vis" the masculine dominant.

The space that Mahasweta's fiction inhabits is rather special, even within this specifying argument. It is the space of the "subaltern," displaced even from the catachrestic relationship between decolonization and the Enlightenment, with feminism inscribed within it.

Especially in cultural critique, the event of political independence can be automatically assumed to stand in between colony and decolonization as an unexamined good that operates a reversal. As I am insisting, the new nation is run by a regulative logic derived from a reversal of the old colony from within the cited episteme of the postcolonial subject: secularism, democracy, socialism, national identity, capitalist development. There is however a space that did not share in the energy of this reversal, a space that had no firmly established agency of traffic with the *culture* of imperialism. Paradoxically, this space is also outside of organized labor, below the attempted reversals of capital logic. Conventionally, this space is described as the habitat of the *sub*proletariat or the *sub*altern. Mahasweta's fiction suggests that *this* is the space of the displacement of the colonization-decolonization reversal. This is the space that can become, for her, a dystopic representation of decolonization *as such*. In this context, "decolonization" becomes only a convenient and misleading word, used because no other can be found.

If neocolonialism is only seen from the undoubtedly complex and important but restrictive perspective of metropolitan internal colonization or the postcolonial migrant or immigrant, this particular scenario of displacement becomes invisible, drops out of sight. The *pouvoir-savoir* or know-it-as-this/can-do-it-as-this of the discourse of feminism is obviously counterintuitive to the inhabitants of this space, the space of Mahasweta's fiction. As she works actively to move the subalterns into hegemony, in her struggle in the field, she pushes them toward that other episteme, where the "intuitions" of feminism become accessible. I am not arguing a fiction/reality

opposition here. The narrow and the general sense infiltrate each other, bring each other to crisis, although they are not inscribed into a continuum.

Thus, if we think back about the *pouvoir-savoir* example of mother-daughter relationships in new immigration, we can see another conjuncture of similar strands here—writer/ activist, subaltern/citizen—in the same fiction. Especially in the postcolonial womanspace, this is a much more "complex set of relationships" than Rorty's public-private.

Mahasweta's fictions are thus not stories of the improbable awakening of feminist consciousness in the gendered subaltern. They are also not spoken *for* them, whatever that might mean. She does not speak *as* them, or *to* them. These are singular, paralogical figures of women (sometimes wild men, mad men) who spell out no model for imitation. I will mention a few that I have tried to capture in commentary and translation and then talk about a couple that belong to my translation work in progress.

Draupadi and Jashoda are explosions of the Hindu traditional imagination of the female. In Mahasweta's stories, Draupadi stands finally fixed and naked, a figure of refusal, in front of the police officer, her breasts mangled and her vagina torn and bleeding. She is at a distance from the political activism of the male. Jashoda lies dead, her breast putrefied with cancer, a figure that blasts mothering right out of its affective coding. She is at a distance from the gradual emancipation of the bourgeois female.[86]

Mary Oraon in "The Hunt" is the child of the violation of a tribal Christian servant-woman by the white planter who leaves the plantation at Independence. Child of violation, Mary Oraon is the very figure of postcoloniality, displaced to the subaltern level. At the end of "The Hunt," she has just murdered the exploitative rural contractor. Drunk on alcohol and violence, she is in flight, running along the railroad line. A half-caste, she is at a distance from the authentic ethnic.[87]

When we are not immediately involved in systemic politics, we are not necessarily exempt from the anxiety of being pushed into an alien, "scientific," or "constitutional" episteme. The philosopher-intellectual can offer nonspecific alternatives, a last-ditch hope that *might* inspire ecological activists in the postmodern economies (not the decolonized subaltern, for whom ancient utopias have become sites of terror under exploitation). But will those activists read literary journals, and can the aggregative apparatuses be made to listen? Michel Serre, for example, not immediately involved in what he calls the "Exact Sciences," can stage the anxiety and propose a utopian solution in the following way. First, the anxiety, here more Manichean, as "terror":

> The terror comes, if I dare to say it, not from the fact of power, but from rightness. The thing is that science is right—it is demonstrably right, fac-

tually right. It is thus right in asserting itself. It is thus right in asserting that which is not right. Nothing is produced, no one is cured, the economy is not improved by the means of sayings, clichés or tragedies.[88]

And then the admirable solution (altogether restricted in its availability) which can, as he says, "chuck the death wish":

> I am seeking a knowledge that is finally adult.... The adult man is educated in a third way. Agronomist and man of the woods, savage and tiller of the fields, he has both culture and science. Criticism is fairly futile—only invention counts. This so-called adult knowledge is convinced and certain that the picture described above is full of sense.

But the anxiety still shows through, as does the binary ranking.

> Seeker, *if you need to find something*...take courses in the history of the sciences.... *My* hope [however] does not follow the straight road, the monotonous and dreary methodology from which novelty has fled; my hope invents the cut-off trail, broken, chosen at random from the wasp, the bee, the fly.

If you are actually involved in changing state policy on the one hand, and earning the right to be heard and trusted by the subaltern on the other, on behalf of a change that is both medicine and poison, you cannot choose to choose the cut-off trail, declaring it as a hope when for some it has been turned into despair. And, if, like Derrida and Foucault, you are a scrupulous academic who *is* largely an academic, you stage the crisis relationship in various ways instead of legitimizing the polarization between the academy and the real world by disavowing it, and then producing elegant solutions that will never be seriously tested either in large-scale decision-making or among the disenfranchised.

Thus the figures of Mahasweta's fiction are at odds with the project of access to national constitutional agency for the tribal and the outcaste upon which Mahasweta is herself actively bent. This is not a contradiction, but rather the critical *rapport sans rapport* of which I spoke earlier. The most spectacular example is from "Douloti the Bountiful."[89] Here the affective, nostalgic tribal world of the young central character, a bonded prostitute, is represented with the great delicacy of a lyric sentiment that is at odds with the harsh, critical collectivity of prostitutes, and the armed struggle of the men in that gender-divided world. The aporia is staged *in* the fiction. These women of Mahasweta's fiction are almost like unconnected letters in a script neither archaic nor modern, caught neither in a

past present, nor on the way to a future present. They are monuments to the anxiety of their inevitable disappearance as "justice is done," and the episteme is on the way to regularization. If you consider Mahasweta's fictive and social text together, "feminism" becomes a necessary but misfitting name. We keep pushing her: tell us, you *must* be doing this? She will say, goodnaturedly—yes, yes. Or, being irascible, and not as eager to placate as a senior academic—no.

I think now of the improbable hero of her novel "Pterodactyl, Pirtha, and Puran Sahay": a pterodactyl, discovered in a tribal area in the modern state of Bihar. It could not be kept alive, although the journalist and the child wanted to feed it. The look in its eyes could not be understood. The child drew its picture on the cave wall. The latest entry into that collection of figures, mute guest from an improbable and inaccessible past, before the origin of paleonymy or archaeology, guardian of the margin, calling for but not calling forth the ethical antiphone, measures for me the risk of obliterating the rift between the narrow and the general in the name of a merely liberal politics.

NOTES

1. Michel Foucault, *The History of Sexuality, Vol. 1: An Introduction*, trans. Robert Hurley (New York: Vintage, 1980). The particular title of this volume in French is *The Will to Knowledge*. I will occasionally refer to the book by that title. All translations, from this and other French texts, have been modified when necessary.

2. Ernesto Laclau and Chantal Mouffe's provocative and influential *Hegemony and Socialist Strategy: Towards a Radical Democratic Politics*, trans. Winston Moore and Paul Cammack (London: Verso, 1985) must be counted among these.

3. For the academic circumstance, see Didier Eribon, *Michel Foucault* (Paris: Flammarion, 1989), pp. 144–47. Roy Boyne, *Foucault and Derrida: The Other Side of Reason* (London: Unwin Hyman, 1990) sees Foucault's entire subsequent project as a considered response to Derrida's early critique, going beyond the published reply, which was confined to "the sociological phenomenon of academic disputations" (p. 88).

4. Irene Diamond and Lee Quinby, eds., *Feminism and Foucault: Reflections on Resistance* (Boston: Northeastern University Press, 1988).

5. Zillah R. Eisenstein, *The Female Body and the Law* (Berkeley: University of California Press, 1988), pp. 6–41.

6. Edward W. Said, "Michel Foucault, 1926–1984," in Jonathan Arac, ed., *After Foucault: Humanistic Knowledge, Postmodern Challenges* (New Brunswick: Rutgers University Press, 1988), pp. 1–2.

7. Foucault, *History of Sexuality*, p. 93. The two following passages are also on this page. I have related this to "woman" as masterword in "In a Word," interview with Ellen Rooney, in *Outside*, pp. 1–23.

8. Said's work acknowledges Foucault's influence too frequently for a single reference. I am referring specifically to Edward W. Said, "Foucault and the Imagination of Power," in David Cozens Hoy, ed., *Foucault: A Critical Reader* (Oxford: Blackwell, 1987), pp. 149–55. Sheldon Wolin, "On the Theory and Practice of Power," in *After Foucault*, pp. 179–201.

9. Spivak, *Outside*, pp. 121–40.

10. Hoy, *Reader*, p. 135. The following passage is on the same page.

11. *Ibid.*, pp. 28, 136. Emphasis mine.

12. For a different and most interesting sense of nominalism, see Etienne Balibar, "Foucault et Marx. L'enjue du nominalisme," in George Canguilhem, ed., *Michel Foucault Philosophe: Recontre Internationale Paris, 9, 10, 11 Janvier 1988* (Paris: Seuil, 1989), pp. 75–75.

13. To compile a responsible balance sheet of the two bodies of thought, to bring about articulation, is a somewhat different enterprise. For a consideration of Foucault's politics from a deconstructive point of view, see Tom Keenan, "The 'Paradox' of Knowledge and Power: Reading Foucault on a Bias," *Political Theory* 15:1 (February 1987), pp. 5–32. For a broader articulation, see Boyne, *Foucault and Derrida*. This book came to my attention after I had completed the initial draft of this essay. Although I cannot agree with many of the details of interpretation in it, I am in general sympathy with Boyne's careful attempt at articulation. By contrast, my essay does not offer a survey but rather moves out in irregular circles from one sentence in Foucault.

14. *OG*, 47. The rest of the citations in this paragraph are from the same passage.

15. Boyne's sense of "reason-in-general" in Derrida is much more localized than my own reading of the general and the narrow.

16. Richard Rorty, "Moral Identity and Private Autonomy," in *Foucault Philosophe*, p. 388.

17. Jürgen Habermas, *The Philosophical Discourse of Modernity*, trans. Frederick Lawrence (Cambridge, MA: MIT Press, 1987), pp. 185–210.

18. Rorty, "Moral Identity," p. 390.

19. Although Habermas is more respectful towards Foucault, he puts him with Derrida in his insistence that Foucault is too "literary." *Modernity*, p. 238.

20. Richard Rorty, "Habermas and Lyotard on Postmodernity," in Richard J. Bernstein, ed., *Habermas and Modernity* (Cambridge, MA: MIT Press, 1985), p. 173.

21. For a discussion of the Heideggerian swerve see Jacques Derrida, "The Ends of Man," in *Margins of Philosophy*, and the magisterial *Of Spirit: Heidegger and the Question*, trans. Geoffrey Bennington and Rachel Bowlby (Chicago:

University of Chicago Press, 1989). The Foucault passage on Heidegger is from "Final Interview," trans. Thomas Levin and Isabelle Lorenz, in *Raritan* 5:1 (Summer 1985), p. 8. It is characteristic of Habermas's strong misreading of Foucault that he sees the connection with Heidegger, articulates it as yet another French failure to use German material, contrasts Foucault yet once again to Adorno who did so much better along this line, and finally diagnoses the Heidegger connection as an irritating affinity for Foucault to acknowledge (Habermas, *Modernity*, pp. 256–57)! It is beyond the scope of this essay to engage with Pierre Bourdieu's account of the Heideggerian trajectory itself in Pierre Bourdieu, *The Political Ontology of Heidegger*, trans. Peter Collier (Oxford: Polity Press, 1991).

22. Jacques Derrida, "Comment Donner Raison? 'How To Concede, with Reasons?,'" *Diacritics* 19:3–4 (Fall–Winter 1989), p. 8. This is no place for undertaking a commentary on Derrida's turning of Heidegger. As of this writing, Herman Rappaport, *Heidegger and Derrida: Reflections on Time and Language* (Lincoln: University of Nebraska Press, 1989) is perhaps the most recent extended publication on this subject.

23. Michel Foucault, *La volonté de savoir* (Paris: Gallimard, 1976), p. 122.

24. This pervasive suggestion in Derrida begins to appear as early as "Structure, Sign, and Play in the Science of Man," in Richard Macksey and Eugenio Donato, eds., *The Structuralist Controversy: the Languages of Criticism and he Sciences of Man* (Baltimore: The Johns Hopkins University Press, 1972).

25. Jean Baudrillard is excited by the electrical metaphor and understands the need for catachresis in his *Forget Foucault*, English trans. (New York: Semiotext(e), 1987), pp. 33f. But he is so intent on proving the superiority of his own idea that the real is forgettable, that he seeks to demolish Foucault's notion of power by complaining that there is *no* such example of power to be found in reality!

26. Walter J. Ong, *Orality and Literacy: The Technology of the Word* (New York: Methuen, 1982).

27. Rorty, "Moral Identity," p. 388.

28. *The Common Good: Social Welfare and the American Future* (New York: Ford Foundation, 1989), p. 2.

29. Hoy, *Reader*, pp. 142–43.

30. *Ibid.*, p. 139.

31. Michel Foucault, "The Subject and Power," in Hubert L. Dreyfus and Paul Rabinow, *Michel Foucault: Beyond Structuralism and Hermeneutics* (Chicago: University of Chicago Press, 1983), 2nd ed., p. 225.

32. Jana Sawicki, "Feminism and the Power of Foucauldian Discourse," in *After Foucault*, p. 166.

33. For a detailed discussion of these aggregative apparatuses, see Gilles Deleuze, "Qu'est ce qu'un dispositif?," in *Foucault Philosophe*, pp. 185–93.

34. Habermas's casual inattention is nowhere more marked than in his bulldozing of this passage, with no reference: "In his later studies Foucault will...comprehend power as the interaction of warring parties, as the decentered network of bodily, face-to-face confrontations, and ultimately as the productive penetration and subjectivizing subjugation of a bodily opponent" (*Modernity*, p. 255).

35. François Ewald (of Richard Rorty), "Compte rendu des discussions," *Foucault Philosophe*, pp. 39f.

36. Jacques Derrida, "Cogito and the History of Madness," in *Writing and Difference*, trans. Alan Bass (Chicago: University of Chicago Press, 1987), p. 49; word order rearranged for coherent citation.

37. Although Hegel is not mentioned in Derrida's essay, this extinction may be dramatized in the break between the Absolute Necessity of Being and the beginning of Determinate Being in Hegel's *Science of Logic*, trans. A. V. Miller (New York: Humanities Press, 1969), pp. 108–09.

38. Derrida, "Cogito," pp. 57–58, 61.

39. *Ibid.*, p. 60. Was Foucault "right or wrong" in rapping Derrida on the knuckles in his well-known response, "My Body, This Paper, This Fire"? Trans. Geoff Bennington, *Oxford Literary Review* 4:1 (Autumn 1979), pp. 9–28. Let the more mature Foucault provide the answer: "There are the sterilizing effects: Has anyone ever seen a new idea come out of a polemic? And how could it be otherwise, given that here the interlocutors are incited, not to advance, not to take more and more risks in what they say . . ." ("Polemics, Politics, and Problemizations," in Paul Rabinow, ed., *The Foucault Reader* [New York: Pantheon, 1984]). Derrida's point is not really about dreams and madness. But Foucault has a lot at stake in dreams. For the reader of the exchange, it remains interesting that Foucault's avowed origin is in the decipherment of dreams (Michel Foucault and Ludwig Binswanger, *Dream and Existence*, trans. Forrest Williams and Jacob Needleman, a special issue from *Review of Existential Psychology and Psychiatry* 19:1 [1984–85]), and the end is also with a book of dreams: *The Care of the Self* opens with Artemidorus's *Interpretation of Dreams*.

40. I believe this to be so much an ordinary-language aspect of the doublet that most French interpretations simply take it for granted. See for example *Foucault Philosophe*, pp. 61, 65, 95–96, 207. Deleuze's book on *Foucault*, trans. Sean Hand (Minneapolis: University of Minnesota Press, 1988), comes alive if this is kept in mind. I have hyphenated *pouvoir-savoir* whenever I have wanted to emphasize this aspect.

41. For relevant discussions in the later Foucault, see "The Ethic of Care for the Self As a Practice of Freedom," in James Bernauer and David Rasmussen, eds., *The Final Foucault* (Cambridge, MA: MIT Press, 1988), pp. 114, 122–23, 130. At this point the ontico-ontological *différance* has been rewritten as an entryway: "I have tried to know [*savoir*] how the human subject entered into games of truth"; *pouvoir-savoir* rendered into "how games of truth can put themselves

in place and be linked relationships of burden of paleonymy": "The word 'game' can lead you into error: when I say 'game,' I say an ensemble of rules for truth-production [*je dis un ensemble de règles de production de la vérité*]."

42. This fits the United States case. Looking forward to my last section, let me simply remind the reader that the possibilities within a feminist pedagogy of the oppressed in decolonized areas are of course much more complicated.

43. Michel Foucault, *The Archaeology of Knowledge and the Discourse on Language*, trans. A. M. Sheridan Smith (New York: Pantheon, 1973), pp. 15f. The next passage is on p. 119.

44. Foucault, *Archaeology*, pp. 79–80.

45. Derrida, *Of Spirit*, p. 32. Heidegger, *BT*, 423.

46. For a staging of this see Derrida, "My Chances/*Mes Chances*: A Rendezvous with Some Epicurean Stereophonics," trans. Irene Harvey and Avitall Ronell, in Joseph H. Smith and William Kerrigan, eds., *Taking Chances: Derrida, Psychoanalysis, and Literature* (Baltimore: Johns Hopkins University Press, 1984), pp. 1–32.

47. Foucault and Binswanger, *Dream and Existence*. "To study forms of experience in this way—in their history—is an idea that originated with an earlier project, in which I made use of the methods of existential analysis in the field of psychiatry and in the domain of 'mental illness'" (Preface to the *History of Sexuality*, vol. 2, in Rabinow, *Reader*, p. 334. At that earlier stage, Foucault conceived of his project in Husserlian terms. But the lineaments of the thematic—of making the constitutive rupture workable—that I have been at pains to disclose are straining through.

Phenomenology has managed to make images speak; but it has given no one the possibility of understanding their language.... The dream is situated in the ultimate moment in which existence is still its world; once beyond, at the dawn of wakefulness, already it is no longer its world.... Analysis of a dream starting from the images supplied by waking consciousness must precisely have the goal of bridging that distance between image and imagination.... Thus is the passage from anthropology to ontology, which seems to us from the outset the major problem of the analysis of *Dasein*, actually accomplished [Foucault and Binswanger, *Dream and Existence*, pp. 42, 59, 73].

With benefit of hindsight, one can see the way clear from the rarefied *énoncé* of the *Archaeology* to the ethical self-constitution of the final phase: "The dream is not meaningful only to the extent that psychological motivations and physiological determinations interact and cross-index in a thousand ways; on the contrary, it is rich by reason of the poverty of its objective context [English translation unaccountably has 'content' here].... Cultural history had carefully presented this theme of the ethical value of the dream" (Derrida, "My Chances/*Me Chances*," pp. 44, 52).

48. Quoted in Eribon, *Foucault*, p. 94.

49. Foucault, *Archaeology*, p. 16.

50. Boyne, *Foucault and Derrida*, p. 32; the next passages are from pp. 35, 70. I have quoted these three passages from Boyne to demonstrate Boyne's feeling for the readings, though not necessarily for their philosophical moorings and undermoorings.

51. Derrida, *Glas*, trans. John P. Leavey, Jr., and Richard Rand (Lincoln: University of Nebraska Press, 1986).

52. Michel Foucault, *Folie et déraison: Histoire de la folié à l'âge classique* (Paris: Plon, 1961).

53. "I did not want to make history of that language; rather the archaeology of that silence" (Foucault, *Folie et déraison*, p. v).

54. Dreyfus and Rabinow, *Foucault*, p. 209.

55. See Derrida, "The Ends of Man." Hubert L. Dreyfus can make the case for a substantive affinity between Heidegger's "Being" and Foucault's "power" by rendering Heidegger into what I shall call the Anglo-United States episteme later in this essay, and by refusing to "read" all the passage from Foucault that he cites, in "De la mise en ordre de choses: L'Etre et le Pouvoir chez Heidegger et Foucault," in *Foucault Philosophe*, pp. 101–21.

56. This point of view is to be found in Rorty, "Moral Identity."

57. André Glucksmann, "Le nihilisme de Michel Foucault," in *Foucault Philosophe*, p. 389.

58. Jacques Derrida, "The Politics of Friendship," *Journal of Philosophy* 85:11 (November 1988), pp. 632–44. This is an abridged version of a longer, unpublished paper, "Of Friendship and Democracy."

59. Jacques Derrida, "Violence and Metaphysics," in *Writing and Difference*, pp. 79–153.

60. In view of Derrida's intense concern for "the sign 'man'" since "The Ends of Man," Boyne's *Foucault and Derrida*, p. 89 note 18 is surprising. Major Derrida texts mobilized by this concern are *Glas* and *The Post Card*, trans. Alan Bass (Chicago: University of Chicago Press, 1986). On the latter I feel constrained to cite Spivak, "Love Me, Love My Ombre, Elle," in *Diacritics* 14:4 (1984), pp. 19–36 because it is a feminist discussion.

61. James Joyce, *Finnegans Wake* (New York: Viking, 1969), p. 51.

62. Dreyfus and Rabinow, *Foucault*, p. 240. The earlier passage is from Foucault, "An Aesthetics of Existence," in John Johnston, trans. *Foucault Live: Interviews, 1966–84* (New York: Semiotext[e], 1989), p. 312, 310–11.

63. Foucault, "Preface to the *History of Sexuality*," vol. 2, p. 339.

64. Foucault, "Ethic of Care," p. 118.

65. *Ibid.*, p. 256.

66. Rabinow, *Reader*, p. 389.

67. Habermas, *Modernity*, p. 256. Thus I must read Thomas Flynn's account of the change in Foucault's last lectures as, strictly speaking, a displacement

upon the constituted subject where it is the agent of truth-telling rather than simply a changeover to "the subject as the 'agent' of truth-telling" (Thomas Flynn, "Foucault as Parrhesiast: His Last Course at the Collège de France," in Bernauer and Rasmussen, *The Final Foucault*, p. 106). Flynn's lovely essay can take this reading on board. As he writes: "It is clear that Foucault continued to respect these 'structuralist' concepts as he insisted that we 'rethink the question of the subject'.... He was not growing soft on subjectivism" (Flynn, "Parrhesiast," p. 225).

68. Foucault, "Final Interview," p. 12. Emphasis mine.

69. Foucault, "Polemics," in Rabinow, *Reader*, p. 389.

70. Foucault, "Ethic of Care," p. 115.

71. For my use of (im)possibility, see Spivak, "A Literary Representation of the Subaltern: A Woman's Text from the Third World," in *Worlds*, pp. 263, 308 n. 81. Flynn signals the final shift as follows: "What is at issue is not a 'testing' of one's life once and for all but an ongoing practice, a certain style of life" (Flynn, "Parrhesiast," p. 219). In the model I derive from Derrida, it is the testing itself that is an askew on-going practical counterpoint, employing all the subterfuges of any serious *technè*.

72. Gary Gutting, *Michel Foucault's Archaeology of Scientific Reason* (Cambridge: Cambridge University Press, 1989).

73. Gutting, *Foucault's Archaeology*, p. 261. Michael Donnelly wants "to reformulate some of Foucault's concepts, to make them at once more analytically adequate and more accessible to historians and social science researchers" ("Des divers usages de la notion de biopouvoir," *Foucault Philosophe*, p. 231). Manfred Frank throws down the gauntlet for Foucault's critique of ethics by suggesting that the writing of books like *The Birth of the Clinic* and *Discipline and Punish* presupposed an ethical decision (*Foucault Philosophe*, p. 259). And Frank Lentricchia, finding Foucault a champion of the individual, writes: "Foucault is not sanguine about the survival of the individual. Discipline insidiously invades the ground of individuality in order to master it," *Ariel and the Police: Michel Foucault, William James, Wallace Stevens* (Madison: University of Wisconsin Press, 1988), p. 26.

74. Dreyfus and Rabinow, *Foucault*, p. 231.

75. Paul Bové, "The Foucault Phenomenon: The Problematics of Style," in Gilles Deleuze, *Foucault*, trans. Seàn Hand (Minneapolis: University of Minnesota Press, 1988), pp. ixf.

76. Boyne, *Foucault and Derrida*, p. 158; subsequent passages in this paragraph are from pp. 130, 131, 143.

77. For the relevant passage in Derrida, see "Of Grammatology as a Positive Science" (*OG*, pp. 74–93).

78. The passages in this paragraph are from Boyne, *Foucault and Derrida*, pp. 79, 90, 170.

79. Against Habermas's feeling that, for Foucault, "the politics that has stood under the sign for the revolution since 1789 has come to an end" (*Modernity*, p. 282), or Rorty's that Foucault's "remoteness...reminds one of the conservative who pours cold water on hopes for reform, who affects to look at the problems of his fellow-citizens with the eye of the future historian" (Rorty, "Habermas and Lyotard," p. 172), is the final Foucault's counterpointed distance: "We have a subject who was endowed with rights or who was not and who, by the institution of a political society, has received or has lost rights.... On the other hand, the notion of governmentality allows one, I believe, to set off the freedom of the subject and the relationship to others, i.e., that which constitutes the very matter of ethics" ("Ethic of Care," p. 131).

80. Alessandro Pizzorno, "Foucault et la conception libérale de l'individu," *Foucault Philosophe*, p. 238.

81. Flynn, "Parrhesiast," p. 227.

82. Foucault, "Ethic of Care," pp. 112–14.

83. Bhikhu Parekh, "Identities on Parade," in *Marxism Today* (June 1989), p. 27.

84. I cannot go here into the considerable difference in historico-political inscription of our two philosophers. Suffice it to say that as a Sephardic Jew growing up in North Africa, Derrida as not exactly a participating member in the colonial enterprise.

85. Rorty, "Moral Identity," p. 387.

86. The rejection of Melanie Klein by official North Atlantic feminism can resonate with this.

87. Mahasweta Devi, "Draupadi," "Breast-Giver," in Spivak, *Worlds*, pp. 179–96, 222–40. A discussion of "The Hunt" is to be found in Spivak, "Who Claims Alterity?," in Barbara Kruger and Phil Mariani, eds., *Remaking History* (Seattle: Bay Press, 1989), pp. 269–92.

88. Michel Serre, "Literature and the Exact Sciences," *Sub-Stance* 18:2 (1989), p. 4. The subsequent passages are from pp. 6, 23.

89. In Mahasweta Devi, *Imaginary Maps,*, trans. Gayatri Chakravorty Spivak (New York: Routledge, 1995), pp. 19–93. For more on this story, see "Limits and Openings of Marx in Derrida," in *Outside*, pp. 97–119. "Pterodactyl" is also included in *Imaginary Maps*, pp. 95–196.

Echo

(1993)

In the previous chapter, Spivak observed of Foucault's Anglo-American reception: "It is as if, assembled at a race where the point is to stay on a bicycle at as slow a speed as possible—see how close you can get to *pouvoir-savoir* degree zero in order to think ethics in its 'real' problems—these colleagues would murmur, you can use these machines to get places fast too, you know!" She found in Foucault's notion of *pouvoir-savoir* yet another powerful rationale for not entering into a United States-style Tour de France in the name of ethics. She offered us instead the radically ethical procedure of a slow, persistent deconstructive critique of liberal humanist desires. Thus she declared herself to be game to continue participating in the grand debates that fill the pages of the most prestigious Euro-American intellectual journals devoted to critical theory and philosophy. In spite of her turn toward Third World issues and multicultural and identity politics over the last twelve years, and really also because of it, Spivak has never abandoned the philosophical arena or ceased to do battle with humanist high-mindedness.

The irony attached to her ethical enterprise these days is that Spivak works within the philosophical arena as a postcolonial critic; in doing this, she is bound to be read by Eurocentric humanists as an Other, but she does so in order to change the rules so that the participants might unlearn that very structure of imperial othering. Following her work with Bimal Krishna Matilal—a distinguished Fellow of All Souls College, Oxford—on Indic ethics and epics, Spivak in this essay rereads Ovid's and Freud's narratives of Narcissus and Echo. She wonders how it is that Freud and, more recently, Christopher Lasch have attributed narcissism primarily to women, when Narcissus was a boy. And, she asks, where is Echo, the woman in the story? Spivak's feminist reading of the Narcissus and Echo text is, she claims, "an attempt to 'give woman' to Echo, to deconstruct

her out of traditional *and* deconstructive representation and (non)representation, however imperfectly."

Attending to situated ethical performance by way of "reading" narrative as an ethical instance, Spivak offers her readers the ethical instantiation that is Echo's: the potential undoing of Narcissus's self-fixation. For Ovid's Echo is staged "as the instrument of the possibility of a truth not dependent upon intention." Through texts by Mahasweta Devi and the Algerian writer Assia Djebar, Spivak applies this new ethic to the question of feminism and decolonization. Lest, however, her essay be cast aside after a merely pious reading of yet another Third World intervention—so that the serious mainstream work of deconstruction can go on—Spivak addresses some of that work (Claire Nouvet, André Green, Samuel Weber) directly in a powerful conclusion that aims to secure her further exchanges in these high ethical debates. In doing so, she makes it ethically impossible to displace the position of the Third World feminist interventionist and return to business as usual.

I started to think specifically about Narcissus when I came across Christopher Lasch's *The Culture of Narcissism*.[1] The book seemed such an attack on the few social gains made by feminism. Yet Narcissus was a boy! What seemed particularly unjust was the description of the young executive as "the happy hooker." (The word *Yuppie* had not yet come into the common language.) Prostitutes, however, were already organizing precisely because their class position was rather different from that of young executives.[2] I turned to Freud and found that he too had located the richest examples of narcissism among women, especially women unfulfilled by the secondary narcissism of motherhood. Where was Echo, the woman in Narcissus's story? My essay is an attempt to "give woman" to Echo, to deconstruct her out of traditional *and* deconstructive representation and (non)representation, however imperfectly.

There is a curious moment, peculiarly susceptible to racist misuses, in Freud's "On Narcissism: An Introduction": "We have learned that libidinal instinctual inferences undergo the vicissitudes of pathogenic repression if they come into conflict with the subject's cultural and ethical ideas.... What he projects before him as his ideal is the *Ersatz* of the lost narcissism of his childhood, in which he was his own ideal.... The ego ideal...has a social side; it is also the common ideal of a family, a class or a nation."[3] It is certainly at least implied here that the felicitous emergence of the superego happens because there is something other than mere conflict between cultural and ethical ideas and the libidinal instinctual inferences.

The full-blown version of this particular theme—of non-European cultures being stuck in varieties of narcissism and its vicissitudes—is not uncommon. Asia and Africa are always supposed to have had trouble with Oedipus. (Very broadly and irreverently speaking, if—as a man—you can't get to Oedipus, you are stuck with Narcissus. Women can't pass through Oedipus, and therefore the secondary narcissism of attachment to the (boy)child saves them from themselves, from penis envy, and so forth.) Their growth is arrested on the civilizational scale. Hegel trumped Freud in this in his plotting of the itinerary of the Spirit of Art.[4] In the case of India, which in a certain way I "know" best, Sudhir Kakar, the eminent psychoanalyst, has diagnosed the Indian male type to be arrested in the moment of Narcissus.[5] V. S. Naipaul, a diasporic Indian visiting India for the first time in 1962, fell on this diagnosis with a vengeance. Although he has put down his earlier overreaction against India to his own ancestral Indo-Caribbean past in his new book, this particular definitive view seems unchanged; "underdeveloped ego" in the first book, infantile golden-ageism in the second. These are the two moments: Narcissus and the ego ideal.[6] Thus you might say that I am interested in the psychoanalytic Narcissus because, in a kind of "colonial" reconstellation of the matter of "Greece," he is made to stand at the door of the free discourse of Oedipus.

I have always felt uneasy about the use of psychoanalysis in cultural critique since it is so culture-specific in its provenance. Like many others, I too have felt that Marxism, focusing on something on a higher level of abstraction than the machinery, production, and performance of the mental theater, and as obviously global as capitalism, is not open to this particular charge. (To say capitalism is all over the place is not as universalist as to say everyone's psyche is patterned the same.) Although I feel the weight of Derrida's critique of institutional psychoanalysis in the world, especially with regard to such deeply ambivalent questions as psychiatric care for the Union Carbide victims of Bhopal, since I am not qualified to speak of psychoanalysis as clinical practice, I must leave it largely alone.[7]

For the use of feminist psychoanalysis in understanding sexual difference and gendering I feel some sympathy because it is so actively contestatory. But general cultural critique has always seemed to me to be quite another matter. Without the risks or responsibilities of transference, at least implicitly diagnostic and taxonomic, ignoring geopolitical and historical detail in the interest of making group behavior intelligible, and not accountable to any method of verification, the brilliance of psychoanalytic cultural criticism has always left me a bit suspicious.

Yet Freud has remained one of my flawed heroes, an intimate enemy. To his race-, class-, and gender-specificity I would apply a version of the words I wrote about Charlotte Brontë more than a decade ago: "If even minimal-

ly successful, my reading should incite a degree of rage against the gendered/imperialist narrativization of history, that it should produce so abject a script for him."[8]

Both Freud and Marx move me in their engagement with ethics. Freud thought he had revised Kant, the representative ethical philosopher of the Enlightenment.[9] In spite of all Freud's claims, it is his vulnerability as a moral philosopher that is for me a lesson of history.

It was finally my contact with the ethical philosopher Bimal Krishna Matilal that allowed me to make room for Freud in my intellectual world. Professor Matilal argued that nineteenth-century Indologists were basically correct in estimating that India had no tradition of moral philosophy in the Western European sense.[10] But they had not been able to grasp either the Indic tradition of rational critique or the tradition of practical ethics in India. According to Matilal, the latter was based on the reading of narrative instantiations of ethical problems. We read some of the *Mahābhārata* together in this way. I realized that this way of doing rather than exclusively talking about doing (the other is also an ethical decision, of course—this is at the root of my unease with the use of psychoanalysis in cultural critique) ethics was a rather widespread, rather global, phenomenon, not confined to non-European cultures. It had been ranked as "popular" by most high-cultural European-model moral philosophical systems. (I am speaking of diagnosing story lines as formal allegories, drawing morals from parables, or attention to the "moral dimension" of fiction.) Jon Elster's *Ulysses and the Sirens*, which I as reading at the time, seemed an example of moral philosophizing on that "popular" model.[11] And psychoanalysis, as a challenge to systematic moral philosophy, had certainly read received narratives and the sequentially constructed narratives of analysands as instantiations of socio-ethical problems. As a cultural critic rather than a clinical practitioner, I was not obliged to take the conclusions as a scientific system. As a being in ethics, I could share them as malleable situational lessons.

Professor Matilal also suggested that the moral dilemma was the most important terrain for the exercise of this type of practical ethics as encountered in the Indic tradition. Freud's recognition of the aporia between terminable and interminable analyses resonated with this suggestion.[12] Derrida's work is also a critique of traditional European systematic moral philosophy, after all. Further, this particular privileging of the aporia in the field of ethical decision seemed quite apposite to the tale of Narcissus. As I will attempt to show in my reading of Ovid, it is a tale of the aporia between self-knowledge and knowledge for others.

In this matter of knowledge for others I also received an impetus from my discussions with Bimal Matilal. He discussed an argument advanced by Gaṅgeśa, a twelfth-century linguist, that the production of truth was

not necessarily dependent upon the speaker's intention. (This is *bhrāntapratārakavākya*, the case of the deluded deceiver, who speaks the truth while thinking to lie.)[13] I felt that Ovid himself, against his probable intentions, had monumentalized in neglected Echo the random possibility of the emergence of an occasional truth of a kind.[14]

Freud's "On Narcissism," written on the threshold of *The Metapsychological Papers*, is philosophically bold. The desire of psychoanalysis is to tap the illogic that produces the subject's logic, and also the logic of the subject's illogic. Thus at the opening of the essay, Freud quietly asserts that at the origin "of the hypothesis of separate ego- and sexual-drives" (N, 79) there is no grounding unity but only a riddle, the grounding riddle or *Grundrätsel* of biology. Unlike the Sphinx's riddling question to Oedipus, which for Hegel signifies the turn to Europe, "it is as idle to dispute" this absence of ground "as to affirm it" (N, 79).[15] The theory of the separation of the ego and sexual drives, as necessary to psychoanalysis as the separation of Mind and Knowledge to Hegel, arises simply out of the fact that "it is a necessary hypothesis that a unity comparable to the ego cannot be available [*vorhanden*] to the individual from the start" (N, 76–77). This acknowledgment of risk, the revelation of the ground of the cure as a necessary methodological presupposition, is the Freud of the dilemma, the one who resonates with all my predilections for the dilemma as the type case of the ethical situation, which I have outlined in the opening pages of this essay. (If there is an objection to seeing the analyst's behavior as a species of ethical behavior—doing the right thing for the other person in light of the best knowledge available—then this resonance will fail.) How then does he interrupt the risk with the claim to science? "I am of the opinion that that is just the difference between a speculative theory and a science built upon the interpretation of the empirical. The latter will not envy speculation its privilege of having a smooth, logically unassailable foundation [*Fundamentierung*].... The fundament [*Fundament*] of science...is observation alone" (N, 77).

It is a nice reversal of received ideas: speculation is logically firm; science is logically ungrounded but has an observational foundation. It will not surprise us that the science is anthropology and the observation fieldwork: specifically, his speculation about "the mental life of primitive peoples." This speculation then allows him to draw conclusions about "the mental life of children"—although in the sentence describing the nature of these observations he conflates the two groups of people, as though primitive peoples were childless (N, 75). In fact, if the analogy between primitive peoples and children were not scientific, the fundament of the science would be blown away. I am obliged to notice that the ground of the differ-

entiation between the speculative and the scientific is becoming rather shaky here as well. We are told not to try to grapple with the grounding biological riddle of sexual difference providing a basis for a theory arguing the ego's initial separation from sexual drives because it would be as ridiculous as attempting to prove inheritance by arguing from the kinship of all races. Does not the childlike behavior of primitive peoples belong to the same order of argument? In fact, is it not, in a certain way, exactly the opposite of arguments about the universal kinship of races? If the other term of the analogy brings the activities of the analyst practicing terminable analysis into the same workaday register as the settlement of legal disputes, then the entire justification of the scientificity of the diagnosis of narcissism is dubious.

What does Freud observe, when he tells us that "this extension of the libido theory receives reinforcement from our observations and views [speculations?] on the mental life of children and primitive peoples" (N, 75)? "In the latter," he continues, "we find characteristics which, if they occurred singly, might be put down to megalomania. In the children of today, whose development is much more opaque [undurchsichtbar] to us..." (N, 75). Why are the characteristics of remote primitive peoples transparent to "us"? So that they can offer a basis for the firm foundation of science? And why do "we expect to find an exactly analogous attitude" (N, 75) in the children of today? Is this not the same sort of desire for a methodological certainty which had been sternly put in its place earlier? Once the analogy is "found," or rather the declaration of its expectation is offered as its finding, the primitive peoples are not heard of again.

I am not complaining that Freud is not sufficiently scientific. I have already said that it is the Freud who acknowledges dilemmas with whom I am in sympathy. I am remarking that the scientific basis that Freud needs is deeply marked by a rather offensive sort of casual racism for which there is certainly no precedent in the authoritative staging of the Narcissus narrative in Ovid. Freud was a man of considerable classical education and a sensitive reader. One might even invent a curious connection between Ovid's stated project in the Metamorphoses and Freud's stated project in the narcissism essays. Freud: I am "replacing the special chemical substances [of the organic soil (Boden) of the psyche] by special psychical forces" (N, 78). And Ovid, at the opening of Metamorphoses: "My mind is bent to tell of bodies changed into new forms."16

Yet Freud leaves Ovid alone. In fact, Ovid's Narcissus, at first sight, seems to suffer from Freud's version of secondary narcissism. In one Freudian articulation at least, primary narcissism is an "absolute self-sufficien[cy] from which we step, toward noticing a changeful world outside and the beginnings of finding objects, by being born [mit dem

Geborenwerden]."[17] Here the mother is nothing but, in Luce Irigaray's word, an "envelope."[18] By contrast, in Ovid, Liriopes's womb has a history. It comes to envelop Narcissus by a primary rape by Cephisus, demidivine violence as sexual violence that does not offend the political economy of the gods. The entire pretext of Tiresias and Echo as major players is cross-hatched by a story of punishment and reward. When Freud and Lacan use the narratives as psycho-ethical instantiations they ignore this framing.

(It may be argued that Lacan dispenses with the story lines of Oedipus and Narcissus.[19] But Lacan is not a monolithic proper name. I cannot now spend time on the various turns in Lacan's career, nor on the connection between proper names and the psychoanalytic institution. Here suffice it to say that the idea of the Mirror Stage, Lacan's reinscription of Narcissus, was launched in 1936. In the 1949 version Oedipus is present without qualification; and the end of psychoanalysis is a rewriting of Narcissus's *iste ego sum* [I am that] into an ec-static *"Thou art that."* For Lacan, it is in this that "is revealed to [the patient] the cipher of his mortal destiny."[20] I will argue that it is Ovid's Narcissus who is an icon of mortiferous self-knowledge.)

Lacan's mirror-stage baby assumes his "specular image" jubilantly, thus "exhibit[ing] in an exemplary situation"—exactly as narratives instantiate active ethical structures—the "primordial form...[that] situates the agency of the ego, before its social determination, in a fictional direction, which will always remain irreducible for the individual alone."[21] Freud's secondary Narcissus is unenlightened.

How different this modern Narcissus—plotted (in both the early Lacan and Christopher Lasch) in terms of a rather banal contrast between group ("social") and individual ("fictional") or, in an admittedly subtler form in Freud, of an irreducible secondariness which alone gives a clue to the primary fiction, again a methodological, underived fiction—from Ovid's Narcissus, emerging from a scene of responsibility and punishment.[22]

Even as Freud and Lacan use an approximation of the Narcissus narrative for ethical instantiation, they ignore its framing. Indeed, as I look into the mass of learned literature on both the Narcissus tradition and narcissism, not only do I notice a singular absence of independent attention to the narrativization of Echo (the Renaissance practice of Echolalia has rather little to do with the rhetorical philosopheme called Echo), but also an ignoring of the frame.[23] I myself, although attentive to the frame, had not noticed Echo's part in it ten years ago. Here is what I wrote:

> The Narcissus story in Ovid is introduced by other accounts of sexual difference and divine violence. It unfolds while on earth a child torn from its mother's womb—because the mortal Semele could not withstand her lover

Jove's heavenly glory, a sight she craved by Juno's vengeful temptation—gestates in the Father's thigh, god appropriating woman's power. In the preamble of the Narcissus story as such stands Tiresias. He too names a site where sexual difference is suspended. To become woman was his initial punishment for disturbing the copulation of holy serpents. Retaining the memory of maleness he had realized that being-woman was a punishment. He had repeated his offense deliberately—an act of self-knowledge which will find its parallel in Narcissus—and won back maleness: a transformation-punishment that is thus also the fulfillment of his desire. Now he retains the memory of having-been-woman. He gives the opinion that women have greater sexual pleasure, an opinion contradicted by Narcissus' fulfillment and Echo's perpetual lack that we encounter in the embedded story. Juno punishes him with blindness; Jupiter compensates with clairvoyance.[24]

Ten years ago, Echo's figuration became clear. She too had served Jupiter. As he played with nymphs, she would engage Juno in prudent chat. It is this beguiling prudence that Juno takes from her: You can no longer speak for yourself. Talkative girl, you can only give back, you are now the respondent as such. Jupiter does not give her anything in return.

The story of Narcissus is framed, then, in the value-coding or gendering of affect in a spectacular dynamics of transgression and reward. For Narcissus himself, we remember Tiresias's famous line: He will live as long as he does not know himself. He can instantiate, in the kind of reading I am proposing, the construction of the self as an object of knowledge. (It is perhaps in the recognition of this mortiferous autoerotic model of self-knowledge that Rousseau made *Narcisse* the artist.)

There is a moment of exquisite anguish before the boy can describe his predicament: *et placet, et video; sed quod videoque placetque, / non tamen invenio* (M, 154, lines 446–47) (It pleases, and I see it; but I cannot reach what I see and what pleases). In his description, it is clearly knowledge of the division in identity that kills and inscribes him in nature. He points and declares, *iste ego sum*: "I am that…. I now know my image…. I have what I desire. Strange prayer for a lover, I would that what I love were absent…. Death is not serious for me for in death I will leave my sorrow" (M, 156, lines 463–71).

It should be noticed that *sum* in Narcissus's declaration is grammatically precarious in this declaration, yet possible. When Freud topologizes the psyche, it is the impossibility of self-knowledge as such that is captured in *wo Es war soll Ich werden* (where it was, I shall become). Narcissus's formula might run: *Wo Es ist, bin Ich (nicht)* (*Where it is, I am [not]*); the limit of the possibility of self-knowledge. In Freud's ethical reading of narratives, however, this relationship cannot be established. Freud's reading is

no different from the magisterial Christian reading of *Paradise Lost*.[25] And therefore we remain accustomed to interpreting the declaration of the Ovidian Narcissus as a psychic problem. Attending to the frame and the text, I am obliged to say: if this is pathogenic repression, what is on the other side is family romance. And Ovid's Narcissus, unlike Freud's, is not incapable of wishing for his own death.

Insofar as I am culturally banished from Oedipus, I relate the narcissian proposition to another type of ethical instantiation in the narrative moment. Here is the utterance of Mary Oraon, in "The Hunt" by Mahasweta Devi.[26] Mary is the girl-child of rape, of an Indian tribal by a colonial Englishman; as Narcissus is the boy-child of divine rape. Mary is the emblem of the subaltern postcolonial. "My mother should have killed me when I was born," says she. "And then, what about you?" asks another. "I would not have been," she answers.

This is the moment of Narcissus: If I make disappear what I cannot not desire, I disappear too. But this is only one end of the shuttle. We move now to Echo.

Echo in Ovid is staged as the instrument of the possibility of a truth not dependent upon intention, a reward uncoupled from, indeed set free from, the recipient. Throughout the reported exchange between Narcissus and Echo, she behaves according to her punishment and gives back the end of each statement. Ovid "quotes" her, except when Narcissus asks, *Quid...me fugis* (Why do you fly from me [M, 150, lines 383–84])? Caught in the discrepancy between second person interrogative (*fugis*) and the imperative (*fugi*), Ovid cannot allow her to *be*, even Echo, so that Narcissus, flying from her, could have made of the ethical structure of response a fulfilled antiphone. He reports her speech in the name of Narcissus: *quot dixit, verba recepit* (M, 150, line 384)—he receives back the words he says. The discrepancy is effaced in the discrepancy of translation. In English, Echo could have echoed "Fly from me" and remained echo.[27]

Narcissus is punished with the knowledge of the relationship between death and self-knowledge because he had not responded to the desire of others. But this punishment is not in the name of Echo. Here too Echo, by definition dependent, remains uncoupled from the effect of herself as cause. It is another youth of indeterminate sex who brings Nemesis down upon Narcissus. You scorn us; know yourself. Child of rape, know as your Mother knows—for Tiresias's answer about the consequences of Narcissus's self-knowledge had been given to Liriope: you disappear if you act on your knowledge.

Echo is dead in the narrative before this happens. And in her brief exchange with Narcissus, she marks the withheld possibility of a truth outside intention.

Is there a radical counterfactual future anterior, where Echo, against her intention, a poor thing at best, will forever have exercised the negative transference ("fly from me," between question and order) that will have short-circuited the punishment of mortiferous self-knowledge? Is that the impossible experience of identity as wound? The *a-venir* of history not written? But this can only be the radical interruption of ethical hope, which must be cut down to logical size so a calculus can be proposed. Let us look at Echo's death.

In an interruption of narrative time, Echo comes to echo farewell, to echo the rites of mourning.

At the moment of Narcissus's death, his sisters come to mourn him and in the place of the body find the flower. The body seems to have been inscribed into nature by the sheer force of the agon of self-knowledge. The flower nods at the water here on earth to be the *a-letheia* (truth as unforgetting) of the limits of self-knowledge, as Narcissus still gazes upon the waters of Lethe—though, unlike the Loeb translation, Ovid does not mention an image there: *in Stygia spectabat aqua* (M, 158, line 505, translated in the Loeb edition as "he kept on gazing on his image in the Stygian pool").[28]

By contrast, Echo's echoing farewell comes from a space already insufficiently inscribed—an insufficiency that is the name not of the limits of self-knowledge but of the possibility of deconstruction. The rest of my essay will elaborate on this theme.

At first there is nothing but voice and desiccated body. Finally there is nothing but voice, "for they say that her bones were turned to stone." Ovid uses a peculiar formulation: *vox manent* (M, 152, line 399). Received wisdom has it that it is *scripta* that *manent*—it is writing that remains. But in this singular space, voice remains, the body having become stone. "This structural possibility of being severed from its referent or signified (and therefore from communication and its context) seems to me to make of every mark, even if oral, a grapheme in general,...the nonpresent *remaining* of a differential mark cut off from its alleged 'production' or origin."[29]

Let us now consider this figuring of Echo in two related but different ways.

First, how does it give us the offer of a precarious foothold outside of the subject-position of the "wild" psychoanalytic cultural critic, producing an irresponsible simulacrum of the analyst in her consulting room? Just as Oedipus *has to be* male, Echo has to be female. (Narcissus as figured can go both ways and, as we have seen, in the banalized psychic-problematic interpretation, has been most often located in the female.) Echo is female figured because the asymmetry of the reward-punishment compensation circuit between herself and Tiresias is equalized, still asymmetrically, from the moment of the impossibility of echoing as punishment. This impossibility

lies between the Latin interrogative and imperative form of "fly from me," the two subject-positions named Narcissus and Echo in the exchange, where someone called Ovid (the analysand? the cultural critic? the received story-teller as writer? us?) has to take a role and fill in with "what happened"—which is never exactly "what happened"—marked with a difference, here the difference between question and response, questioner and respondent. Guarding this difference is Echo's punishment turned into reward, a decon-structive lever for future users. We remember that even if Echo had been able to echo and act according to mere punishment with no difference of subject-position, the response would have been a refusal to answer or (we cannot be sure) a suggestion that this particular respondent is inappropriate. Thus: *N: Why do you fly from me? E: Fly from me*—I cannot answer you, or I am not your proper respondent—a deferment independent of, indeed the oppo-site of, the sender's intention. A difference and a deferment together are, strictly speaking—but can one be strict about this?—*différance*.

Here is the figuration of Echo's "reward." Her punishment fails (in order) to mark *différance*. Ovid covers it over with telling; we open it.[30]

It is this mode of utterance that is covered over in Ovid's report that Echo says "fly from me[?]." In the rest of the narrative, through the repre-sentation of a stable-yet-unstable, same-yet-different non-originary voice that remains, an unintentional vehicle of a possible cure—the figured though separated accompaniment of a successful mortiferous self-knowl-edge that cannot advance—is glimpsed, a cure that is one possible case among many.

For Echo is obliged to echo everyone who speaks. Her desire and per-formance are dispensed into absolute chance rather than an obstinate choice, as in the case of Narcissus. If the ever-renewed narcissus flower is a "natural monument" to the fulfillment of Narcissus's desire-as-punishment out of this world, the lithography of Echo's bony remains merely points to the risk of response. It has no identity proper to itself. It is obliged to be imperfectly and interceptively responsive to another's desire, if only for the self-separation of speech. It is the catachresis of response as such.

Echo's mourning is outside the opposition of mourning and a melan-cholia only half of which is narcissism. She is inscribed as *destinerrance* as such. She gives the lie even to Derrida's absent interlocutrice, whom Derrida echoes and corrects (reaching for Narcissus and Ovid in one) in *The Post Card*: "P.S. I forgot, you are quite right: one of the paradoxes of destination, is that if you wanted to *demonstrate*, expressly for someone, that something never arrives at its destination, it's no use. The demonstra-tion, once it has reached its end, will have proved what one should not demonstrate. But this is why, dear friend, I always say 'a letter *can* always *not* arrive at its destination, etc.'"[31]

In my ethically instantiated reading of the Ovidian narrative, the traces of Echo occupy the position of something like an analyst. Under the broken rebus—legendary bones and paradoxically persistent absent voice, connected by nothing at all—that is her mark or guarantee that she will be around, the mastership of truth (Derrida's critique of the Lacanian analyst) *is* the experience of the impossible (Derrida's description of ethics).[32] Echo will not have been dragged into the circuit of political imitations.

And now the second question: What ethical instantiation does this figuration of Echo offer "us"—the worldwide collectivity of conscientized feminists of color from bourgeois origins or in passive capitalist social relations? We must catch the undoing moment of Echo as she attends, at a distance, every act of cultural narcissism.

This feminist is *culturally* divided from the women at the bottom. I have already indicated that what she sees as *her* face she knows to be an "it" which she loves, and of which she desires the disappearance—the precarious moment of the Ovidian Narcissus—in order not to speak for, speak to, listen to, but respond to the subaltern sister. In the current conjuncture, national identity debates in the South and "liberal" multiculturalism in the North want her to engage in restricted-definition narcissism as well. Simply put: love-your-own-face, love-your-own-culture, remain-fixated-in-cultural-difference, simulate what is really pathogenic repression in the form of questioning the European universalist superego.

If this position can raise a "why do you fly from me?" toward the subaltern separated from the feminist, then the feminist might, just might, ventriloquize the "fly from me" toward the Narcissus-face, both the self-knowing Ovidian and the deluded Freudian. In fact, the subaltern herself is also sometimes caught in the desire for Narcissus and the "fly from me" gesture, on another level. Once there is an effort to engage in the politics of subalternity-on-the-move, who questions and who answers "fly from me" is not at all clear. The only thing we know is that "be like me, be my image" can never be on the agenda, from either side. I should also emphasize that this "imitation" cannot be the slow-motion thinking-through of a raised consciousness. In the field of decisions, it can only be the sort of much-practiced reflex that shows the steps in slow motion if anyone cares to analyze after the fact; and analysis, notoriously, is inadequate to its object. If, under such circumstances, the imitation of Echo takes us this far, we have to remember that Echo produces the possibility of a cure against the grain of her intention, and, even, finally, uncoupled from intention. Echo will not have been dragged into the circuit of adequate political imitation. The "practice of freedom," especially in the context of women divided into feminists and women, does not come simply because of the fact of gaining

something called independence.

In the context of the difference between Isma (colloquial Arabic for "she is called," with the proper name to be filled in, and thus, in this case, a blank), the central character in *Fantasia*, a self-knowing woman (and therefore mortiferously aware of the limits of self-knowledge, caught in the moment of the Ovidian Narcissus) who has learned the practice of the writing of the hegemonic language, and women in her so-called traditional culture, Assia Djebar has written something called "*a-phonie*," which I discuss below.[33]

As an Algerian woman who has learned the practice of French writing, Assia Djebar is not-quite-not-Narcissus. She has some doubt about claiming the historico-philosophical "I," for traditional women of her class will insist that she insert her "self" into a received orality—strictly speaking, a graph ("the stitched seam of arche-writing, condition of the [so-called oral] language, and of writing in the narrow sense" [*OG*, 175]—as the only appropriate mode of expression for her. This is her "law of genre":[34]

> Each gathering, weekly or monthly, carries over the web [*tissu*] of an impossible revolt. Each speaker [*parleuse*]—the one who clamors too high or the one who whispers too fast—is freed. The "I" of the first person will never be used: in stereotyped formulas the voice has deposited its burden of rancor and of rales rasping the throat. Each woman, flayed inside, is eased in the collective listening. And the same for gaiety, or happiness—which you must guess at; litotes, proverb, to the point of riddles or transmitted stories, all the verbal stagings are unrolled for unpicking fate, or exorcising it, but never to strip it bare [*F*, 154–55].

Over and against this chain of mere whispered *souvenir* that survives in the acknowledgment of the exclusion from the writing of classical Arabic she moves to French for a narrative *mémoire*. Yet she cannot be the Rousseauistic *Narcisse* of French tradition either. She must make the other acknowledgment as well: that the French dictionary cannot grasp the rhetoric of the Algerian woman's body. The fragmentary finale of *Fantasia* begins with two French dictionary entries that read a figure in that corporeal tropology in two opposed ways. One *tzarl-rit* means "to utter cries of joy while smacking the lips (of women)."[35] The other *tzarl-rit* means to "shout, vociferate (of women when some *misfortune* befalls them)."[36] Mourning or jubilation, Narcissus cannot know.

Caught in this middle space, all she can insert, ambiguously, is a sheltering *a-phonie*, a concept-metaphor for which I find no literal referent: "All words, too lit-up, become braggadoccio, and *aphonie*, untamed [*inentamé*— the history of the language will allow *unbroached*] resistance" (*F*, 178).

A-phonie, midway between women's oral culture and patriarchal scripture, is a willed imitation of Echo's warning-in-longing that must continue to fail, since one cannot Echo willingly. It is the impossibility in view of which the risk of legal battles like the fight for a uniform civil law must be undertaken. And if this is interpreted in terms of the mirrorstage narcissism of Enlightenment phallocracy, *vox manet*.[37]

If I read the deconstructive embrace between Isma and Echo as an ethical instantiation, here then is what emerges: something relating to the need of a uniform civil code for men and women, not personal codes that keep women minors; something that would make it impossible for patterns of transgression and reward to be asymmetrically gendered in the calculus of the law.

Negotiating without much choice with various structures inherited from colonialism; necessarily fighting to write the body in the normative, privative, rational abstractions of a uniform civil law, rather than a culturally inherited and imperially consolidated personal code; the body "bereft of voice" is a stone (*F*, 156). In this divided field, the recovery of a woman's voice is useless in autobiography and equally anthropologistic if it does not acknowledge that the woman in culture may be the site of internalized phallocracy. It is thus that, between writing in French and the culturally patriarchal woman's voice, Djebar gives to the supercolonized woman the task of *aphonie*: not a writing, not a graph, but not the phonocentric responsibility-rather-than-rights-based patriarchal-functionalist unmediated woman's voice either. This may claim "identity" with the impossible dimension of the rhetoricity of Ovid's Echo: *vox manet*.

In "Can the Subaltern Speak?" I wrote of Freud as a monitory model.[38] In this essay as well, as I read narrative as a guide to action and limits to action, Freud remains an ally, as class, race, and gender-bound, in his different ways, as no doubt am I. Assia Djebar's brilliant essay on the gaze in Delacroix can be included in this alliance.[39] The deconstructive embrace that holds the elite texts reporting on the nineteenth-century subaltern and the subalternist historians is another example. The elite allies can serve as monitory models for the decolonizing feminist, but they—Ovid, Freud, Delacroix, colonial elite—lose their lineaments in the process. They cannot serve when we try to learn—outside of the closed circuit of the production of academic knowledge—the impossible response to the gendered subaltern. In her own separate enclosure, the subaltern still cannot speak as the subject of a speech act. Dishing out our personal pain in academic bestsellers serves women on the make or catharsizing voyeurs. And Rigoberta Menchú, a spirited subaltern who has networked herself into the structure of hegemonic discourse, immediately becomes the object of right-wing critique.

What follows is an extended appendix. Readings such as the above are read, if at all, with a certain "political piety" as a "Third World intervention" and then laid aside when the serious mainstream work of deconstruction is undertaken. I have therefore included the following three examples:

I am in a deconstructive embrace with Claire Nouvet's "An Impossible Response," which I read after completing the preceding pages.[40] It is a brilliant and much more adroit example of the same genre of reading. Our embrace is asymmetrical, as are all embraces. The asymmetry can be tabulated as a difference in stakes, which cannot not be reckoned (with) in ethical-instantiation readings. Her stake seems to be the figurality of the self. What my stake is the reader will decide. Within the warmth of an embrace, then, I reckon our asymmetry:

In spite of her careful reading of Echo, Narcissus remains the hero of the predicament of the "self." He it is who, character or figure, with the help of Echo, figure or character, thematizes or figurates the impossibility signaled in Nouvet's title.

In place of the "self," the Ovidian text, deconstructing itself, is invested with a certain sovereignty. Much of this sovereignty is established by allowing it to perform an undermining of "character" by "figure."[41] I see this as a contemporary fading-away of the "polytheist" habit of mind—of thinking being and principle in an agile slippage.[42] One focus does not necessarily "undermine" or "correct" the other (although that power claim is the substance of "polytheisms" as sites of conflict) in a "live polytheist" discourse. Who knows how a "Roman" thought a "Greek" story? I am not interested in a vulgar Heideggerian narrative of religion-in-ethics. But it does not seem necessary to censor the genealogical imagination either.

Perhaps it is this imperative to keep Narcissus center stage that does not allow Nouvet to notice Echo as also in an anterior and asymmetrical frame of punishment and reward with Tiresias. Therefore she must inscribe Ovid's inability to let Echo be Echo as Narcissus unechoed (IR, 121). Indeed, if the failure of the echo between interrogative and imperative is finessed by Ovid in reported speech, Nouvet's text, replete with quotations, gives this "passage" (in every sense) as three pages of report.

This stake in the "drama and story" of the "self" seems to limit the question of the feminine. Since the unbalanced parallel of Tiresias and Echo as male and female singularities is not seen, at a certain point in Nouvet's essay, Echo is simply seen as "the feminine" rather than "*bad* girl," "talkative girl," "girl of deluding tongue," as in Ovid. In a few pages of her essay, the "self" becomes genderless, until the resounding first person plural at the end of the essay operates simply in terms of being human:

Ovid's text opens a dangerous question: if a humanist self-assertion is "criminal" [I should have trouble here because of the failure of the polytheist imagination, the confusion of self-recognition and self-knowledge (of this more later), and the meaning of "punishment"], can *we* ever hope to avoid this crime?... It is by definition "incomprehensible" since it revokes the very notion of a self. *We* therefore cannot pretend to comprehend it, but can only expose *our* "selves" to its questioning, a questioning which can only disturb the comfort of *our* "good conscience" by confronting us to the uncertain status of *our* "subjectivity," of *our* "selfhood," and even of our "humanity" [*IR*, 133–34; emphasis mine].

Ethics are not a problem of knowledge but a call of relationship (where being without relationship is the limit case). But the problem and the call are in a deconstructive embrace: Narcissus and Echo. If we see ourselves only as subjects (or "selves") of a knowledge that cannot relate and see the "self" as writing, our unavoidable ethical decisions will be caught in the more empirical, less philosophical "night of non-knowledge,"[43] a "decenter[ing] of the subject, as is easily said, without challenging anew the bond between, on the one hand, responsibility, and, on the other, freedom of subjective consciousness or purity of intentionality...a parade of irresponsibilizing destruction, whose surest effect would be to leave everything as it is," and to flatten gender.[44]

If we move to Echo as the (un)intending subject of ethics, we are allowed to understand the mysterious responsibility of ethics that its subject cannot not comprehend.[45] In fact, if in the curious protocol of a deconstructive embrace I transgress Nouvet's text by displacing the antecedent of "it" from "Ovid's text" to "Echo," the move is made. Yet this is not simply to make Echo say *I am it now* (*nunc sum ego iste*), for we are levering her out where Ovid's text signals its loss of sovereignty; that it cannot catch her as such and make her act Echo.

Because she is obliged to give to Ovid's text this self-deconstructive sovereignty, Nouvet describes the Narcissus split as self-recognition rather than self-knowledge.[46] It is, of course, not a question of right or wrong readings. Between different ethical-instantiation fields, the difference may be no more than between seeing the glass half full rather than half empty. For Nouvet the self-recognition is inscribed in negatively charged language, as a "problem" and a "decomposition" (*IR*, 124, 125). For us, Narcissus's self-knowledge is an accession to a clarity that is so clear that it will not lead to relation: to know that to know the self is to slip into visible silence. Some call it writing. If Ovid and Freud are other readers/writers of a narrateme in a tradition of ethical performance, then "Ovid" (the reader function of the Narcissus story in *Metamorphoses*) is as much a text as his "text," and

deconstruction is as much an experience of the impossible as it is a response to the impossible as an impossible response.

My stake in Echo will not allow me to ignore Freud's ignoring of Ovid's staging of (Narcissus and) Echo. Freud is part of the precomprehended scenario of "An Impossible Response," emerging via Blanchot's invocation of the primal scene as scene of writing.[47] Nouvet performs an in-house reading, where the text is sovereign in its self-deconstruction, even as the "self" becomes (dis)figured.

It is perhaps this that makes for the peculiar blind spot of the essay: the reading of Narcissus's death as a liquefaction (*IR*, 125–28). It is indeed an "ambiguous" death; this is not because it is a liquefaction, but because it is a burning as well as a liquefaction. The two vehicles of the similes that describe Narcissus's demise are "yellow wax" and "hoar frost." How render both, as does Nouvet, to "water"? It is only if we remember the yellow flower and Narcissus in Styx that we can "understand" Echo as still "around." "Is there anyone around?" is not, strictly speaking, a question whose "response…inhabits the question" (*IR*, 110). Its answer may inhabit the question, when Echo answers, by default. *Vox manet*, but only sometimes as resident answers.

Under the rebus of Echo then—since we are nowhere without a blind spot— I invite Nouvet to share mine. Rather than overlook the play of burning and melting, I "naturalize" *in-fans* (speechless) into more than a pun with infancy; into a (historically and specifically) feminine infancy of speech (as ambiguous as liquefying through burning). This speech can no longer be written when self-knowledge inhabits the ambiguity of a "live autopsy," a contemporary *re*articulation of Narcissus's desire for the death of the loved object: *un parler d'enfance qui ne s'écrit plus* (a speaking of infancy which can no longer be written). In an impossible response to this Djebar proposes *a-phonie*, not Narcissus's disaster but Echo's peculiar "reward": to "fail" to order flight from fixation with, in this case, a self that cannot accede to an "I," to an *ego sum*, to the *iste ego sum* of writing, which would itself have been unable to ask for that failed response except through the failure of self-knowledge, imagining that the shadow flies the shadower. I ask Claire Nouvet to attend to *a-phonie*, Echo's responsibility. This would allow her to escape the tedium of the Oedipal chain (here represented by Blanchot-Schlegel; one might have included Rousseau) reading Narcissus. Insert Echo as the unintending force field that teaches us "that the imperative quality of *il faut* proceeds in fact from a relentless and *demanding* uncertainty" (*IR*, 131–32). Echo the brothers in a self-knowledge that "kills."

One question remains: Can this narrative be read without the specific ethical burden of the feminist in decolonization? By definition, ethical-

instantiation readings must have different stakes, different experiences of impossibility. I have already referred to Freud's mature reflection upon the impossibility of an adequately justified psychoanalysis. Keeping that aporia in view, I offer here the outlines of a reading from "a general psychoanalytic position," as if, beset by schools and subschools as the "science" is, such a thing were possible. I have chosen André Green's *Narcissisme de vie, narcissisme de mort* (Narcissism of Life, Narcissism of Death) simply because it is neither too conservative nor too current, innovative in one or two details without being aggressively original, and not yet in touch with feminism.[48]

Green remains within the invariable telos: Narcissus marks an arrest where there should be a passageway to others or the Other. Given his stake in the telos within the forgotten ethical impossibility of psychoanalysis, I will show how his text too asks for supplementation by Echo.

First, of course, Narcissus. Green has an intuition of the part of mortiferous self-knowledge; the part he calls "epistemophilia...implying the eroticization of the process of thought" (*Nvnm*, 33). Green's contribution in this text is the suggestion of a positive and a negative narcissism, and epistemophilia is the negative. But without Echo, the death generated by positive narcissism lacks the dignity of the Ovidian narrative: "for shame, the only way open is that of negative narcissism. A neutralization of affects is at work, a mortiferous enterprise where the work of a Sisyphus operates. I love no one. I love only myself. I love myself. I do not love. I no. I 0. Same series for hatred. I hate no one. I hate only myself. I hate myself. I no. I 0. This series of propositions illustrates the evolution towards the affirmation of the megalomaniac I as the last step before disappearance" (*Nvnm*, 201).[49]

Yet Echo struggles to break through the argument. Here is the description of the psychic apparatus, admittedly the boldest Freudian breakthrough: "It is logical to admit that the effect of structuration [condition and effect of the apparatus] must come *from elsewhere* if the Self is thus engaged in the instantaneousness of the present" (*Nvnm*, 93; emphasis mine). Narcissus immobile, Echo from elsewhere.

In an uncanny description of the project of psychoanalytic *thought*, Green writes, ostensibly about narcissism: "Narcissism is the effacement of the trace of the Other in the Desire of the One" (*Nvnm*, 127). We see the effacement at work when, considering negative narcissism in a woman, Green faithfully emphasizes her penultimate declaration, "*My mind is blank and I can't think*," but ignores her final remark: "Since I cannot work, I telephone someone" (*Nvnm*, 157). "Tele-phone," distant-voice, *vox manet*, an effort at domesticating Echo; but she will not yield to imitation, to the apparatus that would harness the distant voice to matching questions and answers.

"Echo" in lower case gives us a clue to her foreclosure. When Green proposes a complex of the dead mother, he says, in passing, "in fact, the complaint against X was really against a mother absorbed perhaps by something else, and unreachable without echo, but always sad" (*Nvnm*, 235). Echo's dispersal into the common language has not only foreclosed her narrative, but reversed and scrambled the narrative: an unreachable desired mother of the homosexual son.

Speaking of the treatment of moral narcissists, Green writes, "To the extent that it [transference] remains expressed by way of the words of the analyst in terms of object, it has little echo on this material covered over by the narcissistic carapace" (*Nvnm*, 201). Again, a longing for Echo, lost in the history of the language, not facing the terrifying ethical possibility that Echo/Transference might be as "absurd" as Narcissus/Self-representation (*Nvnm*, 139).

Our reading proposes a shifting of the stakes. For us Narcissus is not necessarily a stalling of/in the self where there should be a passageway to others or the Other. There is access to the founding dilemma of ethics if we read the Narcissus-Echo *pair* as an icon (or, more accurately, a graph) of the passage, crossed easily and imperfectly in the exchange of everyday life, and authoritatively in the production of theory on all levels of civil and military enterprise. Then at "ground" level, where justification is sought and offered, we see the knowledge of the self as writing, stalled; and the symbolic circuit not as a relatively fixed Eurocentric scenario, but as a contentless, enclitic, monstrative vector, its definitive responsive character unfilled with the *subject's* intention, though the intentional moment (Echo's speech toward Narcissus) is not absent.[50] Who can deny that, in the construction of the subject's history, the driving force of the symbolic is a desire for self-knowledge, even though full self-knowledge would mean an end to symbolicity? Why, in spite of so many hard lessons to the contrary—not the least from the vicissitudes of many cultural and gender inscriptions—do we still cling to the rotarian epistemology of *advancing* from the Imaginary to the Symbolic?[51]

The plausibility of this reading is marked by Echo's struggle for emergence in the text. She will be found in the text, even as she marked the moment of textual transgression in Ovid.

One re-forming entailed by this intervention is to make the self "writing" and "male"—and to make the Symbolic "feminine." Will this change a historical habit? I can hope.

I am in another sort of deconstructive embrace with my old graduate school friend Samuel Weber, both of us students of the predeconstructive Paul de Man, excited early by Derrida's work, untroubled by changes in critical

fashion, in our own different ways attempting to carve out political trajectories within what we know and learn. It is no surprise to me that in his *Legend of Freud*, Weber does not give sovereignty to the self-deconstructive "text" (here Freud) but produces a new reading from where it transgresses itself in terms of its own protocols.[52] In doing so, Weber produces a reading of psychoanalysis where narcissism is not a stage to be superseded, but rather plays a constitutive and operative role. I give below a summary of Weber's remarkable rewriting of the Freudian enterprise, and end, again, by rescuing Echo, struggling to break through.

Weber sees "speculation," reflection in the mirror or speculum, as itself narcissistic, and sees the project of the adequation of the self and of thought as an unwitting description of the narcissistic predicament. He provides a brilliant summary of scholarship in support of his contention that both French and Anglo-American Freudians "have shared the conviction that Freud articulated the death drive as an alternative, or even antidote to the power exercised over his thought by the theory of narcissism" (*LF*, 124). Although he is, I believe, somewhat unjust to Lacan here, he also suggests that in Freud, as opposed to what we find in Lacan, the scene is not one of progression *from* the Imaginary to the Symbolic, but "that there is an *other scene* of the Symbolic, of the Fort-Da game, and it is precisely: the Imaginary, in all of its aggressive, narcissistic ambivalence" (*LF*, 97).[53] It is unjust to Ovid too. The acknowledgment of the mortiferous quality of the self as writing is inscribed in Ovid's narrativization; and Narcissus longs for death.

I resonate, nonetheless, with Weber when he suggests that Freud's thought would develop according to the paradigm of a dynamic disunity of which narcissism is the organized, if ambiguous, part.

> [W]hat is at stake here is the possibility of elaborating and rethinking what Deleuze has called the 'transcendental' nature of speculation in terms of a certain notion of narcissism, one that is never fully explicated in the writings of Freud, but which is all the more powerfully at work in his texts because it remains, in part at least, implicit.... The power of narcissism then, would entail not simply the symptom of an individual subject, 'Freud': but rather the theoretical project of psychoanalysis itself, putting its limits into play [*LF*, 128, 125–26, 125].

"The power of narcissism." Where does it come from? The last words Echo gives back to Narcissus, to his *emoriar, quam sit tibi copia nostri* (*M*, 150, line 391)—translated in the Loeb edition as "May I die before I give you power o'er me!"—are *sit tibi copia nostri*! (I give you power over me). *Copia nostri* is "our plenty, our plenitude," but also "the provisions that

we have laid up for the future," even "our forces," as in military forces—the same metaphor as in *Besetzung*, lost both in "cathexis" and *investissement*. Following the powerful tricks of Ovid's text, Narcissus's ambivalence toward death here—"May I die," nothing more than a rhetorical exclamation—is turned into truth independent of intention (explicit-implicit in Weber's text; *bhrāntapratārakavākya* in Gaṅgeśa, even as Echo bequeathes her reserves to him by way of an "imperfect" repetition.[54]

Let us step out of the psychoanalytic enclosure for a moment here and repeat that, in terms of a feminism as such (whatever that might be), *sit tibi copia nostri* is a variation on the old game of playing female power within the male establishment. The Narcissus-Echo relationship is more complex. The homeopathic double bind of feminism in decolonization—which seeks in the new state to cure the poison of patriarchy with the poison of the legacy of colonialism—can read it as an instantiation of an ethical dilemma: choice in no choice, attendant upon particular articulations of narcissism, ready to await the sounds to which she may give back her own words.

Back to Weber's text: let us now trace Echo's struggle to step forth. I believe her lineaments in the following passage are clear enough for me not to have to retrace them at this stage. Indeed, the mortiferous Narcissus and Echo as devious voice are indistinguishably imbricated here: "the very *Stummheit* (muteness) of the death drive precludes it from ever speaking for itself; it is inevitably dependent on another discourse to be seen or heard. And that discourse, however much it may seek to efface itself before the 'silence' it seeks to articulate, is anything but innocent or neutral. The death drive may be dumb, but its articulation in a theoretical and speculative [or risky and activist; see my previous paragraph discourse] is not" (*LF*, 129).

It is in the following passage that I find it disturbing that Echo still remains foreclosed. Weber is describing Freud's imprisonment within the discourse of the same, even as he gropes for radical difference:

> [I]f Freud's initial stories deal with men, betrayal, and ingratitude, death enters the scene with—as?—the passive female.... The *Schicksalzug* (trait of destiny) that Freud asserts it represents, is...a recurrent fatality linked to the female: she either eliminates the male or is eliminated by him. But nothing is more difficult to do away with than this persistent female: you kill her once, and her soul returns, "imprisoned in a tree"; you "slash with (your) sword at (the) tree," and a voice comes to accuse you. The activity of the subject, in this final story, consists indeed of a repetition, but what he repeats, actively, is the narcissistic wound that never heals without leaving scars [*LF*, 134].

Freud's story comes from Torquato Tasso's *Gerusalemme Liberata* (1576), a text that is itself among the European reinscriptions of Ovid. If Freud had paid as much attention to Ovid, the "persistent female" might have come to undo the Freudian Narcissus. In any event, I agree with Weber that "[f]or Freud…the stories he has told are not versions of the narrative of narcissism, but evidence of something radically different. And yet, when he seeks to describe that difference, it emerges as more of the same" (*LF*, 135).

"The two sources of psychoanalytic concepts are psychoanalytic practice on the one hand, and the epistemological horizon on the other" (*Nvnm*, 32). Good words, with which psychoanalysts of any school would find it hard to disagree. I have spoken only of the latter. Psychoanalytic practice, being a species of performative ethics within the calculus of professional exchange, must suit its terms to every analytic situation. An essay such as this one must remain scrupulously parasitic to that space, rather than claim it for an irresponsibilizing cultural diagnosis.

Let's step off in closing, beyond "humanity" and short of it, where Ovid and Freud are flashes of species-being in the great ecosystem of species-life. Narcissus is fixed, but Echo can disseminate. Whales, those paleo-mammals that were once creatures of the earth, *echo*-locate objects and other inhabitants in the sea world, which is not their home but merely their makeshift dwelling place. The interior of the body, inside Narcissus's carapace, can give us back echoes that hi-tech can intercept to bypass the "Self." Ava Gerber's stunning "body art" can be an example of an impossible imitation of Echo, attending to the failed narcissism of United States body culture. Wallace Stevens's "beauty is immortal in the flesh"[55] celebrates every change in the flesh as beauty, down to its inscription in the economy (*Haushaltung*) of nature after what the Biblical Elders would decipher as decay and death. James Joyce is another flash in the system, canniest of men on the track of women: "Hush! Caution! Echoland!"[56]

NOTES

1. See Christopher Lasch, *The Culture of Narcissism* (1979; rpt. New York: Norton, 1983). For a socialist-feminist reading of Lasch's book, see Michèle Barrett and Mary McIntosh, "Narcissism and the Family: A Critique of Lasch," *New Left Review* 135 (1982), pp. 35–48.

2. See *Sex Work: Writings by Women in the Sex Industry*, eds. Frédérique Delacoste and Priscilla Alexander (Pittsburgh and San Francisco: Cleis Press, 1987).

3. Freud, "On Narcissism: An Introduction," in *Works*, vol. 14, pp. 93–94, 101;

hereafter cited in text as *N.*

4. See Gayatri Chakravorty Spivak, "Time and Timing: Law and History," in *Chronotypes: The Construction of Time*, ed. John Bender and David Wellbery (Stanford: Stanford University Press, 1991), pp. 99–117.

5. See my "The Politics of Translation," in *Destabilizing Theory: Contemporary Feminist Debates*, ed. Michèle Barrett and Anne Phillips (Cambridge: Polity, 1992), pp. 181–84; rpt. in *Outside*, pp. 183–85.

6. See V. S. Naipaul, *India: A Wounded Civilization* (New York: Knopf, 1977), pp. 107–23; see also V. S. Naipaul, *India: A Million Mutinies Now* (New York: Viking, 1991), passim. In the case of the United States, here is a peculiar rag-bag, all denominated "narcissism": "After all the machinations of the *leftist sects, homosexual activists, self-indulgent businessmen, therapeutic functionaries, would-be and actual politicos and others*, the killer continues to punctuate the real tragedy: the total domination and helplessness that define clientage in organized capitalism," Adolph Reed, Jr., "Narcissistic Politics in Atlanta," *Telos* 14:48 [Summer 1981], p. 105.

7. See Jacques Derrida, "Geopsychanalyze—'And the Rest of the World,'" in *Negotiations: Writings*, eds. Deborah Esch and Thomas Keenan (Minneapolis: University of Minnesota Press, forthcoming).

8. Spivak, "Three Women's Texts," p. 263 (wording modified).

9. "Kant's categorical imperative is thus the direct heir of the Oedipus complex" (Freud, "The Economic Problem of Masochism," in *Works*, vol. 19, p. 16) might be the most self-assured declaration of this affiliation. For more extensive documentation, see, of course, the Kant entry in the Index to the *Works*, vol. 24, p. 212.

10. See Bimal Krishna Matilal and Gayatri Chakravorty Spivak, *Epic and Ethic* (New York: Routledge, forthcoming).

11. See Jon Elster, *Ulysses and the Sirens: Studies in Rationality and Irrationality* (Cambridge: Cambridge University Press, 1979).

12. See Freud, "Analysis Terminable and Interminable," in *Works*, vol. 23, pp. 211–53; also Derrida, "The Force of Law: The 'Mystical Foundation of Authority,'" trans. Mary Quaintance, *Cardozo Law Review* 11 (1989–90), pp. 920–1045.

13. See Bimal Krishna Matilal, *The Word and the World: India's Contribution to the Study of Language* (New Delhi: Oxford University Press, 1990), pp. 70–71.

14. Investigations of Echo in Indic discourse would lead us into the rational linguistic tradition of *dhvani* and *pratidhvani*, quite apart from mythic and epic narrative.

15. See Georg Wilhelm Friedrich Hegel, *Aesthetics: Lectures on Fine Art*, trans. Thomas M. Knox, 2 vols. (Oxford: Oxford University Press, 1975), p. 361.

16. Ovid, *Metamorphoses*, trans. Frank Justus Miller (Loeb classical library), 2nd

ed. (Cambridge, MA: Harvard University Press, 1966), vol. 1, p. 3; hereafter cited by page and line number in text as *M* (translations modified).

17. Freud, "Group Psychology and the Analysis of the Ego," in *Works*, vol. 18, p. 130.

18. Irigaray, "Sexual Difference," trans. Seán Hand, in *French Feminist Thought: A Reader*, ed. Toril Moi (Oxford: Blackwell, 1987), p. 122.

19. See Ellie Ragland-Sullivan, "Jacques Lacan: Feminism and the Problem of Gender Identity," *Sub-Stance* 11:3 (1982), pp. 6–19.

20. Lacan, "The Mirror Stage as Formative of the Function of the I as Revealed in Psychoanalytic Experience," in *Ecrits*, pp. 6, 7.

21. *Ibid.*, p. 2.

22. The notion of an underived fiction is borrowed from Derrida, *Limited Inc.*, p. 96. Jacqueline Rose indicates the difference between Freud and Lacan without commenting on the relative philosophical banality of Lacan's position. She shows that in the later Lacan the subject's move from primary to secondary narcissism is the move from the Imaginary to the Symbolic. What interests me, as my final extended comments on Claire Nouvet will show, is that although the insertion into the Symbolic seems to invite a consideration of the Echo-response situation, Rose does not mention her: "the two moments of [the mirror] phase, that of the corporeal image [which Lacan describes as primary narcissism], prior and resistant to symbolization, and that of the *relation to the other* [the place of secondary narcissism], ultimately dependent on such symbolisation" (Rose, *Sexuality in the Field of Vision* [London: Verso, 1986], pp. 178–79).

23. For an extensive treatment of the Narcissus tradition and narcissism, see Louise Vinge, *The Narcissus Theme in Western European Literature up to the Early 19th Century*, trans. Robert Dewsnap et al. (Lünd: Gleerups, 1967). (Professor Georgia Nugent has pointed out to me that there is a mythic tradition of Echo as coupled with Pan which is rather different from the Ovidian narrative. An ethical-instantiation reading focuses on a narrativization rather than a myth. I look forward to a historical meditation upon the vicissitudes of Echo in the history of myth, but that is not my concern here.) Any consideration of Narcissus and narcissism would fall into the literary and the psychoanalytic. I have not considered them in detail in my text because they do not, strictly speaking, have much bearing on a performative ethical reading in the context of feminism in decolonization. Among the Christian allegorical readings in the *Ovid moralisé*, we find Echo interpreted as "good reputation" and, in Christine de Pisan's *Epistre d'Orthéa* as "anyone who asks for help in great need" (see Vinge, *Narcissus*, pp. 94, 101). I have no doubt that an extended look at these texts with a gender-sensitive theoretical perspective would yield exciting results. Although not particularly gender sensitive, Joseph Loewenstein's *Responsive Readings: Versions of Echo in Pastoral, Epic, and the Jonsonian Masque* (New Haven: Yale University Press, 1984) is a more theoretical and sympathetic analysis of the trajectory of Echo than

Vinge's older study. He is, however, interested in the "myth of Echo," that which remains across rhetorical narrativizations "as the myth of cultural memory" (p. 5). His Echo is caught between "the genius of myth, of sorts" and the "phenomenology of acoustical reflection itself" (pp. 10, 9). When he speaks of ethics, he is analyzing the structuring of stories rather than the conduct of the rhetorical texture of storying as instantiations of ethical responsibility (p. 12). To be sure, the predicament of the self-conscious feminist allied by class with imperialism has something in common with the romantic notion of the self-conscious artist as Narcissus (Rousseau's *Narcisse*, Friedrich Schlegel's *Lucinde*), for those texts emerge at the height of Western European colonialism and imperialism. The trajectory of romanticism is so well travelled that I will wait for future criticism to lay bare that common ground from this political perspective. Since Echo's role is not significantly an independent position in psychoanalytic treatments, I have paid little or no attention to the growing literature on identification from this perspective. In conclusion, I have addressed "psychoanalysis" in a general way.

24. Spivak, unpublished earlier draft of the present essay.

25. For the definitive discussion of this passage, see John Brenkman, "Narcissus in the Text," *Georgia Review* 30 (1976), pp. 293–327.

26. Devi, "The Hunt," trans. Spivak, in *Women in Performance* 5:1 (1990), pp. 80–92; rpt. in *Imaginary Maps*, pp. 1–17.

27. Strictly speaking, there is another bit of reported speech in the narrative. When Narcissus cries *veni*! (Come!) Ovid does not give the perfectly possible echo—*veni*! (Come!)—or even, with a little trick of vowel length, again perfectly acceptable within echo as a phenomenon, "I have come!" (I am grateful for this latter suggestion to Professor Georgia Nugent.) In this particular case, it seems as if there is an embarrassment of successful response here, ,as opposed to the ethically more useful bit that I discuss. And indeed the style of Ovid's reportage is also noticeably different. If in the *fugis/fugi* reporting, Ovid reports Narcissus as receiving back the words he said, in the *veni/veni* reporting, Ovid gives Echo a plenitude of voicing: *vocat illa vocantem* (M, 150, line 382; she calls him calling, calls the calling one, voices the voicer). The ethical-instantiation reader must choose between a gendered agency that can speak its desire *within* gendering, where the narrator reports her (internalized constraint as a version of) fulfilled choice, or a gendered aporia that goes beyond mere (historically contaminated) intention. For our part, a greater responsibility beckons in the instantiation of the possibility that history is in all respects larger than personal goodwill.

28. The reader will notice that I too have played a translator's trick here, substituting the Greek *Lethe* for the Latin *Styx*. Latin does not have an exact equivalent of *aletheia* for truth (thereby hangs Heidegger).

29. Derrida, "Signature Event Context," in *Margins*, p. 318.

30. For the importance of reported speech in the Law of Genre, we must elaborate a position from V. N. Vološinov, *Marxism and the Philosophy of Language*

trans. Matejka Ladislaw and I. R. Tutinik (1973; rpt. Cambridge, MA: Harvard University Press, 1986), pp. 115ff. I have attempted to do this in the context of multiracial representation as well (unpublished colloquium, Congress of South African Writers, Cape Town, 15 August 1992).

31. Derrida, *The Post Card*, p. 123 (translation slightly modified). Cited in Derrida, "Pour l'amour de Lacan," in Natalia S. Avtonomova et al., *Lacan avec les philosophes* (Paris: Albin Michel, 1991), pp. 416–17.

32. See Derrida, "Le Facteur de la vérité," in *The Post Card*, pp. 413–96; also "The Force of Law," p. 981 and passim.

33. Djebar, *Fantasia: An Algerian Cavalcade*, trans. Dorothy S. Blair (New York: Quartet Books, 1985); hereafter cited in text as *F* followed by page number.

34. Here and elsewhere, I am struck by the affinities and differences between Djebar and Derrida, two compatriots separated by ethno-cultural and sexual difference. If in *Glas* Derrida kept the name of the mother blank by the positioning of the "L" (French *elle* = mother) on the page, and the female thing unnamed by contrasting *Savoir absolu* to *Sa* (the third person singular genitive with an unspecified female object), Djebar keeps the autobiographical culture-divided female subject's name a blank by the ruse of proper naming. (*Sa* is everywhere in Derrida, *Glas*. For the placing of the "L," see p. 261b).

35. See the listing under *tzarl-rit*, in *Dictionnaire pratique arabe-français*, ed. Marcelin Beaussier (1887; rpt. Algiers: La Maison des Livres, 1958), quoted in *F*, 221 (my emphasis).

36. See the listing under *tzarl-rit*, in *Dictionnaire pratique arabe-français*, ed. Albert de Biberstein Kazimirski (Paris: Maisonneuve, 1860), quoted in *F*, 221 (my emphasis).

37. In the context of a traditional culture that is fully oral, I would like to refer here to the African National Congress Women's Charter of 1954; see Raymond Suttner and Jeremy Cronin, eds., *Thirty Years of the Freedom Charter* (Johannesburg: Ravan Press, 1986), pp. 162–64.

38. See Spivak, "Can the Subaltern Speak?" in *Marxism and the Interpretation of Culture*, eds. Cary Nelson and Lawrence Grossberg (Urbana: University of Illinois Press, 1988), pp. 296–97.

39. Djebar, "Forbidden Gaze, Severed Sound," in *Women of Algiers in Their Apartments*, trans. Marjolijn de Jager (Charlottesville: University of Virginia Press, 1992).

40. Nouvet, "An Impossible Response: The Disaster of Narcissus," *Yale French Studies* 79 (1991), pp. 103–34; hereafter cited as *IR*, followed by page number. I am grateful to Dorothea von Mücke for bringing this essay to my attention.

41. *IR*, 111. Yet on the next page, Nouvet makes a peculiarly characterological move when she assigns to Narcissus one, rather than another, phenomenal affect—fear rather than pride—and constructs a new reading on it. As the next sentence of my text will suggest, such a slippage is good "polytheist"

practice, and problematic only if one sees character and figure in opposition.

42. I have commented on the "monotheist" habit of imagining the subject of the ethical decision in a number of texts; most accessibly in my "Not Virgin Enough to Say That [S]he Occupies the Place of the Other," in Spivak, *Outside*, pp. 173–78, and in Matilal and Spivak, *Epic and Ethic*.

43. Derrida, "The Force of Law," p. 967.

44. Derrida, "*Mochlos* or the Conflict of the Faculties," trans. Richard Rand and Amy Wygant, in *Logomachia: The Conflict of the Faculties Today* (Lincoln: University of Nebraska Press, 1992); the French original of this quotation is to be found in Derrida, *Du droit à la philosophie* (Paris: Galilée, 1990), pp. 408, 424.

45. Incidentally, this shift is reflected in Derrida's move from "reticen[ce]" because the ethical "presupposes...the self" (Stanislaus Breton and Francis Guibal, *Altérités: Jacques Derrida et Pierre-Jean Labarrière: avec des études de Francis Guibal et Stanislaus Breton* [Paris: Osiris, 1986], p. 76; cited in *IR*, 103) to ethics as "the *experience* of the impossible ("The Force of Law," p. 981, emphasis mine). That this move is particularly significant for Derrida is indicated by the fact that in the latter Derrida is citing an earlier piece by himself.

46. Is this because of Lacan's unseen presence? "Two factors emerge from this preliminary delineation of the Imaginary—the factor of aggression, rivalry, the image as alienation on the one hand, and the more structurally oriented notion of a fundamental misrecognition as the foundation of subjectivity, with the image as salutary fiction, on the other" (Rose, *Sexuality*, p. 175). The difference between the subject's history and mythic story being that in myth it is a "knowledge" rather than a misrecognition, and the fiction is not "salutary" in a curative sense. Oedipus does sleep with his mother; he does not just *want* to.

47. See Maurice Blanchot, *The Writing of the Disaster*, trans. Ann Smock (Lincoln: University of Nebraska Press, 1986), pp. 125ff; cited in *IR*, 128ff.

48. See Green, *Narcissisme de vie, narcissisme de mort* (Paris: Minuit, 1983); hereafter cited in text as *Nvnm* (my translations).

49. Luce Irigaray will undo this in her brilliant *Je, tu, nous: Pour une culture de la différence* (Paris: Grasset & Fasquelle, 1990); English trans., Alison Martin, *Je, Tu, Nous: Towards a Culture of Difference* (New York: Routledge, 1993).

50. Incidentally, this would enrich and dislocate Lacan's geometry of the gaze in interesting ways.

51. The best reading within this epistemology is Juliet Mitchell's (although I am not sure why she writes that "Narcissus never believed that what he saw in the pond's mirror was himself"): "the mirror did not give him himself, because the only one in the world he had to tell him where he was, was Echo, the absolute other, to whom none could get attached because she would not listen [why?] and who did no more than repeat the words of

Narcissus's own self-fascination. But no one would have done any more; for Narcissus is confined in intra-subjectivity" (Mitchell, *Psychoanalysis and Feminism* [Harmondsworth: Penguin, 1975], pp. 38, 39).

52. Weber, *The Legend of Freud* (Minneapolis: University of Minnesota Press, 1982); hereafter cited in text as *LF*.

53. As Jacqueline Rose has pointed out, in the mature Lacan the Imaginary slides into the Symbolic: primary into secondary narcissism. A single sentence will have to suffice here: "Hence, the *symbolic* equation that we rediscover between these objects arises from an alternating mechanism of expulsion of introjection, of projection and absorption, that is to say from an *imaginary* interplay" (Lacan, "The Topic of the Imaginary," in Jacques-Alain Miller, ed., *The Seminar of Jacques Lacan: Book 1, Freud's Papers on Technique 1953–54*, trans. John Forrester [Cambridge and New York: Cambridge University Press, 1988], p. 82; emphasis mine). This is still, of course, a continuist simplification of Freud's discontinuous dynamics, what Weber calls "The play of speculation." I refer my reader to Freud's reverse definitions of speculation and science, quoted on page 179 above.

54. ওর বনে আমার রুক্ষ গিগরি ঠিবরঠিল ।
 সাগী বনে আমার রাধা শতিঃ সক্ষিবিন, এইেস পারবে কেন ?

55. Stevens, "Peter Quince at the Clavier," in *Collected Poems*, p. 91. The lines of the poem read, "Beauty is momentary in the mind— /...But in the flesh it is immortal."

56. Joyce, *Finnegans Wake*, p. 13.

Subaltern Studies

Deconstructing Historiography

(1985)

This influential essay marks the occasion of Spivak's official collaboration with the Subaltern Studies collective of historians, who are rewriting the history of colonial India from below, from the point of view of peasant insurgency. This is a paradoxical historical project since the documentary evidence is so one-sided that no positive, or positivist, account of subaltern insurgency is possible. There simply are no subaltern testimonials, memoirs, diaries, or official histories. Yet as one of the collective, Ranajit Guha, argues, though the documentary evidence of the colonial archive, or what he calls the prose of counterinsurgency, takes its shape from the will of the colonial administrators themselves, it is also predicated upon another will, that of the insurgent. Consequently, it should be possible to read the presence of a rebel consciousness as a factor in the construction of that body of evidence. Dipesh Chakrabarty, another of the Subalternists, in attempting to represent the conditions of the jute mill workers of Calcutta during a specific period, tries to account for gaps in the historical record. He argues that those gaps are as revealing of working-class conditions as any direct reference to them. As Spivak herself observes, "it is only the texts of counterinsurgency or elite documentation that give us the news of the consciousness of the subaltern."

Who or what is this subaltern? Loosely derived from the writings of the Italian Marxist Antonio Gramsci, the term "subaltern" designates nonelite or subordinated social groups. It is at once without any particular theoretical rigor and useful for problemizing humanist concepts of the sovereign subject. In the unrevised first version of her essay, "Can the Subaltern Speak?," Spivak cites Ranajit Guha's definition of subalternity: "The social groups and elements included in this category represent *the demographic difference between the total Indian population and all those whom we have described as the 'elite.'*" As Spivak observes, "The object of the group's

investigation, in the case not even of the people as such but of the floating buffer zone of the regional elite-subaltern, is a deviation from an ideal—the people or subaltern—which is itself defined as a difference from the elite." Guha's definition of this floating buffer zone of elite-subalternity is close to Marx's well-known comments on the French peasantry in *The Eighteenth Brumaire*: "At the regional and local levels [the dominant indigenous groups] . . . if belonging to social strata hierarchically inferior to those of the dominant all-Indian groups *acted in the interests of the latter and not in conformity to interests corresponding truly to their own social being*" ("Can the Subaltern Speak?," pp. 284–85).

According to Spivak, then, the subaltern as subject-effect shows up the contrivance of more positivist models of the subject. The subaltern emerges from the Subalternists' research not as a positive identity complete with a sovereign self-consciousness but as the product of a network of differential, potentially contradictory strands. However successful traditional history-writing might be at hiding this sleight-of-hand substitution of an effect for a cause, the effort is still doomed to cognitive failure, since it is merely a convenient disciplinary fiction.

In one sense, then, this essay initiates Spivak's continuing relationship with the discipline of history and historiography, or the art of history-writing. From the early through the mid–1980s, Spivak was reading in the East India Company archives and engaging in dialogue with colonial historians. Other essays germinated during this period represent her substantive contributions to Subalternist history by way of research on the Rani of Sirmur and on the larger question of *sati* within British imperial governance of India. "The Rani of Sirmur," "Can the Subaltern Speak?," and "Three Women's Texts and a Critique of Imperialism" are three important essays from this fruitful period that form the basis of her long-awaited book from Harvard University Press, *An Unfashionable Grammatology*.

This essay's engagement with the Subaltern Studies group, however, also represents an extension of Spivak's work as a historically grounded literary critic: she is in the archive, but in there busily theorizing deconstructive reading. Thus she is able to read the Subalternists both with and against the grain of their appropriation of French poststructuralism and antihumanism, particularly the work of Michel Foucault, Roland Barthes, and Claude Lévi-Strauss. The crux of her reading of the texts of Subaltern Studies is that in practice the group are more deconstructive than they might themselves admit.

Spivak sees their positing of a theoretically and historically possible, if finally irrecoverable, subaltern consciousness as a form of "strategic essentialism." Particularly because the group write as if aware of their complicity with subaltern insurgency—they do not only work *on* it—Spivak

praises their "*strategic* use of positivist essentialism in a scrupulously visible political interest." At the same time, gender and the figure of woman operate in relatively unexamined ways in the Subalternists' texts. Making a start on that particular decolonizing of the mind represented by feminist critique, while attending to the new possibilities for historical research opened up by it, constitutes the grounds of Spivak's own contribution to the Subaltern Studies collective project, theoretically and archivally speaking.

CHANGE AND CRISIS

The work of the Subaltern Studies group offers a theory of change. The insertion of India into colonialism is generally defined as a change from semi-feudalism into capitalist subjection. Such a definition theorizes the change within the great narrative of the modes of production and, by uneasy implication, within the narrative of the transition from feudalism to capitalism. Concurrently, this change is seen as the inauguration of politicization for the colonized. The colonial subject is seen as emerging from those parts of the indigenous elite that have come to be loosely described as "bourgeois nationalist." The Subaltern Studies group seems to me to be revising this general definition and its theorization by proposing at least two things: first, that the moment(s) of change be pluralized and plotted as confrontations rather than transition (they would thus be seen in relation to histories of domination and exploitation rather than within the great modes-of-production narrative) and, second, that such changes are signaled or marked by a functional change in sign-systems. The most important functional change is from the religious to the militant. There are, however, many other functional changes in sign-systems indicated in these collections of writings: from crime to insurgency, from bondsman to worker, and so on.

The most significant outcome of this revision or shift in perspective is that the agency of change is located in the insurgent or the "subaltern."

(In fact their concern with function changes in sign-systems—the phrase "discursive displacements" is slightly shorter—extends beyond the arena of insurgent or subaltern activity. In more than one article Dipesh Chakrabarty discusses how the "self-consciously socialist discourse" of the left sector of the indigenous elite is, willy-nilly, attempting to displace the discourse of feudal authority and charge it with new functions.[1] Partha Chatterjee shows Gandhi "political[ly] appropriat[ing] the popular in the evolving forms of the new Indian state [3, 156]. The meticulously documented account of the emergence of Gandhi—far from a "subaltern"—as

a political signifier within the social text, spanning many of the essays in the three collections, is one of the most stunning achievements of these studies.)

A functional change in a sign-system is a violent event. Even when it is perceived as "gradual," or "failed," or yet "reversing itself," the change itself can only be operated by the force of a crisis. What Paul de Man writes of criticism can here be extended to a subalternity that is turning things "upside down": "In periods that are not periods of crisis, or in individuals bent upon avoiding crisis at all cost, there can be all kinds of approaches to [the social]...but there can be no [insurgency]."[2] Yet, if the space for a change (necessarily also an addition) had not been there in the prior function of the sign-system, the crisis could not have made the change happen. The change in signification-function supplements the previous function. "The movement of signification adds something...but this addition...comes to perform a vicarious function, to supplement a lack on the part of the signified."[3] The Subaltern Studies collective scrupulously annotates this double movement.

They generally perceive their task as making a theory of consciousness or culture rather than specifically a theory of change. It is because of this, I think, that the force of crisis, *although never far from their argument*, is not systematically emphasized in their work, and sometimes disarmingly alluded to as "impingement," "combination," "getting caught up in a general wave," "circumstances for unification," "reasons for change," "ambiguity," "unease," "transit," "bringing into focus"; even as it is also described as "switch," "catching fire" and, pervasively, as "turning upside down"—all critical concept-metaphors that would indicate force.[4] Indeed, a general sobriety of tone will not allow them to emphasize sufficiently that they are themselves bringing hegemonic historiography to crisis. This leads them to describe the clandestine operation of supplementarity as the inexorable speculative logic of the dialectic. In this they seem to me to do themselves a disservice, for, as self-professed dialecticians, they open themselves to older debates between spontaneity and consciousness or structure and history. Their actual practice, which, I will argue, is closer to deconstruction, puts these oppositions into question. A theory of change as the site of the displacement of function between sign systems—which is what they oblige me to read in them—is a theory of reading in the strongest possible general sense. The site of displacement of the function of signs is the name of reading as active transaction between past and future. This transactional reading as (the possibility of) action, even at its most dynamic, is perhaps what Antonio Gramsci meant by "elaboration," *e-laborare*, working out.[5] If seen in this way, the work of the Subaltern Studies group repeatedly makes it possible for us to grasp that the concept-metaphor of the "social text" is not the

reduction of real life to the page of a book. My theoretical intervention is a modest attempt to remind us of this.

It can be advanced that their work presupposes that the entire socius, at least insofar as it is the object of their study, is what Nietzsche would call a *fortgesetzte Zeichenkette*—a "continuous sign-chain." The possibility of action lies in the dynamics of the disruption of this object, the breaking and relinking of the chain. This line of argument does not set consciousness over against the socius, but sees consciousness as itself also constituted as and on a semiotic chain. It is thus an instrument of study which participates in the nature of the object of study. To see consciousness thus is to place the historian in a position of irreducible compromise. I believe it is because of this double bind that it is possible to unpack the aphoristic remark of Nietzsche's that follows the image of the sign-chain with reference to this double bind: "All concepts in which an entire process is comprehended [*sich zusammenfasst*] withdraws itself from [*sich entzieht*] definition; only that which has no history is definable."[6]

COGNITIVE FAILURE IS IRREDUCIBLE

All of the accounts of attempted discursive displacements provided by the group are accounts of failures. For the subaltern displacements, the reason for failure most often given is the much greater scope, organization, and strength of the colonial authorities. In the case of the nationalist movement for independence it is clearly pointed out that the bourgeoisie's "interested" refusal to recognize the importance of, and to ally themselves with, a politicized peasantry accounted for the failure of the discursive displacement that operated the peasants' politicization. Yet there is also an incipient evolutionism here which, trying perhaps to avoid a vulgar Marxist glorification of the peasant, lays the blame on "the existing level of peasant consciousness" for the fact "that peasant solidarity and peasant power were seldom sufficient or sustained enough" (3, 52; 3, 115). This contradicts the general politics of the group—which sees the elite's hegemonic access to "consciousness" as an interpretable construct.

To examine this contradiction we must first note that discursive displacements wittingly or unwittingly operated from above are also failures. Chakrabarty, Arvind N. Das, and N. K. Chandra chart the failures of trade union socialism, functionalist entrepreneurialism, and agrarian communism to displace a semifeudal into a "modern" discourse. Chatterjee shows how Gandhi's initial dynamic transaction with the discursive field of the Hindu religious Imaginary had to be travestied in order that his ethics of resistance could be displaced in the sign-system of bourgeois politics.[7] (No doubt if an "entity" like "bourgeois politics" were to be opened up to discursive analysis the same microdynamics of displacement would emerge.)

My point is, simply, that failures or partial successes in discursive-field displacement do not necessarily relate, following a progressivist scale, to the "level of consciousness" of a class.

Let us now proceed to note that what has seemingly been thoroughly successful, namely elite historiography, on the right or the left, nationalist or colonialist, is itself, by the analysis of this group, shown to be constituted by cognitive failures. Indeed, if the theory of change as the site of the displacement of a discursive field is their most pervasive argument, this comes a close second. Here too no distinction is made, quite properly in my estimation, between witting and unwitting lapses. Hardiman points at the Nationalists' persistent (mis)cognition of discursive-field displacement on the part of the subaltern as the signature of Sanskritization (3, 214). He reads contemporary analysis such as Paul Brass's study of factionalism for the symptoms of what Edward Said has called "orientalism" (1, 227). It is correctly suggested that the sophisticated vocabulary of much contemporary historiography *successfully* shields this cognitive *failure* and that this success-in-failure, this sanctioned ignorance, is inseparable from colonial domination. Das shows rational expectation theory, that hegemonic yet defunct (successful cognitive failure once again) mainstay neocolonialism, at work in India's "Green Revolution To Prevent a Red One" (2, 198–99).

Within this tracking of successful cognitive failure, the most interesting maneuver is to examine the production of "evidence," the cornerstone of the edifice of historical truth (3, 231–70), and to anatomize the mechanics of the construction of the self-consolidating Other—the insurgent and insurgency. In this part of the project, Guha seems to radicalize the historiography of colonial India through a combination of Soviet and Barthesian semiotic analysis. The discursivity (cognitive failure) of disinterested (successful and therefore true) historiography is revealed. The Muse of History and counterinsurgency are shown to be complicit (2, 1–42; *EAP*).

I am suggesting that an implicitly evolutionist or progressivist set of presuppositions measuring failure or success in terms of level of consciousness is too simple for the practice of the collective. If we look at the varieties of activity treated by them—subaltern, insurgent, nationalist, colonialist, historiographic—it is a general field of failures that we see. In fact the work of the collective is to make the distinction between success and failure indeterminate—for the most successful historical record is disclosed by them to be crosshatched by cognitive failure. Since in the case of the subaltern they are considering consciousness (however "negative") and culture (however determining); and in the case of the elite, culture and manipulation, the subaltern is also operating in the theater of "cognition." At any rate, where does cognition begin and end? I will consider later the possible problems with such compartmentalized views of consciousness. Here suffice it to say

that by ordinary standards of coherence, and in terms of their own method-
ology, the possibility of failure cannot be derived from any criterion of suc-
cess unless the latter is a theoretical fiction.[8]

A word on "alienation," as used by members of this group, to mean "a
failure of *self*-cognition," is in order here.

> To overestimate...[the] lucidity or depth [of the subaltern consciousness]
> will be...ill-advised.... This characteristic expression of a negative con-
> sciousness on the insurgent's part matched its other symptom, that is, his
> self-alienation. He was still committed to envisaging the coming war on the
> Raj as the project of a will independent of himself and his own role in it as
> no more than instrumental.... [In their own] parwana [proclamation]...the
> authors did not recognize even their own voice, but heard only that of God
> [*EAP*, 28].

To be sure, within his progressivist narrative taxonomy Hegel describes the
march of history in terms of a diminution in the self-alienation of the so-
called world historical agent. Kojève and his followers in France distin-
guished between this Hegel, the narrator of (a) history, and the speculative
Hegel who outlined a system of logic.[9] Unless the subject separates from
itself to grasp the object there is no cognition, indeed no thinking, no judg-
ment. Being and Absolute Idea, the first and last sections of *The Science of
Logic*, two accounts of simple unalienability, are not accessible to individ-
ual or personal consciousness. From the strictly philosophical point of view,
then, (a) elite historiography and (b) the bourgeois nationalist account, as
well as (c) reinscription by the Subaltern Studies group, are operated by
alienation—*Verfremdung* as well as *Entäußerung*. Derrida's reading of
Hegel as in *Glas* would question the argument for the inalienability even
of Absolute Necessity and Absolute Knowledge, but here we need not move
that far. We must ask the opposite question. How shall we deal with Marx's
suggestion that man must strive toward self-determination and unalienated
practice and Gramsci's that "the lower classes" must "achieve self-aware-
ness via a series of negations"?[10]

Formulating an answer to this question might lead to far-reaching prac-
tical effects if the risks of the irreducibility of cognitive "failure" and of
"alienation" are accepted. The group's own practice can then be graphed on
this grid of "failures," with the concept of failure generalized and rein-
scribed as I have suggested above. This subverts the inevitable vanguardism
of a theory that otherwise criticizes the vanguardism of theory. This is why
I hope to align them with deconstruction: "Operating necessarily from the
inside, borrowing all the strategic and economic resources of subversion
from the old structure, borrowing them structurally, that is to say without

being able to isolate their elements and atoms, the enterprise of deconstruction always in a certain way falls prey to its own work" (*OG*, 24).

This is the greatest gift of deconstruction: to question the authority of the investigating subject without paralyzing him, persistently transforming conditions of impossibility into possibility.[11] Let us pursue the implications of this in our particular case.

The group, as we have seen, tracks failures in attempts to displace discursive fields. A deconstructive approach would bring into focus the fact that they are themselves engaged in an attempt at displacing discursive fields, that they themselves "fail" (in the general sense) for reasons as "historical" as those they adduce for the heterogeneous agents they study; and it would attempt to forge a practice that would take this into account. Otherwise, if they were to refuse to acknowledge the implications of their own line of work because that would be politically incorrect, they would, willy-nilly, "insidiously objectify" the subaltern (2, 262), control him through knowledge even as they restore versions of causality and self-determination to him (2, 30), become complicit, in their desire for totality (and therefore totalization) (3, 317), with a "law [that] assign[s] a[n] undifferentiated [proper] name" (*EAP*, 159) to "the subaltern as such."

SUBALTERN STUDIES AND THE EUROPEAN CRITIQUE OF HUMANISM

A "religious idiom gave the hillmen [of the Eastern Ghats] a framework, within which to conceptualize their predicament and to seek solutions to it" (*1*, 140–41). The idiom of recent European theories of interpretation seems to offer this collective a similar framework. As they work their displacement, they are, as I suggest above, expanding the semantic range of "reading" and "text," words that are, incidentally, not prominent in their vocabulary. This is a bold transaction and can be compared favorably to some similar attempts made by historians in the United States.[12] It is appropriately marked by attempts to find local parallels, as in the concept of *atideśa* in Guha's work, and to insert the local into the general, as in the pervasive invocation of English, French, German, and occasionally Italian insurgency in Guha's book on peasant insurgency, and in the invocation of the anthropology of Africa in Partha Chatterjee's work on modes of power.

It is the force of a crisis that operates functional displacements in discursive fields. In my reading of the volumes of *Subaltern Studies*, this critical force or bringing-to-crisis can be located in the energy of the questioning of humanism in the post-Nietzschean sector of Western European structuralism, for our group Michel Foucault, Roland Barthes, and a certain Lévi-Strauss. These structuralists question humanism by exposing its hero—the sovereign subject as author, the subject of authority, legitimacy, and power. There is an affinity between the imperialist subject and the

subject of humanism. Yet the crisis of anti-humanism—*like all crises*—does not move our collective "fully." The rupture shows itself to be also a repetition. The collective falls back upon notions of consciousness-as-agent, totality, and culturalism that are discontinuous with the critique of humanism. They seem unaware of the historico-political provenance of their various Western "collaborators." Vygotsky and Lotman, Victor Turner and Lévi-Strauss, Evans-Prichard and Hindess and Hirst can, for them, fuel the same fire as Foucault and Barthes. Since one cannot accuse this group of the eclecticism of the supermarket consumer, one must see in their practice a repetition of as well as a rupture from the colonial predicament: the transactional quality of interconflicting metropolitan sources often eludes the (post)colonial intellectual.

I remind the reader that, in my view, such "cognitive failures" are irreducible. As I comment on the place of "consciousness" in the work of Subaltern Studies, it is therefore not my intent to suggest a formula for correct cognitive moves.

THE PROBLEM OF SUBALTERN CONSCIOUSNESS
I have been trying to read the work of the group against the grain of their theoretical self-representation. Their figuration of peasant or subaltern consciousness makes such a reading particularly productive.

To investigate, discover, and establish a subaltern or peasant consciousness seems at first to be a positivistic project—a project which assumes that, if properly prosecuted, it will lead to firm ground, to some *thing* that can be disclosed. This is all the more significant in the case of recovering a consciousness because, within the post-Enlightenment tradition that the collective participates in as interventionist historians, consciousness is *the* ground that makes all disclosures possible.

And, indeed, the group is susceptible to this interpretation. There *is* a certain univocal reflection or signification-theory presupposed here by which "peasant action in famine as in rebellion" is taken to "reflect...a single underlying consciousness" (3, 112); and "solidarity" is seen as a "signifier of consciousness," where signification is representation, figuration, propriation (stringent delimitation within a unique and self-adequate outline), and imprinting (*EAP*, 169).

Yet even as "consciousness" is thus entertained as an indivisible self-proximate signified or ground, there is a force at work here which would contradict such metaphysics. For consciousness here is not consciousness-in-general, but a historicized political species thereof, subaltern consciousness. In a passage where "transcendental" is used as "transcending, because informing a hegemonic narrative" rather than in a strictly philosophical sense, Guha puts this admirably: "Once a peasant rebellion has been assim-

ilated to the career of the Raj, the Nation or the people [the hegemonic narratives], it becomes easy for the historian to abdicate the responsibility he has of exploring and describing the consciousness specific to that rebellion and be content to ascribe to it a transcendental consciousness...representing them merely as instruments of some other will" (2, 38).

Because of this bestowal of a historical specificity to consciousness in the narrow sense, even as it implicitly operates as a metaphysical methodological presupposition in the general sense, there is always a counterpointing suggestion in the work of the group that subaltern consciousness is subject to the cathexis of the elite, that it is never fully recoverable, that it is always askew from its received signifiers, indeed that it is effaced even as it is disclosed, that it is irreducibly discursive. It is, for example, chiefly a matter of "negative consciousness" in the more theoretical of these essays. Although "negative consciousness" is conceived of here as a historical stage peculiar to the subaltern, there is no logical reason why, given that the argument is inevitably historicized, this "negative," rather than the grounding positive view of the consciousness, should not be generalized as the group's methodological presupposition. One view of "negative consciousness," for instance, sees it as the consciousness not of the being of the subaltern, but of that of the oppressors (*EAP*, chap. 2; *3*, 183). Here, in vague Hegelian limnings, it is the anti-humanist and anti-positivist position that it is always the desire for/of (the power of the Other) that produces an image of the self. If this is generalized, as in my reading of the "cognitive failure" argument, it is the subaltern who provides the model for a general theory of consciousness. And yet, since the "subaltern" cannot appear without the thought of the "elite," the generalization is by definition incomplete—in philosophical language "nonoriginary," or, in an earlier version of "*unursprünglich*," nonprimordial. This "instituted trace at the origin" is a representation of the deconstructive critique of simple origins. Of the practical consequences of recognizing the traces of this strategy in the work of the group I will speak below.

Another note in the counterpoint deconstructing the metaphysics of consciousness in these texts is provided by the reiterated fact that it is only the texts of counterinsurgency or elite documentation that give us the news of the consciousness of the subaltern. "The peasants' view of the struggle will probably never be recovered, and whatever we say about it at this stage must be very tentative" (*1*, 50); "Given the problems of documenting the consciousness of the jute mill workers, their will to resist and question the authority of their employers can be read only in terms of the sense of crisis it produced among the people in authority" (*3*, 121); "It should be possible to read the presence of a rebel consciousness as a necessary and pervasive element within that body of evidence" (*EAP*, 15). To be sure, it

is the vocabulary of "this stage," "will to resist," and "presence." Yet the language seems also to be straining to acknowledge that the subaltern's view, will, presence, can be no more than a theoretical fiction to entitle the project of reading. It cannot be recovered; "it will probably never be recovered." If I shifted to the slightly esoteric register of the language of French poststructuralism, I could put it thus: "Thought [here the thought of subaltern consciousness] is here for me a perfectly neutral name, the blank part of the text, the necessarily indeterminate index of a future epoch of difference."[13]

Once again, in the work of this group, what had seemed the historical predicament of the colonial subaltern can be made to become the allegory of the predicament of all thought, all deliberative consciousness, though the elite profess otherwise. This might seem preposterous at first glance. A double take is in order. I will propose it in closing this section of my paper.

The definitive accessibility of subaltern consciousness is counterpointed also by situating it in the place of a difference rather than an identity: "The terms 'people' and 'subaltern classes' have been used as synonymous throughout this [introductory] note [to *1*]. The social groups and elements included in this category represent the *demographic difference between the total Indian population and all those whom we have described as the 'elite'*" (*1*, 83: italics author's). I refer the reader to an essay where I have commented extensively on the specific counterpointing here: between the ostensible language of quantification—*demographic* difference—which is positivistic, and the discourse of a definitive difference—demographic *difference*—which opens the door to deconstructive gestures.[14]

I am progressively inclined, then, to read the retrieval of subaltern consciousness as the charting of what in poststructuralist language would be called the subaltern subject-effect.[15] A subject-effect can be briefly plotted as follows: that which seems to operate as a subject may be part of an immense discontinuous network ("text" in the general sense) of strands that may be termed politics, ideology, economics, history, sexuality, language, and so on. (Each of these strands, if they are isolated, can also be seen as woven of many strands.) Different knottings and configurations of these strands, determined by heterogeneous determinations which are themselves dependent upon myriad circumstances, produce the effect of an operating subject. Yet the continuist and homogenist deliberative consciousness symptomatically requires a continuous and homogeneous cause for this effect and thus posits a sovereign and determining subject. This latter is, then, the effect of an effect, and its positing a metalepsis, or the substitution of an effect for a cause. Thus do the texts of counterinsurgency locate, in the following description, a "will" as the sovereign cause when it is no more than an effect of the subaltern subject-effect, itself produced by

the particular conjunctures called forth by the crises meticulously described in the various *Subaltern Studies*:

> It is of course true that the reports, despatches, minutes, judgements, laws, letters, etc. in which policemen, soldiers, bureaucrats, landlords, usurers and others hostile to insurgency register their sentiments, amount to a representation of their will. But these documents do not get their content from that will alone, for the latter is predicated on another will—that of the insurgent. It should be possible therefore to read the presence of a rebel consciousness as a necessary and pervasive element within that body of evidence [EAP, 15].

Reading the work of Subaltern Studies from within but against the grain, I would suggest that elements in their text would warrant a reading of the project to retrieve the subaltern consciousness as the attempt to undo a massive historiographic metalepsis and "situate" the effect of the subject as subaltern. I would read it, then, as a *strategic* use of positivist essentialism in a scrupulously visible political interest. This would put them in line with the Marx who locates fetishization, the ideological determination of the "concrete," and spins the narrative of the development of the money-form; with the Nietzsche who offers us genealogy in place of historiography, the Foucault who plots the construction of a "counter-memory," the Barthes of semiotrophy, and the Derrida of "affirmative deconstruction." This would allow them to use the critical force of anti-humanism, in other words, even as they share its constitutive paradox: that the essentializing moment, the object of their criticism, is irreducible.

The strategy becomes most useful when "consciousness" is being used in the narrow sense, as self-consciousness. When "consciousness" is being used in that way, Marx's notion of unalienated practice or Gramsci's notion of an "ideologically *coherent*," "spontaneous philosophy of the multitude" are plausible and powerful.[16] For class-consciousness does not engage the ground level of consciousness—consciousness in general. "Class" is not, after all, an inalienable description of a human reality. Class-consciousness on the *descriptive* level is itself a strategic and artificial rallying awareness which, on the *transformative* level, seeks to destroy the mechanics which come to construct the outlines of the very class of which a collective consciousness has been situationally developed. "Any member of the insurgent community"—Guha spends an entire chapter showing how that collective consciousness of community develops—"who chooses to continue in such subalternity is regarded as hostile towards the inversive process initiated by the struggle and hence as being on the enemy's side" (*EAP*, 202). The task of the "consciousness" of class or collectivity within a social field of

exploitation and domination is thus necessarily self-alienating. The tradition of the English translations of Marx often obliterates this. Consider, for example, the following well-known passage from the *Communist Manifesto*: "If the proletariat in struggle [*im Kampfe*] against the bourgeoisie is compelled to unite itself in a class [*sich notwendig zum Klasse vereint*], and, by means of a revolution, it makes itself the ruling class, and, as such, sweeps away by force the old conditions of production, it thus sweeps away the conditions of class oppositions [*Klassengegensatz*] and of classes generally, and abolishes its own lordship [*Herrschaft*] as a class."[17] The phrases translated as "sweeps away," "sweeps away," and "abolishes" are, in Marx's text, "aufhebt." "'Aufheben' has a twofold meaning in the language: on the one hand it means to preserve, to maintain, and equally it also means to cause to cease, to put an end to.... The two definitions of 'Aufheben' which we have given can be quoted as two dictionary *meanings* of this word."[18] In this spirit of "maintain *and* cause to cease," we would rewrite "inversive" in the passage from *EAP* as "displacing."

It is within the framework of a strategic interest in the self-alienating displacing move of and by a consciousness of collectivity, then, that self-determination and an unalienated self-consciousness can be broached. In the definitions of "consciousness" offered by the Subaltern Studies group there are plenty of indications that they are in fact concerned with consciousness not in the general, but in this crucial narrow sense.

Subaltern consciousness as self-consciousness of a sort is what inhabits "the whole area of independent thought and conjecture and speculation...on the part of the peasant" (*1*, 188), what offers the "clear proof of a distinctly independent interpretation of [Gandhi's] message" (*3*, 7), what animates the parley[s] among...the principal [insurgents] seriously to weigh the pros and cons of any recourse to arms" (*2*, 1), indeed what underwrites all invocations of the will of the subaltern.

Subaltern consciousness as emergent collective consciousness is one of the main themes of these books. Among the many examples that can be found, I will cite two: "what is indubitably represented in these extracts from Abdul Majid [a weaver]'s diary is a consciousness of the 'collective'—the community. Yet this consciousness of community was an ambiguous one, straddling as it did the religious fraternity, class *qasba*, and mohalla" (*3*, 269). "[The tribe's] consciousness of itself as a body of insurgents was thus indistinguishable from its recognition of its ethnic self" (*EAP*, 286). The group places this theory of the emergent collective subaltern consciousness squarely in the context of that tendency within Western Marxism which would refuse class-consciousness to the precapitalist subaltern, especially in the theaters of Imperialism. Their gesture thus confronts E. J. Hobsbawm's notion of the "pre-political" as much as

functionalist arguments from "reciprocity and moral economy" between "agrarian labourers" and "peasant proprietors," which are "an attempt to deny the relevance of class identities and class conflict to agrarian relations in Asia until a very recent date" (3, 78). Chakrabarty's analysis of how historically unsound it is simply to reverse the gesture and try to impose a Marxian *working*-class consciousness upon the urban proletariat in a colonial context and, by implication, as Guha shows, upon the rural subaltern, takes its place within this confrontation.

For readers who notice the points of contact between the Subaltern Studies group and critics of humanism such as Barthes and Foucault, confusion arises because of the use of the word "consciousness," unavoidably a postphenomenological and postpsychoanalytic issue with such writers. I am not trying to clear the confusion by revealing through analysis that the Subaltern Studies group is not entertaining "consciousness" within that configuration at all, but is rather working exclusively with the second-level collective consciousness to be encountered in Marx and the classical Marxist tradition. I am suggesting, rather, that although the group does not wittingly engage with the poststructuralist understanding of "consciousness," our own transactional reading of them is enhanced if we see them as *strategically* adhering to the essentialist notion of consciousness, that would fall prey to an anti-humanist critique, within a historiographic practice that draws many of its strengths from that very critique.

HISTORIOGRAPHY AS STRATEGY

Can a strategy be unwitting? Of course not fully so. Consider, however, statements such as the following: "[a] discrepancy...is necessarily there at certain stages of the class struggle between the level of its objective articulation and that of the consciousness of its subjects"; or, "with all their practical involvement in a rebellion the masses could still be tricked by a false consciousness into trusting the magical faculties of warrior heroes..."; or yet, "the peasant rebel of colonial India could do so [learn his very first lesson in power] only by translating it backwards into the semi-feudal language of politics to which he was born" (*EAP*, 173, 270, 76). A theory which allows a partial lack of fit in the fabrication of any strategy cannot consider itself immune from its own system. It must remain caught within the possibility of that predicament in its own case. If in translating bits and pieces of discourse theory and the critique of humanism back into an essentialist historiography the historian of subalternity aligns himself to the pattern of conduct of the subaltern himself, it is only a progressivist view that diagnoses the subaltern as necessarily inferior, that will see such an alignment to be without interventionist value. Indeed it is in their very insistence upon the subaltern as the subject of history that the group acts out such a

translating back, an interventionist strategy that is only partially unwitting.

If it were embraced as a strategy, then the emphasis upon the "sovereign-ty,...consistency and...logic" of "rebel consciousness" (*EAP*, 13) could be seen as "affirmative deconstruction": knowing that such an emphasis is the-oretically nonviable, the historian then breaks his theory in a scrupulously delineated "political interest."[19] If, on the other hand, the restoration of the subaltern's subject-position in history is seen by the historian as the estab-lishment of an inalienable and final truth of things, then any emphasis on sovereignty, consistency, and logic will, as I have suggested above, inevitably objectify the subaltern and be caught in the game of knowledge as power. Even if the discursivity of history is seen as a *fortgesetzte Zeichenkette*, a restorative genealogy cannot be undertaken without the strategic blindness that will entangle the genealogist in the chain. Seeing this, Foucault in 1971 recommended the "historical sense," much like a newscaster's persistently revised daily bulletin, in the place of the arrogance of a successful genealo-gy.[20] It is in this spirit that I read *Subaltern Studies* against its grain and sug-gest that its own subalternity in claiming a *positive* subject-position for the subaltern might be reinscribed as a strategy for our times.

What good does such a reinscription do? It acknowledges that the arena of the subaltern's persistent emergence into hegemony must always and by definition remain heterogeneous to the efforts of the disciplinary historian. The historian must persist in *his* efforts in this awareness that the subaltern is necessarily the absolute limit of the place where history is narrativized into logic. It is a hard lesson to learn, but not to learn it is merely to nominate elegant solutions to be correct theoretical practice. When has history ever contradicted that practice norms theory, as subaltern practice norms official historiography in this case? If that assumption, rather than the dissonant thesis of the subaltern's infantility, were to inhabit *Subaltern Studies*, then their project would be proper to itself in recognizing that it can never be proper to "subaltern consciousness"; that it can never be continuous with the subaltern's situational and uneven entry into political (not merely disci-plinary, as in the case of the collective) hegemony as the content of an after-the-fact description. This is the always asymmetrical relationship between the interpretation and transformation of the world which Marx marks in the eleventh thesis on Feuerbach. There the contrast is between the words *haben interpretiert* (present participle—a completed action—of *inter-pretieren*—the Romance verb which emphasizes the establishment of a meaning that is commensurate with a phenomenon through the metaphor of the fair exchange of prices) and *zu verändern* (infinitive—always open to the future—of the German verb which "means" strictly speaking, "to make other"). The latter expression matches *haben interpretiert* neither in its Latinate philosophical weight nor in its signification of propriety and com-

pletion, as *transformierien* would have done. Although not an unusual word, it is not the most common word for "change" in German—*verwandeln*. In the open-ended "making-other"—*Veränderung*—of the properly self-identical—adequately *interpretiert*—lies an allegory of the theorist's relationship to his subject-matter. (There is no room here to comment on the richness of "es kommt darauf an," the syntactical phrase that joins the two parts of the Eleventh Thesis.) It is not only *"bad"* theory but *all* theory that is susceptible to this open-endedness.

Theoretical descriptions cannot produce universals. They can only ever produce provisional generalizations, even as the theorist realizes the crucial importance of their persistent production. Otherwise, because they desire perhaps to claim some unspecified direct hand in subaltern practice, the conclusions to the essays become abrupt, inconclusive, sometimes a series of postponements of some empirical project. One striking example of this foreclosed desire is where Das, in an otherwise brilliant essay, repudiates *formalization* as thwarting for practice, even as he deplores the lack of sufficient *generalization* that might have allowed subaltern practice to flourish (2, 227).

Louis Althusser spoke of the limit of disciplinary theoretical production in the following way: "[A] new practice of philosophy can transform philosophy. And in addition it can in its way *help* [*aider à sa mesure*] in the transformation of the world. Help only...."[21] In his trivializing critique of Althusser, E. P. Thompson privileges the British style of history teaching as against the French style of philosophy teaching.[22] Whatever position we take in the ancient quarrel between history and philosophy, it is incumbent upon us to realize that as *disciplines* they must both remain heterogeneous to, and discontinuous with, subaltern social practice. To acknowledge this is not to give way to functionalist abdication. It is a curious fact of Michel Foucault's career that, in a certain phase of his influential last period, he performed something like an abdication: he refused to "represent" (as if such a refusal were possible), and privileged the oppressed subject, who could seemingly speak for himself.[23] The Subaltern Studies group, methodical trackers of representation, cannot follow that route. Barthes, after he "situated" semiology, turned in large measure to autobiography and a celebration of the fragment. Not only because of their devotion to semiotics, but also because they are trying to assemble a historical *biography* of those whose active lives are only disclosed by a deliberately fragmentary record produced elsewhere, the Subaltern Studies group cannot follow Barthes here. They must remain committed to the subaltern as the subject of his history. As they choose this strategy, they reveal the limits of the critique of humanism as produced in the West.

The radical intellectual in the West is either caught in a deliberate choice

of subalternity, granting to the oppressed either that very expressive subjectivity which s/he criticizes or, instead, a total unrepresentability. The logical negation of this position is produced by the discourse of postmodernism, where the "mass is only the mass because its social energy has already frozen. It is a cold reservoir, capable of absorbing and neutralizing any hot energy. It resembles those half-dead systems into which more energy is injected than is withdrawn, those paid-out deposits exorbitantly maintained in a state of artificial exploitation." This negation leads to an emptying of the subject-position: "Not to arrive at the point where no one longer says I, but at the point where it's no longer of any importance whether one says I or not."[24] Although some of these Western intellectuals express genuine concern about the ravages of contemporary neocolonialism in their own nation-states, they are not knowledgeable in the history of imperialism, in the epistemic violence that constituted/effaced a subject that was obliged to cathect (occupy in response to a desire) the space of the Imperialists' self-consolidating other. It is almost as if the force generated by their crisis is separated from its appropriate field by a sanctioned ignorance of that history.

It is my contention that, if the Subaltern Studies group saw their own work of subject-restoration as crucially strategic, they would not miss this symptomatic blank in contemporary Western anti-humanism. In his innovative essay on modes of power, Partha Chatterjee quotes Foucault on the eighteenth century and writes:

> Foucault has sought to demonstrate the complexities of this novel regime of power in his studies of the history of mental illness, of clinical practice, of the prison, of sexuality and of the rise of the human sciences. When one looks at the regimes of power in the so-called backward countries of the world today, not only does the dominance of the characteristically "modern" modes of exercise of power seem limited and qualified by the persistence of older modes, but by the fact of their combination in a particular state and formation, it seems to open up at the same time an entirely new range of possibilities for the ruling classes to exercise their domination. [3, 348–9].

I have written earlier that the force of crisis is not systematically emphasized in the work of the group. The Foucauldian example being considered here, for instance, can be seen as marking a crisis *within* European consciousness. A few months before I had read Chatterjee's essay, I wrote a few sentences uncannily similar in sentiment on the very same passage in Foucault. I write, of course, within a workplace engaged in the ideological production of neocolonialism even through the influence of such

thinkers as Foucault. It is not therefore necessarily a mark of extraordinary acumen that what I am calling the crisis in European consciousness is much more strongly marked in my paragraph, which I take the liberty of quoting here. My contention below is that the relationship between First World, anti-humanist post-Marxism and the history of imperialism is not merely a question of "enlarging the range of possibilities," as Chatterjee soberly suggests above.

> Although Foucault is a brilliant thinker of power-in-spacing, the awareness of the topographic reinscription of imperialism does not inform his presuppositions. He is taken in by the restricted version of the West produced by that reinscription and thus helps to consolidate its effects. Notice, for example, the omission of the fact, in the following passage, that the new mechanism of power in the seventeenth and eighteenth centuries (the extraction of surplus-value without extraeconomic coercion is its Marxist description) is secured *by means of* territorial imperialism—the Earth and its products— "elsewhere." The representation of sovereignty is crucial in those theatres: "In the seventeenth and eighteenth centuries, we have the production of an important phenomenon, the emergence, or rather the invention, of a new mechanism of power possessed of highly specific procedural techniques...which is also, I believe, absolutely incompatible with the relations of sovereignty...." I am suggesting that to buy a self-contained version of the West is symptomatically to ignore its production by the spacing-timing of the imperialist project. Sometimes it seems as if the very brilliance of Foucault's analysis of the centuries of European imperialism produces a miniature version of that heterogeneous phenomenon: management of space—but by doctors, development of administrations—but in asylums, considerations of the periphery—but in terms of the insane, prisoners, and children. The clinic, the asylum, the prison, the university, seem screen-allegories that foreclose a reading of the broader narratives of imperialism.[25]

Thus the discourse of the unified consciousness of the subaltern *must* inhabit the strategy of these historians, even as the discourse of the micrologized or "situated" subject must mark that of anti-humanists on the other side of the international division of labor. The two following remarks by Ranajit Guha and Louis Althusser can then be seen as marking not a contradiction, but the fracture of a discontinuity of philosophic levels, *as well as* a strategic asymmetry: "Yet we propose," writes Guha in the eighties, "to focus on this consciousness as our central theme, because it is not possible to make sense of the experience of insurgency merely as a history of events without a subject" (4, 11). Precisely, "it is not possible." And Althusser, writing in 1967:

Undeniably, for it has passed into his works, and *Capital* demonstrates it, Marx owes to Hegel the decisive philosophical category of process. He owes him yet more, that Feuerbach himself did not suspect. He owes him the concept of the process *without subject*.... The origin, indispensable to the teleological nature of the process...must be *denied* from the start, so that the process of alienation may be a process without subject.... Hegel's logic is of the affirmed-denied Origin: first form of a concept that Derrida has introduced into philosophical reflection, the *erasure*.[26]

As Chakrabarty has rightly stated, "Marx thought that the logic of capital could be best deciphered only in a society where 'the notion of human equality has already acquired the fixity of a popular prejudice'" (2, 263). The first lesson of ideology is that a "popular prejudice" mistakes itself for "human nature," the original mother tongue of history. Marxist historiography can be caught within the mother tongue of history and a culture that had graduated to bourgeois individualism. As groups such as the Subaltern Studies collective attempt to open up the texts of Marx beyond his European provenance, beyond a homogeneous internationalism, to the persistent recognition of heterogeneity, the very goal of "forget[ting] his original [or 'rooted'—*die ihm angestammte Sprache*] language while using the new one" must be reinscribed.[27] A repeated acknowledgment of the complicity of the new and the "original" is now on the agenda. I have tried to indicate this by deconstructing the opposition between the collective and their object of investigation—the subaltern—on the one hand; and by deconstructing the seeming continuity between them and their anti-humanist models on the other. From this point of view, it would be interesting if, instead of finding their only internationalism in European *history* and African *anthropology* (an interesting disciplinary breakdown), they were also to find their lines of contact, let us say, with the *political economy* of the independent peasant movement in Mexico.[28]

You can only read against the grain if misfits in the text signal the way. (These are sometimes called "moments of transgression.") I should like to bring the body of my argument to a close by discussing two such moments in the work of this group. First, the discussion of rumor; and, second, the place of woman in their argument.

RUMOR

The most extensive discussion of rumors, to be found in Guha's *Peasant Insurgency* is not, strictly speaking, part of the work of the group. I think I am correct, however, in maintaining that Guha's pages make explicit an implicit set of assumptions about the nature and role of subaltern means of communication, such as rumor, in the mobilization of insurgency,

present in the work of the entire group. Guha's discussion also points up the contradiction inherent in their general practice, which leans toward poststructuralism, and their espousal of the early semiological Barthes, Lévi-Strauss, Greimas, and taxonomic Soviet structuralists such as Vygotsky, Lotman, and Propp.

Steven Ungar plots Barthes's trajectory from semiology through semio-clasty to semiotropy in *Roland Barthes: the Professor of Desire*.[29] Any use of the Barthes of the first period would have to refute, however briefly, Barthes's own refutation and rejection of his early positions.

One of the enterprises made problematic by the critique of the subject of knowledge identified with poststructuralist anti-humanism is the desire to produce exhaustive taxonomies, "to assign names by a metalinguistic operation" (2, 10). I have already discussed this issue lengthily in another part of my essay. All of the figures listed above would be susceptible to this charge. Here I want to point at their common phonocentrism, the conviction that speech is a direct and immediate representation of voice-consciousness, and writing an indirect transcript of speech. Or, as Guha quotes Vygotsky, "The speed of oral speech is unfavourable to a complicated process of formulation—it does not leave time for deliberation and choice. Dialogue implies immediate unpremeditated utterance" (*EAP*, 261).

By this reckoning the history of writing is coincident with the inauguration and development of exploitation. Now there is no reason to question this well-documented story of what one might call writing in the "narrow" or "restricted" sense. However, over against this restricted model of writing one must not set up a model of speech to which is assigned a total self-identity based on a psychological model so crude as to imply that the space of "premeditation" is confined to the deliberative consciousness, and on empirical "evidence" so impressionistic as "the speed of oral speech."

By contrast, poststructuralist theories of consciousness and language suggest that all possibility of expression, spoken or written, shares a common distancing from a self so that meaning can arise—not only meaning for others but also the meaning of the self to the self. I have advanced this idea in my discussion of "alienation." These theories suggest further that the "self" is itself always production rather than ground, an idea I have broached in my discussion of the "subject-effect." If writing is seen in terms of its historical predication, the production of our sense of self as ground would seem to be structured like writing:

> [T]he essential predicates in a minimal determination of the classical concept of writing...[are that a] written sign...is...a mark that remains [*reste*]...[that] carries with it a force that breaks with its context,...[and that] this force of rupture is tied to the spacing...which separates it from other elements of the

internal contextual chain.... Are these three predicates, along with the entire system they entail, limited, as is so often believed, strictly to "written" communication, in the narrow sense of the word? Are they not also to be found in all language, for example in spoken language, and ultimately in the totality of "experience," insofar as it is inseparable from this field of the mark, which is to say, from the network of effacement and of difference, of units of iterability, which are separable from their internal and external context and also from themselves, inasmuch as the very iterability which constitutes their identity does not permit them ever to be a unit of self-identity?[30]

For the burden of the extended consideration of how the exigencies of theory forbid an ideological manipulation of *naïve* psychologism and empiricism, we should turn to Derrida's "Signature Event Context," from where the long passage above is taken. Here suffice it to say that this line of thinking can be made consonant with the argument that the abstract determines the "concrete."[31] That argument is not about chronological but logical priority. And it is a pity that, thanks to Engels's noble efforts to make Marx accessible, "determination" in it is most often reduced to "causality." I cannot belabor this historical situation here. Suffice it further to say that by this line of argument it would not only appear that to "describe speech as the immediate expression of the self" marks the site of a desire that is obliged to overlook the complexity of the production of (a) sense(s) of self. One would, by this, also have to acknowledge that no speech, no "natural language" (an unwitting oxymoron), not even a "language" of gesture, can signify, indicate, or express without the mediation of a pre-existing code. One would further begin to suspect that the most authoritative and potentially exploitative manifestations of writing in the narrow sense—the codes of law—operate on an implicit phonocentrism, the presupposition that speech is the immediate expression of the self.

I would submit that it is more appropriate to think of the power of rumor in the subaltern context as deriving from its participation in the structure of illegitimate writing, rather than in the authoritative writing of the law—itself sanctioned by the phonocentric model of the spirit of the law. "Writing, the outlaw, the lost son. It must be recalled here that Plato always associates speech and law, *logos* and *nomos*. Laws speak. In the personification of *Crito*, they speak to Socrates directly."[32]

Let us now consider the point in *Peasant Insurgency* where the analysis of rumor is performed (*EAP*, 259–64; these pages are cited in 3, 112, n. 157). Let us also remember that the mind-set of the peasants is as much affected by the phonocentrism of a tradition where *śruti*—that which is heard—has the greatest authority, as is the mind-set of the historian by the

phonocentrism of Western linguistics. Once again, it is a question of complicity rather than the distance of knowledge.

If, then, "rumor is spoken utterance *par excellence*" (*EAP*, 256), it must be seen that its "functional immediacy" is its nonbelonging to any *one* voice-consciousness. This is supposed to be the signal characteristic of writing. Any reader can "fill" it with her "consciousness." Rumor evokes comradeship because it belongs to every "reader" or "transmitter." No one is its origin or source. Thus rumor is not error but primordially (originally) errant, always in circulation with no assignable source. This illegitimacy makes it accessible to insurgency. Its "absolute" (we would say "indefinite," since "fictive source[s] may be assigned to it") "transitivity," collapsed at origin and end (a clear picture of writing), can be described as the received model of *speech* in the narrow sense ("the collaterality of word and deed issuing from a common will") only under the influence of phonocentrism. In fact the author himself comes closer to the case about fifteen pages later, when he notices the open verbality of rumor being restricted by the insurgents—who are also under the influence of phonocentrism—by an apocalyptic horizon. Subaltern, elite authority, and critic of historiography become complicit here. Yet the description of rumor in its "distinctive features [of] anonymity and transitivity" (*EAP*, 260) signal a contradiction that allows us to read the text of *Subaltern Studies* against its grain.

The odd coupling of Soviet structuralism and French anti-humanism sometimes produces a misleading effect. For example, the applicability to rumor of Barthes's suggestion that ascription of an author closes up *writing* should alert us to rumor's writing-like (*scriptible*) character rather than oblige us to displace Barthes's remark to speech via Vygotsky. Dialogue, Vygotsky's example, is the privileged example of the so-called communication of direct verbality, of two immediately self-present sources or "authors." Dialogue is supposed to be "unpremeditated" (although theories of subject-effect or the abstract determination of the concrete would find this a dubious claim). Rumor is a relay of something always assumed to be preexistent. In fact the mistake of the colonial authorities was to take rumor for speech, to impose the requirements of speech in the narrow sense upon something that draws its strength from participation in writing in the general sense.

The Subaltern Studies group has here led us to a theme of great richness. The crosshatching of the revolutionary nonpossessive possibilities in the structure of writing in general and its control by subaltern phonocentrism give us access to the micrology or minute-scale functioning of the subaltern's philosophical world. The matter of the "blank paper falling from heaven" or the use of apparently "random" material "to...convey...the Thakur's own command in writing" (*EAP*, 248–49), for instance, can

provide us a most complex text for the use of the structure of writing in the fable of "insurgent consciousness." The matter of the role of "the reading aloud of newspapers" in the construction of Gandhi as a signifier is perhaps too quickly put to rest as a reliance on "spoken language," when, through such an act, "a story acquires its authentication from its motif and the name of its place of origin rather than the authority of the correspondent" (3, 48–49). I have dwelt on this point so long that it might now suffice to say no more than that the newspaper is exploitative writing in the narrow sense, "spoken language" is a phonocentric concept where authority is supposed to spring directly from the voice-consciousness of the self-present speaker, and the reading out of someone else's text as "an actor does on the stage" is a setting-in-motion of writing in the general sense. To find corroboration of this, one can see the contrast made between speaker and rhetor in the Western tradition from the Platonic Socrates through Hobbes and Rousseau to J. L. Austin.[33] When newspapers start reporting rumors (3, 88), the range of speculative possibilities becomes even more seductive. The investigator seems herself beckoned by the circuit of "absolute transitivity."

Without yielding to that seduction, the following question can be asked: what is the use of noticing this misfit between the suggested structure of writing in general and the declared interest in phonocentrism? What is the use of pointing out that a common phonocentrism binds subaltern, elite authority, and disciplinary-critical historian together, and only a reading against the grain discloses the espousal of illegitimacy by the first and the third? Or, to quote Terry Eagleton:

> Marx is a metaphysician, and so is Schopenhauer, and so is Ronald Reagan. Has anything been gained by this manoeuvre? If it is true, is it informative? What is ideologically at stake in such homogenizing? What differences does it exist to suppress? Would it make Reagan feel uncomfortable or depressed? If what is in question for deconstructionism is metaphysical discourse, and if this is all-pervasive, then there is a sense in which in reading against the grain we are subverting everything and nothing.[34]

Not all ways of understanding the world and acting upon it are *equally* metaphysical or phonocentric. If, on the other hand, there *is* something shared by elite (Reagan), colonial authority, subaltern, and mediator (Eagleton/Subaltern Studies) that we would rather not acknowledge, any elegant solution devised by means of such a refusal would merely mark a site of desire. It is best to attempt to forge a practice that can bear the weight of that acknowledgment. And, using the buried operation of the structure of writing as a lever, the strategic reader can reveal the asymmetry between

the three groups above. Yet, since a "reading against the grain" must forever remain strategic, it can never claim to have established the authoritative truth of a text, it must forever remain dependent upon practical exigencies, never legitimately lead to a theoretical orthodoxy. In the case of the Subaltern Studies group, it would get the group off the dangerous hook of claiming to establish the truth-knowledge of the subaltern and his consciousness.

WOMAN

The group is scrupulous in its consideration toward women. They record moments when men and women are joined in struggle (*1*, 178; *EAP*, 130), and moments when their conditions of work or education suffer from gender or class discrimination (2, 71, 241, 243, 257, 275). But I think they overlook how important the concept-metaphor woman is to the functioning of their discourse. This consideration will bring to an end the body of my argument.

In a certain reading, the figure of woman is pervasively instrumental in the shifting of the function of discursive systems, as in insurgent mobilization. Questions of the mechanics of this instrumentality are seldom raised by our group. "Femininity" is as important a discursive field for the predominantly male insurgents as "religion." When cow-protection becomes a volatile signified in the reinscription of the social position of various kinds of subaltern, semisubaltern, and indigenous elite groups, the cow is turned into a female figure of one kind or another. Considering that in the British nineteenth century the female access to "possessive individualism" was one of the most important social forces, what does it mean to imply that "femininity" has the same discursive sense and force for all the heterogeneous groups meticulously documented by Gyanendra Pandey? Analogous research into the figure of the "worker" is performed by Chakrabarty. No such luck for the "female."

On the most "ancient and indigenous" religious level, a level that "perhaps gave the [rebellious hillmen] an extra potency [sic] in times of collective distress and outside oppression" (*1*, 98), all the deities are man-eating goddesses. As this preinsurgent level of collectivity begins to graduate into revolt, the sacrifices continue to be made to goddesses rather than gods. And, even as this level of subaltern-led revolt is contrasted to the "elite struggles of the earlier period" (*1*, 124), we notice that in that earlier period the struggles began on two occasions because men would not accept female leadership:

With the deposition in 1836 of Ananta Bhupati, the 17th Zamindar of Golgonda, the Collector of Vishakhapatnam installed Jamma Devamma,

widow of the 15th Zamindar, in his place. This was an affront to the *muttadars* and *mokhasadars* of Gudem who were not consulted...and who protested that they had never before been ruled by a woman.... In Rampa, the death of the Mansabdar Ram Bhupati Dev in March 1835 was followed by a revolt of *muttadars* against the daughter who had been appointed as the successor [*1*, 102].

In terms of social semiosis, what is the difference between man-eating goddesses, objects of reverence and generators of solidarity on the one hand, and secular daughters and widows, unacceptable as leaders, on the other? On the occasion of the "culture of sugarcane" in Eastern UP, Shahid Amin speaks of the deliberate noncoincidence created between the natural inscription (script as used when referring to a play) of the harvest calendar and the artificial inscription of the circuit of colonial monopoly capital. It is of course of great interest to wonder in what ways the composition of the peasantry and landowners would have developed had the two been allowed to coincide. Yet I think it should also be noticed that it is dowry that is the invariably mentioned *social* demand that allowed the demands of nature to devastate the peasant via the demands of empire. Should one trouble about the constitution of the subaltern as (sexed) subject when the exploitation of sexual difference seems to have so crucial a role on so many fronts? Should one notice that the proverb on 1, 53 is sung by a young daughter who will deny her lover's demands in order to preserve her father's fields? Should one notice this metaphoric division of sexuality (in the woman's case, sex is of course identical with selfhood or consciousness) as property to be passed on or not from father to lover? Indeed, in a collective where so much attention is rightly paid to the subjectivity or subject-positioning of the subaltern, it should be surprising to encounter such indifference to the subjectivity, not to mention the indispensable presence, of the woman as crucial instrument. These four sentences should illustrate my argument:

> It was not uncommon for a "superior" Patidar to spend his dowry money and return his wife to her father so that he could marry for a new dowry. Amongst Patidars, it was considered very shameful to have to take back a daughter [!] ...Gols were formed to prevent ruinous hypergamous marriages with "superior" Patidar lineages.... Here, therefore, we discover a strong form of subaltern organization within the Patidar caste which provided a check on the power of the Patidar elite.... Even Mahatma Gandhi was unable to break the solidarity of the Patidar *gol* of twenty-one villages.

I do not see how the crucial instrumentality of woman as symbolic object of exchange can be overlooked here. Yet the conclusion is: "the solidarity of

the *Gols* was a form of *class* solidarity" (*1*, 202, 203, 207). As in the case of the insurgent under colonial power, the condition of the woman gets "bettered" as a byproduct, but what's the difference? Male subaltern and historian are here united in the common assumption that the procreative sex is a species apart, scarcely if at all to be considered a part of civil society.

These are not unimportant questions in the context of contemporary India. Just as the *ulgulan* of 1899–1901 dehegemonized millenarian Christianity in the Indian context, so also did the Adivasis seem to have tapped the emergent possibilities of a goddess-centered religion in the Devi movement of 1922–23, a movement that actively contested the reinscription of land into private property.[35] In the current Indian context, neither religion nor femininity shows emergent potential of this kind.

I have left till last the two broad areas where the instrumentality of woman seems most striking: notions of territoriality and of the communal mode of power.

CONCEPT-METAPHORS OF TERRITORIALITY AND OF WOMAN

The concept of territoriality is implicit in most of the essays of the three volumes of *Subaltern Studies*. Here again the explicit theoretical statement is to be found in Guha's *Peasant Insurgency*. Territoriality is the combined "pull of the primordial ties of kinship, community" which is part "of the actual mechanics of...autonomous mobilization" (*EAP*, 118). On the simplest possible level, it is evident that notions of kinship are anchored and consolidated by the exchange of women. This consolidation, according to Guha, cuts across the religious division of Hindu and Muslim. "In Tamil Nadu...with all four [subdivisions of the Muslim community,] endogamy helps to reinforce their separate identities in both kinship and territorial terms" (*EAP*, 299). In "Allahabad...the Mewati...effect[ed] a massive mobilization of their close knit exogamous villages" (*EAP*, 316). In all these examples woman is the neglected syntagm of the semiosis of subalternity or insurgency.

Throughout these pages it has been my purpose to show the complicity between subject and object of investigation—the Subaltern Studies group and subalternity. Here too, the historians' tendency, not to ignore, but to rename the semiosis of sexual difference "class" or "caste-solidarity" (*EAP*, 316) bears something like a relationship with the peasants' general attempt to undo the distinction between consanguinity and co-residence. Here, as in the case of the brutal marriage customs of the Patidars, the historian mentions, but does not pause to reflect upon, the significance of the simple exclusion of the subaltern as female (sexed) subject: "In each of these [rebel villages] nearly all the population, *barring females acquired by marriage*, claimed descent from a common partrilineage, consanguinal or mythical,

and regarded themselves as members of the same clan or gotra. This belief in a shared ancestry made the village assert itself positively by acting as a solidarity unit and negatively by operating an elaborate code of discrimination against aliens" (*EAP*, 314; italics mine).

Although it was unemphatically and trivially accepted by everyone that it was the woman, without proper identity, who operated this consanguinal or mythic patrilineage; and although, in the historian's estimation, "these village-based primordial ties were the principal means of rebel mobilization, mauza by mauza, throughout northern and central India in 1857" (*EAP*, 315), it seems that we may not stop to investigate the subject-deprivation of the female in the operation of this mobilization and this solidarity. It seems to me that, if the question of female subaltern consciousness, whose instrumentality is so often seen to be crucial, is a red herring, the question of subaltern consciousness as such must be judged a red herring as well.

"Territoriality acted to no small extent in putting the brakes on resistance against the Raj" (*EAP*, 331). What was needed for this resistance was a concept of "nation." Today, after the computerization of global economics, concepts of nationhood are themselves becoming problematic in specific ways.

> The mode of integration of underdeveloped countries into the international economy has shifted from a base relying exclusively on the exploitation of primary resources and labor to one in which manufactures have gained preponderance. This movement has paralleled the proliferation of export-processing zones (EPZs) throughout the world. More than a uniformly defined or geographically delimited concept, the export-processing zone provides a series of incentives and loosened restrictions for multinational corporations by developing countries in their effort to attract foreign investment in export oriented manufacturing. This has given rise to new ideas about development which *often question preexisting notions of national sovereignty.*[36]

If the peasant insurgent was the victim and the unsung hero of the first wave of resistance against territorial imperialism in India, it is well known that, for reasons of collusion between pre-existing structures of patriarchy and transnational capitalism, it is the urban subproletarian female who is the paradigmatic subject of the current configuration of the International Division of Labor.[37] As we investigate the pattern of resistance among these "permanent casual"-s, questions of the subject-constitution of the subaltern female gain a certain importance.

THE COMMUNAL MODE OF POWER AND THE CONCEPT OF WOMAN

Although Partha Chatterjee's concept of the communal mode of power is not as pervasively implicit in all the work of the group, it is an important sustaining argument for the enterprise of Subaltern Studies. Here the importance of communal power structures, based largely on kin and clan, are shown to embrace far-flung parts of the precapitalist world. And, once again, the crucial syntagmatic and micrologically prior defining importance of sexual difference in the deployment of such power is foreclosed so that sexuality is seen only as one element among the many that drive this "social organization of production" (2, 322). The making-visible of the figure of woman is perhaps not a task that the group should fairly be asked to perform. It seems to this reader, however, that a feminist historian of the subaltern must raise the question of woman as a structural rather than marginal issue in each of the many different types and cultures that Chatterjee invokes in "More on Modes of Power and the Peasantry."

If in the explanation of territoriality I notice a tension between consanguinal and spatial accounts shared by subaltern and historian alike, in the case of "the communal mode of power" we are shown a clash between explanations from kinship and "political" perceptions. This is a version of the same battle—the apparent gender-neutralizing of the world finally explained through reason, domestic society sublated and subsumed in the civil.

The clash between kinship and politics is one of Chatterjee's main points. What role does the figure of woman play here? In the dispersal of this field of power, the sexual division of labor is progressively defined from above as power-sharing. That story is the underside of the taxonomy of power that Chatterjee unfolds.

Thus there might be other ways of accounting for the suggestion that "the structure of communal authority must be located primarily in ideology." Our account would notice the specifically patriarchal structures producing the discursive field of the unity of the "community as a whole." "It is the community as a whole which is the source of all authority, no one is a permanent repository of delegated powers" (2, 341). If the narrative of "the institutionalization of communal authority" (2, 323) is read with this in mind, the taxonomy of modes of power can be made to interact with the history of sexuality.

Chatterjee quotes Victor Turner, who suggests that the resurgence of communal modes of power often generates ways to fight feudal structures: "resistance or revolt often takes on the form of...*communitas*" (2, 339). This is particularly provocative in the case of the dehegemonization of monarchy. In this fast-paced fable of the progress of modes of power, it can be seen that the idea of one kind of a king may have supplemented a built-

in gap in the ideology of community as a whole: "a new kind of chief whom Tacitus calls 'king' (*rex*) who was elected from within a 'royal clan'" (2, 323). The figure of the exchanged woman still produces the cohesive unity of a "clan," even as what emerges is a "king." And thus, when the insurgent *community* invokes monarch against *feudal* authority, the explanation that they are recathecting or refilling the king with the old patriarchal ideology of consanguinity, never far from the metaphor of the King as Father, seems even less surprising (3, 344).

My point is, of course, that through all of these heterogeneous examples of territoriality and the communal mode of power, the figure of the woman, moving from clan to clan and family to family as daughter/sister and wife/mother, syntaxes patriarchal continuity even as she is herself drained of proper identity. In this particular area, the continuity of community or history, for subaltern and historian alike, is produced on (I intend the copulative metaphor—philosophically and sexually) the dissimulation of her discontinuity, on the repeated emptying of her meaning as instrument.

If I seem to be intransigent here, perhaps the distance traveled between high structuralism and current anti-humanism can best be measured by two celebrated passages by two famous men. First the Olympian dismissal, ignoring the role of representation in subject-constitution:

> These results can be achieved only on one condition: considering marriage regulations and kinship systems as a kind of language.... That the "message" [*message*] should be constituted by the *women of the group*, which are circulated between class, lineages, or families, in place of the *words of the group*, which are *circulated* between individuals, does not at all change the identity of the phenomenon considered in the two cases... This ambiguity [between values and signs] is clearly manifested in the critique sometimes addressed to the *Elementary Structures of Kinship* as an "anti-feminist" book by some, because women are there treated as objects.... [But] words do not speak, while women do. The latter are signs and producers of signs; as such, they cannot be reduced to the status of symbols or tokens.[38]

And, second, the recognition of a limit:

> The significations or conceptual values which apparently form the stakes or means of all Nietzschean analyses on sexual difference, on the "unceasing war between the sexes," on the "mortal hatred of the sexes" and "love," eroticism, etc., are all on the vector of what might be called the process of *propriation* (appropriation, expropriation, taking, taking possession, gift and exchange, mastery, servitude, etc.). Through numerous analyses, that I cannot follow here, it appears, by the law already formalized, that some-

times the woman is woman by giving, *giving herself*, while the man takes, possesses, takes possession, and sometimes by contrast the woman by giving herself, gives-herself-as, and thus simulates and assures for herself possessive mastery.... As a sexual operation propriation is more powerful, because undecidable, than the question *ti esti* [what is it], than the question of the veil of truth or the meaning of Being. All the more—and this argument is neither secondary nor supplementary—because the process of propriation organizes the totality of the process of language and symbolic exchange in general, including, therefore, all ontological statements [*énoncés*].[39]

I quote these passages, by Lévi-Strauss and Derrida, and separated by twenty years, as a sign of the times. But I need not add that, in the latter case, the question of being and the ontological statement would relate to the phenomenality of subaltern consciousness itself.

ENVOI

In these pages, I have repeatedly emphasized the complicity between subject and object of investigation. My role in this essay, as subject of investigation, has been entirely parasitical, since my only object has been the *Subaltern Studies* themselves. Yet I am part of their object as well. Situated within the current academic theater of cultural imperialism, with a certain *carte d'entrée* into the elite theoretical *ateliers* in France, I bring news of power lines within the palace. Nothing can function without us, yet the part is at least historically ironic.

What of the poststructuralist suggestion that *all* work is parasitical, slightly to the side of that which one wishes adequately to cover, that critic (historian) and text (subaltern) are always "beside themselves"? The chain of complicity does not halt at the closure of an essay.

NOTES

1. Ranajit Guha, ed. *Subaltern Studies III: Writings on South Asian History and Society* (New Delhi: Oxford University Press, 1984), p. 351. The three volumes of *Subaltern Studies* are hereafter cited in my text as *1*, *2*, and *3*, with page references following.

2. Paul de Man, *Blindness and Insight: Essays in the Rhetoric of Contemporary Criticism* (Minneapolis: University of Minnesota Press, 1983), p. 8.

3. Jacques Derrida, *Writing and Difference*, p. 289. All translations modified when deemed necessary.

4. *1*, 83, 86, 186; *2*, 65, 115; *3*, 21, 71. Also Ranajit Guha, *Elementary Aspects of Peasant Insurgency in Colonial India* (New Delhi: Oxford University Press,

1983), pp. 88, 226, 30, 318; hereafter cited in my text as *EAP*, with page reference following.

5. See Edward W. Said, *The World, the Text, and the Critic* (Cambridge, MA: Harvard University Press, 1983), pp. 170–72 for a discussion of "elaboration" in Gramsci.

6. Friedrich Nietzsche, *On the Genealogy of Morals and Ecce Homo*, trans. Walter J. Kauffmann (New York: Vintage Books, 1969), pp. 77. 80.

7. Dipesh Chakrabarty, "Conditions for Knowledge of Working-Class Conditions: Employers, Government and the Jute Workers of Calcutta, 1890–1940," in *Selected Subaltern Studies*, pp. 179–230, Arvind N. Das, "Agrarian Change from Above and Below: Bihar, 1947–78," and N. K. Chandra, "Agricultural Workers in Burdwan," both in *Subaltern Studies II*. I am using the word "Imaginary" loosely in the sense given to it by Jacques Lacan. For a short definition, see Jean Laplanche and J. B. Pontalis, *The Language of Psycho-Analysis*, trans. David Nicholson-Smith (New York: Norton, 1973), p. 210.

8. As always my preferred example of a theoretical fiction remains the primary process in Freud; see *Works*, vol. 5, pp. 598f.

9. For an excellent discussion of this, see Judith Butler, "Geist ist Zeit: French Interpretations of Hegel's Absolute," *Berkshire Review* 20 (Summer, 1985), pp. 66–80; an extended form of Butler's arguments can be found in *Subjects of Desire: Hegelian Reflections in Twentieth-Century France* (New York: Columbia University Press, 1987).

10. Gramsci, cited in *EAP*, 28.

11. Since the historian is gender-specific in the work of the collective (see pp. 33–43), I have consistently used "he."

12. The most important example of this is Dominick LaCapra, *Rethinking Intellectual History* (Ithaca: Cornell University Press, 1983) and *History and Criticism* (Ithaca: Cornell University Press, 1984).

13. *OG*, 93. Since my intention here is simply to offer a moment of transcoding, I have not undertaken to "explain" the Derridean passage.

14. Spivak, "Can the Subaltern Speak?".

15. The most, perhaps too, spectacular deployment of the argument is in Gilles Deleuze and Félix Guattari, *Anti-Oedipus*.

16. Gramsci, *Selections from the Prison Notebooks*, trans. Quintin Hoare and Geoffrey Nowell-Smith (New York: International Publishers, 1971), p. 421.

17. Karl Marx and Friedrich Engels, "The Manifesto of the Communist Party," in *Selected Works* (Moscow: Foreign Languages Publishing House, 1951), p. 51.

18. George Friedrich Wilhelm Hegel, *The Science of Logic*, trans. A. V. Miller (New York: Humanities Press, 1976), p. 107.

19. This concept-metaphor of "interest" is orchestrated by Derrida in *Spurs*,

trans. Barbara Harlow (Chicago: University of Chicago Press, 1978) with notions of "affirmative deconstructions," which would acknowledge that no example of deconstruction can match its discourse.

20. Michel Foucault, *Language, Counter-Memory, Practice*, trans. Donald F. Bouchard and Sherry Simon (Ithaca: Cornell University Press, 1977), pp. 156, 154.

21. Althusser, *Lenin and Philosophy*, p. 68.

22. I discuss the mechanics of Thompson's critique briefly in "Explanation and Culture"; see chapter 2 above.

23. An exemplary statement is found in "Intellectuals and Power," in *Language, Counter-Memory, Practice*.

24. Jean Baudrillard, *In the Shadow of the Silent Majorities or the End of the Social and Other Essays*, trans. Paul Foss, et al. (New York: Semiotext(e), 1983), p. 26; and Deleuze and Guattari, *On the Line*, trans. John Johnston (New York: Semiotext(e), 1983), p. 1.

25. Spivak, "Can the Subaltern Speak?," pp. 290–91; early version.

26. Althusser, "Sur le rapport de Marx à Hegel," in *Hegel et la pensée moderne*, ed. Jacques d'Hondt (Paris: Presses universitaires, 1970), pp. 108–09.

27. Karl Marx, "The Eighteenth Brumaire of Louis Bonaparte," in *Surveys from Exile*, ed. David Fernbach (New York: Vintage Books, 1974), p. 147.

28. For historical work that would relate to the contemporary struggle, see John Womack, *Zapata and the Mexican Revolution* (New York: Knopf, 1969).

29. Steven Ungar, *Roland Barthes: the Professor of Desire* (Lincoln: The University of Nebraska Press, 1983).

30. Derrida, "Signature Event Context," trans. Bass, pp. 317–18; translation modified.

31. For another contemporary transformation of this notion see Antonio Negri, *Marx Beyond Marx: Lessons on the Grundrisse*, trans. Harry Cleaver et al. (South Hadley: Begin and Garvey, 1984), pp. 41–58.

32. Derrida, "Plato's Pharmacy," in *Dissemination*, trans. Barbara Johnson (Chicago: University of Chicago Press, 1981), p. 146.

33. Hobbes's discussion of authority in the *Leviathan* and Kant's discussion of the genius in *The Critique of Judgment* are two of the many *loci classici*. There are lengthy discussion of this thematic—as found in the Platonic Socrates, in Rousseau, and in J. L. Austin—in Derrida's "Plato's Pharmacy," *Of Grammatology*, and "Signature Event Context," respectively.

34. Terry Eagleton, *Walter Benjamin: or Towards a Revolutionary Criticism* (London: Verso Press, 1981), p. 140.

35. See Hardiman, "Adivasi Assertion in South Gujarat: The Devi Movement of 1922–3," in 3.

36. June Nash and María Patricia Fernández-Kelly, eds., *Women, Men, and the*

International Division of Labor (Albany: State University of New York Press, 1983), p. viii.

37. I have discussed this issue with reference to its further development in the Post-Soviet world in the "Afterword" to Mahasweta Devi, *Imaginary Maps*; see below, chapter 10.

38. Claude Lévi-Strauss, *Structural Anthropology*, trans. Claire Jacobson and Brooke Grundfest Schoepf (Garden City: Anchor Books, 1967), p. 60.

39. Derrida, *Spurs*, pp. 109–11.

How to Teach a "Culturally Different" Book

(1991)

NINE

This essay began life as a paper Spivak presented in March 1991 at the Shelby Cullom Davis Center for Historical Studies at Princeton University in New Jersey, where she was a fellow in residence. That paper, entitled "Once Again a Leap into the Postcolonial Banal," was published in the feminist journal *differences* 3:3 (Fall 1991), pp. 139–70, and accompanied by a comment by the historian Joan Scott. The published paper and comment constituted an exchange about questions of theory and history directed at the community of academic historians.

The revised version included here has appeared in a collection of essays, *Colonial Discourse/Post-Colonial Theory*, edited by Francis Barker, Peter Hulme, and Margaret Iverson for Manchester University Press. This version focuses more clearly than the original paper did on what Cultural Studies as a subdiscipline of literary criticism can contribute to reading the texts of global English. Here Spivak offers sound pedagogical advice for those scores of teachers who increasingly find themselves trying to teach the multicultural canon with inadequate preparation, and for whom, as for their students, it is particularly difficult to attend historically and politically to "culturally different" or non-First World texts. If the collective goal of revisionist history-writing is "the decolonization of the imagination," in the Kenyan writer Ngũgĩ wa Thiong'o's phrase, then Spivak's questions arise: Who decolonizes? and how?

Taking R. K. Narayan's 1980 novel *The Guide* as her example of a post-colonial—or in this case, "Indo-Anglian"—text, Spivak gives us some of the ingredients for a responsible reading. She examines a number of layers of materiality in Narayan's text, including his use of English in relation to various Indian vernaculars, and his representation of a *devadāsī*, or temple dancer, as instrumental for his narrative about a male protagonist, Raju, a clever tourist guide who becomes a fake saint. Since the feminist teacher

is likely to be interested in the character of Rosie/Nalini, Spivak investigates the current state of knowledge about the *devadāsī* from various perspectives, discovering that the debate about the status of the *devadāsī* reproduces the class stratification so typical of metropolitan information about the cultural other. Finally, she reads the "Bollywood" or Bombay film version of *The Guide* as an indigenous translation, as it were, of Narayan's novel from an elite colonial text to a popular national text: from English to Hindi. No more than the colonial text, can this translation do without the commodification of the *devadāsī* as instrumental to the male protagonist's representation and narrative agency. Spivak's guide to *The Guide* offers a rich instance of the problems of a too quick embracing of the other grounded in neocolonial notions of national identities and ethnic minorities. For her feminism remains crucial to any project of decolonization and provokes us to ask again: Who decolonizes? And how?

One of the painfully slow results of the demand for a multicultural canon is the inclusion of global English on the college curriculum. The results of this uncertain victory are often dubious, because neither teacher nor student is usually prepared to take the texts historically and/or politically. This paper is an attempt to walk a conscientious teacher through a limpid novel, R. K. Narayan's *The Guide*.[1]

In the late fifties, the term "Indo-Anglian" was coined by the Writers' Workshop collective in Calcutta, under the editorship of P. Lal, to describe Indian writing in English. Although the term has not gained international currency, it is useful as a self-description.

The first question to be asked of a piece of Indo-Anglian fiction is the author's relationship to the creative use of his or her native language. This question is not identical with that asked by Ngũgĩ wa Thiong'o.[2]

The complexity of Ngũgĩ's staging of the relationship between English and Gikuyu also involves the relationship between dominant *literature* and subordinate *orature*. To draw that parallel in an admittedly asymmetrical way, we should have to consider the millennially suppressed oral cultures of the aboriginals of India. We have not yet seen an Indo-Anglian fiction writer of tribal origin; we are far from seeing one who has gone back to his or her own oral heritage. Indeed, anyone aware of the ruthless history of the expunging of tribal culture from the so-called Indic heritage, and the erasure of the tribal *paraph*—the authenticating flourish above or below the signature—from Indian identity, will know that the case is difficult to imagine.

By contrast, literary activity is usually prolific in the mother tongue of the writer of Indo-Anglian prose or poetry. The writer of Indo-Anglian

literature might represent the dynamic base of regional public culture as if it is no more than a medium of private exchange or a rather quaint simulacrum of the genuine public sphere. This artificial separation of public and private is, strictly speaking, a cultural class-separation. The relationship between the writer of "vernacular" and Indo-Anglian literatures is a site of class-cultural struggle. This struggle is not reflected in personal confrontations. Indeed, the spheres of Indo-Anglian writing and vernacular writing are usually not in serious contact. By "class-cultural struggle" is meant a struggle in the production of cultural or cultural-political identity. If literature is a vehicle of cultural self-representation, the "Indian cultural identity" projected by Indo-Anglian fiction, and, more obliquely, poetry, can give little more than a hint of the seriousness and contemporaneity of the many "India"-s fragmentarily represented in the many Indian literatures.

In fact, since the late sixties, as metropolitan (multi)cultural studies began to establish itself through the good works of the Birmingham School, inaugurated by Richard Hoggart's *The Uses of Literacy* and continued under the able direction of Stuart Hall, the Indo-Anglian writer began to acquire and transmit an increasingly "postcolonial" aura of cultural self-representation.[3] How does international cultural exchange of this sort operate? This question should be kept alive, not answered too quickly. A too-quick answer, taking the novels as direct expressions of cultural consciousness, with no sense of the neocolonial traffic in cultural identity and the slow and agonizing triumph of the migrant voice, would simply see them as repositories of postcolonial selves, postcolonial*ism*, even postcolonial resistance.

However difficult it is to fix and name the phenomenon, one might consider it carefully because its tempo is so different from the boomerang effect of the cultural shuttle in fully telematic (computerized and videographic) circuits of popular culture. Consider merengue in New York: the artists are in Santo Domingo, the market is supported by the Dominicanos in New York, and the trend changes from the original "pure" strain as fast as you can count.[4] Consider Rap in South Africa, where the singers themselves acknowledge American influence, and remark on how African the United States groups sound; the South African newscaster considers this a cultural reappropriation of what originated in Africa; and the United States group compliments the South African group on being so comprehensible in English, of having so little "African accent." Consider the Chicarricano "border art" of the Mexican artist Guillermo Gómez Peña.

The only Indo-Anglian postcolonialist novel in this telematic tempo is Shashi Tharoor's *The Great Indian Novel*, inspired by Peter Brook's *Mahābhārata*, which prompted the author to read the *Mahābhārata* for the first time, in its condensed English version as the play-script for Brook's

production of the epic.[5] The novel is an amusing verbal comic-strip super-imposing the struggle among the great nationalists of the Indian Independence Movement upon the family feud at the heart of the ancient epic. Translation is immediate here. *Mahā* is literally "great" and *Bhārata*, all complexities of history and geography forgotten, can be taken as identical with the contemporary (Hindi) name for India. *Mahā-Bhārata* = Great India; the postcolonial politicians' fantasy to make the present identical with the hallowed past, and thus win votes for a politics of identity at degree zero of history.

This example remains an anomaly. The spoof is inaccessible to the international readership of Commonwealth Literature. And the Indo-Anglian novel is simply not a part of "popular" culture on the subcontinent, whether global "kitsch" or indigenous "folk." To think of the Indo-Anglian novel, even in its aggressively postcolonial manifestations, as "popular," is to think of *Sons and Lovers* as a novel of the international working class. The tragedy (or the bitter farce?) of *The Satanic Verses* is that, precisely through electoral manipulation in India, it became available to, though not read by, the "people" of whom it spoke.

By contrast, the general tempo of two-way traffic in the course of change in the Indo-Anglian novel in India and in its readership, institutional or otherwise, is less tractable. The change that we begin to notice in the early seventies is an exuberantly mocking representation of the native language. In the wake of swiftly changing global cosmopolitan identities riding like foam on waves of diversified diasporas, what was an upper class, upwardly mobile, or upwardly aspiring private relationship to a vernacular in national peripheral space is literally "reterritorialized" as the public declaration of ethnic identity in the metropolitan space of the newish migrant writer, borrowing his or her discursive strategy from the field prepared for the new immigrant by the only slightly less new.[6] Although *The Satanic Verses* might be the classic case of this, the landmark text, before the preparation of its readership, is G. V. Desani's *All About H. Hatterr* (1986), a virtuoso novel where "English" attempts to claim its status as one of the Indian languages (belonging to a national underclass) through the technique of sustained literal translation of the vernacular rather than islands of direct monstrous speech in a sea of authorial Standard English.[7]

Writers like R. K. Narayan (Nayantara Sahgal, Kamala Markandeya, Ruth Prawer Jhabwala, Mulk Raj Anand, Raha Rao, et al.) predate this hyperreal scramble for identity on the move.[8] The "internal evidence" for this is the stilted English of the dialogue in their novels, whenever it happens between the rural or underclass folk they often choose to represent; and of the representation of the subjectivity of such characters in so-called "indirect free style."[9] The situation of the underclass, or rural

characters, or yet of the language of indirect free style, is dealt with quite differently in the vernaculars. With this earlier group of reportorial realist writers, then, one must be specifically aware of the relationship with the vernacular.

The group started publishing fiction in English well before Indian Independence in 1947. Narayan's first book, *Swami and Friends*, was published in 1935. If the emergence of a mode of production of identity recognizably "postcolonial" by a younger group meant a setting wild of the private space of the mother tongue, then negotiated political independence set this earlier group adrift, away from the current from which the postcolonial monstrous would emerge. They become novelists of the nation as local color, the nostalgic rather than the hyperreal.

The representation of the temple dance in *The Guide* stands out in this miniaturized world of a nostalgia remote from the turbulence of postcolonial identity. The story, given in flashbacks, in between an autobiography, in the book's present, of the male lead released from prison and sheltering in an imageless temple, to a devotee who authenticates his felicity as a saint, can be summarized as follows:

With the coming of the railway station, Raju's father's shop moves up in class. With his father's death, Raju is able to respond to this upward move. He becomes not only a railway store owner, but also a flashy and resourceful guide of conducted taxi tours of local beauty spots. On such a tour he meets Rosie/Nalini, daughter of a temple dancer (henceforth *devadāsī*—female servants of the Lord); the dancing in her blood is strictly suppressed, first by a personal ambition that prompts her to take a Master's Degree in Political Science, and second by an archaeologist/art historian husband. Raju the Guide seduces her, she comes to live with him, his mother leaves home with his scandalized uncle, he makes immense amounts of money by setting her up as a dancer and being her agent, and then he goes to jail for forging her signature in order to prevent reestablishment of contact between herself and her husband. She disappears from the scene. After a brief stint in prison, he emerges and takes shelter in the temple. He attracts one follower and then, as a result, an entire village full of devotees. When he is urged to fast and stand knee-deep in water for twelve days to end a regional drought, he starts telling his story to Velan, his follower.

The novel is not arranged in this straightforward way. It begins with Raju talking to Velan in the temple. We are not aware that the account is a confession, for two contradictory motives bleed into each other: avoidance of the hardship of fast and penance; avoidance of "enforced sainthood."[10] We only know these motives toward the end of the book. In the meantime, some of the chapters begin to move out of the frame narrative as regular

flashbacks. To put it in code, the reader begins to say "yes" to Raju's past by inhabiting the roguish personality of a past character so unlike the present one. That is the historically established power of the indirect free style of storytelling. The reader does not have to exercise his mind to get used to the experiment. When the story makes no difference to Velan, the reader can say "yes" to that indifference as well.

(Given primitive distinctions such as First World-Third World, self-other, and the like, I tend to classify readers by slightly less crude stereotypes. In that spirit, and in the strict interest of decolonizing the *imagination*, let it be proposed that, for the metropolitan reader or teacher reading or teaching Commonwealth Literature, the limpid local color prose of this style is quite satisfactory. For the rather special Indian readership of Indo-Anglian fiction, this class-distanced hyperreal is also satisfying, perhaps because it conveys a cozy sense of identification at a distance, thus identity in difference. The person who reads "popular" vernacular literature for fun will not read *The Guide*. The reader of "high" vernacular literature will, if s/he reads English literature with her antennae up, be dissatisfied with the "subjectivity" opened up by the free indirect style, precisely because the limpid prose would seem a bit "unreal," a tourist's convenience directed toward a casual, unmoored international audience.

Narayan tells us that the novel was written in a hotel room in Berkeley, California. There is a sizable literature of displaced writers writing from abroad within the various vernacular literatures. *The Guide* has no need to make use of that convention.

To classify readers in this way is a denial of contingency, which seems a particular loss when talking about literature. Deconstruction has taught us that taking contingency into account entails the immense labor of forging a style that seems only to bewilder.[11] If literary study is to work with established metropolitan colonial history, it seems best that one stay with the outlines of rational agency and give a hint of postcolonial heterogeneity according to the impoverished conventions of mere reasonableness.)

This fake saint then becomes a sacrifice. To what? Faith is not, after all, reasonable. And the line between virtue and the sustained simulation (making something happen by insisting it is so) of virtue is hard, perhaps finally impossible, to fix. So the book can suggest, in the end, that perhaps Raju *is* a miracle worker, after all: "Raju opened his eyes, looked about, and said, 'Velan, it's raining in the hills. I can feel it coming up under my feet, up my legs—' He sagged down" (*G*, 220). A nice bit of controlled indeterminacy there, resting upon one of the most firmly established European cultural conventions: the transition from Christian psychobiography to Romantic

Imagination.[12] (In a broader field it is seen as the transformation of Christianity into "secular" ethics, theology into philosophy.) Michel de Certeau and Michel Foucault, among others, have speculated about the relationship between these changes and the turn to capitalism.[13] The dominant Hindu "colonial subject" in India came to terms with his Hinduism with the help of the epistemic trick allowed (often clandestinely) by this shift. At the colonial limit, sacred geography thus became an interior landscape. The problem of irrational faith was interiorized into allegory in the narrowest possible sense. Religion as cultural allegory allowed the Indo-Anglian writer of the first phase to produce an immediately accessible "other" without tangling with the problem of racism or exploitation. Raja Rao is perhaps the most striking example of this.

In the literary history of Britain, one reads this transition or transformation by way of the nineteenth-century project of rewriting Milton: by Blake, Wordsworth, Shelley. In Wordsworth's "Hail to thee, Urania!" Imagination is supposed at last to be triumphant.

Alas, this high register, where literary production is in the same cultural inscription as is the implied reader, cannot be employed for the epistemic ruses of the colonial subject. No Indo-Anglian writer of Narayan's generation can speak of his education in English literature without self-irony, however gentle.

Narayan offers a vividly ironic account of his own education in English Literature in chapters four to six of his *My Days: A Memoir*. It would be difficult to imagine from this book that his conversations with his grandmother and the street people might have taken place in his native Tamil. "Thus ended one phase of my life as a man of Madras; I became a Mysorean thenceforth."[14] This meant a bilingual move—from Tamil to Kannada—for an adolescent. Can one surmise that the bilingualness of the move was not significant for largely English-speaking Narayan? Of course, from these memoirs or, indeed, from the self-contained small-town world of *The Guide*, one would not be able to guess either that Tamil has one of the longest continuous literatures in India, or that both Tamil and Kannada were active in literary production and experimentation at the time of the writing of *The Guide*.[15] For example, the literary and cultural-political universe inhabited by Anantha Murthy, the Kannadese novelist, is at many removes of "concreteness" in terms of the weaving together of the fabric of national identity, torn from end to end in the current conjuncture. Native readers of Tamil and Kannada literature suggest that there might have been a surreptitious and unacknowledged one-way traffic between Indo-Anglian writing produced by Tamilian and Kannadese writers and the vernacular literatures in this case. This writer, whose mother tongue is neither, cannot vouch for this judgment without extensive

research, although she is *au courante* in her own.

In Narayan's own estimation at least, the novel's core is the predicament of the male lead.[16] Rosie/Nalini is therefore merely instrumental for the progress of the narrative.

My method of considering this instrumentality will be "allegorical" in the most ordinary sense (one-to-one correspondence, as we used to say), or semiotic in the most formulaic way (this "means" that). This may be the only way in which the literary critic can be helpful for the study of culture, and for the historical study of the aftermath of colonialism and the post-colonial present. It is an enabling limitation, a *découpage* for the sake of the discipline.[17]

Rosie/Nalini is, then, the remote instrument of Raju's enforced sanctity. How does Narayan represent her so that the narrative of Raju's transformation may be revealed? Let us notice, first of all, that she is absent at the actual transformation, the present of the frame-narrative. She is only instrumental in getting him to jail. Release from that chain of events, release from imprisonment, is release onto the road to sanctity.

The story is not just a boy-girl story, however. It is also a decently muted tale of access to folk-ethnicity (protected by that nice indeterminacy already mentioned). Here the main burden of the frame-narrative is that Raju transforms Rosie into Nalini or lotus. But that is represented as not an authentic entry into folk ethnicity. The author makes clear that that attempt was the vulgarization of culture in the interest of class mobility. Raju transforms Rosie into Miss Nalini and, as her impresario, becomes besotted by his access to money and the attendant social power. Within the miniature field of Indo-Anglian fiction this authorial judgment is the celebration of tradition over modernity that its readership can devoutly wish, *at a tasteful distance*. But, since Raju's obsession with money and power interferes with his obsessive love for Rosie, it resonates on the boy-girl register as well. It is by a neat and accessible irony that his forgery, prompted by "love" (he wants to keep Rosie from further contact with her husband), is mistaken for "love of money."

Rosie has tried to lift herself from the patriarchal ethnos by going the route of institutional Western education. But dancing is in her blood. If the railway train as a harbinger of progress and class mobility is a cliché of the literature of imperialism, the *nautch* (dance) girl is a cliché of the imagining of British India. Raju is first taken by her in a passage indicating the rhythm in her blood:

> He [a derelict cobra man] pulled out his gourd flute and played on it shrilly, and the cobra raised itself and darted hither and thither and swayed....

She watched it swaying with the raptest attention. She stretched out her arm slightly and swayed it in imitation of the movement; she swayed her whole body to the rhythm—for just a second, but that was sufficient to tell me what she was, the greatest dancer of the century [G, 58].

But Raju the entrepreneur cannot bring Nalini to life. It is her husband the gentleman archaeologist who wins her back, at least in spirit. There is a bond between them in their passion for their cultural labor. Narayan has the modernist literary tact not to conclude her story, and Raju's last word shows his inability to grasp the mysterious bond. Reporting to him in prison, his secretary

Mani explained that the only article that she carried out of the house was the book [her husband's book about the caves—a counter-*Guide* that we never get to read].... Mani said, "After the case, she got into the car and went home, and he got into his and went to the railway station—they didn't meet." "I'm happy at least about this one thing," I said. "She had the self-respect not to try and fall at his feet again" [G, 205].

She is not needed in the last phase of the book: the phase of ethnicity over culture. India *is* folk kitsch. E. M. Forster had written the "Temple" section.[18]

Although (or perhaps precisely because) the dancer is not central to the novel, a feminist reader or teacher in the United States might wish to know a little more about the temple dancer in order to grasp the representation of Rosie/Nalini.

The source book most readily available to her is Frédérique Marglin's *Wives of the God-King*.[19] Although for most metropolitan teachers of Commonwealth literature, the terrain of *The Guide* exists as "India," the reader might have specified it to herself as Southern India from internal and external signals.[20] The state where Marglin did her field-work is not Narayan's South, but Orissa, where the Southeast meets the Northeast. How does Orissan *devadāsī* (or *dei*), imprisoned in her own temple-community of women in a gender hierarchy that mixes "tradition" and "modernity" in its unique blend, communicate with her counterpart in the South, in Mysore or Bangalore? Certainly not in her mother tongue. In fact, it is unrealistic to think that there can be actual situations of communication between them. These are subaltern women, unorganized precapitalist labor, and it is not yet possible to think of them as *Indian* collectives of resistance, although the Indian Constitution appropriately thinks of them collectively as victims and thus offers a redress that has never been fully implemented in

the individual states. Indeed, current feminist activism around this issue, dependent upon the direction and organization of the women's movement in various regions, is much more forceful and visible in the states of Maharashtra, Karnataka, and Tamil Nadu (roughly Narayan's area) than in Orissa, Marglin's field of work. The language barriers that allow the Indo-Anglian writer precisely to represent one of them as our implausible Rosie keeps her locked in isolated communities. The patriarchal system that informs *The Guide* so that Raju can finally occupy the temple as saint makes the temple her prison.

(There are a very few rags-to-riches stories of the daughters of temple dancers becoming great *artistes*, but Narayan's focus on Rosie is too slight for us to feel that this is the point of her representation. To emphasize that point, Rosie's entry into secondary and postsecondary education would have to be dramatized.)

Is literature obliged to be historically or politically correct? Because it is not, this sort of literary criticism is a category mistake, derided as "politically correct." But it should be considered that literature is not obliged to be formally excellent to entertain, either. Critical evaluation is dismissed as "pedantic" by the real consumers of popular culture. Here again is class negotiation. This way of reading, pointing at a text's cultural and political provenance, can be useful in the specific situation where the heterogeneous agency of the colonized in postcoloniality cannot be imagined, although the details of colonial history are known professionally.

As the feminist reader moves into *Wives of the God-King*, she notices a peculiar blandness in the reporting of the *devadāsī*'s prostitution. This curious, apologetic finessing of judgment, invariably called cultural relativism, has become an unavoidable mark of the field investigator who has become sensitive to the risks of neocolonial knowledge, but will compromise with it. This is perhaps exacerbated by the investigator who learns the social practice as artistic performance (in this case *Odissi* dance), now the property of the middle and upper-middle classes.[21]

The transmogrification of female dance from male-dependent prostitution to emancipated performance helps the indigenous colonial elite engage in a species of "historical (hysterical) retrospection" which produces a golden age.[22] Raju in *The Guide* enters the hallucination without any particular historical thickening.

Dr. Marglin's traffic with a great many Indian men, acknowledged in her book, is coded as exchange with a student of the *devadāsī*-system or a student of *Odissi*, eager cultural self-representation in response to altogether laudable white interest in our heritage; rather different from the traffic between men and women described in her chilling prose. It would be impossible to suspect from this account that feminists have internationally

battled and are today battling (not the least in India) against this view of the role of the woman in reproduction:

> The chastity of the wives of the temple brahmins is crucial not because it is they who transmit the characteristics of the caste and the *kula* to their children, but to ensure that only the produce of the species of seed that has been sown in it is the one that will be reaped and not the produce of some other species of seed. A woman, like a field, must be well guarded, for one wants to reap what one has sown and not what another has sown, since the produce of a field belongs to its owner. Such an idea was expressed long ago by Manu.... This theory by the ancient law-giver certainly corresponds well to what is the case today in Puri.... Women are like the earth, and the earth is one, although it is owned by many different types of men.... the woman palace servant (*dei*) told me that her mother answered her query [about menstruation rituals]...in the following way:... "God has taken shelter" (in you)...."You have married and you'll do the work of the god...." The "work of god" and "the shelter of the god" she said referred to the fact that from that time on she would start her rituals in the palace and would become the concubine of the king.[23]

Wives of the God-King is a thoroughly vetted and rather well-known book. It is hard to imagine that it was published in 1985! The author takes at face value the invocation of the golden age by orientalist and bourgeois alike. The usual anti-Muslim explanation of the decay of Indian (read Hindu Aryan) culture under the Muslim rule, and hence the deterioration of the *devadāsī*s into prostitutes draws this from the author:

> This view is representative of many if not most English-educated Indians today. The historical research necessary to confirm or refute the above statement was beyond my abilities, even if the records were available, which is highly doubtful. My training has prepared me to do ethnography, which happily the particular historical circumstances of Puri made possible.[24]

"Ancient sources" are so regularly proclaimed that our inquisitive feminist literary critic will probably be daunted away: especially since there are so many repetitions of postcolonial piety and the claim that if Dr. Marglin had been born a hundred years ago, her views would have coincided with those of Annie Besant, the noted Theosophist. Would the feminist investigator check this claim by consulting Mrs. Besant's biography? Amrita Srinivasan has given a fine analysis of the relationship between the Theosophist interest in saving the dance rather than the dancer and the establishment of Western-style residential schools for dance, like *Kalākshetra* (literally the artistic field)

in Madras, by the indigenous elite.[25]

There seems nothing to link the women in Marglin with the world of *The Guide* except to imagine that the daughter of one of these hapless women had been able to enter the educational system with nothing but her mother's good wishes as her resource.

And if the Indian colleague or friend who is the United States feminist's "native informant" happens to be a not untypical woman from the emancipated bourgeoisie, the work of her own uneven emancipation will have been undertaken by the slow acculturation of imperialism that is, in its neo-colonial displacement, the topic of our discussion. If this imaginary informant happens to be a careful student of the dance form, she has learned the entire social ritual *as* ritual reverently museumized in an otherwise "modern" existence. She might see the dance as directly expressive of female resistance in its very choreography. The result of this innocent ethnic validation is Cultural Studies as alibi.

Vigilance, then, about class as we read the novel and look for background. Impatient non-major students of required English courses often mutter, "Can we not just read for pleasure?" Their teachers were taught to offer a consolation from United States New Criticism, "Knowing the rules of the game does not detract from the pleasure." But reading in the style of Cultural Studies, looking into the class-provenance of form and information, may not enhance pleasure. The most it can do is give a clue to the roadblocks to a too-quick enthusiasm for the other, in the aftermath of colonialism, even as it attempts to offer untrained resistance to the arrogance of the discipline.

One of the most tedious aspects of racism as the science of the everyday is the need to refer every contemporary act of life or mind performed by the cultural other to her cultural origin, as if that origin is a sovereign presence uncontaminated by history. In order to stem that tide vis-à-vis Narayan's novel, some brief and inexpert comments on the so-called "ancient texts" are offered below. My gratitude to Dr. Mandakranta Bose, who has helped locate the texts.

There are no known direct references to dancing in the temple in the oldest books of dance theory and trade talk on dance practice, *Nātya Śāstra* and *Abhinaya Darpana*. (The current debate seems to be between where the limits of dance and drama are fixed.) There is a passage in the *Nātya Śāstra* (second or third century A.D.) on how to transform the body into a space of writing and turning. The yoking of dance to the body is in order proficiently to lead toward what is signified by the body as a collection of *akṣara* or letters. "Leading toward"—*abhinaya*—is crudely translated as "drama" by English translators, so that even without the *devadāsī* we fall

into the Aristotelianized problematics of mimesis. There is no mention of temple-dancing in this early text, though an interesting distinction between the improper and proper use of the signification-representing body, in consecrated lust and in the consolidation of attraction respectively, is made.[26]

A millennium later, the *Nātya Śāstra* is being legitimized as holy knowledge of *Vēda* in the *Sangitaratnākara*.[27] *Lāsya*, or carnal affection, is being recuperated into theogony. The word relates to the root *las*, which, at its most rarefied, means "to appear in shining."

It is not surprising that the *Sangitaratnākara* also gives a list of *social* rather than interpersonal occasions where dance is appropriate: coronations, great feasts, voyages, valedictions to divine images after periodic festivals, marriages, meetings with the beloved, entries into the city, the birth of a son. Dance enhances the auspiciousness of all these activities. No temple dancers yet. *Lāsya* can still mean only dance, which belongs to the ceremonial life of kings and well-placed householders.

The first mention of temple dancing is located in the medieval collection of stories called *Kathāsaritsāgara* or the Sea of Stories.[28] Aparna Chattopadhyay offers a theory of West and Central Asian provenance and offers connections with Corinth and Phoenicia. Legitimation by "Vedic" origin becomes all the more interesting.

Of particular interest is the twelfth-century *Kuttinimatam* (The Art of the Temptress) by Damodargupta. Here the stylization of seduction through body movements is taught as practice by an older prostitute to a younger.[29]

Who knows exactly how *lāsya* changes into the art of lust? Muslim conquest is about as useful as the international Jewish conspiracy. Words change meaning bit by bit, here excess, there lack. We find fossils of "earliest use" and strain this intimate mystery of linguistic change at ease from the incomprehensible social field of manifestation and concealment and sublate it into one line of a dictionary.[30] Any history that tries to imagine a narrative of the subaltern woman's oppression must imagine that familiar lexicographical space, that line in the dictionary, into the uncanny; the strange in the familiar. That space is the mute signature of the process by which the woman becomes a ventriloquist, beginning to act as an "agent" for *lāsya*. If this painful invitation to the imagination does not produce the disciplinary writing of history, then, as an apologetic outsider, I would submit that it might strengthen the discipline to recognize it as a limit.[31]

As part of preliminary on-site research, I viewed documentary footage shot by Dr. Veena Sethi when she traveled with the Indian National Commission on Self-Employed Women in 1987. I discovered the existence of this footage on a research trip to India in December 1990. In that mate-

rial, there is a discussion, in the presence of the temple pimps, between the *devadāsīs* and the activists. Some resistance to rehabilitation can be sensed in that conversation. This may be due to the presence of the pimps, to the class separation between activist and subaltern, to the bitter awareness of the absence of follow-up to keep "the new way of life in place," and/or to patriarchal ventriloquism.[32]

If the *devadāsī* cannot speak *to* an unreconstructed subalternist history, and *in* the entrepreneurial fantasy of Indo-Anglian fiction, she also cannot speak by way of capital logic.

Shramshakti (labor-power), the impressively heavy report of the Commission published in 1988, mentions the encounter with the *devadāsīs* in a few paragraphs in the prefatory material and moves on to "regular" prostitutes:

> Another group of women represented at this Pune meeting were the *devadāsīs*, of whom there are many here. Most of them are girls of poor, landless, low caste families who dedicate their girls to the service of God. Their "services" are taken for granted by upper class men. Although this practice is sanctioned by tradition and religion, these women usually end up in prostitution or begging. There is no one to look after them when they grow old, and no source of income. Some of them develop diseases which remain untreated. In this meeting, they requested education for their daughters, old age homes, and some income generation programme. A blind woman asked for reservation for the blind in jobs, and special training in telephone exchanges, chalk making, or cane making. At the Kolhapur *devadāsī* Vikas Centre, there were 50 *devadāsīs* present. Shantibai said that she was dedicated to the Devi because her father had promised (God) to do so if he got a son. Now her father is old and blind, and that son is in jail. The Commission heard numerous similar cases: they had been dedicated to God in exchange for a son. Chhayabai and Ratnabai said they were made *devadāsīs* purely because of poverty. "There was not enough at home to feed everyone." So they lived in the temple and got fed there. At the age of 13 they started serving the devi with men, and started bearing children. In all cases, the men do not stay with the *devadāsīs* or the children. On Tuesday and Friday near temples they have some income out of begging alms. But generally they have lost their capacity to earn by hard honest labour. Their priority is education for their children, which is problematical. Because the father's name is not given, the children are often not admitted.[33]

This report was published three years after Marglin's book. The tenor of the conversations seems somewhat different. The reader is convinced of the contrast between the United States anthropologist and the Indian

activist. (Although a single example does not prove a case, a single counterexample makes human generalizations imperfect.) I am nonetheless arguing that even an effort as thoughtfully organized as Self-Employed Women's Association's cannot allow the agency of the *devadāsī* to emerge, because she is not written in the idiom of organized or unorganized labor, self-employment or other-employment (autocentrism versus extraversion in broader registers; namely capital logic).[34]

In the body of the report, the "occupation" *devadāsī* does not emerge in the many tables. The master list, included in the chapter headed "Demographic and Economic Profile," includes thirty "types of skill." The last two are "others" and "no skill." The percentage distribution is Rural: 0.97 and 89.69; and Urban: 3.26 and 69.48. How would the *devadāsī* be docketed? Is *lāsya*—the convincing representation of lust—still her skill?

There is no reason at this point not to credit the tiny but significant report of their agency (out of which comes the demand): "Their priority is education." There can be no doubt that education is perceived by them as a way out of the vicious impasse of female proletarianization (reduced to nothing but your body) outside of capital logic. It is not difficult for R. K. Narayan to put his finger on this pulse. But we are concerned with another story: that at the utterly remote other end of the trajectory denoted by "education" (international conferences), one must still engage in the question of "decolonizing the imagination." I should be able to say right away that one of the important tasks of the local women's movements in the *devadāsī* areas is to fight in an organized way against the lethal requirement of "the father's name." The novel can ignore the hurdle and present the query as coming from Raju's mother and immediately deflected by Raju himself—a proof of his masculine ingenuity. But we, decolonizing our imagination, must admit that even if this first barrier is crossed, and justifiably, in the imagination of these hapless infirm *devadāsī*s, education is an instrument of upward class-mobility. These women are correct in perceiving that it is class-jumping that gives the woman "freedom" in patriarchy (and access to feminism as a matter of choice).[35] If their daughters and granddaughters emerge for the "New Europe" as objects of domination and exploitation only when they emerge *in* the "New Europe" as migrant labor, this obscure moment of the agency of the infirm *devadāsī*s ("their priority is education for their children...") remains a negligible part of a minor agenda, rather than the most serious necessity for educational reform "originating" out of a subaltern or subproletarian priority. This is not the question of militant centers of localized "pedagogy of the oppressed," but of overhauling the presuppositions in general national education. If the subaltern—and the contemporary *devadāsī* is an example—is listened to as agent and not simply as victim, we might not be obliged to rehearse decol-

onization interminably from above, as agendas for new schools of post-colonial criticism. But the subaltern is not heard. And one of the most interesting philosophical questions about decolonizing remains: who decolonizes, and how?

Let us get back on the track of our feminist teacher. She will encounter a debate about the "real" *devadāsī*: Was the "real" *devadāsi* a "free woman, an artist"? Is her present condition a result of a collusion between colonial and nationalist reformists, supported by men of her own community who stood to gain by her fall?

Amrita Srinivasan advances an affirmative answer to this question. She offers a challenge to the critical imagination when she "anthropologizes" colonial reform and asks us to consider the ways in which it rewrote its object: "If sacrificial infanticide and *sati* had been banned earlier as 'murder,' then by the late nineteenth century temple dancers were being presented as 'prostitutes,' and early marriage for women as 'rape' and 'child-molestation'" ("Reform," 178–79). She situates the Theosophist impulse mentioned by Marglin: "The British government officials and missionaries were not slow to play up non-Brahmin suspicion of Indian nationalism, coming as it did from the largely Brahmin-dominated Theosophical circles and Congress alike" ("Reform," 197). Marglin treats Orissa; Srinivasan treats Tamil Nadu (R. K. Narayan's Madras). And she is on target about the appropriation of the dance form by the elite:

> By 1947, the programme for the revival of *sadir* [the name of the dance form of the Tamil *devadāsīs*] as Bharatanatyam, India's ancient classical dance, was already well underway with the patronage and support of Brahmin dominated Congress lobbies of élite Indians drawn from all parts of the country ["Reform," 197].

Her analysis of the precolonial *devadāsī*'s controlling position within "the efficacy of the temple as a living centre of religious and social life, in all its political, commercial and cultural aspects" ("Reform," 184) is indeed an attempt at decolonizing the imagination, however difficult it might be to agree that

> the conscious theological rejection [on the part of the *devadāsī*?] of the harsh, puritanical ascetic ideal for women in the bhakti sects, softened for the devadāsī the rigours of domestic asceticism in the shape of the widow, and religious asceticism in the shape of the Jain and Buddhist nun ["Reform," 191].

If one must see conscious agency here, one might think of Marx's suggestion that the capitalist carries the subject of capital. For although it is no doubt true that in Tamil Nadu the *devadāsī* was free of marriage and domestic duties, Srinivasan herself shows us that there can be no doubt that the *devadāsī*'s exceptional sexual status was tightly and gender-divisively controlled in the interest of economic production:

> In the *nāgeswaram* tradition the women of the group were scrupulously kept out of public, professional life.... Married girls were not *permitted* to specialise in the classical temple dance and its allied music.... The devadāsīs represented a badge of fortune, a form of honour managed for civil society by the temple.... The devadāsī acted as a conduit for honour, divine acceptance and competitive reward at the same time that she invited "investment," economic, political and emotional, in the deity ["Reform," 186, 183; emphasis mine].

In this context, to claim that "the devadāsī stood at the root of a rather unique and specialised temple artisan community, which displayed in its internal organisation the operation of pragmatic, competitive and economic considerations encouraging sophisticated, professional and artistic activity" ("Reform," 192) might be to emphasize social productivity isolated from forces and relations of production. Perhaps in reaction against colonial-nationalist elite collaboration, Srinivasan has created a bit of a static utopian past as well. She is surely right in noticing the interest of the men of the group in pushing through colonial reforms so that the *devadāsīs*' economic "power" could be broken. But to perceive these forces as supervening upon a freely functioning structure seems unconvincing. In fact the *devadāsī* structure was subsumed in a general patriarchal structure. As Gail Omvedt puts it: "Can any special section of women be free of patriarchy in a patriarchal society?"[36]

Srinivasan's utopian solidarity for these competitive, robustly celibate prostitutes (her Indocentric redefinition of "celibacy" is her boldest attempt at unsettling our imagination) is combined with a contempt for contemporary popular culture which must also be examined.

> In the midst of new forms of vulgarity surrounding the dance profession today, such as the commercial cinema, it is the *devadāsī* tradition alone which is propagated by the élite schools as representative of the ancient and pure Bharatanatyam.... If the *devadāsī*'s dance was a sacred tradition worth preserving and the legislation (justified though it was on the grounds of anti-prostitution) came down with a punitive hand not on prostitutes in general but on the devadāsī alone—why did the devadāsī need to go? [*AS*, 198]

This question cannot be asked alone but must be put in the context of broader questions: Why did precapitalist institutions disappear under imperialism? Why can the *devadāsī* not be fully captured in capital logic today? Srinivasan's own economic argument would suggest that this pre-colonial economic institution was "supplemented" by capital-formation: the *devadāsī* had to go not only because she was the member of a non-Christian female artists' community who challenged notions of female chastity (Srinivasan's argument), but because the structure of competition and production in the community was precapitalist (also her argument). Because of her functionalist utopianism, she cannot see that the commodification of woman's body in art in the commercial cinema is not different in kind from its imperfect commodification in the commercial temple. They are two links on the chain of displacement of capitalist/colonial production.

Let us attempt to project this sequential displacement onto a cross-section of class stratification:

(a) As Gail Omvedt suggests, the contemporary predicament of the *devadāsi* is a social tradition pressed into the service of capitalism ("pimps from the Bombay prostitution industry pay for the dedication ceremony, and often pay something to the girl's parents, in order to directly recruit the girl for a commercial brothel in Bombay");

(b) the *devadāsī* dance forms of *Odissi* and *Bharatanātyam* have, as their felicitous goals, the commodification of superstars in "high" cultural performances (on the authority of a male dancer, reputedly the son of a *devadāsī*, now a regular teacher of classical dance in Puri, the actual performance of the *devadāsī*s was much more improvisatory; the various stages of the dance were not as fixed); and

(c) the *devadāsī* dance form in the convention of the musical film commodifies women's bodies in "popular" cultural performance.

With this projection, the debate about the *devadāsī* would be as fully inscribed in women's class-stratification as the sources of metropolitan information about the cultural other.

Do *devadāsī*s visit the commercial cinema? What have they thought of the film version of *The Guide*? It seemed impertinent, indeed absurd, to put the question to the oldest living *devadāsī* in Puri, a woman ravaged by poverty and disease, one of Marglin's informants.

The film is an indigenous translation of Narayan's novel. It is part of the immensely popular, internationally distributed and prolific Bombay film industry. Here *The Guide* is lifted onto an altogether broader canvas. Almost every detail of the film recorded below is absent in the novel and in contradiction with its spirit.

Folabo Ajayi Soyinka, a renowned dancer from Nigeria and a professor of women's studies and theater in the United States, said recently to Sanjukta Panigrahi, an internationally renowned cultural performer of *Odissi*, that she had been partially prepared for Ms. Panigrahi's live performance by the many filmic representations of Indian dance that she had seen.[37] Thus the "popular," scorned by the Indo-Anglian novelist and treated with amused contempt by his or her Indian readership, can mediate the relationship between practicing artists.

The film thus speaks *for* India, as does Indo-Anglian fiction. The translation of the absent Tamil-Kannadese specificity into Hindi makes nonsense of the material situation of the *devadāsī*. The terrain of the film is now Rajasthan, an area which allows the regulation long-skirt costume popular in Hindi film.

Narayan is apart from "the people," a ruefully apologetic but affectionate commentator. "He never misses an eccentricity of Indian English," offers *The Times* of London as jacket blurb. *The Guide* in the Hindi film version is the condition and effect of the *vox populi*. As such, the film brings into bold relief the multiculturalism of (the now-precarious) official Indian self-representation, the religious tolerance of the Hindu majority that was still ideologically operative in the Nehruvian atmosphere of the sixties, and the protected subject/object status of the woman in love and performance ("Your caste is the same as Uday Shankar's and Shantha Rao's," says the film's Raju, mentioning two famous Indian dancers the histories of whose production are about as different as can be). These cultural generalizations catch a moment in postcolonial history that still hung on to the shreds of the dream of decolonization immediately after Independence, especially in the first two areas—of multiculturalism and religious tolerance. The violence of the translation of the English novel into the national language (not the appropriate vernacular) forces into the open the relay between empire and nation, English and Hindi, and the rivalry between them.

At this stage, the American girl reporter is still the boorish outsider. The sequence of the reporter questioning the dying and saintly Raju is repeated in *Gandhi*, but of course one dare not say that Attenborough cites *The Guide*.

The novel *is* in English, the film fights *with* it (in both senses); neither scenario captures the different beat of Indian literatures. The film mocks the ugly American and gives shelter to vernacular heterogeneity in certain brief moments, under the paternalist arm of the multicultural nation. It is possible to suggest, although such suggestions are always debatable, that, since the Emergency of 1975, the de-emphasizing of the federal structure, the manipulation of electoral politics, the attempt at centralizing power, the

emergence of the new politics of fragmentary consolidation(s) of opposition, as well as the rise of Hindu fundamentalism, the presentation of multiculturality and Hindi as protector of the vernaculars is not part of the current "task of the translator" in India. The first item, reprogrammed within dominant global capital, has now moved to the space of migrant postcoloniality. *The Satanic Verses* opens with the citation of a song from a 1960s film, *Shri 420*, where the invocation of unity in diversity is even broader in scope.[38]

At the beginning of the film of *The Guide*, we have a scene where a betel-leaf vendor rattles off a list of the places from where the ingredients of the little betel-leaf pack of spices (*pān*) have come: the nuts from Mysore, the leaves from Calcutta, the lime wash from Bikaner, the caoutchou from Bombay. And Raju answers back: you seem to be fostering national unity from your *pān*-stall alone. In the very next sequence, Raju the guide is shown managing at least two Indian languages and English with some degree of flair.

These two invocations of national unity stand at the beginning of the film, to "set the mood," as it were. The fight *with* English, however, plays an integral part in making the heavily moralized story come across to the reader. When Raju is first established as a holy man, two village priests challenge him with a Sanskrit *sloka* or couplet. Raju is of course clueless in Sanskrit. After an electric pause, he comes back at them in English: "For generations you've been fooling these innocent people. It's about time you put a stop to this!" The priests are bested, for they do not know English. The villagers rejoice. Raju is legitimized.

Of course Raju is himself a fraud as well. He *has* to be if the story is to remain a transformation story. But the seriousness of the message in English cuts across the mere story-line and indicates a major theme: the new nation will get rid of religious bigotry through the light of Western reason. The West is now to be used as an equal rather than a subordinate. This is the promise of decolonization, immediately broken by that other relay race between colonialism and neocolonialism, and the rise of isolationist fundamentalism which stages the West only as violator.

A metropolitan focus on popular history sometimes denies this first confident hope of decolonization. It can also be argued that it is the denial of this hope by global capital and racism in postcoloniality and migrancy, and the popular dissemination of that denial, that has brought us to the general scene of super-state powers versus guerilla counterwarfare and particular scenes of domestic confusion and violence.

Let us review the situation schematically: (a) The gendered subaltern woman, the contemporary *devadāsī*, can yield "real" information as an agent only with the greatest difficulty, not the least because methods of

describing her sympathetically are already in place. There is a gulf fixed between the anthropologist's object of investigation and the activists' interlocutor. She slips through both cultural relativism and capital logic. (b) The "popular" film forces the issues of the immediate post-decolonization nation up into view because it speaks to *and* from the "people" as it constitutes itself for representation and self-representation as the Constitutional subject; it also transforms itself into its asymmetrical opposite through the circuit of distribution—as commodity it performs the function of representing the nation to an international (though not international) audience. (c) The Indo-Anglian novel in the colonial mode puts the lid on (a) by its apparent accessibility.

And an "Indian" commentator is not necessarily helpful. To think the contrary is to fetishize national origin and deny the historical production of the colonial subject. Indo-Anglian fiction, as well as Commonwealth Literature, has now been disciplinarized in Indian English departments. The history and management of the University in the colonies are by and large conservative. Here for example is a Reader in English at a reputable Indian University, sounding like the usual unproblematic Reader's Guide:

> The next important novel of our study should be *The Guide* (1958), which is perhaps the most widely discussed of Narayan's works. The book, *which has all the ingredients of a commercial film* (indeed it was made into one), both on the maturity of the comic vision and in the novelist's artistic sophistication shown in the treatment of his theme (a sophistication which was lacking in the earlier novels), *transcends* the limits of a seemingly bizarre story. The *authenticity* in the treatment of Raju, an ordinary tourist guide with no extraordinary qualities except a certain cunning with which he plays on the gullibility of the village folk and Rosie the dancer, shows Narayan's artistic restraint in projecting Raju as a saint. It is this restraint which makes Raju's character and Narayan's art look credible.[39]

Upon being questioned, the author of this passage dismissed the film as not faithful to the novel.[40] True and false, of course. In this passage the making of the film is parenthetical, and perhaps what one is discussing in the present essay is the relationship between the text and that parenthesis.

At the end of the film, English is withheld by the saintly and triumphant Raju. He is fasting, waxy, bearded, and swathed—in some shots deliberately made up to look like a standing photograph of the nineteenth-century popular visionary Sri Rama Drishna, one of the most recognizable icons of liberated Hinduism. The reconciled Rosie—here the film diverges wildly from the novel—holds him up and an immense crowd is gathered. An American reporter appears. She is in safari clothes. She asks a few inane

questions: Do you believe in science, have you been in love, et cetera. The moribund saint answers in Hindi through an interpreter, and surprises her with an English-language answer in the end. The American answers with a delight that is, alas, still typical: You speak English! The journalist too denies history by conveniently mistaking the progressive bourgeoisie for the primitive.

Another important theme desubtilized by the film is Woman with a capital W. Rosie is a failed enterprise in the modernization of culture in the novel. In the film she appears in the house of an unreally opulent good-whore *devadāsī* mother who inserts her into the mainstream through marriage. (Rumor has it that the star Waheeda Rahman—a Muslim—who plays the role, was rescued by the actor-director Guru Dutt from the red-light district of Bombay.)

In response to the stylistic requirements of the morality play of decolonization, the greatest identity-change is undergone by Rosie's husband, who becomes the lascivious instrument of the *devadāsī*'s daughter's social liberation. In the novel he is rather an odd, obsessive archaeologist who is troubled by his wife's dubious profession. He is privately christened Marco by Raju because his obsession puts Raju in mind of Marco Polo, a cliché figure for the small-town guide. In the film he becomes that anomalous and detested thing, a Eurasian Indian (a reminder that we were not always "equal to the West"), whose last name becomes Marco. Rosie is Rosie Marco before she becomes Miss Nalini.

Both Raju and Nalini become more and more like fashionable Delhi and Bombay undergraduates and young executives as their love progresses. Indeed, although the end of the film is ideologically most satisfying in terms of the new nationalism, this love story is the part that, in context, is trend-setting.

This is also where "form" and "content" split apart to put into the field of vision the fault lines in the self-representation of the nation, precisely in terms of the woman as object seen. For this genre of musical film, especially in the sixties, is always an elaborately staged frame for song and dance. These are Bombay musicals actively transforming the filmic conventions of the Hollywood musical and recoding the myth of India in the process. What is remembered across classes, genders, nations—years afterward, in other countries—are the songs by famous artists lip-synched by famous actors and actresses and, in *The Guide*, the spectacular solo and group dance numbers. Here the cultural good is most visibly deauthenticated and reterritorialized. In the strictest sense of commodity (a product produced for exchange), the three classical dance traditions of India and multiple folk forms are put into a hopper and swirled around with free-form musical structuring to produce a global "India."

One of the most cliché items routinely noticed in Indian classical dance is the *mudra*—or the range of expressive hand-head-eye gestures. The Sanskrit word *mudra* is also coin—a common concept-metaphor straddling the money-form and the simple semiotics of stylized gesture, capable of considerable elaboration, but incapable of incorporating contingency. It is also, characteristically, the word for engraving, imprint. It is not by chance, then, that it is through this already-in-place value-form that the expressive repertoire of the Hollywood musical rushes in, culture-marked with the proper name "India," ready for exchange.

The film is plotted in easy doubles. If Raju is purified through jail and drought, Nalini is purified through her search for and discovery of Raju. In usual patriarchal fashion, that process is not shown but implied. Let us consider it through a few moments of the "real" time of our film, rather than the flashback temporality of the narrative.

At the jail gate, six months after Raju's good-conduct release, Raju's mother and Nalini arrive polarized, the former on foot from the village, the latter by car, just back from London. Their reconciliation starts the flashback in response to the mother's question: "If you were going to step out, why did you marry?"

In the flashback her dance impulse is opened up at her own request. One of the film stills, framed by the bare legs of the rural snake-dancer, shows us the couple caught in the gaze of the dancer, whose graphic symbol is shaped like the female sex. The focus of the riveted gaze of the couple is indeterminate.

But dancing as such is not important to the film's Rosie. It is revealed through a conversation between Rosie and Mr. Marco (where the juxtaposition of sculptured dancers and Rosie makes the point that he is not in touch with life) that Rosie needs to dance because Marco cannot give her a child. Thus the cultural politics of the film do not allow the commodity value of the dance-woman to be anything more than a splendid distraction which gives national information outside the nation, unaffected by the forces fabricating "national identity" out of progressivism and nostalgia. The function of the novel (giving information without attention to its historical production) has more in common with the dynamic kitsch of the film's frame than one would suspect; it is just that the target audiences are different.

The transformation of the classical *mudra* (money-form of expressive equivalence) into the vocabulary of the musical comes to a climax in the final dance, ending this central part of the film, where Waheeda Rahman's eyes, arms, and hands combine an expressive (or free) understanding of gesture with vestiges of the (bound) traditional lexicon of the *mudra*, visible through the crescendo of music and tempo as she brings the refrain to its repeated conclusion: *hai, hai re hai, sainya be-iman* (alas, alas, [my] lover [is

a] traitor). Whatever the eyes do, the mouth is fixed in a rictus that signals the separation of the dance from the direct expression of anguish or anger. From a complex set of perspectives, this is the *devadāsī* as living doll, stunningly expert in her art. Here the representation of *lāsya* is indeed again a skill, distanced by the work of the screen.

The first version of this essay was written in Princeton, New Jersey. The circulating library of videotapes in a Princeton shopping mall where I obtained a videotape of the film is one of thousands spread across the United States and indeed all countries where there is a sizable Indian immigrant presence. The value of the film in class-heterogeneous migrant subcultures has globalized the film differently from its earlier popular international presence, which continues on its own course. It has already been suggested that the current situation of the fabrication of "national" identity in India makes of the film an anachronism. This new globalization brings it clear out of the nation-theater into the space of cosmopolitan diasporic culture, at the other end from the radical cacophony of *The Satanic Verses*. At the end of the opening sequence of the central movement of the film (Miss Nalini's dancing career), where Miss Nalini is shown receiving a prize, the film cuts to Raju's gloating face. In the place of the original fade-out, we read the following message:

WORLD DISTRIBUTION
ESQUIRE ELECTRONICS LTD.
HONG KONG

There seems to be an appropriate if obscure typographic felicity— "Esquire" is in the copyright typeface of the United States-based men's magazine.

If the gendered subaltern, the young Maharashtrian *devadāsī* encountered by the SEWA group, is at one end of the spectrum, this message on the screen, inside as well as outside the film, points at the immense network at the other end. The space in between is not a continuity. It offers a cross-section where the travestied premodern marks the failure of modernization in the circuit of postmodernity. In the meantime, the muted modernism of the novel is in the classroom that molds the traditional disciplinary dominant in the pluralist academy.

The film accommodates two minor and completely outdated gestures toward Hindu-Muslim secularism quite absent in the novel. As Raju lies in the arms of his mother and Nalini, Gaffur (the Muslim taxi-driver from his days as a guide) arrives, drawn by rumor. The villagers will not let him enter. Raju insists. They embrace. And, on a more atmospheric level, a popular

folk song, a prayer for rain, from what was then East Pakistan (now Bangladesh), is played in the film's otherwise Hindi soundtrack. Since Bangladesh is a Muslim-majority area of the subcontinent the prayer is addressed to Allah, and the Bengali is Urduized enough for one line of the song to pass as Hindustani. Only one word needed to be altered and in the syllabic space thus released the name of Rama is inserted, the Hindu god-king who was Gandhi's totem, and in whose name India is being "ethnically cleansed" of its Muslim population in the nineties. If in the embrace of Gaffur the nineteenth-century Rama Krishna is glimpsed, the coupling of Allah and Rama in song brings the Mahatma himself to mind. In the contemporary context of religious strife, these overdetermined moments would either have to be suppressed or elaborated.

Still remaining within the taxonomic impulse, it may be submitted that the film translates the novel from elite colonial to popular national; from English to Hindi. Nowhere is this more apparent than at the end. The novel makes miracle tastefully indeterminate as mental allegory. The film, in a bravura move, leaves Raju's body dying and discovered dead by a fully Indianized and respectable Nalini. Raju's spirit splits in two, the fashionable anglicized Raju dressed in the hip clothing of mid-film, and the resplendent Hindu Raju swathed in light, wrapped in a saffron-gold toga. The film's final moments: lightning, then rain, the people dancing, the mother weeping; Western Raju squirms and dies, Indian (secularist Hindu) Raju stands tall and smiling, with this to say to his other self: *tum ahamkā, main atmā hum* (you are the ego, I the spirit). The corporeal Raju lies smilingly dead, mourned by his beloved. This portion is uncontaminated by song; there is no lipsynching here; the connection between voice and consciousness remains intact. At the same time, the center of the film, the woman's place of song and dance, retains its outline as commodity.

To conclude:

The itinerary from colonial through national to postcolonial and/or migrant subjects is complex, diverse, many-leveled. This essay has tried to plot a few way-stations on that itinerary by reading a text of cultural self-presentation. The method of reading has kept to the representation of agency. These representations are gender-divided. The medium of the male agent's self-representation in this case is the *devadāsī*. Such readings in the subdiscipline of Cultural Studies cannot claim the attention of the disciplinary historian of the aftermath of colonialism. They can timidly solicit the attention of the teacher of multicultural literature courses so that s/he can remain aware of the differences and deferments within "national identity" and "ethnic minority," and not take the latter as the invariable starting-point of every decolonization of the mind.

NOTES

1. R. K. Narayan, *The Guide* (New York: Penguin, 1980). Hereafter cited in the text as *G*, followed by page number.

2. Ngũgĩ wa Thiong'o, *Decolonizing the Mind* (London: Heinemann, 1986).

3. Richard Hoggart, *The Uses of Literacy: Aspects of Working-Class Life* (New York: Oxford University Press, 1970); Stuart Hall, *Culture, Media, Language: Working Papers in Cultural Studies* (London: Hutchinson, 1980). Work produced from a Black British subject-position, such as the early and influential *The Empire Strikes Back* produced by the Centre for Contemporary Cultural Studies at the University of Birmingham in 1982, has a singularly different aura from its effect on postcolonial self-representation in Indo-Anglian writing.

4. For an extended discussion of the role of popular music in this telematic cultural field, see Jean Franco, "The Sound of Music," in *Border Patrol* (Cambridge, Mass.: Harvard University Press, forthcoming).

5. Shashi Tharoor, *The Great Indian Novel* (New York: Arcade, 1989). This information is provided in the biographical blurb in the inside back cover.

6. Dipesh Chakrabarty notes the divide, but does not account for it in his "Open Space/Public Place: Garbage, Modernity and India," *Economic and Political Weekly* 27:10–11 (March 7–14, 1992), p. 541–47: "Until the Salman Rushdies arrived on the scene and made the intellectual ferment of modern India more visible to the outsider...," p. 541.

7. G. V. Desani, *All About H. Hatterr* (New Paltz: McPherson, 1986).

8. For "hyperreal," see Jean Baudrillard, "The Precession of Simulacra," in *Simulations*, trans. Paul Foss, et al. (New York: Semiotext(e), 1983), p. 2.

9. V. N. Vološinov proposed a classification of literary form in terms of the reporting of speech (Vološinov, *Marxism and the Philosophy of Language*, p. 133). I have commented on the problems of bilingual representation of subjectivity with reference to Nadine Gordimer's *July's People* in "The Burden of English," in Rajeswari Sunder Rajan, ed., *The Lie of the Land: English Literary Studies in India* (Delhi: Oxford University Press, 1992), pp. 275–99.

10. R. K. Narayan, *My Days: A Memoir* (London: Penguin, 1989), p. 167.

11. In this respect, the visible "difficulty" of *Glas*, trans. John P. Leavy, Jr., and Richard Rand (Lincoln: University of Nebraska Press, 1986) is less "bewildering" than the philosophical prose of *Of Spirit: Heidegger and the Question*, trans. Geoffrey Bennington and Rachel Bowlby (Chicago: University of Chicago Press, 1989), where Derrida "follows" every principle of style developed in his thought so implicitly that an uninstructed or too-quick reading can and often does interpret his grave denunciation of Heidegger's betrayal of himself in his later politics as an apology!

12. The best-known elaboration of this argument is to be found in M. H.

Abrams, *The Mirror and the Lamp: Romantic Theory and the Critical Tradition* (New York: Oxford University Press, 1971).

13. This is one of the supporting arguments in that part of Foucault's work which is interested in a chronological narrative of discursive formations. The argument is most persuasively made in Michel de Certeau, "The Formality of Practices: From Religious Systems to the Ethics of Enlightenment (the Seventeenth and Eighteenth Centuries)," in *The Writing of History* (New York: Columbia University Press, 1988), pp. 147–205.

14. Narayan, *Memoir*, p. 48.

15. Narayan is thus able to make this sweeping generalization, worthy of a Macaulay: "all imaginative writing in India has had its origin in the *Rāmāyana* and the *Mahābhārata* ("The Problem of the Indian Writer," in *A Story-Teller's World* [New Delhi: Penguin India, 1989], p. 14). The problem of "English in India" becomes a jolly safari arranged by some better-bred version of the India Tourist Board. Is Narayan naive or ironic in the following passage? "In the final analysis America and India differ basically though it would be wonderful if they could complement each other's values.... One may hope that the next generation of Indians (American grown) will do better by accepting the American climate spontaneously or, in the alternative, by returning to India to live a different life" (*ibid.*, p. 30). It is significant that only on the Raj is he uncompromisingly dismissive: "The Raj concept seems to be just childish nonsense, indicating a glamorized, romanticized period piece, somewhat phony" (*ibid.*, p. 31). His word on decolonization is back on the track of general niceness (perhaps we should allow for the fact that this piece was first published in the United States *TV Guide*): "With all the irritants removed [at Independence], a period of mutual goodwill began between the two countries" (*ibid.*, p. 33). It is possible that, as a result of his general avoidance of conflict, Narayan is a preferred author in the underclass multicultural classroom in Britain (information received from Badar Nissar Kaler, Oxford).

16. Narayan, *Memoir*, pp. 168–69.

17. For *découpage* see Derrida, "My Chances/*Mes Chances*," in *Taking Chances*, p. 28.

18. E. M. Forster, *A Passage to India* (New York: Harper Torchbooks, 1952), pp. 283–322.

19. Frédérique Apffel Marglin, *Wives of the God-King: The Rituals of the devadāsīs of Puri* (Delhi: Oxford University Press, 1985). This book has been criticized by Indian scholars, but the politics of that criticism is itself a text for interpretation.

20. Narayan would like this not to be so ("After the Raj," in *Story-Teller's World*, p. 32), and the Malgudi novels might have some unspecified regional specificity. *The Guide* does not carry specific regional signals.

21. Making dancing acceptable as a full-fledged career, inserting *Odissi* into the

classical repertoire, has its own "feminist" histories, in quite a different space from subalternity. My conversations with Sanjukta Panigrahi, an *Odissi* dancer of my own generation and class, brought this home to me yet once again. This history must not be allowed to take first place. And the role of the quiet protofeminist mothers of this generation who, working with immense innovativeness behind the scenes, made their daughters' career freedom possible must not be obliterated in the accounts of the daughters' struggles.

22. Baudrillard, "Precession," p. 16.

23. Marglin, *Wives*, pp. 67, 73.

24. *Ibid*, p. 11.

25. Amrita Srinivasan, "Reform or Conformity? Temple 'Prostitution' and the Community in the Madras Presidency," in Bina Agarwal, ed., *Structures of Patriarchy: State, Community, and Household in Modernizing Asia* (Delhi: Kali for Women, 1988). Hereafter cited in text as "Reform," followed by page reference. One wonders how seriously one should examine Marglin's claim of solidarity with Mrs. Besant. Annie Besant (1847–1933) was a brilliant woman of extraordinary enthusiasms and unremitting activism: for Christianity, atheist secularism, Socialism, and Theosophy/India, respectively. It is well known that her aim for India was "Self-Government Within the Empire" ("Manifesto," included in Raj Kumar, *Annie Besant's Rise to Power in Indian Politics 1914–1917* [New Delhi: Concept, 1981], p. 139). Indeed, her Theosophist millenarianism "was to bring about a universal, theocratic state under whose firm, wise rule men could not but behave as brothers" (Anne Taylor, *Annie Besant: A Biography* [New York, Oxford University Press, 1991], p. 277). As Taylor comments further, her "historical account of India's spiritual past [was] heavily biased towards Hinduism.... Indians as well as Europeans blamed her for inciting race hatred and caste hatred.... 'A democratic socialism controlled by majority votes, guided by numbers, can never succeed,' she wrote as early as 1908; 'a truly aristocratic socialism, controlled by duty, guided by wisdom is the next step upward in civilisation'" (pp. 311, 327, 313). Her attitude toward Indian women was consonant with her conviction that "knowledge of British ways and political methods [would lead] to India's strengthening" (Kumar, *Besant's Rise*, p. 102) and with her "approval [of] a proletariat in the condition of a child, ready to be governed, ready to admit the superiority of its elders" (Taylor, *Besant*, p. 313). I recommend a browse through a document like Besant's *Wake Up, India* (Adyar: Theosophical Publishing House, 1913) for a sense of her attitude to Indian women's education. It is no underestimation of her commitment, but a recognition of her historical inscription, to acknowledge that "Victorian and Edwardian feminists collaborated in the ideological work of empire, reproducing the moral discourse of imperialism and embedding feminist ideology within it" (Antoinette M. Burton, "The White Woman's Burden: British Feminists and the Indian Woman, 1865-1915," *Women's Studies International Forum* 13:4 [1990], p. 295). If Marglin's throwaway claim had

been serious, her own invocation of a century's difference between herself and Besant would have led to considerations of the relationship between imperialism and neocolonialism, liberal humanism and cultural relativism. Who decolonizes? And how?

26. Manavalli Ramakrishna Kavi, ed. *Nāṭyaśāstra: With the Commentary of Abhinavagupta* (Baroda: Central Library, 1926), vol. 1:5, pp. 103–25.

27. Hari Narayan Apte, ed. *Saṅgītaratnākara* (Gwalior: Anandāśram, 1897), vol. 7, pp. 3–16.

28. Aparna Chattopadhyay, "The Institution of 'devadāsīs' According to the Kathāsaritsāgara," *Journal of the Oriental Institute* 16:3 (March 1967), pp. 216–22. The famous reference in Kālidāsa's *Meghadūta* is not necessarily a reference to the institution.

29. Mandakranta Bose, *"Lāsya*: Dance or Drama?," in Bimal Krishna Matilal and Purushottam Bilimoria, eds., *Sanskrit and Related Studies* (Delhi: Indian Books Centre, 1990), p. 125–34. I am grateful to Dr. Bose for allowing me to summarize unpublished material.

30. "Sublate" is a newish translation of *Aufhebung*, usually translated *overcoming* or *superseding*, words that do not keep the colloquial German aura of preserving in a higher way while destroying in the lower way.

31. The technique of analogizing from individual pathology through the history of the language to the history of culture can perhaps do no more than figure forth the impossibility of ever performing this task successfully. For a bold excursion into this area, one might consult Freud's essay on the word "uncanny," which still stops short of the cultural history of gendering (Freud, "The Uncanny," in *Works*, vol. 17, pp. 218–56).

32. Gyan Prakash has theorized this resistance in terms of precapitalist/precolonial and capitalist/colonial/postcolonial discursive productions (without reference to gender) in *Bonded Histories: Genealogies of Labor Servitude in Colonial India* (New York: Cambridge University Press, 1990). Recognition of this resistance makes Kamala Kumar, "Improving Quality of Life and Status of Women Through Enhancing Effectiveness of Organizations Working for Women's Development," unpublished report (New Delhi: Asian Centre for Organisation and Development, 1987), an unusually valuable source-document. Activists interpret this resistance in various ways. From a distance it gives rise both to theories about the "natural" inferiority of ethnic/racial groups, classes, and genders; as well as cultural relativism. A certain variety of armchair resistance refuses to recognize its reality as well as its critical potential.

33. *Shramshakti* (New Delhi: National Commission on Self Employed Women & Women in the Informal Sector, 1988), p. liii.

34. For more on SEWA (Self-Employed Women's Association), see Sheila Allen and Carol Wolkowitz, *Homeworking: Myths and Realities* (London: Macmillan, 1987), p. 149.

35. "I am using 'feminism' here in a loose sense: (a) Work for the removal of social practices based on and perpetuating exploitation of women; (b) follow-up support so that implementation of (a) does not in fact become impossible through masculist and class reprisal; and (c) education so that men and women want to be free of gender-bias and not consider the consequences of gender-freedom demeaning to themselves as men and women, and necessarily destructive of the social fabric" (Spivak, "Marxist Feminism," *Frontier* 23:24 [26 January 1991], p. 17).

36. Gail Omvedt, "devadāsī Custom and the Fight Against It," *Manushi* 19 (1983), p. 17.

37. Discussion of Panigrahi's performance, Conference on Intercultural Performance, Bellagio, Italy, 18 February 1991. Ajayi's questioning was most perceptive, and revealed the difference in approach between performer and academic theorist. The bit about the film is the only part that relates to my argument.

38. Srinivas Aravamudan, "Being God's Postman Is No Fun, Yaar: Salman Rushdie's *The Satanic Verses*," *Diacritics* 9:2 (Summer 1989), pp. 3–20.

39. C. N. Srinath, *The Literary Landscape: Essays on Indian Fiction and Poetry in English* (Delhi: Mittal, 1986), pp. 7–8; emphases mine.

40. The author of the novel would endorse this sentiment. See "After the Raj," in *Story-Teller's World*, p. 32.

Translator's Preface and Afterword to Mahasweta Devi, *Imaginary Maps*

(1995)

TEN

Translation is a labor of love. We should remember Spivak's early fame as translator of Derrida's *Of Grammatology* in 1976 when we read her more recent translations of the fiction of Bengali author and activist Mahasweta Devi. Derrida and Devi: to these very different figures Spivak has given her best efforts as a translator, become a medium for their ideas, given herself over to the dissemination of their texts for English-reading audiences with passionate intellectual devotion.

In one sense this preface and afterword to three of Mahasweta Devi's stories is Spivak's most up-to-date word on the phenomenon of the subaltern, particularly the gendered subaltern. In another sense these essays usher in the new ecological turn of Spivak's pronouncements on contemporary global politics. Her call to ethical responsibility as an embrace, a one-on-one, intimate, and loving exchange between the investigating subject and the other in which each learns from the other, stands as a challenge not only to other ways of negotiating with the subaltern, but to hyper-rational, self-interested, post-Enlightenment ways of dealing with nature and the environment.

One thing that can perhaps be culled from Mahasweta's fiction, even taking into consideration the inevitable commodification and ill-informed benevolence that tend to circulate through the multicultural classroom in which these translations will so often be read, is the beginning of new ecologically imaginative possibilities. Her fiction resonates with new social movements such as the non-Eurocentric ecological movement and various women's movements against reproductive engineering and international population-control policy. These are women and ecological activists joining together not so much internationally as globally, because they join forces without seeking state power. In a just-published essay, "Supplementing Marxism," Spivak names these new movements "globe-girdling," since

they confront the new economic order on its own globe-clinching terms (in Steven Cullenberg and Bernd Magnus, eds., *Whither Marxism?* [New York: Routledge, 1995]).

Here in the Preface and Afterword to *Imaginary Maps*, we can see Spivak's articulation of Mahasweta Devi's differing but entangled texts of fiction and activism. From the very differences between the projects of imaginative writing and organizing politically there emerges, according to Spivak, a "dream" of "how to construct a sense of sacred Nature which can help mobilize a general ecological mindset beyond the reasonable and self-interested grounds of longterm global survival." Unlearning the hypocrisies of the so-called "Green Revolution"—which is another name for exploitative development—is a first step here.

Once again the questions are posed for us: Who decolonizes? And how? The literary is no substitute for local or global activism, but neither can activism alone put forward the new imaginary maps to an ecologically emancipated and sexually democratized future that fictions like Mahasweta's can obliquely provide.

TRANSLATOR'S PREFACE

I. CONSTRAINTS ON METHOD

Imaginary Maps is to be published in both India and the United States. As such it faces in two directions, encounters two readerships with a strong exchange in various enclaves. As a translator and a commentator, I must imagine them as I write. Indeed, much of what I write will be produced by these two-faced imaginings, even as it will no doubt produce the difference, yet once again. But the "imaginary" in our title—"imaginary maps"—points at other kinds of divisions as well. "India" is not an undivided perspective, much as both conservatives and radicals in the United States would strive to represent it as such. And the divisions within the United States are there for deconstructive pedagogic use, although politicians and ideologues on both sides in India would like to convince us otherwise. In what interest or interests does the necessity to keep up this game of difference—India is "India" and the United States is the "United States," and the two are as different as can be—emerge, today? The stories translated in *Imaginary Maps* can help us imagine that interest or those interests. I am convinced that the multiculturalist United States reader can at least be made to *see* this difference at work, and it is the expatriate critic who *can* make the effort. I also remain convinced that the urban, radical, academic Indian reader can be made to question his or her complicity with keeping the

United States as demonized other while reaping or attempting to reap the benefits of its "belittling befriending." But then Mahasweta must not be commodified as a "national cultural artifact," *only* accessible to "Indians," a seamless national identity after all, when her entire effort focuses on what has been left out of such a definition; for that feeds that transnational United States multiculturalist hunger on both right and left. Add to this the fact that cultural studies in the United States today is also fed by the migrant academic's desire to museumize a culture left behind, gaining thus an alibi for the profound Eurocentrism of academic migrancy.

This myth of pure difference is the displacement of an old slogan, after all: "East is East…" et cetera. Or is the "imagination" of new maps in the name of decolonization or the New World Order too crucial an enterprise for it to be exposed to serious intellectual investigation?

I want to use the risky word "deconstruction" again, to keep at bay the easy rewards of inspirational prose. In the particular context that I have described generally above, where both the "United States" and "India" are interested in claiming sometimes the place of the "same" (or self, or knower) and sometimes the "other," it is the following deconstructive formula that I find myself acting out:

> The same, precisely, is *différance*…as the displaced and equivocal passage of one different thing to another, from one term of an opposition [here "India" and "United States"] to the other. Thus one could reconsider all the pairs of opposites…on which our discourse lives [precisely to include the subaltern, here the Indian tribal], not in order to see opposition [between "India and the "United States"] be erased but to see what indicates that each of the terms *must* appear as the *différance* of the other, as the other different and deferred in the economy of the same….[1]

In this traffic of same-and-othering, the groups that do receive some attention in the cultural sphere are the new immigrants (sometimes unjustifiably conflated with exiles, refugees, diasporics, and post-colonials *in* the former colonies), old minorities in the North, urban radicals sponsoring organized protest, the historical or contemporary ethnographic other in the South, and, sometimes, the indigenous organic intellectual of the South, this last celebrated as *the* "subaltern" in the North.[2] In the Afterword to *Imaginary Maps*, I will try my best to show how the figures in Mahasweta's fiction do not belong to this catalogue.[3] Here let me say that no amount of raised-consciousness fieldwork can even approach the painstaking labor to establish ethical singularity with the subaltern.[4]

"Ethical singularity" is neither "mass contact," nor engagement with "the common sense of the people." We all know that when we engage pro-

foundly with one person, the responses come from both sides: this is responsibility and accountability. We also know that in such engagements we want to reveal and reveal, conceal nothing. Yet on both sides there is always a sense that something has not got across. This we call the "secret," not something that one wants to reveal. In this sense the effort of "ethical singularity" may be called a "secret encounter." Please note that I am not speaking of meeting in secret. In this secret singularity, the object of ethical action is not an object of benevolence, for here responses flow from both sides. It is not identical with the frank and open exchange between radicals and the oppressed in times of crisis, or the intimacy that anthropologists often claim with their informant groups, although the importance of at least the former should not be minimized. This encounter can only happen when the respondents inhabit something like normality. Most political movements fail in the long run because of the absence of this engagement. In fact, it is impossible for all leaders (subaltern or otherwise) to engage every subaltern in this way, especially across the gender divide. This is why ethics is the experience of the impossible. Please note that I am not saying that ethics are impossible, but rather that ethics is the experience of the impossible. This understanding only sharpens the sense of the crucial and continuing need for collective political struggle. For a collective struggle *supplemented* by the impossibility of full ethical engagement—not in the rationalist sense of "doing the right thing," but in this more familiar sense of the impossibility of "love" in the one-on-one way for each human being—the future is always around the corner; there is no victory, but only victories that are also warnings.

The initial attempt in the Bandung Conference (1955) to establish a third way—neither with the Eastern nor within the Western bloc—in the world system, in response to the seemingly new world order established after the Second World War, was not accompanied by a commensurate intellectual effort. The only idioms deployed for the nurturing of this nascent Third World in the cultural field belonged then to positions emerging from resistance within the supposedly "old" world order—antiimperialism and/or nationalism. The idioms that are coming in to fill that space in *this* new world order, to ascertain, perhaps, that the cultural lobby be of no help in producing an appropriate subject, are: national origin, subnationalism, nationalism, cultural nativism, religion, and/or hybridism.[5] I have written extensively about these problems elsewhere. In the Afterword I will attempt to show how Mahasweta's fiction resonates with the possibility of constructing a new type of responsibility for the cultural worker.

It has always fascinated me that, although her writing and her activism reflect one another, they are precisely that—"a folding back upon" one another—re-flection in the root sense. The Afterword will therefore also

concentrate upon the difference between the literary text and the textile of activism. Indeed, if one reads carefully, one may be seen as the other's *différance*.

11. THE ORGANIC INTELLECTUAL

I want to clear up a few confusions by way of conclusion. Reading merely "Douloti," a migrant academic dismissed it as an exercise by the pessimistic and jaded postcolonial middle class. Reading my commentaries on the guardians of the horizon—such as the pterodactyl in the final novella—my friend Sara Suleri has unaccountably diagnosed a case of exoticization.[6] And there is also a feeling that perhaps this is a denial of voice to "the subaltern," so that she can only be spoken for. Sujit Mukherjee, a prominent intellectual of the publishing world particularly concerned with the quality of translations, has called me a *dwārpālika* (female doorkeeper) of Mahasweta in the West.[7] There is some truth in this and I want to perform the door-keeper's obligation by commenting briefly on these misapprehensions, part of the risk taken by work such as Mahasweta's. If these comments are seen as "too theoretical," I will remind the readers of this translation, with respect, that the migrant in the North, a species of "wild anthropologist," at least knows the points of rejection or contempt hidden behind the mask of untheorized solidarity, without liabilities.

When the subaltern "speaks" in order to be heard and gets into the structure of responsible (responding and being responded to) resistance, he or she is on the way to becoming an organic intellectual. By way of Mahasweta's political generosity, I have had the good fortune of encountering a handful of contemporary tribal intellectuals among whom two have seemed to me to have traversed the hardest road: Chuni Kotal and Jaladhar Sabar. Chuni, as a woman daring to breach the general "intellectual" establishment, took her own life under the weight of social prejudice.[8] I had initially thought to include some documents of ground-level intervention produced by Jaladhar Sabar in this Introduction. But now, because of my double-edged feeling about the *type* and *area of effectiveness* of testimonial work, I hesitate to commodify them here. They were not produced for this sort of exchange, and I obtained them through my archival interest.[9] Mahasweta has published what amounts to politically interventionist and informative testimonials in her journal *Bartika* for years, without making a noticeable mark upon the general reading public in West Bengal, let alone enthusiasts of multiculturalism and Cultural Studies in the United States. The misguided and uninvolved benevolence that sometimes stands for political pedagogy in the United States might find in this particular documentation as interesting a research novelty as Madonna. (I have tried to bypass this by always insisting upon the sheer difficulty of teaching

Mahasweta, in her turn, as an Indian cultural exhibit.)

The point I am trying to make is that there is no lack of the celebration of the organic intellectual in Mahasweta's work and writing work. In the present collection of stories, Mary Oraon in "The Hunt" is one of those figures. Yet in her case, a share of violent imperialist blood and her consequent singularity are emphasized. I look for postcolonial women writers cognizant of the aporias or ethico-historical dilemmas in women's decolonization.[10] It is in this spirit that Assia Djebar of Algeria claims that the ancestress of the Algerian *mujahidat* or women freedom-fighters is Pauline Rolland, the French revolutionary of 1848 whom France banished to Anaba.[11]

In my estimation, in the case of "Douloti," Mahasweta confronts a much more severe truth: that one of the bases in women's subalternity (and indeed in unequal gendering on other levels of society) is internalized constraints seen as responsibility, and therefore the very basis of gender-ethics. Here woman's separation from organic intellectuality is a complicity with gendering that cannot not be perceived by many as sweetness, virtue, innocence, simplicity. If in the case of Bhubaneswari Bhaduri ("Can the Subaltern Speak?") and Jashoda in Mahasweta's "Stanadayini," it is parts of the sexed body—menstruation, lactation—that are invested with meaning and yet are not heard and not read, in "Douloti" it is the bonded prostitute's body that Mahasweta makes visible as graphic comment on the entire map of India. It is a mistake to think that this fierce love is the jaded pessimism of the bourgeoisie.

Yet sweet, innocent, responsible Douloti is not a subject of resistance. Mahasweta dramatizes that difficult truth: internalized gendering perceived as ethical choice is the hardest roadblock for women the world over. The recognition of male exploitation must be supplemented with this acknowledgment.[12] And the only way to break it is by establishing an ethical singularity with the woman in question, itself a necessary supplement to a collective action to which the woman might offer resistance, passive or active. Douloti as a subject is a site of this acknowledgment.[13]

Sujit Mukherjee has also complained—and this is particularly important for United States readers who are looking for either local flavor or Indian endorsement—that the English of my translation is not "sufficiently accessible to readers in this country [India]."[14] This may indeed be true, but may not be sufficient grounds for complaint. I am aware that the English of my translation belongs more to the rootless, American-based academic prose than to the more subcontinental idiom of my youth. This is an interesting question, unique to India: should Indian texts be translated into the English of the subcontinent? I think Sri Mukherjee is begging rather than considering this question.

Let me end with the South African writer J. M. Coetzee's comments on his translation of the Dutch poet Achterberg. (It should be noted that Coetzee's relationship to both English—his is an Afrikaans name—and Dutch is askew, as is mine to English and to Bengali, though in a different way):

> It is in the nature of the literary work to present its translator with problems for which the perfect solution is impossible.... There is never enough closeness of fit between languages for formal features of a work to be mapped across from one language to another without shift of value.... Something must be "lost"; that is, features embodying certain complexes of values must be replaced with features embodying different complexes of values in the target language. At such moments the translator chooses in accordance with his [sic] conception of the whole—there is no way of simply translating the words. These choices are based, literally, on preconceptions, prejudgment, prejudice.[15]

Upon this acknowledgment of prejudice (not derived from the possibility of an unprejudiced translation, even in reading), bequeathed by a writer who responds to the compromised position of "white writing" in South Africa (a much greater compromise than translating Mahasweta into "American"), I invite you to acknowledge your own and turn now to the text.

AFTERWORD

"If read carefully," Mahasweta says in conversation, "'Pterodactyl' will communicate the agony of the tribals." And in December 1992, Gopiballabh Singh Deo lovingly complained, again in conversation, "Didi [Mahasweta] leaves too much unsaid. Not everyone can understand her point of view." Ranajit Guha has commented on the Sanskritized translation of "culture" innovated by Bankimchandra Chatterjee, the celebrated nineteenth-century Bengali nationalist writer and intellectual: *anushilan*.[16] Here as elsewhere, the colloquial language takes away the project of an intellectual. In colloquial Bengali today, *anushilan* is attention, concentration. What Mahasweta asks for is *anushilan*, on our part, of the First Nation, the *Adim Jati*.

I am learning to write on Mahasweta as if an attentive reading of her texts permits us to imagine an impossible, undivided world, without which no literature should be possible. This is a learning because such a permission can be earned only by way of attention to the specificity of these writings. Since the general tendency in reading and teaching so-called "Third World"

literature is toward an uninstructed cultural relativism, I have always written companion essays with each of my translations, attempting to intervene and transform this tendency. I have, perhaps foolishly, attempted to open the structure of an impossible social justice glimpsed through remote and secret encounters with singular figures; to bear witness to the specificity of language, theme, and history as well as to supplement hegemonic notions of a hybrid global culture with this experience of an impossible global justice.[17]

I believe that the same habit of mind—a vision of impossible justice through attention to specificity—may draw a reader to Marx, to Mahasweta, and to Derrida, in different ways. My earlier companion essays perhaps showed this too enthusiastically. And the general uneasiness about (or unexamined celebration of) Derrida's critique of humanism compromised their reception. My own sense of their inadequacy is related to an insufficient preparation in the specific political situation of the Indian tribal. I have tried to remedy this, indeed compensate for this, by letting Mahasweta's intimate and abyssal responsibility toward that originary history of India, that must haunt any present that India might want to shore up, speak itself at the head of *Imaginary Maps*. Here I want to supplement her remarks by a few observations about a general (rather than nation-specific) political urgency to which these stories relate—a vision of internationality that is not only impossible but necessary.

In the contemporary context, when the world is broadly divided simply into North and South, the World Bank has no barrier to its division of that world into a map that is as fantastic as it is real.[18] This constantly changing map draws economic rather than national boundaries, as fluid as the spectacular dynamics of international capital. One of the not inconsiderable elements in the drawing up of these maps is the appropriation of the Fourth World's ecology.[19] Here a kinship can be felt through the land-grabbing and deforestation practiced against the First Nations of the Americas, the destruction of the reindeer forests of the Suomis of Scandinavia and Russia, and the tree-felling and eucalyptus plantations on the land of the original nations, indeed of all the early civilizations that have been pushed back and away to make way for what we call the geographic lineaments of the map of the world today.

Upon the body of this North-South world, and to sustain the imaginary map-making of the World Bank, yet another kind of unification is being practiced as the barriers between international capital and the fragile national economies of the South are being removed. The possibility of social redistribution in these states, uncertain at best, is disappearing even further.

In this context, it is important to notice that the stories in this volume are not only linked by the common thread of profound ecological loss, the

loss of the forest as foundation of life, but also of the complicity, however apparently remote, of the power lines of local developers with the forces of global capital. This is no secret to the initiative for a global movement for non-Eurocentric ecological justice. But this is certainly a secret to the benevolent study of other cultures in the North. And here a strong connection, indeed a complicity, between the bourgeoisie of the Third World and migrants in the First cannot be ignored. We have to keep this particularly in mind because this is also the traffic line in Cultural Studies. Mahasweta's texts are thus not only of substantial interest to us, but may also be a critique of our academic practice. Is it more or less "Indian" to insist on this open secret?

What follows is not a romanticization of the tribal.[20] Indeed, "Pterodactyl" is a critique of any such effort. The following paragraphs outline a dream based on the conviction that large-scale mind change is hardly ever possible on grounds of reason alone. In order to mobilize for non-violence, for example, one relies, however remotely, on building up a conviction of the "sacredness" of human life. "Sacred" here need not have a religious sanction, but simply a sanction that cannot be contained within the principle of reason alone. Nature is no longer sacred in this sense for civilizations based on the control of Nature. The result is global devastation due to a failure of ecology. It is noticeable that the less advantaged groups among the Indian tribals still retain this sense as a matter of their cultural conformity, if only because they have been excluded from the mainstream. It is also true that more self-conscious First Nation groups such as the Canadian Native American Movement use this possibility of cultural conformity precisely to mobilize for ecological sanity as well as against historical injustice. What we are dreaming of here is not how to keep the tribal in a state of excluded cultural conformity but how to construct a sense of sacred Nature which can help mobilize a general ecological mindset beyond the reasonable and self-interested grounds of longterm global survival.

Indeed, if this seems an impractical dream, we should perhaps learn a lesson from the other side. In the World Bank's Environmental Report for the fiscal year 1992, we read:

> The World's remaining indigenous peoples—estimated to number more than 250 million in seventy countries—possess knowledge fundamental to the sustainable management of resources in these regions.... In cooperation with the Center for Indigenous Knowledge, the Environmental Department prepared a Bank discussion paper entitled *Using Indigenous Knowledge in Agricultural Development* (Warren 1991). Region-specific technical papers are being prepared to support the implementation of the directive.[21]

World Bank assistance comes at the request of governments. These sto-
ries prepare us to take a critical stance toward such "assistance." Within
that framework, we should remind ourselves that the preparation of "tech-
nical papers" that will extract methods from so-called "indigenous knowl-
edge" will not be accompanied by any change of mindset in the researchers.
By contrast, we draw out from literary and social texts some impossible yet
necessary project of changing the minds that innocently support a vicious
system. That is what "learning from below" means here. Mahasweta writes
in "Pterodactyl" that the tribals remain largely spectators as India moves
toward the twenty-first century. Assia Djebar has written that women
remained largely spectators as Algeria moved toward Independence. "If
only one could cathect [*investir*] that single spectator body that remains,
encircle it more and more tightly in order to forget the defeat!" she writes.[22]
This wish is another version of ethical singularity. It should not be conflat-
ed with romanticizing the tribal as figure for the Unconscious.

Having seen, then, the powerful yet risky role played by Christian liber-
ation theology, some of us have dreamt of animist liberation theologies to
girdle the perhaps impossible vision of an ecologically just world. Indeed
the name "theology" is alien to this thinking. Nature "is" also super-nature
in this way of thinking and knowing. (Please be sure that I am not positing
some generalized "tribal mind.") Even "super" as in "supernatural" is out-
of-the-way. For Nature, the sacred other of the human community is, in
this thinking, also bound by the structure of ethical responsibility of which
I have spoken in connection with women's justice. The pterodactyl is not
only the ungraspable other, but also the ghost of the ancestors that haunts
our present and our future. We must learn "love" (a simple name for ethi-
cal responsibility-in-singularity), as Puran does in "Pterodactyl," in viewing
the impossibility of communication.[23] No individual-transcendence theol-
ogy, being just in this world in view of the next—however the next is under-
played—can bring us to this.

Indeed, it is my conviction that the inter-nationality of ecological justice
in that impossible, undivided world cannot be reached by invoking any of
the so-called "great" religions of the world, because the history of their
"greatness" is too deeply imbricated in the narrative of the ebb-and-flow
of power. In the case of Hindu India—a terrifying phrase—no amount of
reinventing the nature poetry of the *Rg-Veda* will, in this view, suffice to
undo that history.[24] I have no doubt that we must *learn* to learn from the
original practical ecological philosophers of the world, through the slow,
attentive, mind-changing (on both sides) ethical singularity that deserves
the name of "love"—to supplement necessary collective efforts to change
laws, modes of production, systems of education and health care. This for
me is the lesson of Mahasweta, activist/journalist *and* writer. This rela-

tionship, a witnessing love and a supplementing collective struggle, is the relationship between her "literary" writing and her activism. Indeed, in the general global predicament today, such a supplementation must become the relationship between the silent gift of the subaltern and the thunderous imperative of the Enlightenment to "the public use of Reason," however hopeless that undertaking might seem.[25] One filling the other's gap.

Mary Oraon comes closest to a momentary performance of this supplementation, though there is no possibility of collectivity for her. And it is Douloti in whom the love of land, of Nature indistinguishable from parents and home, is seen at its strongest and most vulnerable. Yet, as I have argued above, the *literary* text cannot successfully represent a supplementation without standing in the way of such practical effort. That text (textile as the weave of work) is in the field of activism, e-laborated in labor.

Woman is in the interstices of "Pterodactyl." If the non-Eurocentric ecological movement offers us one vision of an undivided world, the women's movement against population control and reproductive engineering offers us another.[26] And here too Mahasweta shows us the complicity of the state. The bitter humor with which she treats the government's family planning posters shows us that the entire initiative is cruelly unmindful of the robbing of the women and men of Pirtha of the dignity of their reproductive responsibility. All collective struggles for the right to sexual preference and pleasure, the right to equitable work outside and in the home, the right to equality in education, must be supplemented by the memory that to be human is to be always and already inserted into a structure of responsibility. Capitalism, based on remote-control suffering, is obliged to reject the model of the acknowledgment of being inserted into responsibility as unprogressive, in order to be able to justify itself to passive capitalist members of society. Demanding rights or choosing responsibility is more useful for its purposes.

This position should be distinguished as strictly as possible from oppressive traditionalism, the so-called communitarian or neofamilial or nativist positions within capitalist societies that would deflect the interests of the underclass, from above, by separating them from their rights. The imposition of personal family codes on colonized societies is one scandalous example from which women are still suffering all over the world. Yet the possibility of learning from below should not be forever foreclosed because of these forces of reaction.[27] And it is this learning that can only be earned by the slow effort at ethical responding—a two-way road—with the compromised other as teacher.

I have published longer essays on the first two stories translated here, which may deserve the critique of insufficient political specificity.[28] In all of them I have tried to address myself to the dominant readership and have

emphasized the elements that are different from the activist's account. The former ranged from groups of benevolent, cultural-relativist women, through migrant intellectuals who conflated Eurocentric migrancy with postcoloniality as such, to audiences where "nations" were not acknowledged as a palimpsest upon the ignored Fourth World.

In "The Hunt" I emphasized, among other things, the fact that, unlike the ethnographic account of tribal identity in rituals, Mahasweta shows an individual activating ritual into contemporary resistance. She chooses a character who is not a full member of tribal society, and shows her judging the mainstream exploiter before the act of rape can take place. In discussing the transformation of rapist/exploiter into ritual prey, I focused on Mahasweta's use of the words *janowar* (animal) and *bonno* (savage), and commented on Mary's negotiations with resources of the other side, a transvestism of spirit. With "Douloti" I emphasized gender-division in resistance and gendering as the foundation of postcolonial exploitation. (This last is helpful also in discussing the role of international "home-working," women's sweated labor at home.) In my writings about both I pointed out with the greatest possible urgency that a conflation of Eurocentric migrancy with postcoloniality lets drop the vicissitudes of decolonization and ignores the question: Who decolonizes?

A discussion of "Pterodactyl" comes at the end of an address on academic freedom presented at the University of Cape Town, from which I have already quoted. Since that has only been published as an occasional pamphlet, I here take the liberty of quoting a few more passages from it. I have included a brief consideration of Mary Shelley's *Frankenstein* in the hope that it might be pedagogically useful in distinguishing a piece of writing from the postcolonial world from colonial discourse studies:

> In a piece published some years ago, I suggest that *Frankenstein* attempts to come to terms with the making of the colonial subject.[29] Sympathetic yet monstrous, clandestinely reared on sacred and profane histories of salvation and empire, shunned by the civilization which produces his subjectivity, the Monster's destructive rage propels him out of that novel into an indefinite future. When, however, it comes to the colonial subject's prehistory, Shelley's political imagination fails. Her emancipatory vision cannot extend beyond the speculary situation of the colonial enterprise, where the master alone has a history, master and subject locked up in the cracked mirror of the present, and the subject's future, although indefinite, is vectored specifically toward and away from the master. Within this restricted vision, Shelley gives to the Monster the right to refuse the withholding of the master's returned gaze—to refuse an apartheid of speculation, as it were: "'I will not be tempted to set myself in opposition to thee.... How can I move

thee?'... [He] placed his hated hands before my [Frankenstein's] eyes, which I flung from me with violence; 'thus I take from thee a sight which you abhor. Still thou canst listen to me....'"[30] His request, not granted, is for a gendered future, for the colonial female subject. The task of the postcolonial cannot be restrained within the specular master-slave enclosure. I turn to Mahasweta Devi's "Pterodactyl, Pirtha, and Puran Sahay" to measure out some of the differences between the sympathetic and supportive colonial staging of the situation of the refusal of the withholding of specular exchange in favor of the monstrous colonial subject; and the postcolonial performance of the construction of the Constitutional subject of the new nation. Devi stages the workings of the postcolonial state with minute knowledge, anger, and loving despair. There are suppressed dissident radicals, there is the national government seeking electoral publicity, there are systemic bureaucrats beneath good and evil, subaltern state functionaries to whom the so-called Enlightenment principles of "democracy" are counter-intuitive. There is the worst product of postcoloniality, the Indian who uses the alibis of Development to exploit the tribals and destroy their life-system. Over against him is the handful of conscientious and understanding government workers who operate through a system of official sabotage and small compromises. The central figure is Puran Sahay, a journalist. (Devi herself, in addition to being an ecology-health-literacy activist and a fiction writer, is also an indefatigable interventionist journalist.) But all this is a frame narrative. Inside the frame is a story of funeral rites. A tribal boy has drawn the picture of a pterodactyl on the cave wall. Puran and a "good" government officer do not allow this to become public. Through his unintentionally successful "prediction" of rain, Puran becomes part of the tribe's ongoing historical record. He sees the pterodactyl. If the exchange between the nameless Monster (without history) and Victor Frankenstein is a finally futile refusal of withheld specularity, the situation of the gaze between pterodactyl (before history) and a "national" history that holds tribal and non-tribal together, is somewhat different. There can be no speculation here; the tribal and the non-tribal must pull together. We are both in the nation, conjuring against the State, "the aggressive advance of the strong as it obliterates the weak,...think if you are going forward or back.... What will you finally grow in the soil, having murdered nature in the application of man-imposed substitutes?... The dusky lidless eyes remain unresponsive." For the modern Indian the pterodactyl is an empirical impossibility. For the modern tribal Indian the pterodactyl is the soul of the ancestors.[31] The fiction does not judge between the registers of truth and exactitude, simply stages them in separate spaces. This is not science fiction. And the pterodactyl is not a symbol. The pterodactyl dies and Bikhia, the boy struck dumb—withdrawn from communication by becoming the ptero-

dactyl's "guardian," its "priest"—buries him in the underground caverns of the stream, walls resplendent with "undiscovered" cave-paintings. He allows Puran to accompany him. The burial itself is removed from current practice. Now, Shankar says, they burn bodies, like Hindus. "We bury the ash and receive a stone." The desecration of the dead is a common theme in postcolonial writing. This burial, then, can be situated in a community of longing. The particularity in this case is that the scene is one of internal colonization in the name of decolonization. A caste-Hindu, remote outsider in a now Hindu-majority land, earns the right to assist at the laying to rest of a previous civilization, in a rhetorical space that is textually separate from a frame narrative that may as well be the central narrative—of the separate agendas of tribal and journalistic resistances to development, each aporetic to the other, the site of a dilemma. Like the Monster in *Frankenstein*, Puran too steps away from the narrative of this tale, but into action within the postcolonial new nation: "A truck comes by. Puran raises his hand, steps up."

Ignoring all warnings, Mahasweta Devi has pulled me from the web of her fiction into the weaving of her work. I present my services to her work—translation, preface, afterword—in the hope that you will judge the instructive strength of that embrace.

NOTES

Imaginary Maps contains translations of three texts by Mahasweta Devi— "The Hunt," "Douloti the Bountiful," and "Pterodactyl, Pirtha, and Puran Sahay." Since we removed the Translator's Preface and Afterword from this context, we have modified phrasing and syntax as necessary.—Eds.

1. Jacques Derrida, "Differance," in *Margins of Philosophy*, p. 17; emphasis mine.

2. By "new immigrant" I mean the continuing influx of immigrants since, by "[t]he Immigration and Nationality Act of October 1, 1965," Lyndon Johnson "swept away both the national-origins system and the Asia-Pacific Triangle"; precisely the groups escaping decolonization, one way or another. "That the Act would, for example, create a massive brain drain from developing countries and increase Asian immigration 500 per cent was entirely unexpected" (Maldwyn Allen Jones, *American Immigration*, 2nd. ed. (Chicago: University of Chicago Press, 1992), pp. 266, 267.

3. I have kept to the Indian custom of referring to thoroughly public figures by their first name as a sign of recognition of their stature.

4. I will use the word "subaltern" sparingly. Although I read it first in Gramsci, I encountered it in its current usage first in the work of the Subaltern Studies group. As a result of the publication of *Selected Subaltern Studies*, eds.

Ranajit Guha and Gayatri Chakravorty Spivak (New York: Oxford University Press, 1987), in the United States, the word has now lost some of its definitive power.

5. Indeed, Gramsci is useful here if read freely. Necessarily without a detailed awareness of the rich history of African-American struggle, he was somewhat off the mark when he presented the following "hypothesis" for "verification": "1. that American expansionism should use American negroes [*sic*] as its agents in the conquest of the African market and the extension of American civilisation" (Gramsci, "The Intellectuals," in *Prison Notebooks*, p. 21). If, however, these words are applied to the new immigrant intellectuals and their countries of national origin, the words seem particularly apposite today. The partners are, of course, "Cultural Studies," liberal multiculturalism, and post-Fordist transnational capitalism.

6. Sara Suleri, *The Rhetoric of English India* (Chicago: University of Chicago Press, 1991), pp. 11–12.

7. Sujit Mukherjee, "Mahasweta Devi's Writings—An Evaluation" [the title given by Mukherjee had been "Operation?—Mahasweta Devi], *Book Review* 15:3 (May–June 1991), p. 31.

8. For a succinct account of the events surrounding Chuni Kotal's suicide, see Mahasweta Devi, "Story of Chuni Kotal," *Economic and Political Weekly* 27:35 (29 August 1992), pp. 1836–37. Incidentally, derisive comments made by upper-middle-class Indian Americans about the public version of Chuni's suicide put me in mind of the dismissal of Bhubaneswari Bhaduri's suicide by women of the next generation, anger against which produced my remark that the subaltern could not speak. In her book *Aranyer Adhikar* Mahasweta has celebrated the great Ulgulan, or uprising, of 1899–1901, lead by Birsha Munda, the tribal leader. "Every trace of independent initiative on the part of subaltern groups should therefore be of incalculable value for the integral historian. Consequently, this kind of history can only be dealt with monographically, and each monograph requires an immense quantity of material which is often hard to collect" (Gramsci, "Notes on Italian History," *Prison Notebooks*, p. 55). In the matter of the "organic intellectual," however, we must commemorate Gramsci's uniqueness by supplementing with our own different history. "Every social group, coming into existence on the original terrain of an essential function in the world of economic production," Gramsci writes, "creates together with itself, organically, one or more strata of intellectuals which give it homogeneity and an awareness of its own function not only in the economic but also in the social and political fields" ("The Intellectuals," in *ibid.*, p. 5). Writing in the context of Fascist Italy, where the power of the organized intellectual clerisy was more than millennial, Gramsci is not confident of the possibility of organic intellectuals being elaborated (worked through) among the "peasant masses" (*ibid.*, p. 6). By contrast, the recently denotified Indian tribes had been millennially separated from the mainstream peasant underclass. This difference between the Italian and

Indian cases allows the elaboration of a Jaladhar Sabar. Again, Gramsci sees a difficulty in the formation of the peasant organic intellectual because he (Gramsci is incapable of imagining a female type) must go through traditional education in order to enter intellectuality. Sabar's education, in the most robust sense, has been through association with Mahasweta Devi, herself a female organic intellectual of unusual ethical responsibleness, elaborated as a permanent persuader type by way of the resistant left bourgeoisie (to keep to these forbidding and formulaic descriptions): "The mode of being of the new intellectual can no longer consist in eloquence,...but in active participation in practical life, as constructor, organizer, 'permanent persuader'"... (ibid., p. 10). It can be said that people of Sabar's kind and Mahasweta's kind elaborate each other as organic intellectuals from different social groups. Chuni's suffering in this regard was first because she was a woman and secondly because she was trying to infiltrate institutions of traditional intellectuality. In conclusion to this long note, it must be said that the organic intellectual is not a concept of identity but rather of a focus on that part of the subject which takes on the intellectual's function. Mahasweta Devi, Jaladhar Sabar, Gopiballabh Singh Deo (caste-Hindu head of the local landowning family, conscientized and politicized through left struggle, now thoroughly identified with the tribal movement and an indefatigable worker on its behalf), and Prasanta Rakshit (a young man of provincial petty-bourgeois origin who lives and works with the Sobor Kherias) form, therefore, a metonymic collectivity. Keeping in mind that the word "class" loses its lineaments here, we might remember the following remark: "the 'organic' intellectuals which every new class creates alongside itself and elaborates in the course of its development, are for the most part 'specializations' of partial aspects of the primitive activity of the new social type which the new class has brought into prominence" (ibid., p. 6).

9. A recent piece in *Frontier* about the commodification of another organic intellectual, Rigoberta Menchú, is apposite here; see "Recognising a Maya Indian," *Frontier* 15:13 (7 November 1992), p. 2.

10. I use the word "dilemma" as a synonym for "aporia" to avoid the charge of obscurantism. An aporia is different from a dilemma in that it is insoluble—each choice cancels the other—and yet it is solved by an unavoidable decision that can never be pure. Dilemma is a logical, aporia a practical item.

11. It is again a phenomenon of the unequal distribution of knowledge that this gifted novelist of the French language, who published the novel *Fantasia: An Algerian Cavalcade*, trans. Dorothy S. Blair (London: Quartet, 1985), in 1985, has not received sufficient attention in the North among non-specialist feminists, to the extent that so politically aware a feminist as Sheila Rowbotham recently mentioned and discussed Pauline Rolland as a "find," without, of course, being aware of Djebar's claim of kinship. For further discussion of Djebar, see Winifred Woodhull, *Transfigurations of the Maghreb: Feminism, Decolonization, and Literatures* (Minneapolis: University of Minnesota Press, 1993).

12. In *Bonded Histories: Genealogies of Labor Servitude in Colonial India* (New York: Cambridge University Press, 1990), Gyan Prakash has studied this from a Foucauldian and ungendered perspective. He argues that the colonial/ postcolonial, capitalist, exploitative social relations were imposed upon the historical construction of bonded labor within a precapitalist, hierarchical, socially functional structure. The dominant lord became the exploitative landlord without the *kamiya*'s participation. There was therefore no attendant change in their mindset, their discursive formation. (Mahasweta's account of Census and Elections in "Douloti" can take this analysis on board, though Shankar in "Pterodactyl" escapes this line of reasoning.) Prakash therefore argues that the discourse of "freedom" is counter-intuitive to the *kamiya*. Such a conclusion is obliged to ignore the history and possibility of the emergence of the "organic intellectual." Mahasweta's work also reminds us that when the dominant mode of the country is capitalist, the activist must see the residual mode as "internalised constraint expressed as choice" (Allen and Wolkowitz, *Homeworking*, p. 73), and work for a freedom not necessarily defined by the official decolonizer. This reminder, and a consideration of gendering, would enhance Prakash's good concluding sentiment: "The continuity that the kamias have maintained in their refusal to participate in the official project, and in mounting struggles against domination experienced at the point of power's exercise, far from indicating passivity, ought to be seen as their recognition of power concealed by the juridical guise of rights. It represents their critique of the discourse of freedom, their pronouncement that there is 'bondage' in freedom" (p. 225). Here perhaps is Shankar, standing alone.

13. Although the methods recommended are largely usable in Western European society, and the vocabulary one of popularized psychoanalysis, this is the general insight of Frigga Haug, *Beyond Female Masochism: Memory-Work and Politics*, trans. Rodney Livingstone (London: Verso, 1992). Ethical transcoding of strategy is not impossible in our part of the world. Otherwise we remain caught in a collective disavowal that paradoxically strengthens the long-term possibility of the very thing we seek to avoid: the virulent misogyny of the Right. This is the one absence marked well in Gita Sahgal's documentary on the *sati* of Rup Kanwar. None of the urban feminist radicals in that film was able to acknowledge that, quite apart from the obvious male coercion, brutality, and exploitation, Rup might indeed have seen the *sati* as an ethical choice; just as her obviously loving Mother comments that she believes Rup to have been happy in her choice. Without this acknowledgment and the responsible and caring process of the establishment of ethical singularity (which can only exist between equals) that is its practical consequence, no collective action on the basis of legal calculation, itself absolutely necessary, will last. In this connection, see Mahasweta's "Sati Moyna," *Pratikshan* (forthcoming in my translation).

14. Mukherjee, "Devi's Writings," p. 31. I gratefully accept his correction that "[t]*akma* (a medal-like object of brass or bronze worn by a servitor) cannot be

taken to mean livery," and therefore *"takmadhari"* as "liveried" ("Draupadi," in Spivak, *In Other Worlds*, p. 187) is unacceptable. And I agree completely that Samik Banerjee's "kounter" is infinitely better than my "counter" ("Draupadi," pp. 192, 194, 196). I should mention here that Mahasweta has read the translations in *Imaginary Maps* carefully and I have, for the most part, accepted her suggestions. All mistakes are of course mine.

15. J. M. Coetzee, *Doubling the Point: Essays and Interviews* (Cambridge, MA: Harvard University Press, 1992), p. 88. My translation of "Pterodactyl," the last piece in *Imaginary Maps*, bears little resemblance to the draft translation offered by the author—the only piece for which I had such a text—although I invariably consulted it when I was in doubt, especially about the accepted English names of the various institutions of the bewildering Indian bureaucracy.

16. Ranajit Guha, Opening Address, Subaltern Studies/Anveshi Conference, Hyderabad, 8 January 1993.

17. A reader acquainted with Derrida will find in these thoughts echoes from Derrida's two essays, "The Force of Law," and *Schibboleth: Pour Paul Celan* (Paris: Galilée, 1986); a full-length English version of *Shibboleth*, trans. by Joshua Wilner, is available in Aris Fioretos, ed., *Word Traces: Readings of Paul Celan* (Baltimore: John Hopkins University Press, 1994), pp. 3–72.

18. For a detailed discussion of the implications of World Bank cartography and the uses of the Geographic Information System, see Crystal Bartolovich, "Boundary Disputes: Textuality and the Flows of Transnational Capital," *Mediations* 17:1 (December 1992), pp. 21–33.

19. By "Fourth World" is meant the world's aboriginal peoples who were literally pushed into the margins for the contemporary history and geography of the world's civilizations to be established.

20. Kumkum Sangari is right to criticize such romanticization in "Figures for the 'Unconscious,'" *Journal of Arts and Ideas* 20–21 (1991), pp. 67–84.

21. *The World Bank and the Environment* (Washington: The World Bank, 1992), pp. 106, 107.

22. Djebar, "Forbidden Gaze, Severed Sound," in *Women of Algiers*, p. 141.

23. We cannot even and after all be sure that the pterodactyl *has* a message for us. Yet we must think that it wants to speak. This is rather clear in the story. It is uncanny for me that Derrida's notion of the "trace"—our conviction, faced with a situation, that something wants to signal something else—must also run the risk that there might be no signal. Love is not do-gooding, ethics is not social work, although a bit of both is possible. I am more and more convinced of this as I hang out in the field of work more and more; and it brings me closer to Mahasweta and Derrida—one as seemingly devoted to goodness as the other to truth, yet both astringently describing their devotion as "obsession"; Mahasweta in the Introductory conversation here, and Derrida in a similar interview in Attridge, *Acts*, p. 34—and a bit further away from

academic historiography. "All in all I prefer that to the constitution of a con-
sensual euphoria or, worse, a community of complacent deconstructionists,
reassured and reconciled with the world in ethical certainty, good conscience,
satisfaction of service rendered, and the consciousness of duty accomplished
(or, more heroically still, yet to be accomplished)," (Derrida, "Passions,"
in David Wood, ed., *Derrida: A Critical Reader* [Oxford: Blackwell, 1992],
p. 15).

24. I am aware of the strategic importance of drawing upon principles of tolerance
that are recuperable from religious traditions in order to combat fundamen-
talism. And there the narrative of Hinduism would have to serve in the Indian
national case. But here I am speaking of a new inter-nationality to resist
"development" without irreducible reference to a state power that may be
irretrievably compromised in a financialized globe. Aijaz Ahmed has recent-
ly spoken of confronting the current Indian situation by understanding it as a
displacement of Fascism versus Communism (rather than sectarianism ver-
sus secularism) and an anti-clericalism filled out by industrialization, follow-
ing a Gramscian model ("Gramsci and *Hindutva*" [abridged title], unpub-
lished lecture, Calcutta, 28 December 1992; chapter in a forthcoming book).
For the lack of fit between Italian anti-clericalism and Indian secularism, see
"Translator's Preface," footnote 8 above. As for choosing the Fascism-
Communism model for India, it seems important to remember that, in essays
like "Notes on Italian History," Gramsci is careful to warn against drawing
analogies even between the various European states. Gramsci perceived
Italian Fascism as continuous with nineteenth-century liberalism precisely
because of the presence of a millennial intellectual clerisy. Italy is almost the
only European state where the original position of *seculum* as contaminat-
ed—by procreation because of dynastic succession—and the *ecclesia* as de
facto rational—because held together by discipline—persisted for a few cen-
turies before the reversal into public (secular) and private (religious) led to
the consolidation of liberalism into Fascism. As for *national* industrializa-
tion, no doubt a worthy goal in itself, here the Gramscian model must be re-
constellated from its historical moment in the face of the collaboration
between "sustainable development" and global financialization. Thus, even
though the organic intellectual elaborated by the national electoral Left par-
ties in the post-Soviet South can use a seamless and superficially plausible
Gramscian analogy, our fear is that we will once again lose specificity in an
attempt to fit ourselves into a European coat misappropriated, so that what
is insistently represented as an instrument of freedom from above will become
a strait-jacket that leaves no room for resistance.

25. Immanuel Kant, "What is Enlightenment?," in *On History*, trans. Lewis
White Beck (New York: Macmillan, 1963), p. 5. The historian may remind us
that there were many Enlightenments, but this was the formula internalized by
social engineers, imperialist and otherwise. Even the most unenlightened and
minor entry into the mysteries of capital teaches this lesson as a rule of
thumb.

26. For more extended discussion, see, for example, the documents of FINR-RAGE, available from Pergamon Press, New York.

27. The last five sentences are a modified quotation from my *Thinking Academic Freedom in Gendered Postcoloniality* (Cape Town: University of Cape Town Press, 1992). I take the liberty of quoting from my own work because, over-whelmed by the honor of being asked to speak in post-apartheid South Africa, I discovered how much my reading of Mahasweta expanded to teach me about a general globality. I hope the reader will forgive a further quotation from this text in conclusion.

28. "The Hunt" is discussed in "An Interview with Gayatri Spivak," *Women in Performance* 5:1 (1990), pp. 80–92, and in "Who Claims Alterity?," in Barbara Kruger and Phil Mariani, eds., *Remaking History*, Dia Art Foundation Discussions in Contemporary Culture No. 4 (Seattle: Bay Press, 1989), pp. 269–92. "Douloti" is discussed in "Woman in Difference: Mahasweta Devi's 'Douloti the Bountiful,'" in Andrew Parker, Mary Russo, Doris Sommer, and Patricia Yaeger, eds., *Nationalisms and Sexualities* (New York: Routledge, 1992), pp. 96–117.

29. Spivak, "Three Women's Texts."

30. Mary Wollstonecraft Shelley, *Frankenstein: or the Modern Prometheus* (Chicago: University of Chicago Press, 1974), pp. 95, 96.

31. This is counter-factual. "The idea of the ancestral soul is...my own," Mahasweta writes in an authorial note included with the story. She does not provide material for an anthropologistic romanticization.

Subaltern Talk

Interview with the Editors

(29 OCTOBER 1993)

ELEVEN

This interview took place at Columbia University on 29 October 1993. Because of the controversy surrounding Spivak's argument that the subaltern cannot speak, and consequent confusion over what the implications of that argument might be for a politics of resistance or liberation, we had very much wanted to reprint the essay "Can the Subaltern Speak?" here, either in its first or its unpublished but heavily revised form. Although the early version of this essay—first published in 1988 and based on a 1983 lecture—has recently been reprinted elsewhere, Spivak declined permission for any version to be printed here because of the importance of the revised version for her forthcoming book, *An Unfashionable Grammatology*, and because her revisions, although they leave her conclusions unchanged, have made the original version obsolete. Recognizing, however, that the prospective audience of *The Reader* would be likely to be extremely interested in her arguments concerning the concept of the subaltern, Spivak agreed to an interview addressing this and related questions, including how to get ecology more firmly on the agenda of Cultural Studies than it is at present.

DONNA LANDRY AND GERALD MACLEAN: How do you read the ways "Can the Subaltern Speak?" has provoked response?

GAYATRI CHAKRAVORTY SPIVAK: I haven't read all the responses that the essay has provoked. I believe the general response is that I have not recognized that the subaltern does speak. It has even been suggested by some that I will not *allow* resistance to speak. Now, I do feel that my essay is

too complicated. When I finished writing it I thought that it was so uncontrolled that only someone else could cut it. I sent it to the editors with that request. I was surprised to see the printed version had come out uncut. On the other hand, I think as it stands it reflects something of the struggle I went through trying to write that piece. I was blocked for a long time before I could actually continue to write it. I felt that I was putting the lesson of this young suicide [of Bhubaneswari Bhaduri] over and above Foucault and Deleuze. This is how I perceived it then, and I was not then far enough launched in what I do now that I had the courage of my convictions. I was at the beginning of something. There had been a sort of beginning, before which I have often talked about: When I was asked by the editors of the *Yale French Studies* issue on French feminism to write on French feminism, and by the *Critical Inquiry* issue also to write on deconstructive feminism. I think it was about 1980–81. Suddenly I felt that a strange thing was happening.

I had just about then begun to read and teach *Jane Eyre*. I had discovered that this book that I had read with such pleasure as a child in Calcutta had things in it that I had not noticed. It taught me a lesson of what the making of young colonial subjects was like. For I was looking at myself. As I have written in "French Feminism Revisited," I began to look at the problematics of being asked to write on French feminism by two major United States journals. So that was a kind of beginning, together with the sudden discovery of something in my own "experience" of how the reading subject is produced. In that context "Can the Subaltern Speak?" is the second step. I still didn't know enough to take the step. At that early point, I was concerned with my own production; here I was taking another step talking about other topics, not just about my own production. That's a sterile place to get stuck in. So here I was, trying to find a way of putting this woman as a lesson for me that was more complicated and more apposite than Foucault or Deleuze. I was in a crisis, an intellectual crisis of sorts. How was I going to do it?

I think the uncontrolled construction of the piece reflects something of that. When I finally came to the last page I thought, "My god! That one's done at least; I can't do anything with it anymore!" And that's the stage at which the thing was published. So it bears some marks.

I think the problem with reading the piece too quickly is that one might miss some important things. For example, that I settle myself on a very specific definition of the subaltern. I was just beginning to read *Subaltern Studies* then and I was therefore dependent upon that group's redoing of Gramsci's notion of the subaltern. In the essay I made it clear that I was talking about the space as defined by Ranajit Guha, the space that is cut off from the lines of mobility in a colonized country. You have the foreign

elite and the indigenous elite. Below that you will have the vectors of upward, downward, sideward, backward mobility. But then there is a space which is for all practical purposes outside those lines. Now, if I understand the work of the Subalternists right, every moment of insurgency that they have fastened onto has been a moment when subalternity has been brought to a point of crisis: the cultural constructions that are allowed to exist within subalternity, removed as it is from other lines of mobility, are changed into militancy. In other words, every moment that is noticed as a case of subalternity is undermined. We are never looking at the pure subaltern. There is, then, something of a not-speakingness in the very notion of subalternity.

I think people also go wrong, and this is very much a United States phenomenon, in thinking that we have any interest in preserving subalternity. There is for us no feeling of romantic attachment to pure subalternity as such. And I was not, in fact, choosing a distinctly subaltern person. This woman was middle-class. Thus I implied that, in the case of the woman, the idea of subalternity, because of woman's limited permission to narrate, becomes contaminated. Such details are of course not noticed by anybody who responds negatively to the essay. I respect these negative responses because I think they attach to the uncontrolledness of the piece. But I can see also that there is a feeling that I am making exactly the opposite argument from the one I am making.

I am revising that piece for inclusion as a chapter in another book. I am making it much more straightforward now. It will of course lose the passion and the anguish of that effort. Having said this, let me explain.

By "speaking" I was obviously talking about a transaction between the speaker and the listener. That is what did not happen in the case of a woman who took her own body at the moment of death to inscribe a certain kind of undermining—too weak a word—a certain kind of annulment of all the presuppositions that underlie the regulative psychobiography that writes *sati*. When we act we don't act out of thinking through details; we act in something that Derrida calls, following Kierkegaard, the "night of nonknowledge." Even the just decision thinks itself in the night of nonknowledge. We act out of certain kinds of reflexes that come through, by layering something through learning habits of mind, rather than by merely knowing something. That is the way in which her action was inscribed in her body. And even that incredible effort to speak did not fulfill itself in a speech act. And therefore, in a certain kind of rhetorical anguish after the accounting of this, I said, "the subaltern cannot speak!" This is always read as a rational remark about subalterns as such— Meaghan Morris has made the witty comment that my critics rewrite the sentence as: "the subaltern cannot talk." And, as I have just indicated,

even within the definition of subalternity as such there is a certain not-being-able-to-make-speech acts that is implicit.

This surfaces when you come to think of why general Indian historiography, the historiography of India, does not consider *Subaltern Studies* to be appropriately historical: another example of how the subaltern cannot speak. This discrediting of course finds its greatest proof in the Cambridge school of historians who are driven by definitions of what is political, a definition established by Hobsbawn. Thus an emotional response against this discrediting is misplaced, especially when the kinds of groups that are claimed to be subaltern are simply groups that feel subordinated in any way. I think the word "subaltern" is losing its definitive power because it has become a kind of buzzword for any group that wants something that it does not have. People no longer say "Third World" easily: they know that every time they say "Third World" they have to say "the so-called Third World." There has been a very strong critical debate about whether "postcolonial" is okay anymore, etc. So "subaltern" has somehow come to stand for all of that. And when the subaltern does make an insurgent effort, rich in the collectively contextual female input—as in the case of Bhubaneswari's suicide—an effort that is a bringing into crisis of subalternity and its possible shift into a space where political movement so-called can take place, even there the Cambridge historians' argument is that it is not worth studying because the effort fails. Now the question of the failure is again, in a certain sense, of the genre of "they cannot speak," if one looks at "speak" as the kind of rhetoricity that I was giving to it.

I will give you an example which has rather little to do with women. In the eighteenth century when the British came into the area of Bengal that is now Bangladesh, they encountered fully developed "ancient waterworks." They were in fact very complicated irrigation canals so that the flood area could be managed. What they encountered was a feudal system there. The feudal chiefs actually made their serfs, their subordinates—I am using the European words—manage the canals and keep them up. When the British came in those feudal heads became tax collectors for the British, and they did not then do anything to keep up the canals; the feudal chiefs turned tax collectors did not provide their own subordinates, and no kind of servant of the East India Company was employed to keep up those irrigation canals. The British did not understand that they were irrigation canals for flood-management. What they thought they were I don't know, maybe waterways for transport or whatever. The canals soon became stagnant, infested with mosquitoes, and so they started to destroy these canals.

Now the people, that is to say the former serfs of the feudal landlords, in fact fought with the British police constantly and they constantly failed.

It was in the thirties that a waterworks inspector of the imperial government, and therefore no friend of the subaltern, but simply a smart guy, worked out that these waterways had in fact been an irrigation and flood-management system. It is from his report, a text from the other side, that we realize that the best thing that the British could do was to restore these completely destroyed ancient waterworks, because the affluence of the place had been destroyed, since the place had been left open to incredible floods. Now let me tell you that in that same area today, landless peasants and fisherfolk are breaking the enormous levees constructed by the World Bank. Two hundred years of continuity, always failing: subaltern insurgency. So that to an extent, and in fact, what the ecological workers now suggest is that those ancient waterworks destroyed two hundred years ago be restored, but, and I am paraphrasing Fred Pierce, they cannot be rebuilt because the way that they had been built was slowly, respecting the rhythm of those very young rivers, whereas the way things would be built today would be capital-intensive, cost-efficient, and fast.

Now what we have here is the story of continuous subaltern insurgency, always failing, but continuous to this day. This is a spectacular example of the subaltern not being able to "speak."

Problems arise if you take this "speak" absolutely literally as "talk." There can be and have been attempts to correct me by way of the fact that some of the women on the pyres did actually utter. Now I think that is a very good contribution, but it really doesn't actually touch what I was trying to talk about. The actual fact of giving utterance is not what I was concerned about. What I was concerned about was that even when one uttered, one was constructed by a certain kind of psychobiography, so that the utterance itself—this is another side of the argument—would have to be interpreted in the way in which we historically interpret anything.

Then comes the question of the psychobiography. I was trying to look at the psychobiography that I thought regulated the mindset of the widow. First of all my argument was that the construction of all mindsets is complex: the most so-called uneducated mindset is as complex as so-called sophisticated mindsets; and therefore I looked at the *Dharmaśāstra*.

Now before I began undertaking the reading, I talked about Freud because Freud taught me the idea of regulative psychobiography. Yet within his permissible narratives, he chose the wrong one. And I suggested that I was myself of course, and in a much greater way, susceptible to such a mistake because I knew very little. Running that risk, I was going to try to make an attempt. I don't think anybody looks at that remark. I now know that one does not make those kinds of remarks and then go on to do something in detail. One has to make it clear in the structural behavior of one's writing that what is happening here is an attempt in the dark. That's

I think how I would look at the genuine collection of responses that have come to me in terms of subalternity and its relationship to speaking.

Quite often what happens also is that the remarkable organic intellectuals—this is a point I am making in one of the pieces included in this *Reader*—who become spokespersons for subalternity are taken as token subalterns. This reception is a feature of our desire to fixate on individuals. The effort involved in those singular figures becoming organic intellectuals is completely undone in their positioning as "the" subaltern. And so you have a "belittling befriending" of the remarkable testimonials of a Rigoberta Menchú, of a Poppi Nongena. The effort required for the subaltern to enter into organic intellectuality is ignored by our desire to have our cake and eat it too: that we can continue to be as we are, and yet be in touch with the speaking subaltern. That's something that I think should be added to what I have said.

So, "the subaltern cannot speak," means that even when the subaltern makes an effort to the death to speak, she is not able to be heard, and speaking and hearing complete the speech act. That's what it had meant, and anguish marked the spot.

DL: A tiny question, about whether the lines of mobility, which would include access to political movements, would be the same as what you usually describe as "socialized capital": the subaltern is outside socialized capital, so could socialized capital be more or less equated with lines of mobility, as Guha would have it?

GCS: The subaltern is affected remotely by socialized capital. It's just that in the subaltern's subject production the process is remote. Especially today, when one talks about colonial historiography and the financialized globe, it would be hard to find—as I say, the pure anything doesn't really exist—it would be hard to find a group that is not affected by socialized capital. The story "Doulouti the Bountiful," for example, shows us that, however remotely. But in the production of the subaltern subject, there isn't a corresponding movement, the possibility of mobility. The super-exploited woman, as in Kalpana Bardhan's article that I cite quite often, is of course affected. In a certain way, that old remark of Marx about exporting capital's mode of exploitation but not its mode of production—or its mode of social production—would loosely fit the situation.

DL and GM: If we agree that, as a concept-metaphor, the term "subaltern" functions as an ever-receding horizon of possibility, how might we account for the seeming paradox that, with global super-exploitation on the increase, subaltern groups, far from disappearing, are perhaps on the

increase? Have you a useful formula for tracing ever-receding horizons of subalternity?

GCS: I don't have a useful formula, no. The possibility of subalternity for me acts as a reminder. If it is true that when you seem to have solved a problem, that victory, that solution, is a warning, then I begin to look—it's not a substantive formula—but I always look at that moment for what would upset the apple cart. And that's quite often the moment when one begins to track the newly created subaltern, out of reach. It's more than just strategic exclusion; it's really something that would destroy my generalizations. It's not something like "going in search of the primitive." I don't know that it is an "ever-receding horizon." It is just a space of difference, if you like. And as for the increase in varieties of subalternity, I would say that that probably is accounted for in more orthodox theories of the feudalization of the periphery—the flip-side of capitalist development. When one begins to look at the way in which woman's position is manipulated, even within that space, there is nothing mysterious about it, as there would be about an ever-receding horizon which is always beyond our reach, and so on. It seems to me that finding the subaltern is not so hard, but actually entering into a responsibility structure with the subaltern, with responses flowing both ways: learning to learn without this quick-fix frenzy of doing good with an implicit assumption of cultural supremacy which is legitimized by unexamined romanticization, that's the hard part.

DL: Could you, for students who want to do some homework, name some orthodox theories where one would begin to look?

GCS: The big one of course is Samir Amin, *Unequal Development.* That's been out for twenty years now, but it is still exciting reading for a student who would want to begin. But I think the accounts of Southeast Asian women's labor are extraordinarily interesting. As one of my most brilliant former students said when he was a sophomore—and I never let him forget it—he was just starting on his journey, and he found *Capital* hard to read because it was so full of charts. These books are indeed full of charts. There is a book by Noeleen Heyzer, *Daughters in Industry: Work, Skills, and Consciousness of Women Workers in Asia* (Kuala Lumpur: Asian and Pacific Development Center, 1988), which gives a very fine account of these changes, but there are lots of books in that area. If one wants to look at the construction of the subaltern subject in neocolonialism, that whole area of Southeast Asia is wonderful, especially books written from the women's labor point of view. *Dignity and Daily Bread: New Forms of*

Economic Organizing Among Poor Women in the Third World and the First, edited by Swasti Mitter and Sheila Rowbotham (New York and London: Routledge, 1994), is good. *Homeworking: Myths and Realities*, by Sheila Allen and Carol Wolkowitz (London: Macmillan, 1987), is good.

DL and GM: Here's a question from inside the teaching machine concerning the "shift from (anti-)essentialism to agency." The frictions generated by the institutionalization of multicultural studies between those representing distinct areas of inquiry—"arenas of decolonization proper," First World migrancy, the special case of the "peculiar institution" of slavery in the United States, and the still often overlooked case of native people in First World nation-states, such as the quite different examples of the United States and Canada—are considerable. One might even say that racism is being perpetuated in the guise of agency and in the name of identity. What to do?

GCS: Now, I don't think that agency necessarily follows from identity claims. As I have often pointed out, identity claims are political manipulations of people who seem to share one characteristic and therefore it is a sort of roll-call concept.

Now it seems to me that agency relates to accountable reason. The idea of agency comes from the principle of accountable reason, that one acts with responsibility, that one has to assume the possibility of intention, one has to assume even the freedom of subjectivity in order to be responsible. That's where agency is located.

When one posits an agency from the miraculating ground of identity, the question that should come up is, "What kind of agency?" Agency is a blank word. So the shift from "identity" to "agency" in itself does not assure that the agency is good or bad, it simply entails seeing that the idea that calling everything a social construction is anti-essentialist entails a notion of the social as an essence. If one carries the notion of the social as an essence, that can very quickly lead to an unexamined assumption of capitalist sociality as a kind of essence, as *the* social. So that everything else becomes places of difference. And so from that point of view, I had said that we should rather look, precisely because of the kinds of problems that you are pointing at, we should rather look at varieties of agency.

Now, I have said recently as an outsider, but not a complete outsider, that in my estimation and in terms of internal colonization, African-American society in the United States is an example of the gains and vicissitudes of postcoloniality.

As an outsider who wants to know more (as earlier in the case of Indian subalternity), I construct an analogy. First, subaltern insurgency,

struggles within slavery. Emancipation, Pan-Africanism—something like the nationalist identity necessary for anti-colonial struggles. Within this analogy, not necessarily correct but useful for new immigrants, the gains of the Civil Rights movement may be comparable to negotiated independence, which is when the problems of postcoloniality begin. Indeed, great African Americans like Frederick Douglass and DuBois, they did make the remark that the struggles were about to begin. Identity battles are then like the failure of decolonization that is the usual post-Independence experience. This is added to the rise of racist rage in the dominant polity.

Those of us who have, under Eurocentric migration, come away from the arena of postcoloniality in our places of origin, have something to learn from this example of internal colonization. It raises questions as to where we insert ourselves in it—rather than simply defining ourselves as postcolonial in the First World space—because our general desire is to be included in the national, whereas—by strong contrast—the real desire of the radicals in a postcolonial space is that the developers should get off their backs. These are two different vectors, so it seems to me that *postcoloniality*—and I don't think the word is completely useless—is like *agency*, a word that can be persistently critiqued. In terms of postcoloniality for me, the phenomenon in terms of internal colonization is the African American. And the Chicano/Latino, the Native American, the old Asian-American diaspora, can offer contrasting lessons.

In terms of agency within other marginal groups, I have been talking about transnational literacy, by which I mean a sense of the political, economic, *and* cultural position of the various national origin places in the financialization of the globe. This is a dynamic. We should not consider our national origin in a Eurocentric way, simply from the point of view of our position within the United States. What I am really asking for is that we behave like responsible Americans, however hyphenated. In that position of agency, if we look at the role of the United States, we could see, for example, that Article 301 and Super 301 in the General Agreement on Tariffs and Trade thwarts social redistribution in our countries of origin. How, as Americans, can we help? One could look at the argument over intellectual capital arising from the General Agreement on Tariffs and Trade and see the complicitousness of our advancement with the manipulation of our countries of origin in the New World Order. Then, apart from looking at the example of postcoloniality in the history of internal colonization within the United States, we can also begin to behave as responsible American postcolonialists.

If we say "our culture is as good as the Western" and stop there, we lay ourselves open to the kind of racist policy that we are seeking with the BNP (British Nationalist Party) in Britain: they say, go back to your own cul-

ture, and then we say, well, we don't want to because we are hybrid British or American. So someone like me would say: let us then behave like responsible British or Americans rather than get caught in this vicious circle. This is not possible for the underclass. In terms of our activism for the underclass of the old and new diasporas, if we engage ourselves not only in the end of the exploitation of our own community, but for the distant and impossible but necessary horizon of the end of exploitation, then we will not be confined within fantasmatic and divisive cultural boundaries.

Exploitation is abstract, and agency is centered, though involved with abstract civil and legal structures. In that understanding I outline some of the ways in which agency can come into play. As for subalternity within First World space, which is the Fourth World pushed back, I think we have to consider the immense space of difference which has not made it possible for those spaces even to claim the kind of agency that I am talking about. The phenomenon of the pushing back of the Fourth World is global, and it did not begin with the current conjuncture of capitalist imperialism. There we have another kind of project, which is not to romanticize but to work for, the Fourth World subaltern.

Now that I know a little more and I am a bit older, the whole idea of who speaks for whom seems to me to be a way of not noticing that we think that knowing and writing inevitably take place within the model of parliamentary representation. We are so formed by this notion of capitalism being free choice, and somehow democracy being connected with that, that we have recast the arena of knowledge in a country where elections are in the area of the hyperreal; we have recast the business of the production of knowledge on the model of an unexamined and primitive ideal of parliamentary representation. I would rather say the point is who works *for* whom, because behind this parliamentary representation business, of course, lies not just speaking, but getting your backside in gear and working for your constituency. But we are stuck on who gets into the international book trade as the correct representative.

The identity claims of Fourth World groups are different from those of new immigrants. In the cultural *conformity* of Fourth World groups there are plenty of attitudes which would be extremely helpful to the problems that a developed postindustrial capitalism is confronting. As long as one knows that those are provisional claims and as long as a persistent critique is generated within those movements, I think identity claims there are fine. We have to take the risk of not having an absolutist standard.

In my piece "Acting Bits" I have already commented on Toni Morrison's consideration of Native Americans. I am extremely heartened to see that in bell hooks's new book, *Black Looks*, there is a very strong and careful consideration of the Red/Black. I was interested to see the very

book that helped me to think this through cited in hooks's bibliography: Jack D. Forbes's *Black Africans and Native Americans: Color, Race, and Caste in the Evolution of Red-Black Peoples*. I wrote a review essay on it three years ago which is just out in *Plantation Society*. In her new book there are moves toward a transnational vision. In Cornel West's new book, in the opening section, he talks about his experience in Addis and what it is to be a New-World African. I think that these things are getting into the arena. The identity arena is not what it used to be, although there is indeed a great deal of racism and a great deal of competition going on, not only in the academy but outside. Living in New York you cannot avoid it. Nonetheless, I think among academic intellectuals that competition is weakening.

We have to look at Africa as post colonial. From the writings of people like Ngũgĩ, of course, we already have got a lot of this, but this is now something that is also being considered in the debate over Afrocentrism within black American writing today. I know that there are very strong voices against that—I remember, to my great desolation, being called a racist when I had asked a Nigerian woman to share something with me because we were both British ex-colonials. I think there are signs that that sort of thing is now in the past.

And the final thing that I would say is that now, especially new immigrants, but also old immigrant groups—I think we should examine our own racism. I myself am Indian, and certainly Indians, as I have written elsewhere, are basically white-identified, for reasons that are as historical as anything. And I have to examine my own. I'm of course, with every bit of my conscious thinking, every bit of my work, in all of my interventions, strongly, fundamentally, and in every way anti-racist. But history is larger than personal goodwill. Therefore I think we must confront the possibility that in what we produce there may be residual elements that can give fuel to the other side. I would say to other new immigrant intellectuals that they should look very carefully at what they produce. Vigilance is absolutely necessary. And in terms of that vigilance, it is agency, accountable reason, that we are talking about, not some sort of cultural difference. The day for that is over, in my estimation. Is that okay as an answer?

GM: Again I am very impressed by your ability to close.

GCS: Well, of course these are questions about which I have some passionate curiosity. All right, should we go on to the next question? (Postscript: Since this conversation, my work has shown me that we must formulate new ideas of nationalism, postcoloniality, and multiculturalism in terms of

298

the diversified, centuries-old imperial history of the Commonwealth of Independent States and the Russian Federation. Another area of effort in ignorance.)

DL: I see no reason not to.

DL and GM: There seems to be a new ecological turn in your recent work, an engagement with the work of Vandana Shiva, for instance, as well as a gesturing toward human cultures and ecosystems threatened by development that represent for most people living in the West almost unthinkable radical alterity. Development for profit and ecological wastage also continue on our very doorsteps in the United States, of course. Have you any suggestions for getting ecology more firmly on the agenda of cultural studies?

GCS: Yes, yes I do. I'm not going to be able to develop it for us today. But I can indicate some lines which will remain cryptic, unfortunately, not because they are not developed in my mind, but because I need more time in order to elaborate them. And in fact, I've been making attempts. Last night, the talk that I gave at the New York Art Institute was, I think, a stage in that attempt. And, the way I work, since I learn as I write, someone's going to have to push me. Unfortunately, I was taping that talk, but my tape-recorder wasn't working. I think someone in the audience taped it, and so I'm hoping that her tape actually is a good tape. So it could get somewhere, but who knows? [Laughter.] [Postscript: No tape yet.]

But it seems to me that we should look at Melanie Klein's work, reading it away from the permissible narratives within which Klein herself worked, and certainly within which Kleinians have worked, looking at it not in terms of the actual clinical practice, but reading it as a text *in* the interpretation of narrative as ethical instantiation. I have written about this in my essay called "Echo," which is perhaps included in the *Reader?* Yes, all right. Now, let's take a look at that: her rewriting, her situating of Oedipus, and rewriting of the making sense of human life in terms of the primary object and its connection with the fact that a major transcendental figuration of our falling into time is birth. All human beings are born, whereas the idea of Oedipus is anthropologically fixated. Freud had to construct a kind of fantasmatic history where polytheisms and Greek goddesses had to end in *Moses and Monotheism*, so that Oedipus and the fight between brothers could be at the beginning of history. Those of us who are from active polytheisms find this a little unnerving, but nonetheless! So, that had to be prehistory for Freud.

The general fact of having mothers and being born is not susceptible

to that kind of stuff. This can be seen as romanticizing motherhood. But the primary object is only incidentally tied to the Mother, just as for Kant the only available example of a rational being is Man. My way of reading is for use. I do not excuse Melanie Klein for the permissible narrative of her era, as I fully expect I will not be excused for the permissible narratives within which I am, around the corners of which I cannot see. But I don't accuse her and make her useless. I run with what in my time seems to be useful. Freud tries to push away the transcendental figuration of the gift of time as birth. He says, for example, that the real model of the fear of the uncanny is the door of that place where we all have been, the mother's genitals. His explanatory model remains generally unconvincing because the story is a permissible narrative. In Melanie Klein, the explanatory model is incredibly powerful, because of the universal availability of the transcendental figuration. Discussions of nationalism which dismiss preimperialist nation-sentiments as nostalgia and want to start all real discussions of nationalism from what they call the Enlightenment imposition are structurally similar to Freud's need to write polytheism off as prehistory. The Kleinian model speculates on the transcendental figuration of the gift of time as land, the coming together of mother and land. For Klein the primary object is capable of taking on both plus and minus. The responsibility to nature can have an itinerary comparable to Reparation in Klein. The idea of a mother-debt, an understanding of the gift of temporalization as a debt, which is not payable back to the mother, but in fact, paradoxically, constantly payable as responsibility to others. Klein's idea of reparation is very closely tied to this one. We are not very far from responsibility to Nature as alterity. By contrast, Eurocentric notions of thinking ecology in terms of limited resources ties ecology to the calculus of logical self-interest, small "r" reason, and so we cannot make it accountable for everyone. But this other one, this other sense of being responsible to nature as figured that way, that's a way in which at least one can begin.

I used to be rather strongly suspicious of psychoanalytic cultural criticism. I am beginning to realize more and more that it was really my repulsion from those sort of Freudian diagnostic impulses without any attempt at analytic engagement. I saw in the recent *Diacritics* talk about bringing transference into psychoanalytic cultural criticism. How the hell would you bring transference into this? This is my question. Transference will become another word. But in terms of Klein, public intervention is much more possible: it's not like saying "unconscious motivation" and always trotting out Reich. Public intervention here is more possible, because the arena of transcendental figuration is way beyond the construction of a system based on an initial mistake made by the male child, because,

uncommonsensically, the male child knows his genitals, the female child doesn't!

We are not talking about global activism; you've asked your question well, in terms of the "agenda of Cultural Studies." since Cultural Studies, a *very* large section of it, has already bought into psychoanalytic cultural studies, perhaps even the "most sophisticated" side of it, I will work at ecological consciousness this way, I think. Does that seem like an answer?

DL: An unexpected answer! [Laughter.]

GCS: An unexpected answer, hmm. Well, but I mean I have already said too much, because, you know, the work is still very fragile. But on the other hand, Jacqueline Rose has raised some of these issues already, her book on Klein and war is already in proofs [*Why War? Psychoanalysis, Politics and the Return to Melanie Klein* (Oxford: Blackwell, 1993)]. So it's not that, you know, it's just—

DL: So that's where she went with her interest in race and rights?

GCS: Indeed. It's a natural trajectory. I did not go into Klein with any kind of prearranged formula. I really wanted to read her as, you know, a person who had demonized the breast. [Laughter.] So that was where I was *at.*

Let me say something else here, talking about the breast. Considerations of the female body within cultural studies, which is a very important issue indeed, should also try to look at this responsibility-based approach to the ecological in general. I think this connection is not to be overlooked. It also seems to me that this can help us expand the idea of rights over a woman's body. We don't want to think about the fact that the sexually segregated, functional structures in other cultural formations which were not significant agents in capitalism, did not necessarily divide into public and private, did not necessarily divide into domestic and civil. There are other gendered divisions—I'm not romanticizing "other" cultures—but they're not, in fact, domestic and civil and public and private. When we look at the question of the rights over a woman's body being dramatized necessarily and correctly for us in the right to abortion, there we tend to forget something. We do not see that the motivation, the absolutely correct motivation, for abortion within *our* cultural formation comes from the fact that we are a consumer society. So that the idea of saddling women with child after child, because of some notion of marriage as built on love, or motherhood built on love, and so on, is in fact reprehensible, because childrearing is not only time-consuming, but indeed resource-consuming. Proper childrearing is resource-consuming.

Those societies which have not acceded to consumption and are the vic-tims of financialized international population control should not be asked to think of this as their general goal, when in fact what we can learn from them is another attitude toward the ecobiome.

It seems to me that with those kinds of questions, so that we do not identify our culture-specific understanding of woman as the global goal, in all of these arenas considerations of transnational ecological problems are extremely important, and we should not there confine our ecological investigations either to the limited-resources problematic or to the question of entry into state power. This is not the case outside, and I believe I have written about this in essays that may be found in the *Reader*. So it seems to me that these concerns are part of the agenda of feminist transnational literacy. Is that an answer? How is this interview going so far?

DL and GM: Wonderfully? [Laughter.] We wouldn't know.

GCS: Well, we'll see. Is the tape still running? Yes. Well, this is a question coming from "General Motors." [Laughter.]

GM: That's it. I was struck, rereading the interview with Ellen Rooney, by what seems like a constant engagement with Roland Barthes and his 1968 essay on "The Death of the Author." What is the place of Barthes in your thinking and reading?

GCS: I was actually reading that essay right then for my revised piece on Salman Rushdie.

GM: I wondered because—

GCS: Yes. So, one is always engaged by something one is reading? Yes, yes, yes. So, yes, I—

GM: And I might not have noticed it had I not taught it the day I was read-ing—

GCS: Yes, you see—so, yes, it is a localized interest, then. I've never written on Bakhtin. Therefore, I realize, I have written on Derrida and Foucault, whom I know much better, and I have even touched on Lacan, whom I know less well but certainly I know somewhat. As for Barthes, I don't know Barthes that well, but the way I use stuff, you know, I run a mile with a little bit, so Barthes gets into the pores, but three moments. One of them is that "Death of the Author" piece, which is actually there, rather

nicely, I hope, as far as my understanding goes, in the argument which opens my Salman Rushdie piece in *Outside in the Teaching Machine*. The other one is Barthes's notion of the writeable, which I absolutely refuse to call the writerly, in spite of Richard Howard's translation, and which I think is extremely useful. I use it all the time, in a somewhat idiosyncratic way, to make available the notion of something like general textuality which writes us but which we cannot read as such. And I also like very much—and I don't even know if I'm being correct; just one floor below me sits a very world-famous Barthes specialist, Antoine Compagnon, and I'm quite sure he'd think I was making mistakes right and left, but it's the Barthes I use, small "b," if you like—I like very much the move from semiology to semiotropy into semioclasty. I believe it's in the Collège de France inaugural lecture. I think that sums up the career of many of these people, who were less up-front about it, who began in a kind of aftermath, in the wake of structuralism, and then slowly saw that structuralism losing its ground. Barthes, a major player, sees it very clearly. So he moves into semiotropy, and then, in that last move, to semioclasty. I think that's a lovely trajectory. So, that moves me.

Let me put in something here, because I heard only the other day a talk in New York, where once again it was said with *confidence* that Foucault and Lacan and Derrida reduced everything to language. I don't think these people who are sort of working with speed-reading and criticism by hearsay have tumbled onto the fact yet that these three names, and a general movement after structuralism, was precisely to *question* the privileging of language and to *question* the notion that the best way to understand everything was to reduce it to sign-systems. This is something that I think has still to be brought to people's attention. I think in the case of Derrida that the word "text," although it has been the robust notion of text, coming from textile, *texere*, rather than the already secondary text, verbal text; although this has been explained in one way or another for the last thirty years, the criticism-by-hearsay groups still launch this as a regular kind of very holier-than-thou [laughter] kind of critique—constantly!—in terms of, you know, "Why aren't you at the picket lines?" the answer to which, or the first answer, is, "How about you?" But after that, one can try to unravel that reduction of "text" to "just language."

I think in the case of Lacan, that early essay, which later he kind of took back in *A Jakobson*, of the unconscious being structured like a language, has done its own bit. But at any rate, I just wanted to put this in here, because it just seems to be such a massive scandal that these identifications should still be made. All right. Shall we go on?

GM: In the first run of Outside in the Teaching Machine "PLEASE INSERT

BENGALI POEM HERE" was printed on page 186—

GCS: —on page 186. You can even say here, "Chorus!"

GM:—in the essay "The Politics of Translation." On the same day that I was planning to teach this page as an instance of postmodern textuality—

GCS: If I may quote you from our telephone conversation, your description was much more vigorous and interesting [laughter]—a pomo joke!

GM: You told me that Jean Franco had correctly recognized it to be a horrendous error, one that resulted in the first run being withdrawn and a new corrected page tipped in. How do you teach United States students unfamiliar with the script to read the correct version?

GCS: Well, I don't really teach United States students unfamiliar with the script to read this correct version. I mean, if it could have been published as *both* the pomo joke and the correct version, that would have been—I didn't think about it, but I think people would also have dismissed it as somewhat frivolous. But the thing is that—I don't think in fact there was a "please" on that page, was there?

DL and GM: Yes.

GM: We were very careful.

GCS: The thing is, I think of the fact that there *are* plenty of Bengali-reading Americans. In fact many of them would be the natural readership of a book by a Bengali person.

GM: Right. And that was true of that piece when it first came out in the United Kingdom collection—

GCS:—the collection by Michèle Barrett, edited by Anne Phillips and Michèle Barrett. Yes, it did have it. And so to an extent I put those things in there because of critics who are trying to question the so-called essentialism—that word again—of European standards; I *must* say, that as a specialist in Brit. lit. I find it extremely offensive when I see European standards called essentialized. I don't think we have anything to gain by trivializing the opposition either way. It seems to me that if you want to take on an extremely massive enemy you ought to take on the enemy in its dominant, dynamic, and spectacular form rather than reflect your own

bogus ignorance by calling it essentialized, especially in academic writing. I'm not talking about what we need to do when we are actually working *for* identity. That's a completely different arena. But in academic writing quite often, well not quite often, sometimes, there is a certain kind of essentializing of Other writing. You know what I mean? And this reflects most strongly in a carelessness about the linguistic specificity of the Other writing. Of course, that piece is even *about* such carelessness. And therefore, in fact, I provide for the *many* Bengali-reading United States readers. And in fact, a *minuscule* portion of them are not Bengali by origin— I am thinking of the South Asia Center in Chicago which has produced a very *good* Bengali grammar, one that's useful for not only non-Bengali-origin Americans, but useful also in fact for people who want to learn Bengali without going through the old grammars that we read in school. I think of my friend, Clinton Seely, who has written a thesis on Jibananda Das: I would very much like him to share the point and for others to have to do a little bit of investigating. Not so much a pomo joke, then, but a multiculti joke, a serious joke.

I had in "Echo" a footnote which was just two lines of Bengali poetry. Now this footnote will be incomprehensible to non-Bengali readers. Now, in order for me to explain this footnote, I would in fact reduce the power of the footnote to a zilcho. You may include the world zilcho [laughing]— in fact, "an zilcho"—in the interview. To an extent that is also my way of pointing at what the arrogance of multiculturalism quite often forgets, that there are very strict limits to multiculturalist benevolence. You see what I mean? So there is that as well. And in fact it is also something about translations, that one has to perceive that every translation—necessary but impossible—is also impossible. In fact, a translation is always an imperfect solution of a problem—as is the original, in another way. So it's also all of that, all of that.

GM: It's simply interesting that the concept of the correct version—

GCS: Oh yes, that issue is perfect, that issue is perfect.

GM:—when it's not correctable by the reader, it could be your laundry list.

GCS: That's right, but who is the reader, is my question?

GM: That's why that question is very awkward, isn't it—

GCS: In fact, the person who is perhaps *my* privileged reader, my mother, who has a 1937 M.A. in Bengali literature. And I think, to an extent, it is

appropriate that there is such a person around. You know what I mean? She kind of sees, and she certainly is subtle enough, being herself Indian-American—in fact, being also the grandmother and now the great-grand-mother of some—the great grandpeople are not yet able to read—but a grandmother of some Indian-Americans who would be incapable of reading my handwriting. Therefore, to her the problem is very clearly visible.

DL: You mention Raymond Williams's essay "The Bloomsbury Fraction" in your reading of *Sammy and Rosie Get Laid*. In spite of the very different contributions of people like the late E. P. Thompson, Gareth Stedman Jones, and Ernesto Laclau and Chantal Mouffe to an understanding of social relations as fractured, relational, fraught with multiple and some-times contradictory identifications and interests—as "fractional," in short—why is it that much of this complexity gets lost when it comes to dealing with decolonized/neocolonial spaces? How much is attributed to the legacy of Orientalism within imperialism, and how much to the inappropriateness of the Euroamerican fractional models?

GCS: Marvelous. I think the model itself is fine. It's just that when you set it to work, you *ignore* all those things. I must say that not all colonial historians ignore it. We are not talking here about colonial historians in that collection of names. Not all colonial historians ignore it. And certainly, there are people in what is the Center for Transnational Studies now, in Chicago, who are capable of looking at it both in a European context and in the post-colonial context. But I think the answer to your first question is a simple yes. I think it is the problem of the legacy of Orientalism within imperialism. And I think it is reflected in the kind of Orientalism that simply thinks that the other side is all unfractioned good. And, in fact, I *have* pointed at this in another essay which has only been published in Swedish. I have pointed out there that this kind of crude national identity is regularly used by the development agencies to justify themselves in front of all kinds of opposition and also in front of benevolent people who share this kind of Orientalist presupposition. Well, you know, when one says "the Somalis asked for it," "the Indians asked for it," "the Bangladeshis asked for it"—in fact, nobody ever asks "*what* Somalis?," "*what* Bangladeshis?" And of course the opposition is always then described as a kind of monstrous enemy-of-the-people type thing. And so it goes beyond just the critics you have mentioned.

It seems to me that, like Orientalism, it reflects an *incredibly* violent political program. It reflects and covers up. But I wouldn't say it is inappropriate. In fact, the Subalternists have done a lot of work on that notion of fractions; it is somewhat different from Raymond Williams's, but

nonetheless the notion of fractions has been used quite interestingly *and* critiqued. So, when you set it to work outside of its so-called appropriate context, there are different ways of doing this. One is to *apply* it; the Other then is lost. I will not name people here, but I have seen some work precisely on Southeast Asia which has this tendency. If you set it to work, with a view also to testing the theory and seeing where resistances come up, I would think it very useful, because you have what you have, and you are going with it, but you are prepared to lose it all—it's like investing in venture capital. I know about this, because at a certain point, I was encouraged by people active in the postcolonial field to sink some cash in a [laughing] miracle membrane for cleaning water. What good it would do! I then thought that I could afford perhaps to lose $2,500. And indeed I lost it! That's how you use these theories. Ready to jettison them. You know what I mean? [Laughter.]

DL: Students frequently ask if the fact that Bhubaneswari's suicide was "misread" by contemporaries and subsequent generations who hear her story, but read, even reconstructed, by you as an "ad hoc, subaltern rewriting of the social text of *sati suicide*" means that the subaltern *can* be read and represented by the attentive, complicitous critic. Would this turn then be the final flourish of the essay's critique of Foucault and Deleuze for disingenuously claiming that because the oppressed can represent themselves, they, as intellectuals, need not represent oppressed (subaltern) groups but simply let them "speak for themselves"?

GCS: I think in a sense it does, it does have that sort of implication. And I feel that, again, to say it again, that Bhubaneswari had tried *damned* hard to represent herself. Because don't forget that on the other side was that whole involvement with the armed guerilla group against nationalism. And talking about gender *in* nationalism, there is a great deal of talk about it these days. I had only looked at it in terms of *sati*. In fact, it deserves notice also as an intervention in the field of gender and nationalism. She *had* tried to represent herself, through self-representation of the body, but it had not come through.

So, to repeat what I have said before, subaltern insurgency, and this is a moment of that, *is* an effort to involve oneself in representation, *not* according to the lines laid down by the official institutional structures of representation. Most often it does not catch. That is the moment that I am calling "not speaking," distinguishing it from the general condition of subalternity where all the speech acts exchanged in subalternity are only accessible to oral history, or a discursive formation different from the investigation. The reason why I learned something from *Subaltern Studies*, and

what they do is much more complicated than what I do, was that I saw that they were trying to attend to the subaltern when all the texts that were available were from the other side. So, in a sense, my text is also a text from the other side. What would be the alternative? The alternative would be to privilege the unexamined mode of catching living subalterns for the international book trade—unexamined mode, hmm? Subaltern history then would fall within that unrealistic notion of parliamentary representation—unrealistic and incomplete because parliamentary representation at least involves "working for." And, so, nobody would do anything. And therefore, the alternative of *not* attending to the subaltern past with all of its difficulties would be not to attend to it at all. So, to an extent, yes, it is necessary to learn how to attend. And you make mistakes. Big deal. One is making mistakes all the time. Yes, I would agree.

Let me say, however, that that passage that has been quoted by so many respected, and justifiably respected, radical critics as the sign of Marx's implacable racism, or classism, or whatever the hell it is—"They cannot represent themselves"—is such a *profoundly* ironic passage as it is used by Marx. I'm surprised that critics of stature have not taken the trouble to read all of that complicated essay, *Eighteenth Brumaire*, carefully enough to know that one doesn't fault Marx on *that* one. There were plenty of problems with Marx's attitudes because they were also within his permissible narrative. But not that phrase. I just wanted to get that said here, since we are talking about people not being able to represent themselves. On the other hand, you know, working *for* the subaltern is precisely to bring them, *not* through cultural benevolence, but through extra-academic work, into the circuit of parliamentary democracy. Because the subaltern, any subaltern anywhere, is today, de jure, a citizen of some place or the other. So this is something that has to be kept in mind. Working for the contemporary subaltern really means putting one's time and skills on the line so that this can happen. Even as we try to learn from and keep alive the rules and fragments of a compromised responsibility-based cluster of attitudes with which the general problems that we confront in postindustrial societies can be critiqued, and perhaps in some remote, impossible future, even solved; even as we try to keep them alive, we cannot forget that working for the subaltern *means* the subaltern's insertion into citizenship, whatever that might mean, and thus the undoing of subaltern space.

From my point of view, that piece in *Socialist Review*, "Can the Subaltern Vote?," which was written by people generally friendly to me, was an interesting piece, because by provisos in various kinds of constitutions, they *can*. And the writing of the new constitution of South Africa certainly also makes this a consideration. And let me say that in that

arena, the feminist constitutionalists, not only in South Africa, but in Southern Africa in general, have confronted the enormous problem, given a largely subaltern electorate and the problems with customary law, of rewriting—not inventing, I don't want Hobsbawm's word there, but *rewriting*—reconceiving customary law in such a way that tradition can become a vehicle of change. In order to confront the internalized gendering of the subaltern female, in order for their entry into citizenship, that effort is really something that *all* so-called global feminists should look at very carefully, without confusing their own internalized gendering for the lineaments of the feminine as such.

And what was the other question?

DL: The other question was that when we arrived in New York today, our friend Doug Henwood, of *Left Business Observer*, said that he had heard from his friend who reads the French press, that Derrida has said, and it's in all the French papers, that it's time to reread Marx. He hadn't any texts so—

GCS: Oh yes, it's coming out quite soon. It's coming out from Routledge—it's called *The Spectres of Marx*. *Les Spectres de Marx* is out in French.

DL: So this is a finished book that's about to appear?

GCS: Yes. It's coming out from Galilée now. And in Peggy Kamuf's translation from Routledge. Routledge has bagged that. [Laughter.] And he gave it as a talk in Riverside in April. He's given it as a talk before. But I heard it for the first time in Riverside, and then he gave it again as a talk in New York. So, you don't have to go to French references. He gave it as a talk in New York on October 7. But Derrida has never really been against reading Marx.

DL: No. I think of the comment "waiting to have the right protocols of reading."

GCS: I really don't want to say a flip thing against my dear friend, ally, and in many ways, although I have never been technically his student, he is in many ways my teacher, Jacques Derrida. [Laughter.] But for those of us who are *constantly* reading Marx [laughing], you know, I am very glad that he has said it so strongly. When was the time to stop reading Marx?

GM: And when did he stop?

Gayatri Chakravorty Spivak
A Checklist of Publications

In compiling the following list of Spivak's publications in English, we have attempted to include all the reprintings. We have not, however, examined copies of every work cited and would welcome notice of any errors or omissions.

1995

"At the *Planchette* of Deconstruction is/in America," in Anselm Haverkamp, ed., *Deconstruction is/in America: A New Sense of the Political*, New York: New York University Press, pp. 237–49.

"Empowering Women?," *Environment* 37:1 (1995), pp. 2–3.

Imaginary Maps: Three Stories by Mahasweta Devi, trans. by Spivak, New York: Routledge and Calcutta: Thema.

"Supplementing Marxism," in Bernd Magnus and Stephen Cullenberg, eds. *Whither Marxism? Global Crises in International Perspective*, New York: Routledge, pp. 109–19.

1994

"Återbesök i den globala byn," in Oscar Hemer, ed., *Kulturen i den globala byn*, Lünd: Aegis Förlag, pp. 165–88.

"Bonding in Difference," in Alfred Arteaga, ed., *An Other Tongue: Nation and Ethnicity in the Linguistic Borderlands*, Durham, N.C.: Duke University Press, pp. 273–85.

"In the New World Order: A Speech," in Antonio Callari, Stephen Cullenberg, and Carole Biewener, eds., *Marxism in the Postmodern Age: Confronting the New World Order*, New York: Guilford Press, pp. 89–97; to be reprinted in *Rethinking Marxism*, forthcoming.

"Introduction," in Harriet Fraad, et al., eds., *Bringing It All Back Home: Class, Gender, and Power in the Modern Household*, London: Pluto Press, pp. ix–xvi.

"Response to Jean-Luc Nancy," in Juliet Flower MacCannell and Laura Zakarin, eds., *Thinking Bodies*, Stanford: Stanford University Press, pp. 32–51; reprinted as "Psychoanalysis in Left Field; and Field-Working: Examples to Fit the Title," in Michael Münchow and Sonu Shamdasani, eds., *Speculations After Freud*, London: Routledge, 1994, pp. 41–75; reprinted as "Examples to Fit the Title" in *American Imago* 51:2 (Summer 1994), pp. 161–96.

"'What Is It For?': Functions of Postcolonial Criticism," *Nineteenth-Century Contexts* 18, pp. 1–8.

1993

"Echo," *New Literary History* 24:1 (Winter 1993), pp. 17–43; to be reprinted in E. Ann Kaplan, ed., *Psychoanalysis and Culture Studies*, London: Verso, forthcoming.

"Excelsior Hotel Coffee Shop," *Assemblage* 20 (April 1993), pp. 74–75.

"Foundations and Cultural Studies," in Hugh J. Silverman, ed., *Continental Philosophy V: Questioning Foundations: Truth/Subjectivity/Culture*, New York: Routledge, pp. 153–75.

"An Interview with Gayatri Chakravorty Spivak," Sara Danius and Stefan Jonsson, *boundary 2* 20:2 (Summer 1993), pp. 24–50.

Outside in the Teaching Machine, New York: Routledge.

"Race Before Racism and the Disappearance of the American: Jack D. Forbes's *Black Africans and Native Americans: Color, Race and Caste in the Evolution of Red-Black Peoples*," *Plantation Society in the Americas* 3:2 (Summer 1993), pp. 73–91.

"Situations of Value: Gayatri Chakravorty Spivak on Feminism and Cultural Work in a Postcolonial Neocolonial Conjuncture," Pheng Cheah, *Australian Feminist Studies* 17 (Autumn 1993), pp. 141–61.

1992

"Acting Bits/Identity Talk," *Critical Inquiry* 18:4 (Summer 1992), pp. 770–803; to be reprinted in anthology edited by Rajeev Patke, National Singapore University, forthcoming.

"Asked To Talk About Myself...," *Third Text* 19 (Summer 1992), pp. 9–18.

"The Burden of English," in Rajeswari Sunder Rajan, ed., *The Lie of the Land: English Literary Studies in India*, Delhi: Oxford University Press, pp. 275–99; reprinted in Carol Breckenridge and Peter van der Veer, eds., *Orientalism and the Postcolonial Predicament: Perspectives on South Asia*, Philadelphia: University of Pennsylvania Press, 1993 and Delhi: Oxford University Press, forthcoming, pp. 134–57.

Entry on Bookwork, *Jamelie/Jamila Project* by J. Hassan and J. Ismail, North Vancouver: Presentation House Gallery.

"Extreme Eurocentrism," *Lusitania* 1:4, pp. 55–60.

"French Feminism Revisited: Ethics and Politics," in Judith Butler and Joan W. Scott, eds., *Feminists Theorize the Political*, New York: Routledge, pp. 54–85; reprinted in *Outside*.

"More on Power/Knowledge," in Thomas E. Wartenberg, ed., *Rethinking Power*, Albany: State University of New York Press, pp. 149–73; reprinted in *Outside*.

"The Politics of Translation," in Michèle Barrett and Anne Phillips, eds., *Destabilizing Theory: Contemporary Feminist Debates*, Cambridge: Polity Press, pp. 177–200; reprinted in *Outside*.

"Teaching for the Times," *MMLA: The Journal of the Midwest Modern Language Association* 25:1 (Spring 1992), pp. 3–22; to be reprinted in Jan Nederveen Pieterse, ed., *Decolonizing the Imagination*, forthcoming.

Thinking Academic Freedom in Gendered Postcoloniality, Cape Town: University of Cape Town Press.

1991

"Identity and Alterity: An Interview," *Arena* 97, pp. 65–76.

"Marxist Feminism," *Frontier* 23:24 (26 January), pp. 17–19.

"Neocolonialism and the Secret Agent of Knowledge: An Interview with Gayatri Chakravorty Spivak," *Oxford Literary Review* 12:1–2, pp. 220–51.

"Not Virgin Enough To Say That [S]he Occupies the Place of the Other," *Cardozo Law Review* 13:4 (December 1991), pp. 1343–48; reprinted in *Outside*.

"Once Again a Leap into the Postcolonial Banal," *differences* 3:3 (Fall 1991), pp. 139–70 (with commentary by Joan Scott); reprinted as "How To Read a 'Culturally Different' Book," in Francis Barker, Peter Hulme, and Margaret Iversen, eds., *Colonial Discourse/Post-Colonial Theory*, University of Manchester Press, 1994, pp. 126–50.

"Reflections on Cultural Studies in the Post-Colonial Conjuncture," *Critical Studies* 3:1–2 (Spring 1991), pp. 63–78.

"Theory in the Margin: Coetzee's *Foe* Reading Defoe's *Crusoe/Roxana*," in Jonathan Arac and Barbara Johnson, eds., *Consequences of Theory: Selected Papers of the English Institute, 1987–88*, Baltimore: The Johns Hopkins University Press, pp. 154–80; reprinted in *English in Africa* 17:2 (October 1990), pp. 1–23.

"Time and Timing: Law and History," in John Bender and David E. Wellbery, eds., *Chronotypes: The Construction of Time*, Stanford: Stanford University Press, pp. 99–117.

1990

"Constitutions and Culture Studies," *Yale Journal of Law and the Humanities* 2:1 (Winter 1990), pp. 133–47; reprinted in Jerry D. Leonard, ed., *Legal Studies as Cultural Studies: A Reader in (Post)Modern Critical Theory*, Albany: State University of New York Press, 1995, pp. 155–74; reprinted in *Outside*.

"Gayatri Spivak on the Politics of the Subaltern," *Socialist Review* 20:3 (July–September 1990), pp. 85–97.

"Inscriptions: of Truth to Size," catalogue essay for *Inscription* by Jamelie Hassan, Regina: Dunlop Art Gallery, pp. 9–34; reprinted in *Outside*.

"An Interview with Gayatri Spivak," *Women in Performance*, 5:1, pp. 80–92.

"Interview with *Radical Philosophy*," *Radical Philosophy* 54 (Spring 1990), pp. 31–34.

"The Making of Americans, the Teaching of English, and the Future of Culture Studies," *New Literary History* 21:4 (Autumn 1990), pp. 781–98; reprinted in *Outside*.

The Post-Colonial Critic: Interviews, Strategies, Dialogues, ed. Sarah Harasym, New York: Routledge.

"Poststructuralism, Marginality, Postcoloniality, and Value," in Peter Collier and Helga Geyer-Ryan, eds., *Literary Theory Today*, Cambridge: Polity Press, pp. 219–44; reprinted in *Sociocriticism* 10 (1989), pp. 43–81; reprinted in *Outside*.

"Rhetoric and Cultural Explanation: A Discussion," with Phillip Sipiora and Janet Atwill, *Journal of Advanced Composition* 10:2 (Fall 1990), pp. 293–304.

"Woman in Difference: Mahasweta Devi's 'Douloti the Bountiful,'" *Cultural Critique* 14 (Winter 1989–90), pp. 105–28; reprinted in Andrew Parker, Mary Russo, Doris Sommer, and Patricia Yaeger, eds., *Nationalisms and Sexualities*, New York: Routledge, 1992, pp. 96–117; reprinted in *Outside*.

1989

"Colloquium on Narrative" (interview), *Typereader* 3 (December 1989). pp. 21–38.

"Feminism and Deconstruction, Again: Negotiating with Unacknowledged Masculinism," in Teresa Brennan, ed., *Between Feminism and Psychoanalysis*, London: Methuen, pp. 206–23; reprinted in *Outside*.

"In Praise of *Sammy and Rosie Get Laid*," *Critical Quarterly* 31:2 (Summer 1989), pp. 80–88; reprinted in *Outside*.

"In a Word. *Interview*," with Ellen Rooney, *differences* 1:2 (Summer 1989), pp. 124–56; reprinted in *Outside*.

"An Interview with Gayatri Spivak," Lukas Barr, *Blast Unlimited* 1 (Summer 1989), pp. 6–8.

"Naming Gayatri Spivak" (interview), *Stanford Humanities Review* 1:1 (Spring 1989), pp. 84–97.

"Negotiating the Structures of Violence: A Conversation with Gayatri Chakravorty Spivak" (interview), *Polygraph* 2–3 (Spring 1989), pp. 218–229; reprinted in *The Post-Colonial Critic*.

"The New Historicism: Political Commitment and the Postmodern Critic" (interview), in H. Aram Veeser, ed., *The New Historicism*, New York: Routledge, pp. 277–92; reprinted in *The Post-Colonial Critic*.

"The Political Economy of Women As Seen by a Literary Critic," in Elizabeth Weed, ed., *Coming to Terms: Feminism, Theory, Politics*, New York: Routledge, pp. 218–29.

"Reading *The Satanic Verses*," *Public Culture* 2:1 (Fall 1989), pp. 79–99; revised and expanded version in *Third Text* 11 (1990), pp. 41–69; reprinted in Maurice Biriotti and Nicola Miller, eds., *What Is an Author?*, Manchester: Manchester University Press, 1993, pp. 103–34; shortened version to be printed in Nigel Wheale, ed., *The Postmodern Arts?*, New York: Routledge, forthcoming; reprinted in *Outside*.

"Who Claims Alterity?" in Barbara Kruger and Phil Mariani, eds., *Remaking History*, Dia Art Foundation Discussions in Contemporary Culture No. 4, Seattle: Bay Press, pp. 269–92; to be reprinted in Heloisa Buarque de Hollanda, ed., *Feminism As Cultural Critique*, Rio de Janeiro: CIEC, forthcoming.

"Who Needs the Great Works? A Debate on the Canon, Core Curricula, and Culture," *Harper's* 279:1672 (September 1989), pp. 43–52.

1988

"Can the Subaltern Speak?" in Cary Nelson and Larry Grossberg, eds., *Marxism and the Interpretation of Culture*, Urbana: University of Illinois Press, pp. 271–313; reprinted in Patrick Williams and Laura Chrisman,

eds., *Colonial Discourse and Post-Colonial Theory: A Reader*, New York: Harvester/Wheatsheaf, 1994, pp. 66–111.

"The *Intervention* Interview," *Southern Humanities Review* 22:4 (Fall 1988), pp. 323–42; reprinted in *The Post-Colonial Critic*.

"A Literary Representation of the Subaltern," in Ranajit Guha, ed., *Subaltern Studies V: Writings on South Asian History and Society*, New Delhi: Oxford University Press, pp. 91–134; reprinted in *Worlds*.

"Practical Politics of the Open End: An Interview with Gayatri Chakravorty Spivak," Sarah Harasym, *Canadian Journal of Political and Social Theory* 12:1–2, pp. 51–69; reprinted in *The Post-Colonial Critic*.

"A Response to 'The Difference Within: Feminism and Critical Theory,'" in Elizabeth Meese and Alice Parker, eds., *The Difference Within: Feminism and Critical Theory*, Amsterdam and Philadelphia: John Benjamin, pp. 208–20.

"A Response to John O'Neill," in Gary Shapiro and Alan Sica, eds., *Hermeneutics: Questions and Prospects*, Amherst, Mass.: University of Massachusetts Press, pp. 183–98.

Selected Subaltern Studies, edited with Ranajit Guha, New York: Oxford University Press.

1987

In Other Worlds: Essays in Cultural Politics, New York: Methuen.

"The Post-Colonial Critic: Interview with Gayatri Chakravorty Spivak," with Rashmi Bhatnagar, Lola Chatterjee, and Rajeswari Sunder Rajan, *The Book Review* 11:3 (May–June), pp. 16–22; reprinted in *The Post-Colonial Critic*.

"Postmarked Calcutta, India," interview with Angela Ingram, November, 1987; reprinted in *The Post-Colonial Critic*.

"Speculations on Reading Marx: After Reading Derrida," in Derek Attridge, Geoff Bennington, and Robert Young, eds., *Post-Structuralism and the Question of History*, Cambridge: Cambridge University Press, pp. 30–62.

1986

"Imperialism and Sexual Difference," *Oxford Literary Review* 8:1–2, pp. 225–40; reprinted in Clayton Koelb and Virgil Lokke, eds., *The Current in Criticism: Essays on the Present and Future of Literary Theory*, West Lafayette: Purdue University Press, 1988, pp. 319–37; reprinted in Robert Con Davis and Ronald Schleifer, eds., *Contemporary Literary Criticism: Literary and Cultural Studies*, New York: Longman, 1989, pp. 517–29.

"Interview with Patrice McDermott," *Art Papers* 10:1 (January–February 1986), pp. 50–52.

"The Problem of Cultural Self-Representation" (interview), *Thesis Eleven* 15, pp. 91–97; reprinted in *The Post-Colonial Critic*.

"Questions of Multiculturalism," with Sneja Gunew, in *Hecate: An Interdisciplinary Journal of Women's Liberation* 12: 1–2 (1986), pp. 136–42; originally broadcast on Australian Broadcasting Commission Radio National on 30 August 1986, on "The Minders," produced by Penny O'Donnell and Ed Brunetti; reprinted in Mary Lynn Broe and Angela Ingram, eds., *Women's Writing in Exile*, Chapel Hill: University of North Carolina Press, pp. 412–20; reprinted in *The Post-Colonial Critic*.

"Strategy, Identity, Writing" (interview), *Melbourne Journal of Politics* 18 (1986/87); reprinted in *The Post-Colonial Critic*.

1985

"Can the Subaltern Speak? Speculations on Widow-Sacrifice," *Wedge* 7/8 (Winter/Spring 1985), pp. 120–30.

"Feminism and Critical Theory," in Paula A. Treichler, Cheris Kramarae, and Beth Stafford, eds., *For Alma Mater: Theory and Practice in Feminist Scholarship*, Urbana and Chicago: University of Illinois Press, pp. 119–52; reprinted in Robert Con Davis and Ronald Schleifer, eds., *Contemporary Literary Criticism: Literary and Cultural Studies*, 2nd ed., New York: Longman, 1994, pp. 519–34; reprinted in *Worlds*.

"The Rani of Sirmur: An Essay in Reading the Archives," *History and Theory* 24:3, pp. 247–72; reprinted in Francis Barker, et al., eds., *Europe and Its Others*, Colchester: University of Essex Press, pp. 128–51.

"Scattered Speculations on the Question of Value," *Diacritics* 15:4 (Winter 1985), pp. 73–93; reprinted in *Worlds*.

"Strategies of Vigilance" (interview), *Block* 10, pp. 5–9.

"Subaltern Studies: Deconstructing Historiography," in Ranajit Guha, ed., *Subaltern Studies IV*, New Delhi: Oxford University Press, pp. 330–63; to be reprinted in Jessica Munns and Gita Rajan, eds., *Cultural Studies: An Anglo-American Reader*, London: Longman, forthcoming; reprinted in *Selected Subaltern Studies* (1988), pp. 3–32, and in *Worlds*.

"Three Women's Texts and a Critique of Imperialism," *Critical Inquiry* 12:1 (Autumn 1985), pp. 243–61; reprinted in Henry Louis Gates, Jr., ed., *"Race," Writing, and Difference*, Chicago: University of Chicago Press, 1986, pp. 262–80; reprinted in Catherine Belsey and Jane Moore, eds., *The Feminist Reader: Essays in Gender and the Politics of Literary Criticism*, Oxford: Blackwell, 1989, pp. 175–95; reprinted in Diane Price Herndl and Robyn Warhol, eds., *Feminisms: Gender and Literary Studies*, New Brunswick, N.J.: Rutgers University Press, 1991, pp. 789–814; revised extract reprinted in Fred Botting, ed., *Frankenstein*, London: Macmillan, 1995, pp. 235–60; to be reprinted in Bill Ashcroft, et al., eds., *A Reader in Post-Colonial Theory*, London: Routledge, forthcoming.

1984

"Criticism, Feminism, and the Institution," interview with Elizabeth Grosz, *Thesis Eleven* 10/11 (1984–85), pp. 175–87; reprinted in *The Post-Colonial Critic*.

"Description and Its Vicissitudes," review article on Marc Eli Blanchard, *Description, Sign, Self, Desire: Critical Theory in the Wake of Semiotics*, *Semiotica* 49: 3/4, pp. 347–60.

"Love Me, Love My Ombre, Elle," *Diacritics* 14:4 (Winter 1984), pp. 19–36.

1983

"Displacement and the Discourse of Woman," in Mark Krupnick, ed., *Displacement: Derrida and After*, Bloomington: Indiana University Press, pp. 169–95; reprinted in Antony Easthope and Kate McGowan, eds., *A Critical and Cultural Theory Reader*, Toronto: University of Toronto Press, 1992.

"Marx After Derrida," in William E. Cain, ed., *Philosophical Approaches to Literature: New Essays on Nineteenth- and Twentieth-Century Texts*, Lewisberg, Penn.: Bucknell University Press, pp. 227–46.

Review essay on Beatrice Farnsworth's *Aleksandra Kollontai*, *Minnesota Review*, new series 20 (Spring 1983), pp. 93–102.

"Some Thoughts on Evaluation," in *CLAM Chowder*, Mark Axelrod, et al., eds., Minneapolis: Comparative Literature Association of Minnesota, pp. 203–12.

1982

"The Politics of Interpretations," *Critical Inquiry*, 9:1 (September 1982), pp. 259–78; reprinted in W. J. T. Mitchell, ed., *The Politics of Interpretation*, Chicago: University of Chicago Press, pp. 259–78; to be reprinted in Esther Fuchs, ed., *Feminist Hermeneutics: A Multidisciplinary Approach*, forthcoming; reprinted in *Worlds*.

1981

"'Draupadi' by Mahasweta Devi," *Critical Inquiry* 8:2 (Winter 1981), pp. 381–402; reprinted in Elizabeth Abel, ed., *Writing and Sexual Difference*, Chicago: University of Chicago Press, 1982, pp. 261–82; reprinted in *Illustrated Weekly of India*, 3:29 (July 20–26, 1991), pp. 24–26; reprinted in Dilip K. Basu and Richard Sisson, eds., *Social and Economic Development in India: A Reassessment*, New Delhi and Beverly Hills: Sage, 1986, pp. 215–40; reprinted in *Worlds*.

"French Feminism in an International Frame," *Yale French Studies* 62, pp. 154–84; reprinted in Camille Roman, Suzanne Juhasz and Christanne Miller, eds., *The Women and Language Debate: A Sourcebook*, New Brunswick: Rutgers University Press, pp. 101–04; reprinted in *Worlds*.

"Il faut s'y prendre en s'en prennant à elles," in Phillipe Lacoue-Labarthe and Jean-Luc Nancy, eds., *Les Fins de l'homme*, Paris: Galilée, pp. 505–16.

"Reading the World: Literary Studies in the Eighties," *College English* 43:7 (November 1981), pp. 671–79; reprinted in G. Douglas Atkins and Michael L. Johnson, eds., *Writing and Reading Differently: Deconstruction and the Teaching of Composition and Literature*, Lawrence: University Press of Kansas, 1985, pp. 27–37; reprinted in *Worlds*.

"Sex and History in *The Prelude* (1805), Books Nine to Thirteen," *Texas Studies in Literature and Language* 23:3 (Fall 1981), pp. 324–60; reprinted in Richard Machin and Christopher Norris, eds., *Post-Structuralist Readings of English Poetry*, Cambridge: Cambridge University Press, 1989, pp. 193–226; reprinted in *Worlds*.

1980

"A Dialogue on the Production of Literary Journals, the Division of the Disciplines, and Ideology Critique with Professors Gayatri Spivak, Bill Galston, and Michael Ryan," *Analecta* 6, pp. 72–87.

"Finding Feminist Readings: Dante-Yeats," *Social Text* 3 (Fall 1980), pp. 73–87; reprinted in Ira Konigsberg, ed., *American Criticism in the Poststructuralist Age*, Ann Arbor: University of Michigan Press, 1981, pp. 42–65; reprinted in *Worlds*.

Review essay on Robert R. Magliola, *Phenomenology and Literature: An Introduction*, *Modern Fiction Studies*, 15:4 (Winter 1979/80), pp. 758–60.

"Revolutions That As Yet Have No Model: Derrida's 'Limited Inc.,'" *Diacritics* 10:4 (Winter 1980), pp. 29–49.

"Three Feminist Readings: McCullers, Drabble, Habermas," *Union Seminary Quarterly Review*, 35:1–2 (Fall–Winter 1979–80), pp. 15–34; to be reprinted in *Critical Essays on Carson McCullers*, Boston: G. K. Hall, forthcoming; reprinted in *Worlds*.

"Unmaking and Making in *To The Lighthouse*," in *Women and Language in Literature and Society*, ed. Sally McConnell-Ginet, et al., New York: Praeger, pp. 310–27; reprinted in *Worlds*.

1979

"Explanation and Culture: Marginalia," *Humanities in Society* 2:3 (Summer 1979), pp. 201–22; reprinted in *Out There: Marginalization and Contemporary Cultures*, Russell Ferguson, et al., eds., New York: New Museum of Contemporary Art and Cambridge, Mass.: MIT Press, 1990, pp. 377–93; reprinted in *Worlds*.

1978

"Anarchism Revisited: A New Philosophy," *Diacritics* 7:2 (Summer 1978), pp. 66–79, with Michael Ryan.

"Feminism and Critical Theory," *Women's Studies International Quarterly* 1, pp. 241–46; reprinted in *Worlds*.

1977

"*Glas*-Piece: A Compete-Rendu," *Diacritics* 7:3 (Fall 1977), pp. 22–43.

"The Letter as Cutting Edge," *Yale French Studies* 55–56, pp. 208–26; reprinted in Shoshana Felman, ed., *Literature and Psychoanalysis: Reading Otherwise*, New Haven: Yale University Press, 1982, pp. 208–26; reprinted in *Worlds*.

1976

Of Grammatology, translation by Spivak with critical introduction of Jacques Derrida, *De La Grammatologie*, Baltimore: Johns Hopkins University Press.

1975

"Some Theoretical Aspects of Yeats's Prose," *Journal of Modern Literature* 4:3 (February 1975), pp. 667–91.

1974

"Decadent Style," *Language and Style* 7:4 (Fall 1974), pp. 227–34.

Myself Must I Remake: The Life and Poetry of W. B. Yeats, New York: Thomas Y. Crowell.

1973

"Indo-Anglian Curiosities," *Novel* 7:1 (Fall 1973), pp. 91–93.

"A Look to the Future," *The Grinnell Magazine* (November–December 1973), pp. 15–16.

1972

"A Stylistic Contrast Between Yeats and Mallarmé," *Language and Style* 5:2 (Spring 1972), pp. 100–07.

"Thoughts on the Principle of Allegory," *Genre* (December 1972), pp. 327–52.

1971

"Allégorie et histoire de la poésie: hypothèse de travail," *Poètique* 8 (1971), pp. 427–44.

1970

"Versions of a Colossus," *Journal of South Asian Literature* 6 (1970), pp. 31–37.

1968

"'Principles of the Mind'": Continuity in Yeats's Poetry," *Modern Language Notes* (December 1968), pp. 282–99.

1965

"Shakespeare in Yeats's 'Last Poems,'" *Shakespeare Commemoration Volume*, Taraknath Sen, ed., Calcutta: Presidency College, pp. 243–84.